MAKING STRANGE

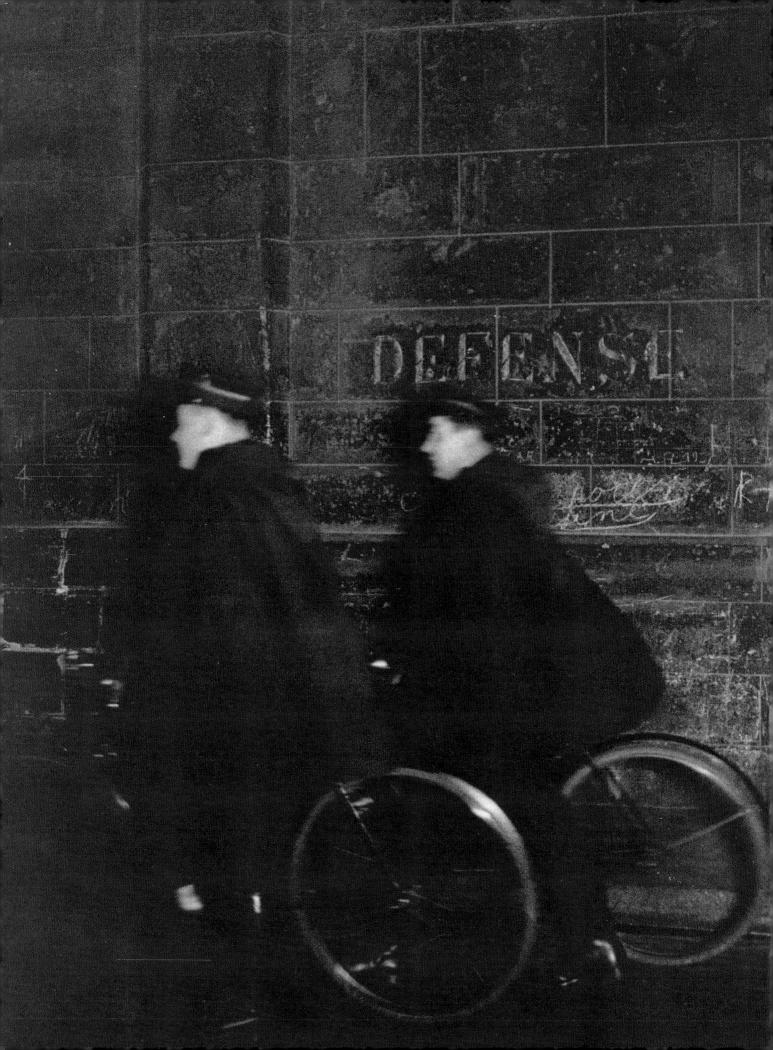

MAKING STRANGE

THE MODERNIST PHOTOBOOK IN FRANCE

KIM SICHEL

YALE UNIVERSITY PRESS NEW HAVEN AND LONDON

Publication of this book has been aided by a grant from the Millard Meiss
Publication Fund of CAA.

yalebooks.com/art

Designed by Leslie Fitch and Jeff Wincapaw

Cover designed by Jeff Wincapaw

Set in Crimson type by Jeff Wincapaw

Printed in China by 1010 Printing International Limited

Library of Congress Control Number: 2019940769

ISBN 978-0-300-24618-6

A catalogue record for this book is available from the British Library.

This paper meets the requirements of ANSI/NISO Z39.48-1992
(Permanence of Paper).

10 9 8 7 6 5 4 3 2 1

On the cover: (front) Pierre Jahan, *Rome capitule* (fig. 59, detail);
(back) from Germaine Krull, *Métal* (fig. 6)

Frontispiece: Brassaï, Cyclist Police (fig. 40, detail)

In loving memory of Susan Erda,
the world's greatest bibliophile

CONTENTS

ACKNOWLEDGMENTS

Any project such as this owes a debt of gratitude to a vast community of people who help to make it possible. In some ways my fascination with the magic of both large and small photography books dates back to my teenaged discovery of Henri Cartier-Bresson's *The Europeans* and Roy DeCarava's *The Sweet Flypaper of Life* on my uncle's bookshelf in New York. My interest in interwar Paris continues undiminished since my years living, working, and researching there in the late 1970s and 1980s, when photography first recaptured public attention in France. Colleagues, curators, librarians, and fellow booklovers around the world have helped to research, advise, and assist in the completion of this book, including Mitra Abbaspour, Stuart Alexander, Sylvie Aubenas, Karl Baden, Quentin Bajac, Anne-Catherine Biedermann, Joanne Bloom, Anne Botella, Ami Bouhassane, Clément Chéroux, Michèle Chomette, Elizabeth Cronin, Malcolm Daniel, Nanni Deng, Francine Deroudille, Delphine Desveaux, Annette Doisneau, Dierdre Donoghue, Ute Eskildsen, Michel Frizot, Kristen Gresh, Karen Haas, Anne Havinga, Manfred Heiting, Christine Hult-Lewis, André Jammes, Katherine Kominis, Olivier Lacroix, Anjuli Lebovitz, Russet Lederman, Linde Lehtinen, Karolina Lewandowska, Yuri Long, David Maisel, Sarah Meister, Aude Raimbault, Gabrielle Reed, Philippe Ribeyrolles, Richard Riis, Michael Shulman, Agnès Sire, Petra Steinhardt, Catherine Tambrun, Anne Tucker, Ivan Vartanian, Dominique Versavel, and Robert Zinck.

The manuscript first saw the light of day during a Senior Faculty Fellowship at the Boston University Center for the Humanities, and I particularly appreciate the contributions of my colleagues there, especially Mary Beaudry, Brooke Blower, Susan Mizruchi, Alice Tseng, and James Winn. Other colleagues at Boston University who have contributed ideas and assistance include Ross Barrett, Cynthia Becker, Jodi Cranston, Fred Kleiner, William Moore, Gregory Williams, and Michael Zell, as well as Susan Rice and Chris Spedaliere. Among long-term friends and colleagues who have supported this project through all of its stages, I especially want to thank Susan Mizruchi, Christine Poggi, Françoise Reynaud, Susan Maycock, Sally Zimmerman, and Rebecca Taniguchi.

Students in my photobook graduate seminars at Boston University contributed greatly to the development of my thinking, especially Leslie Brown, Jacquelyn Canevari, Kimber Chewning, and Tessa Hite, and I also want to thank my research assistants, Lauren Graves and Lydia Harrington. At Yale University Press, I am grateful to the anonymous readers for the Press, and to Amy Canonico, Heidi Downey, Laura Hensley, Mary Mayer, and Raychel Rapazza, who have supported this project with enthusiasm and patience. For publication assistance, I am grateful to the Millard Meiss Publication Fund of the College Art Association, the Boston University Center for the Humanities, and the Humanities Research Fund, College of Arts and Sciences, Boston University.

Finally, none of this could have happened without Alexandra, David, and Richard Brown, who patiently encouraged endless side trips and conversations during the last three years as this book took shape.

INTRODUCTION

When I pick up Brassaï's *Paris de nuit* (1932), I see a modest paperbound volume held together with a black metal spiral binding that recalls a middle-school notebook today, but that epitomized the absolute latest fashion in bindings in 1932. The book is small enough to hold in my hands, with a page resting open in each palm. The binding allows the pages to lie flat, or even to curve backward, and the gravure printing is so dense that black ink comes off on my fingers. That darkness extends to the very edge of each page; I see no white border around the images. Not only are they inky-black, but the facing pages are sutured together by the spiral rings running through a series of holes puncturing each photographic image. The inside cover, unlike the marbled decorative paper of older books, presents on each side a continuous abstract image of nighttime cobblestones, photographed in a sinuous, curving pattern of square stone forms separated by dark shadows (figure 1). It is simultaneously flat and curved, geometric and representational, static and moving, rational and mysterious. Each page is the size of a real cobblestone, and when I move the book, the image undulates, echoing an uneven walk on a bumpy street. These stones divulge nothing about where the street is, who inhabits it, or why

it is worth studying, but its pattern mesmerizes me, and my physical interaction with the volume is visceral.

The same is true for many of the books that form the subject of *Making Strange: The Modernist Photobook in France*. Some are oversize and must be held like an unwieldy package, others have pages that are not bound but that float freely out of portfolio cases to disrupt their ordering, and several are interwoven with experimental type and fonts that become active players in the book, dancing with the photographs. Most of these volumes are printed in the gravure process on matte paper; their black layers of ink create an almost three-dimensional richness to the page. Reading these books is much more a physical experience than is eyeing the elegant, stationary glossiness of today's industry-standard art books, and the experience is much more haptic than scanning an electronic book, visible only on a screen.

In this book I examine the golden age of French modernist photography books, the late 1920s to the late 1950s. Focusing on the avant-garde experiments in text and imagery in France, the book brings a fresh perspective to the field by seeing the photobook through the lens of materiality—as an object, one with which the

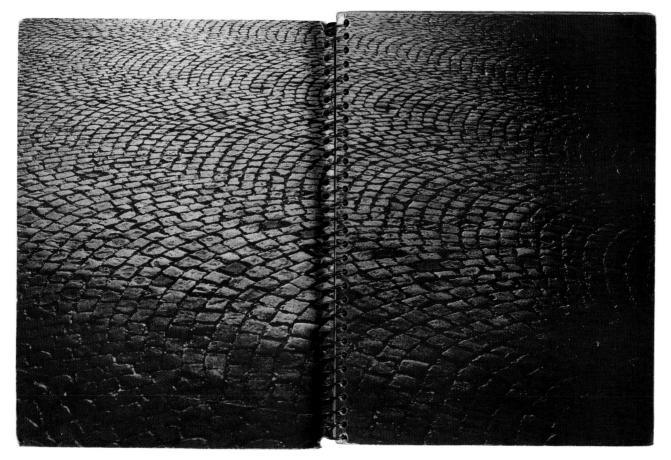

FIGURE 1 Inside cover, Cobblestones, from Brassaï, *Paris de nuit* (Paris: Arts et Métiers Graphiques, 1932). Gravure, page: 10 × 7½ in. (25 × 19.3 cm).

viewer-reader has constant interaction. Design innovations dovetailed with changes in technology and with trenchant cultural commentary to construct the modern photobook. Although the heyday of Parisian publications has passed, these photobooks have influenced generations of artists and are newly relevant today. Innovations in early twentieth-century French photographic book conception and construction cast a long shadow that has been surprisingly understudied until now.

The international publishing scene in Paris from the 1920s through the 1950s served as an experimental arena for now-canonical modernist photographers, including Brassaï, Henri Cartier-Bresson, and Germaine Krull, creators of innovatively designed photographic books whose worldwide impact radiated from Paris. The photography books that emerged during this period create a dynamic, almost wordless modernist language that embodies the political and cultural upheavals of these four decades. The books differ markedly from the travel guidebooks, family albums, scientific typologies, and memorials that had dominated photographic book publishing from the 1850s until World War I. Starting in 1928, these new volumes incorporate the new artistic, cultural, and philosophical ideas of the interwar and postwar eras. The books subvert the conventional narrative method. Using deliberately disorienting multilayered and modernist strategies, photographers worked with publishers and designers to create volumes that are wholly designed collaborative objects, with innovative uses of ink, graphics, and image layout. In France, the books not only pleased the avant-garde but sold briskly to a larger commercial audience as well. Additionally, they enjoyed wide international critical acclaim.

The pictorial language of these modernist books also had a broader impact on larger cultural issues. Through the formal advances of these seminal books, readers absorbed the complicated French reactions to wider events of the mid-twentieth century: post–World War I

reconstruction, the Depression, collaboration and loss during World War II, French nostalgia at the end of its imperial dominance, and the start of the Cold War. By contextualizing basic topics of French identity in a modernist framework, these books reenergize older tropes: the dynamism of the Machine Age, a nostalgia for the individual humanism of French citizens, a belief in supposedly independent thinkers unconstrained by material circumstance (*flâneurs, clochards,* and workers), and an argument for the superiority of French/European Enlightenment thought. The books experiment with montage fragmentation in the roaring 1920s, incorporate dream detective imagery in the Depression-era 1930s, add poetic and elegiac forms during the war-torn 1940s, and deliberately revert to a more narrative yet nostalgic picture-story form in the geopolitical conflicts of the early and mid-1950s. The later 1950s see a return to disruption and fragmentation, but in a more volatile form.

In Paris, bookmaking obsessed not only the most celebrated photographers, such as Brassaï, Cartier-Bresson, and Krull, but also such lesser-known or younger figures as Pierre Jahan, Robert Doisneau, Roger Parry, and Moï Ver. Each chapter of *Making Strange* centers on one decade and one or two volumes that exemplify a particular modernist approach. Krull's *Métal* (1928) displays photographic fragments of industrial imagery, organized according to the nonlinear principles of 1920s film montage rather than according to a static scientific typology. In the following decade, rejecting the older format of conventional city guidebooks, Brassaï's *Paris de nuit* of 1932 offers dreamlike sequences that can be related both to Surrealism and to the detective-novel imagery of the 1930s, as theorized by Pierre Mac Orlan and others. Jahan's *La mort et les statues,* published in 1946, after four years of German occupation, upends the photographic memorializing conventions that one might expect in the aftermath of a world war. Jahan's book, a documentation of melting Parisian monuments for German ammunition, exemplifies a new mode of elegy that creates an imaginary memorial in a poetic yet disturbing style. In 1952 Cartier-Bresson's celebrated volume *Images à la sauvette* (*The Decisive Moment*) was a comment on postwar geopolitical upheavals and French resistance to them; the book transforms conventional family albums into universal nostalgic picture-stories without the comforting memories and narratives of linked names and places, and it constructs an opposition between familiar European norms and non-European global cultures that

are visually controlled. This innovative period in publishing ends with a final set of more explosive projects in the late 1950s, when Paris ceded its central role in innovative publishing to New York and Tokyo. Two French books mark this end point. Robert Delpire's publication of Robert Frank's *Les Américains* (1958) is an uneasy travelogue or ethnographic study, as it transitions towards the clean American formalism of many later Museum of Modern Art books (white page on the left and photograph on the right). William Klein's *Life Is Good and Good for You in New York: Trance Witness Revels* (1956) displays a jagged, jarring cacophony, leading the way to the explosion of 1960s experimental Japanese photobooks by the *Provoke* movement photographers.

THE RESONANCES OF *MAKING STRANGE*

My title, *Making Strange,* carries multiple resonances from the 1920s through the 1950s. The notion of strangeness or alienation in the modern urban world dates to the early twentieth century, when the German sociologist Georg Simmel wrote his seminal essays, "The Stranger" and "The Metropolis and Mental Life." In examining the "inner meaning of specifically modern life," Simmel argues that the "psychological basis of the metropolitan type of individuality consists in the intensification of nervous stimulation which results from the swift and uninterrupted change of outer and inner stimuli." This is in contrast to Baudelaire's more positive nineteenth-century urban observer, the flâneur, who joyfully "enters into the crowd as though it were an immense reservoir of electrical energy." Simmel defines the disorienting impressions of the metropolis less positively: "The rapid crowding of changing images, the sharp discontinuity in the grasp of a single glance, and the unexpectedness of onrushing impressions. These are the psychological conditions which the metropolis creates." For Simmel, the proper response is to become "blasé because it agitates the nerves to their strongest reactivity for such a long time that they finally cease to react at all."[1] But whereas Simmel, writing in 1903, argued for reserve to protect against the overwhelming impressions of the city, photographers in France in the interwar years reveled in cacophony, and their work builds on the disorientation that it creates.

The title *Making Strange* also derives from the Russian Formalist Viktor Shklovsky's theory of "estrangement" (*ostranenie*), a technical device that reanimates perception of well-known forms. Shklovsky coined the term

"ostranenie" in a 1917 essay, "Art as Technique," in which he describes methods to observe the world in a new and sometimes troubling way. This term has been translated in different ways, as "defamiliarization," "estrangement," "enstrangement," and "making strange." *Making Strange* also refers to the defamiliarizing montage structures of avant-garde Soviet films, which were viewed by the photographers discussed here, and to the writings of Sergei Eisenstein and Dziga Vertov, with which they were familiar. The German playwright Bertolt Brecht would advance the term in 1935, seven years after *Métal*'s publication, coining the notion of *verfremdungseffekt* (alienation effect), the technique used to enliven performances by having actors step out of character or by creating surprising or unusual stage effects.[2]

The concept of "making strange" has strong French roots as well, primarily in the Surrealist writings of André Breton, Georges Bataille, and their colleagues. Breton explored a Freudian interpretation of the unconscious, and he developed the Surrealist definition of the "uncanny"—derived from the marvelous, objective chance, and convulsive beauty. Bataille had a more disturbing worldview, best expressed in his concept of *bassesse* (base materialism). Photography's role in Surrealism was never overtly discussed during the 1920s and 1930s; Breton mentioned it only in 1962.[3] The first study of the uncanny in Surrealism and photography came in the groundbreaking 1985 Corcoran Gallery of Art exhibition *L'Amour fou: Photography and Surrealism* (organized by Rosalind Krauss and Jane Livingston) and more recently by scholars such as Dawn Ades, Simon Baker, Clément Chéroux, Hal Foster, Ian Walker, and others. Whereas Foster thoroughly explores the aesthetic and historical roles of the Surrealist "uncanny" in France, as "a concern with events in which repressed material returns in ways that disrupt unitary identity, aesthetic norms, and social order," Walker addresses photographic books, and their uses of realism within the Surrealist project, but he works solely within their Surrealist context rather than the larger popular culture world.[4]

While Surrealist links to art photography have received much attention, the impact of the uncanny or "making strange" effect has been little explored in the wider popular culture of French modernity, except for Robin Walz's *Pulp Surrealism: Insolent Popular Culture in Early Twentieth-Century Paris,* which explores transgressions in the popular press but not photography.[5]

However, even in the time when these books were made, widely read French authors participated in the dialogue about disruptions and disorder in contemporary life, and the primary voice in this discourse is Pierre Mac Orlan, although his impact has been less explored until recently. Mac Orlan was one of the major French critics writing about photography during this period. His criticism, popular writings, and novels developed the idea of the "social fantastic," a concept exploring the unsettling juxtapositions of daily life that create unease and a sense of menace.[6] This menace would find a political voice in Albert Camus's *L'étranger,* published in 1942 in the midst of the war, but looking ahead to the existential unease and colonialist struggles of France in the 1950s.

Defamiliarization took on a whole new meaning during and after World War II, when photography was one tool to express unimaginable events such as the gas chambers and atomic bombs. Although atrocity photographs were published in the journalistic press, bearing witness to the events of the war, they were not made into books in France; it would, as Sharon Sliwinski writes, "take several decades for this visual testimony to settle into understanding."[7] In the meantime, either through metaphor or through abstraction, photographic books lamented the loss of life, global upheaval, and chaos that the war left behind. A whole body of books emerged to play on a new notion of nostalgia, trying to visually rebuild an older generation's society that had changed forever.

Others engaged with the postwar end of European colonialism, and in particular the end of French imperialism—most former colonies in Asia and Africa became independent by the late 1950s, with Algeria the last in 1962. Photographers lauded French culture in numerous books, or contrasted European norms with non-Western ones in book structures that visually froze or controlled places and citizens in places of turbulent, changing governmental structures. In his famous essay on Camus's *L'étranger,* Jean-Paul Sartre brilliantly encapsulates the framing of disorder and order: "*The Outsider* is a classical work, an orderly work, composed about the absurd and against the absurd. . . . How are we to classify this clear, dry work, so carefully composed beneath its seeming disorder, so human, so open, too, once you have the key? . . . It might be regarded as a moralist's short novel."[8] Sartre's writings on colonialism also contributed to this construction, framing the French response to the end of imperialism. Finally, by the middle and end of

the 1950s, a language of fragmentation, disruption, and cacophony even more extreme than that of the interwar period emerged, building upon the materials of photography itself—negatives, dust, scratches on film, and grainy super-enlargements.

The period discussed in *Making Strange* ends in 1958, just before the major social and political transformations of the 1960s. In his essay "Postmodernism and Consumer Society," Fredric Jameson correlates the end of modernist culture with the global transition from classic capitalism to a new economic order of postindustrial or consumer society capitalism, and he marks that moment of change in France as the establishment of the Fifth Republic in 1958, the year that this study ends. Tom McDonough also sees the late 1950s as a key transitional moment in French cultural history, defined by the turn from French Surrealist and Brechtian montage practices to the notions of the cultural appropriation technique of *détournement,* and to the writings of Guy Debord (a great fan of Mac Orlan's writings). As McDonough observes, détournement suggested "the need to struggle for control of the sign's use, its range of reference, and the meaning it would assume in specific, conjunctural instances."[9] But in this new struggle, beautifully designed photographic books began to look too aestheticized in France, though their legacy would resonate elsewhere around the world in the political uprisings of the 1960s.

In addition to its theoretical representations, estrangement is also a cultural and historical phenomenon: it reflects the onslaught of the mechanized Industrial Age, the economic and cultural displacement of poverty, the disorientation of wartime experience, and angst at the global disconnects of political shifts in mid-century Europe. Whether seen through the prism of sociological definition, literary criticism, history, or popular writing, the period from the end of World War I to the end of the 1950s is defined by unease and imbalance, and it is this period that corresponds with the height of twentieth-century modernism.

BOOK CULTURE

The study of photographic books and their tactile qualities is a lively field today, and renewed interest in their materiality may partly be a nostalgic response to the twenty-first-century arrival of electronic publishing. In his 1931 Berlin essay "Unpacking My Library," the German critic Walter Benjamin captures many of the tactile and sensuous qualities of book-owning and book-handling. A true book lover, Benjamin revels in the dust and piles of books he unearths, and he recognizes that "the whole background of an item" is relevant—"the period, the region, the craftsmanship, the former ownership." He appreciates the physical quality of holding a book: "One has only to watch a collector handle the objects in his glass case. As he holds them in his hands, he seems to be seeing through them into their distant past." Benjamin, who wrote frequently and powerfully about the role of photography, does not address photographic books explicitly in this essay, but he relishes the very personal quality of holding and experiencing any volume. But in the era of mechanical reproduction and beyond, his words can also be taken as guidelines to valuing the photographic book as distinct from the photographic print as a single object.[10]

For photography books, even more than for the texts Benjamin collected, the act of physically holding and manipulating the pages is key to their experience.[11] Reading photography books is a personal, tactile, and individual experience, assuming a different dimension for each reader. In the interwar years, when photography books first became widely popular and economically feasible for the general public, these elements were as much a part of their history as the methods of reproduction, the subjects they represented, and the sequence of images they presented. As anthropologist Arjun Appadurai has written, the "concrete, historical circulation of things" is replete with meanings "inscribed in their forms, their uses, their trajectories." These books had a rich cultural life that encompassed their creation, their fully developed physical forms, their uses, and their travels from reader to reader, from country to country. Close formal readings of the physical objects themselves, encompassing modernist texts, images, layout, typography, design, usage, and multiple editions, give us many clues to their complex webs of meanings in early and mid-century Europe.[12]

French photographic books are a firmly modernist enterprise in another realm as well: each evinces a unified creative vision. The books that stand out tend to be driven by a strong authorial voice. Usually the photographer provides the narrative, but at times the editor's vision emerges, and there is often an active collaboration between photographer and editor, and sometimes a textual author. Books in which a writer's voice takes precedence over images tend to belong to another genre, which we might term the "photographically illustrated

book" rather than the "photographic book." This project deals with the latter, image-based form—the photographic book—and part of my aim is to demonstrate that books are in many ways more central to photography's universal message than single prints in exhibitions or periodicals.

Commercial photographic books with large print runs construct an enormously powerful cultural language. They exhibit a narrative pattern by their sequencing, creating a wholly separate category of artistic and cultural commentary. Books are more accessible and have greater physical longevity than single, framed prints hung on gallery or museum walls. Books also last longer than shows: an exhibition might showcase photographs in one city during one month or season, but the books these photographers produced have had a much broader audience. They were printed in large editions and then passed from hand to hand, decade to decade, continent to continent, and they survive today in a new century—sometimes in well-worn and dog-eared copies that physically show the mark of time and use. The other mass-production vehicle for photography, the picture magazine, shares the book's democratic dissemination, but magazines are by their very nature ephemeral. The newsprint pages of magazines—even those with enormous print runs such as the French *VU,* German *Berliner Illustrierte Zeitung,* or American *Life*—are easily damaged, destroyed, or thrown away. In contrast, photographic books are built to last, and the 1920s marks the beginning of their mass production and marketing. *VU'*s innovative layout and design, in particular, became an enormously important force driving experimental photography books.

These books share an adventurous format that began to proliferate in Paris around the time that *VU* first appeared on newsstands in 1928. Three photographic reproductive printing processes also became much more affordable or popular during this time. An intaglio process, photogravure printing (also called *héliogravure* or gravure), allowed for the luxurious matte surfaces and inky printing of many of the century's most beautiful photographic books, first made from a flat plate and then from a cylinder (rotogravure). In 1926–27 this process was introduced in France by J.-H. Lagrange, for books roduced by the publishing house Horizons de France. A second technique, collotype, a planographic process similar to lithography, was a slightly older but elegant process used from the 1880s to about 1960 for more expensive

books. In collotypes, the random grain of the light-sensitized gelatin is invisible, unlike the grid visible in the third process, halftone offset lithography. Offset lithography, in the form of offset halftone photographic reproductions, is a form of relief printing that had been available earlier in the century but developed through the mid-1920s. This improved lithographic technique allowed books and newspapers to make nuanced reproductions at lower cost, although the most beautiful books are printed in gravure.[13]

These revolutions in reproductive photographic techniques paralleled the widely discussed revolution in physical cameras in the mid-1920s, introducing smaller cameras with high-speed lenses such as the Ermanox in 1924, the 35-mm Leica in 1925, and other newly flexible cameras that allowed for greater mobility in experimentation. I emphasize that I am not suggesting that a technological determinacy single-handedly drove the shifts in book production; rather, I believe that experimental cultural and design ideas and possibilities were in the air at a time when technical processes were available to execute them. By 1928 avant-garde book construction, production, and subjects began to change at a time when new ideas about representation were exploding, and this marks the starting point of *Making Strange.*

Finally, imaginative and supportive publishers and presses in Paris worked actively with photographers during these decades, creating collaborative works that would break previous molds. They included A. Calavas of the Librairie des Arts Décoratifs, which published dozens of portfolios of artistic subjects; Charles Peignot at Arts et Métiers Graphiques, who both commissioned innovative new typefaces and published journals and groundbreaking books; the Greek publisher in Paris, Tériade (Efstratios Eleftheriades), who branched out from journals such as *Minotaure* and *Verve* to publish books under the imprint Verve; and Robert Delpire, whose publishing company, Delpire et Cie, brought out the major series of photographic books *Neuf, Huit,* and *Encyclopédie essentielle.* Finally, Éditions du Seuil, created in 1935, referred directly to the *seuil* (threshold) and the "whole excitement of parting and arriving," a metaphor they applied to books, and an idea that Chris Marker expanded in his 1950s series of Seuil's *Petite planète* books.[14] Some of these publishers published art books and photography books, and some concentrated on photobooks uniquely.

Therefore, although they are rarely discussed in this

context, European modernist photography books fall squarely into a tradition of innovative avant-garde artists' books, beginning in the 1890s and continuing until World War II. As they were for artists' books, experimental layouts and typography were key players in the impact of French photography books. In her book *The Century of Artists' Books*, Johanna Drucker gives a clear overview of the genesis of modern artists' books and *livres d'artistes*.[15] She places their prehistory in William Blake's books in the late eighteenth century, and with William Morris's Arts and Crafts Kelmscott Press books in the late nineteenth century. The Symbolist poet Stéphane Mallarmé experimented with typography in his layout for *Un coup de dés jamais n'abolira le hazard* (first published in 1897); his book forms perhaps the most important nineteenth-century precedent for the modernist book, with its free-flowing fragments of text that travel across the pages. Mallarmé's book creates an active and empowered reader through what art historian Anna Arnar calls the "page as an electrical field."[16]

Soon after the turn of the twentieth century, further important experiments were made in text and image relationships for artists' books. The form and placement of words themselves were transformed by the Cubists (including Pablo Picasso's *papiers collés,* as well as Guillaume Apollinaire's visual play with words in his *Calligrammes* poems), Italian Futurists (Filippo Marinetti's *parole in libertà* and particularly his 1914 book *Zang Tumb Tumb*), Russian Futurists (Vladimir Mayakovsky and El Lissitzky's collaborative *For the Voice,* 1923), and Dada artists (Tristan Tzara's 1918 journal *Dada* no. 3); many of these subvert all language and text-layout logic. Innovative combinations of visual art and typography developed from these movements and found extraordinary fruition in several book-length works produced in France around World War I. One was the collaboration of painter Sonia Delaunay-Terk and writer Blaise Cendrars—*La prose du Transsibérien et de la petite Jehanne de France* (1913), a six-foot-long, accordion-pleated book with Delaunay's Cubist designs along one side and Cendrars's simultaneist poem on the other. (Cendrars would provide the text for important photobooks later in the century, such as Robert Doisneau's *La banlieue de Paris.*) A second, lesser-known example is the work of Iliazd (Ilia Zdanevich), who followed his early book experiments in Russian Georgia with a 1923 Parisian book, *Ledentu le phare*. Written in Iliazd's

invented language, zaoum, this book explodes the possibility of experimental typography; letters and words jump across the gutters and defy any linear reading. As Drucker explains, Iliazd "understood the book form and worked with it, displaying a feel for the relations between paper and page size, elements of binding, and the overall integration of conception and construction of a book."[17] Following in the tradition of Iliazd, Parisian type designers and printers such as Arts et Métiers Graphiques, as well as the printing press Draeger Frères, known for its beautiful gravure printings, would contribute greatly to innovative photography books, including many of those discussed in this volume.[18]

MODERNIST PHOTOGRAPHIC BOOKS

Making Strange aims to place modernist photographic books in the context of these textual and visual avant-garde experiments. In recent years, scholars have begun to explore the history of the photographic book, with the growing understanding that the serial and public character of photography is different from other media and lends itself particularly well to book form. My study ventures further than an encyclopedic overview, presenting deep formal and cultural readings of the books under review. Photographic books, like Mallarmé's poetry, can become an interactive book experience, allowing the reader to skim, read backward, or cherish one picture or series of pictures that resonate personally.

Photographic books are increasingly being recognized as an independent art form, and three enormous and important collections of photobooks have recently entered museum collections at the Tate Modern, the Museum of Fine Arts, Houston, and the Bancroft Library at the University of California, Berkeley.[19] Compendia of great examples of photographic books have been published in the last decade, beginning with the three-volume *The Photobook: A History* by Gerry Badger and Martin Parr, which presents a prodigious number of important photographic books and albums, from the nineteenth century to the present day. No scholar can overstate Badger's and Parr's enormous contribution to the field. Their comprehension is encyclopedic, and they attempt to organize their books by history, geography, and intentionality (authorship or editorship). They include only selected spreads of their samples, however, and, because of their overarching scope and very useful historical overviews,

they do not engage deeply either with the narrative structure or with the specific national cultures of the individual books themselves. Andrew Roth's *Book of 101 Books: Seminal Photographic Books of the 20th Century* is a similar illustrated dictionary of extraordinary books, with only two pages per entry, but with discussions by David Levi Strauss and Vince Aletti and an insightful essay by Shelley Rice. Jane Rabb's *Literature and Photography: Interactions, 1840–1990: A Critical Anthology* presents important primary sources of the many interactions between writers and photographers, but few of these writers discuss the photographic picture book per se. Finally, François Brunet's recent *Photography and Literature* attempts a more comprehensive history of books and photography, but, like Rabb's anthology, it is a broad overview; only one chapter, "Photography and the Book," directly addresses the issue of photographic books.[20] More recently, many regionally targeted surveys have been published, providing overviews of Japanese photography books, Swiss photography books, Latin American photography books, Dutch photography books, Chinese photography books, and more, including two dictionary-like overviews of French books and several studies of classic American photobooks.[21] More scholarly cultural studies have been written about some of the later American photobooks of the interwar period after 1936—such as Walker Evans's *American Photographs,* Margaret Bourke-White's *You Have Seen Their Faces,* Dorothea Lange's *An American Exodus,* and Richard Wright's *12 Million Black Voices.*[22] These studies reflect not only a new appreciation for the intersection of books and photographic messaging, but also a lively rare-book market for photographic books, especially enticing in an age when prints are becoming more and more expensive. My project both surveys French photography books but also dives into French mid-century culture, not as an overview but as a deeper formal and theoretical look at some of the most seminal books published in Paris.

Several recent anthologies have begun to address theoretical or historical readings of isolated photography books. In their introduction to *The Photo Book: From Talbot to Ruscha and Beyond,* Patrizia Di Bello and Shamoon Zamir construct a useful history of photography books, both historiographic and thematic. They acknowledge Parr's and Badger's current definition of photobooks as volumes that show design intention and coherence, as well as a primary message carried by photographs rather than words. Both *The Photo Book* and *The Photobook: A*

History define a specific genre of the photobook as distinct from an individual image, a gallery or museum exhibition, or a magazine essay. They also give an overview of the creative combination of text and image that are unique to photobooks, in which pictures drive both the theme and the structure of the whole, but symbiotically depend on the text to create a third entity greater than either medium alone. In fact, Di Bello and Zamir cite Sergei Eisenstein's 1939 essay on montage to honor the "third something" that arises when two dissimilar objects are juxtaposed.[23] Andrea Noble's and Alex Hughes's anthology, *Phototextualities: Intersections of Photography and Narrative,* also theorizes the interactions of photographs and words in individual case studies, and the collected articles in this anthology examine what they call a "post-Barthesian" moment that "in the early twenty-first century, turns on debates over space, place, memory, and identity." Although Noble and Hughes explore photo/text relationships in "the photograph albums, the photographic essay, the magazine photo-story, and the advertisement," the studies largely overlook the photographic book as an object.[24]

To understand the development of the photographic book, it is useful to follow the history of the intersection of photography and book printing. This interaction goes back as far as the invention of photography, to William Henry Fox Talbot's *The Pencil of Nature* (1844). As Carol Armstrong, Larry Schaaf, François Brunet, and Geoffrey Batchen have discussed, Talbot's book includes both photographs and a printed text, and operates as a poem to the role of aesthetic photography. Brunet suggests that the rest of the nineteenth century was devoted more to the scientific uses of photography.[25] But during these years personal albums, diaries with text, and travel narratives also abounded. Most have substantial text interspersed with tipped-in albumen prints.

Nineteenth-century photographic books, however, followed accepted narrative structures. Diaries were a common format: some were narrative stories, others told the history of a family, and a number were autobiographical albums. A second genre followed literary formats either illustrating or paralleling literary fiction. Other nineteenth-century photography books broadened their scope: photographic travel atlases mapped a particular route; scientific dictionaries categorized photographic imagery of particular scientific forms such as stars or flowers; albums collected dramatic or political celebrity

cartes de visite. What they all share is a logical structure of beginning, middle, and end, and a certain narrative plotline to relate. Even for nineteenth-century photography books, only a few scholars directly address their historical and design context. Carol Armstrong's *Scenes in a Library: Reading the Photograph in the Book, 1843–1875* gives a deep and Barthes-inspired series of readings of nineteenth-century British photobooks in context, although she concentrates more on the particularities of reading the works than on the historical contexts of their making. Douglas Nickel analyzes Francis Frith's travel books about Egypt, but in a cultural-historical monographic format.[26]

Many twentieth-century photographic books continue these honorable trends of family album, atlas, and travelogue and transform them into new languages. Photographic diaries or journals are still relevant, and Nan Goldin's account of New York in the 1970s and 1980s, *The Ballad of Sexual Dependency* (1987), is perhaps the most memorable recent example. Family albums, broadly construed, continued strongly into the mid-twentieth century, from Edward Steichen's universalizing Museum of Modern Art show and book, *The Family of Man* (1955), to Roy DeCarava's ode to Harlem, *The Sweet Flypaper of Life* (1955). Books that collect lists continue to be important; often German in origin, they become dictionaries or typologies, and the modernist genre may begin with Karl Blossfeldt's *Urformen der Kunst* in 1928, followed by recent examples such as the typologies of Bernd and Hilla Becher (1988).[27] Travelogues remained a popular genre, and they include the two great American road trip photobooks: Walker Evans's *American Photographs* (1938) and Robert Frank's *Les Américains* (1958), republished in English as *The Americans* (1959). However, extensive analyses of these single photographic books remain rare.

In recent scholarship, these two last American books have received deep formal and cultural analyses. American Studies scholar Alan Trachtenberg thoughtfully discusses Evans's *American Photographs* in his book *Reading American Photographs: Images as History, Mathew Brady to Walker Evans.* Trachtenberg is almost unique in the history of photography writings about the twentieth century; he eloquently unpacks Evans's images in their carefully conceived sequences, showing that they form a wordless photographic narrative in *American Photographs.* Trachtenberg weaves together word and image in a magisterial overview of American culture in photography books, but his analysis concentrates less on the physical

design of the books themselves. Instead, Trachtenberg approaches Evans's book from a literary point of view, writing, "With his eye for signifying detail, for the accidental revelations in juxtaposed objects, including written signs, and with his wit in laying one picture next to the other, Evans set out to prove that apparently documentary photographs could be just as complex as a fine piece of writing." He continues, observing that "not just the picture but its place within a text of pictures, its role in a well-wrought sequence, would point to an original way of seeing things." Recently, Sarah Greenough has joined this small club of in-depth book scholars, in her lyrical discussion of the jazz-like sequencing of Robert Frank's images in *Les Américains*, which will be discussed in the concluding chapter.[28]

German photography books from the interwar era are also widely seen as seminal avant-garde publications, and there are now two in-depth studies of their production and impact. In her recent book *Stop Reading! Look! Modern Vision and the Weimar Photographic Book,* art historian Pepper Stetler has insightfully analyzed Weimar-era German photographic books. Stetler convincingly argues that the Germans aimed for a structured and ordered view of the modern world through a visual language that superseded text. As I do in *Making Strange*, she looks at the collaborative authors of four seminal projects in one nation—in her case László Moholy-Nagy's *Malerei Photographie Film* (1925), Albert Renger-Patzsch's *Die Welt ist Schön* (1928), Karl Blossfeldt's *Urformen der Kunst* (1928), and Helmar Lerski's *Köpfe des Alltags* (1931). Using the theoretical writings of typographer Johannes Molzahn and artist László Moholy-Nagy, she shows us that photographs were replacing texts, much as they were in France. Stetler, however, finds German books to be in search of order; she does not believe "that photographic books sought to imitate the incoherent, fragmented nature of modern life. Rather, Weimar photographic books were inspired by the potential of modernity and called for utopian outcomes." She analyzes Renger-Patzsch's *Die Welt ist Schön* as a utopian book that "attempts to reveal formal unity among a diverse range of objects, thereby restoring a stable system of value to modernity," and sees in Blossfeldt's *Urformen der Kunst* an attempt "to establish formal continuities between past and present" to achieve a sense of "continuity and stability."[29]

In contrast to Stetler, Daniel Magilow claims that German interwar photobooks reflect both unity and

chaos. In his book *The Photography of Crisis: The Photo Essays of Weimar Germany,* Magilow argues that photographic essays participated actively in Weimar Germany's "crucial aesthetic, political, and cultural debates." He includes Werner Graeff's *Es Kommt Der Neue Fotograf!,* Albert Renger-Patzsch's *Die Welt ist Schön,* Paul Dobe's *Wilde Blumen der deutchen Flora,* August Sander's *Antlitz der Zeit,* and portrait books by Helmar Lerski, Erna Lendvai-Dircksen, and Erich Salomon. As I do, he examines the montage of texts and images together following Umberto Eco's notion of "the open work," whose meaning relies on the reader as well as the creator of the photo essay. Magilow concentrates on physiognomies that buttress German identity while sometimes highlighting nationalistic destabilization, arguing that the "physiognomic revival offered thinkers and photographers a powerful means by which to probe the roots of the chaos lurking beneath Weimar Germany's fragile façade of stability." Magilow also suggests an interwar German usage of the snapshot's "moment of decision," reasoning that it "became an important vehicle by which to affirm and critique" crisis in Weimar society.[30] That said, Magilow finds the German books—of the right and the left—to be deeply pessimistic, following Oswald Spengler's concept of the decline of the West.

Walter Benjamin, living in Paris in the 1930s, saw a French contrast to a stabilizing or reifying analysis of *Urformen der Kunst,* seeing instead a "radical conception of the relationship between history and modernity." In general, he preferred French photographers such as Germaine Krull and Eugène Atget, whom he admired for photographing Parisian streets like "scenes of a crime" that become "standard evidence for historical occurrences, and acquire a hidden political significance"; he feels these images "stir the viewer; he feels challenged by them in a new way."[31] For Benjamin, France offered photographic innovations that thrived on unsettled modernity, in contrast to Germany's attempt to reconstitute a stable order.

FRANCE AND THE PHOTOGRAPHIC AVANT-GARDE

My project follows up on Benjamin's premise, and places the genesis of avant-garde photobooks in a French, not German, setting. Although Stetler's discussion of Renger-Patzsch's and Blossfeldt's books is a convincing example of the German search for continuity in their interwar photobooks, France is very different. The French interwar and immediate post–World War II period contributed a new

genre of photobook. In writing about five avant-garde films in *The Filming of Modern Life: European Avant-Garde Films of the 1920s,* Malcolm Turvey defines cinematic "modern vision" as a language of fragmentation to reflect modern environments.[32] For Turvey, the era's multivalent cultural forces created a sense of inspired cacophony— a sensation the French had been celebrating, not fighting against, since the poetry of Apollinaire and Blaise Cendrars and the 1913 Cubist collages of Pablo Picasso. Therefore, Turvey's sense of a fragmentary modernism that reflects the speed and simultaneity of modern life is a better model for French photography books—much as it is for the French avant-garde films Turvey analyzes.

In 1928 several French photographic events occurred that marked a departure from earlier norms, loosening historical formats for more experimental options. Photographs, already a tool of Benjamin's "exhibition value," rather than exclusion or privilege, became a lingua franca in France with Lucien Vogel's innovatively designed weekly photographic news magazine, *VU,* which first appeared in March 1928. For photographers selling images to the publication, *VU*'s format allowed for freedom of composition and layout. Photographers such as Germaine Krull and André Kertész created picture-stories of just a few images, which were then paired with texts by leading writers to create loose vignettes of modern life. Although *VU* included serial stories, the compendium of short picture-stories did not add up to a hierarchical structure, and photographers were able to experiment with less narrative-based and more symbolic vignettes. Krull's May 1928 picture-story about the Eiffel Tower, with a text by critic Florent Fels, is a good example.[33] *VU*'s circulation was enormous, far greater than an avant-garde journal. These newly available, innovative printing techniques, certain kinds of modernist subject matter, and new experimental sequencing and layout techniques all coalesced to lay the groundwork for a high point for photography book publishing in France. Monographs on subjects that were appearing in *VU,* such as modernity, the Machine Age, urban life, and street life, soon blossomed in France.

Two months after the first issue of *VU,* the first modern photography exhibition in Paris opened in May 1928. The Premier Salon Indépendant de la Photographie Moderne is often nicknamed the Salon de l'Escalier because of its location in the staircase of the Théâtre des Champs-Élysées. Although more directed at an art

audience than *VU,* the Salon de l'Escalier highlighted a whole new generation of international photographers, including Laure Albin-Guillot, d'Ora (Dora Kallmuss), Germaine Krull, Berenice Abbott, George Hoyningen-Huené, André Kertész, Paul Outerbridge, and Man Ray, with "historical" antecedents of Nadar and Eugène Atget presented as precursors. The organizing committee for the exhibition included *VU* editor Vogel, along with filmmaker René Clair, writer Jean Prévost, and critics Florent Fels and Georges Charensol. All of these photographers easily crossed back and forth between commercial magazine work, avant-garde exhibition presentations, and mainstream press books, often using the same imagery.

Many of the photographers highlighted in the Salon de l'Escalier published books in these years, and the organizing committee often wrote texts for them as well. Tellingly, they were an international group; the majority of the most startling innovations were contributed by immigrants, fewer by French-born photographers.[34] Germaine Krull, the most prolific of the group, produced eight books in Paris between 1928 and 1945, Laure Albin-Guillot presented a book in 1931, and André Kertész published three volumes in 1933 and 1934. In the wake of these pioneers, other photographers such as Brassaï, Henri Cartier-Bresson, Robert Doisneau, Izis, Pierre Jahan, François Kollar, Willy Ronis, and Moï Ver followed suit in the next decades.[35] Some of the early volumes, such as Kertész's *Enfants* (1933) and *Paris vu par André Kertész* (1934), form the foundations of French humanistic photography, an affable celebration of people and of everyday life that reached its heyday in the 1950s, but the books examined here are more experimental. They are graphically innovative, culturally transgressive, and had long-ranging historical reverberations.

MONTAGE, DREAM DETECTIVES, ELEGY, NOSTALGIA

The central chapters of this book unpack the photographic sequencing, syntax, and grammar in books from several periods—the 1920s, 1930s, 1940s, early 1950s, and late 1950s. The impact of graphic design is equal to that of text and image in the meaning of these works. Each chapter examines individual case studies of specific books to see how they construct models for larger cultural trends in France.

Chapter 1, "Montage," analyzes Germaine Krull's *Métal* (1928) and other montage-based projects including Moï Ver's *Paris* (1931), the most radically abstracted montage books of the turbulent 1920s. These striking volumes,

which include almost no words, juxtapose and intercut industrial images and reform them as a series of abstract yet formally interrelated shards.[36] In *Métal,* unidentifiable metal fragments form interlocking trusses dancing in the air—visual poems of the abstract beauty of industrial metal. In some ways Krull repeats the taxonomies of nineteenth-century scientific atlases, but then she explodes them.

Informed by Cubist collage—with its splintered space and non-sequential organization of information—these books deploy Viktor Shklovsky's and Sergei Eisenstein's Soviet disruptive film montage theories. In Shklovsky's *Theory of Prose,* he writes, "There is such a thing as 'order' in art, but not a single column of a Greek temple fulfills its order perfectly, and artistic rhythm may be said to exist in the order of prose *disrupted.*" A more direct link is to Soviet filmmaker Sergei Eisenstein; Germaine Krull met Eisenstein while involved with the Dutch Filmliga and photographed him in 1926 and 1930.[37] Eisenstein demonstrates that two dissimilar objects can sit next to each other and spark a third, new idea. Krull and Moï Ver use Cubism's impact, developing film montage ideas and the popular dissemination of collage ideas to craft book-length kaleidoscopes of urban and industrial life at the end of the 1920s—constructions of fractured building blocks that develop an abstract, non-storytelling medium. These books mirror the postwar period's cacophonous industrial and urban expansion—reflecting both its enthusiasm and its anxieties.

Chapter 2, "Dream Detectives," decodes Brassaï's *Paris de nuit* (1932) compared with Roger Parry's *Banalité* (1930) and other books as examples of the 1930s mix of Surrealist dream imagery and populist detective clues. Hal Foster and other scholars have ably explored the Freudian "uncanny" in single Surrealist photographs, but the 1930s books' contextual, sequential, and serial structure have been largely ignored, as has their role as symbolic markers of economic depression in France. Pierre Mac Orlan, a contemporary French novelist and critic who coined the term "social fantastic" to describe the uncanny elements that exist in everyday life, best evokes the combinations of dreams and quotidian clues that haunt the 1930s, when economic and political upheavals pushed Surrealists and photographers into a more popular realm. For instance, rejecting the middle-class subjects of conventional city guidebooks, Brassaï's *Paris de nuit* offers dark, nocturnal views of deserted street corners and clochards warming

themselves at trash can fires under the bridges of Paris. These photographers also often utilized Surrealist dream imagery, as did André Breton's Surrealist illustrated novels, *Nadja* (1928) and *L'amour fou* (1937), but their gritty night views and fragmentary book structures can more productively be related to 1930s detective story imagery. Detective fiction's clue-finding strategies were highly popular in that decade, led by Georges Simenon's novels and photo-novels. Roger Parry's *Banalité* (1930) further blends the Surrealist and detective concepts, inserting into Léon-Paul Fargue's text photographs that depict uneasy nocturnal dreams, uncomfortable groups of found objects, and fragments of detective clues.[38]

Chapter 3, "Elegy," addresses photographic books of World War II, particularly Pierre Jahan's *La mort et les statues* (1946). Faced with the impossibility of synthesizing the atrocities of the war, Jahan creates an elegy to mangled bronze relics of war and destruction, crafting what French historian Pierre Nora has called a *"lieu de mémoire."* For Nora, "there are *lieux de mémoire,* sites of memory, because there are no longer *milieux de mémoire,* real environments of memory."[39] *La mort et les statues,* with its introductory text by poet and playwright Jean Cocteau, epitomizes crisis and mourning—both political and personal. Referring back to montage and Surrealist strangeness with a poetic series of crushed metal figures and forms, *La mort et les statues* mimics the violence of war while expressing the destruction of French culture. The book documents the bronze statues toppled and melted down for German ammunition in 1941—a highly contentious subject for the French, who had to survive the years of occupation while attempting to resist. Throughout the book, crushed fragments of statuary stand in for human corpses. *La mort et les statues* serves as a model for understanding other photography publications about the war's trauma, such as Jean Eparvier's and Roger Schall's *À Paris sous la botte des Nazis* (1945), wartime books by Lee Miller, and graphic propaganda volumes such as *KZ* (1945). The complete upheaval of Europe during World War II and the impossibility of publishing in German-occupied France between mid-1940 and the liberation of Paris in August 1944 had upended photographic memorializing conventions, creating a new mode of elegy.[40]

Chapter 4, "Nostalgia," centers on the most celebrated postwar books of the early and mid-1950s, including Henri Cartier-Bresson's *Images à la sauvette* (*The Decisive Moment*) (1952) and *Les Européens* (*The Europeans*) (1955), which were published simultaneously in France and the United States. Nostalgia and estrangement intertwine in these books; Cartier-Bresson comments on a yearning for reinstating European prewar mores while framing the non-European world as different and strange, but visually contained. These books tell surprisingly conservative and nostalgic tales by a photographer who had been a war hero and a prisoner of war. Faced with the loss of its enormous colonial empire and the onset of the Cold War, France struggled to re-establish a national identity in the 1950s, and the photographer's books participate in this cultural project. Unlike scholarly works that look only at Cartier-Bresson's single "decisive moments," this chapter explores his construction of universalizing nostalgic commentaries that epitomize the wish for a return to a simpler life in post–World War II Europe, with French cultural values at its center. These books fit into the slippery French tradition of humanistic photography, exemplified soon after the war by Robert Doisneau's *La banlieue de Paris* (1949).[41] Using both universalizing single images and photo-essay journalism techniques, yet retreating from the Surrealist experiments of his earliest imagery, Cartier-Bresson arrests individuals in timeless poses. *Images à la sauvette* (*The Decisive Moment*) also creates clear distinctions between what the book calls "Occident" and "Orient." Its first half introduces us to what he constructs as "our" world, epitomized by nostalgic prewar images of European culture. Its second half reifies non-European cultures as static entities with its postwar images of Asian countries of differing political structures, some communist, others newly democratic. Cartier-Bresson's sequel, *Les Européens* (*The Europeans*) (1955), employs picture-story structures from *VU* and *Life* magazines to suggest that European nations, even the USSR and Germany, remain unchanged from the timeless rural cultures of the last centuries.[42] As a counterpoint to his volumes promoting European democratic culture, Cartier-Bresson also published two books on newly communist nations during these years, *D'une Chine à l'autre* (*From One China to the Other*) (1954, 1956), and *Moscou* (*The People of Moscow*) (1955). The China book introduces an important essay by Jean-Paul Sartre on colonialism. These books have been studied as individual snapshots of daily life, but Cartier-Bresson's 1950s narratives attempt to freeze history, in a post–World War II redefinition in colonialist terms of the complexities

that Romy Golan has termed modernity and nostalgia in post–World War I France.[43]

Making Strange ends with a conclusion, "Transitions," that centers on shifts occurring in the later 1950s, when Robert Frank and William Klein published two books in Paris that take the United States as their subject and engage a new formal language of alienation. Engaging a visual language of blurs, scratches, and graininess in these books, these two Parisian outsiders act as ethnographers of daily life, making everyday events seem strange and foreign, and presenting the United States as an anthropological construct rather than part of the European tradition. An American expatriate, William Klein published his jazz-filled and chaotic look at New York, *Life Is Good and Good for You in New York: Trance Witness Revels,* in Paris in 1956. Robert Frank's *Les Américains* was first printed by Robert Delpire in 1958, this first French edition punctuated (unlike the 1959 American edition) with a long series of literary texts by Alain Bousquet, Alexis de Tocqueville, Walt Whitman, and others.[44] Both books look forward to global 1960s activist political commentaries. *Les Américains* marked a design return to white pages and centered photographic images, as in Walker Evans's *American Photographs,* and would form a template for many American photography books in the following decade. As evidence of its long shadow, Frank's book was still central to discussions of his enormous influence upon his death in September 2019. In contrast, the chaos of Klein's book formatting and imagery found an enthusiastic audience in Japan in the 1960s and 1970s, epitomized in the Japanese photobooks of Daido Moriyama and Kikuji Kawada.

Making Strange studies French photographic books at the height of the modernist period, the interwar and immediate postwar years. Yet their innovations, including fragmentation, oneiric detective clues, elegy, and picture-story nostalgia, constitute universal bookmaking strategies that exceed the limits of France. Although Paris lost its publishing impact after 1958, photographers in England, Japan, Germany, and the United States adopted these formal methods and book structures in the following decades, and many regard them as newly relevant cultural touchstones today. Most of the photographic volumes I discuss have been republished in the last ten years, either as facsimile reprints or as new editions, in a climate in which their innovations are still influential. The books thus fulfill multiple functions: they are mirrors of their cultures at the time of their production; historical artifacts that allow us to read multiple levels of engagement; remnants of beautifully designed objects; and time travelers that have crossed oceans and decades to find new meanings today.

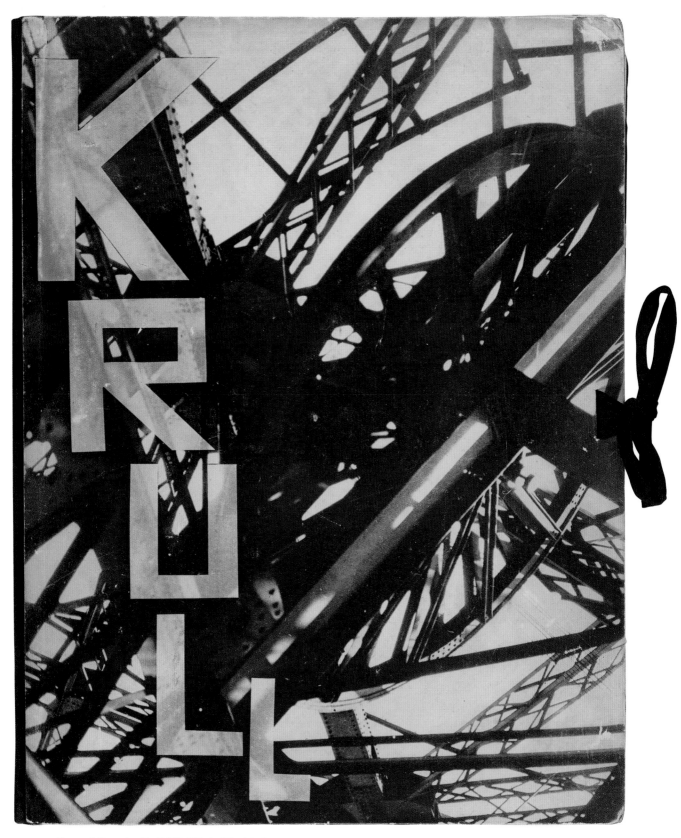

FIGURE 2 Cover of Germaine Krull, *Métal* (Paris: Librairie des Arts Décoratifs, 1928). Collotype, sheet: 11½ × 8¾ in. (29 × 22.5 cm). J. Paul Getty Museum, Los Angeles.

1 MONTAGE

Germaine Krull's *Métal*

Germaine Krull's groundbreaking 1928 album, *Métal*, was published to great acclaim at the end of 1928 (figure 2).[1] The volume begins with a puzzle. In its opening image we gaze up at a tall cylinder bristling with wires and round balls, from a worm's-eye view (figure 3). Krull seems to have aimed her camera at a vertiginous angle upward and to the right. We are immediately disoriented. Are we viewing a ship's smokestack? The radio-transmitting tower at the top of the Eiffel Tower? A factory? In fact, this image comes from a ship in the port of Toulon, but we would never know it from the photograph.[2] Krull's dynamic composition of steel cylinders, wires, balls, and a flag seems to lack a clear meaning. A very close inspection reveals that some of those "balls" are actually humans: five people stand at the top of the tower, looking directly down at us. A woman on the right appears to be smiling, and her companion on the far right is clearly waving a right arm directly at the photographer. Therefore, the image is not as alienating as it might appear at first; we are meant to interact with the experience of this industrial object, and with this first photograph.

Métal is Germaine Krull's most important publication. One of a number of foreign-born photographers who revolutionized photography and photobook publishing in interwar France, Krull was born in 1897 on the German–Polish border; she studied photography in Munich, worked in Berlin and the Netherlands in the early and mid-1920s, and went to Paris in 1926. Through her connections with the German, Dutch, and Parisian avant-gardes, she became one of the most important photojournalists and art photographers of the 1920s. During the decade when she lived in Paris, from 1926 to 1936, she published seven books, of which the first, and the most famous, is *Métal*. Her other volumes include travel books on all regions of France, including Paris and Marseille, and, in 1931, a detective "photo-roman" with Georges Simenon that will be discussed in Chapter 2.[3] *Métal*, an avant-garde amalgam of her commercial work for industry, her photojournalism, and her experimental images, is the French incarnation of the German New Vision. It served as a template for a number of montage-based books in the late 1920s and beyond.

As the first of sixty-four seemingly disconnected industrial abstractions, the introductory image in *Métal* gives us fragmented clues to Krull's intentions throughout the project, and to the set of bookmaking ideas that

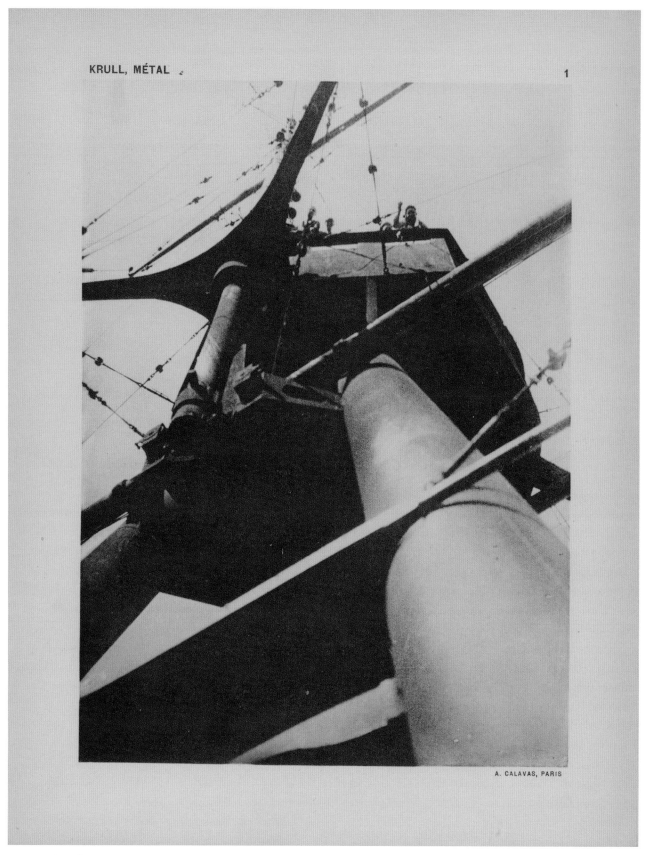

A. CALAVAS, PARIS

FIGURE 3 Plate 1 from Germaine Krull, *Métal* (Paris: Librairie des Arts Décoratifs, 1928). Collotype, sheet: 11½ × 8¾ in. (29 × 22.5 cm).

this volume revolutionizes for Europe and beyond in the late 1920s. To "read" this book that has no immediately obvious order, we must first look at it as a three-dimensional physical object; then study its imagery both for formal patterns and for relevant subjects; then attempt to decode its "narrative pattern"; and finally venture to see what cultural message the book emits as a whole. Although the book at first seems to be a taxonomy of industrial machine parts, Krull's ideas and her structure take many cues from Cubist collage and from avant-garde film montage. Constructed with these avant-garde ideas, *Métal* presents a lyrical and emotionally laden message quite different from its more orderly German counterparts published the same year, Albert Renger-Patzsch's *Die Welt ist Schön* and Karl Blossfeldt's *Urformen der Kunst.*[4] Instead, *Métal* is a scintillating commentary on the Machine Age in France—a collection of industrial fragments symbolizing the French return to strength and industrial leadership after the devastation of World War I. It is not a coincidence that by 1928 France was the most important iron producer in the world; industrial expansion was a valued and necessary response to the carnage that World War I had wreaked on the factory-rich northern sectors of France. Krull's *Métal* celebrates the rebuilding of this region.

Therefore, the first plate, like all the photographs in *Métal,* is an industrial picture from the heart of the Machine Age, full of excitement and admiration for new iron and steel forms. Yet it is abstract—unidentifiable as a specific place, as are almost all the images in the book. At first glance, the anonymous metalwork seems to forbid a narrative description or step-by-step entry into the book's ordering. The image bears clear relationships to the Soviet experimental films that Krull knew so well during these years, and to the theoretical writings by the revolutionary film theorists Sergei Eisenstein, Dziga Vertov, and Vsevolod Pudovkin. Yet unlike the more polemical Soviet industrial films, Krull's image and her book evade an overtly political agenda; instead, *Métal* comments implicitly on industrial culture. Rather than proselytizing, this image seems to tease, not in a mocking manner nor as a tribute, but rather as a lyrical commentary on the subject of industry.

Montage-based lyricism would be a central structuring format for French books of this decade. Through a close analysis of this volume, we can learn of the book's seminal role in influencing non-narrative, montage-structured,

avant-garde books in the late 1920s and early 1930s. Emulators would include Moï Ver's three books—*Ein Ghetto in Osten—Wilna, Paris,* and the posthumously published *Ci-contre*—and even Walker Evans and Hart Crane's early American collaboration, *The Bridge.* More poetic than the strident political rhetoric of other European montage-influenced photobooks, *Métal* models an expressive montage style that would survive (in altered form) all the way to the poetic humanistic photography books of the 1950s. *Métal* would play an important role in book design and avant-garde photography during the next decades; its interactive, dynamic mode of book design still reverberates today.

Krull's *Métal* contains sixty-four plates, each numbered and enclosed loose-leaf in a quarto-sized portfolio case tied with a black ribbon (11¾ by 9⅞ inches, with plates that are 11¼ by 8¾ inches). Although published by a Parisian art-book publisher (the Librairie des Arts Décoratifs, A. Calavas) and marketed as a mass-market art book, it is technically an album of individual plates rather than a bound volume (figure 4). Disbound plates are stacked inside a portfolio case that is tied shut with string, and the volume opens to display loose pages that can be fanned out, separated, inverted, or rearranged. It sold for 150 French francs, roughly equivalent to $80 today. Printed in collotype, an elegant and expensive printing process, each page gives only the words "Krull, Métal" on the top left, a simple plate number on the top right, and the publisher's imprint, "A. Calavas, Paris," at the bottom right. Today, viewers are accustomed to white pages with art images lacking captions; in Krull's day, this was a revolutionary format for a photography book. Early advertisements for *Métal,* promoting its lyrical montage style, referred to it as "the dance of the metal nudes."[5]

The loose collotype images can, in fact, be sorted according to the owner's wishes, mounted on the wall, or even pulled apart like a deck of cards and reshuffled. The reader, therefore, is an active participant rather than a passive observer, empowered to structure the images in any desired form. In contrast to bound and hierarchical nineteenth-century photographic taxonomies, the uncaptioned plates impose no preferred, predetermined valuation of which image is most important, nor do they educate us about any technical properties of individual metals. Aside from their numbers, the pages impose no viewing order; they float freely from the binding and can be held sideways, upside down, or nonsequentially.

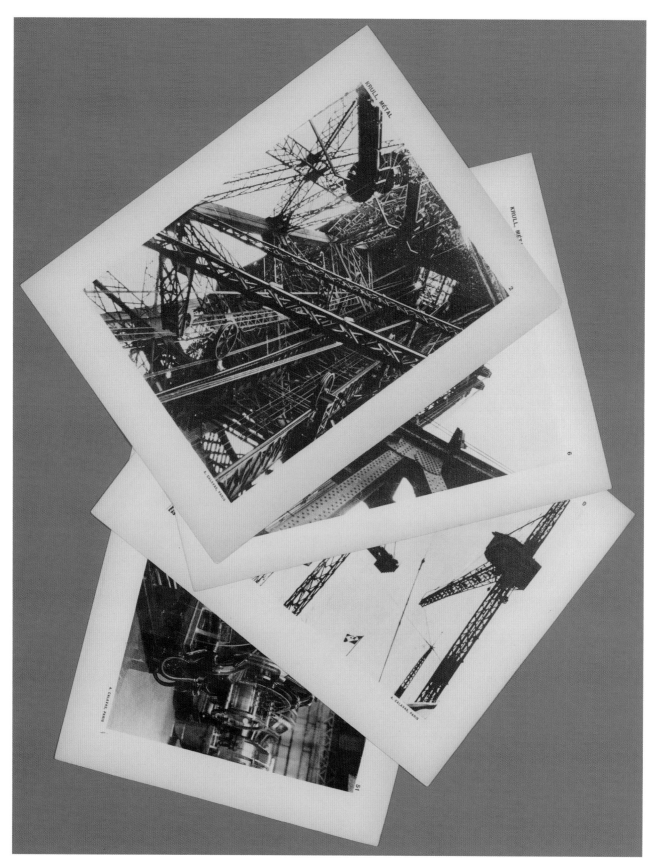

FIGURE 4 Plates 2, 6, 9, and 51 from Germaine Krull, *Métal* (Paris: Librairie des Arts Décoratifs, 1928). Collotype, sheet: 11½ × 8¾ in. (29 × 22.5 cm).

Instead, metal is presented as a metaphorical subject, and the viewer can construct his or her own personalized lyrical dance of metallic forms.

Métal includes a brief two-and-a-half-page introduction by the art critic Florent Fels, and a taciturn set of three sentences by Krull herself: "The Eiffel Tower, the cranes and bridges of Amsterdam, Rotterdam, Marseille and Saint-Malo have furnished the material for a certain number of the plates that form this album. I am grateful to the extremely gracious welcome of the Director of Conservatoire des Arts-et-Métiers in his museum, the Director of the C.P.D.E. at the Electrical Center of Saint-Ouen, and M. André Citroën in his factories. The cover of the book is a composition of M. Tchimoukow."[6]

These three sentences give us some essential clues to the book's identity, and to the larger worlds in which it and its maker moved. Krull, and the album she produced, existed in a vibrant circle of writers, filmmakers, poets, and artists at the center of the interwar Parisian avant-garde. To begin with Krull's last sentence, *Métal* is a consciously designed art object: the book is bound in a beautiful black cloth portfolio case, with an almost completely unidentifiable image of the Eiffel Tower's elevators (also reproduced inside as plate 37) on the cover. The crudely cut-out letters "K R U L L" are glued on top of this image, cascading in irregular fashion down the left side of the front (see figure 2). The downward-sweeping diagonals of the letters *K* and *R* form a counterpoint to the opposite upward angles and great wheels highlighted in the photograph, and instead of being opaque, the letters are translucent, so that iron forms a ghost image even behind the artist's name.

The book cover's designer, Lou Tchimoukow, was a graphic artist, film actor, photographer, and assistant director in the circle of the poet Jacques Prévert and his brother Pierre Prévert.[7] This contribution dates from early in Tchimoukow's career, and seems minimal at best, consisting only of the five cut-out letters glued onto Krull's photograph. The letters suggest the possibility of movement in their awkward placement. Yet when we open the album and unfold the black sleeves cradling the photographic plates, it is as if we were peering into an asymmetrical kaleidoscope, and the images, singly and in their totality, spin and come alive as they spill out of the case. Pages in bound books cannot step out of their bindings, so from the first moment, Krull's pages are freer

and more active than many of their counterparts and embody a three-dimensional experience beyond that of a traditional book.

Krull's first sentence in her brief remarks refers to the sites she depicts—all are new, industrial, and groundbreaking structures: the Eiffel Tower (built in 1889, but still an icon of modernity even as it neared its fortieth birthday); the newly redesigned Rotterdam railroad lifting bridge, De Hef (1927); the new Pont Transbordeur in Marseille (1905); and industrial cranes, gleaming interiors of postwar electrical plants and car factories. Although they are unidentified—and often visually unidentifiable even after repeated examination—in the plates of the book, these are (except for the Eiffel Tower) new structures, gesturing to the rebuilding of Europe's industrial infrastructure as it finally gained steam a full ten years after the end of World War I.

Krull had discovered the cranes of Rotterdam and Amsterdam with her husband, Joris Ivens, the Dutch avant-garde filmmaker who made *De Brug* in 1928.[8] Rotterdam had just reopened its new railroad bridge, De Hef, and Ivens created a classic fifteen-minute city-symphony film, with vertiginous angles and abstract views, to riff on the lifting and lowering of the bridge. The film was immediately hailed internationally as an important avant-garde film, and as will be seen below, Krull's still photographs of the bridge are clearly linked to Ivens's films. (She also photographed him filming the bridge.) However, Ivens still tells a recognizable narrative story of the bridge's lifting and lowering, and he labels his film *De Brug* so that we at least know what it depicts, if not immediately where the bridge actually sits. Krull's images, in contrast, have no identification, and in her 1928 book the ten plates of the Rotterdam Bridge, including plate 6, have no labels, no narrative clarity, no identifiable top and bottom, and no storyline about the bridge (figure 5). Fourteen other images in *Métal* clearly reference cranes that may well come from Rotterdam or Amsterdam, though they are similarly unlabeled and anonymous. Among them, plate 9 is particularly disorienting—a horizontal view mounted sideways in the book, which seems to correspond with Krull's memoir, where she writes of the "turning cranes" she saw in the harbor at Rotterdam while living there before coming to Paris (figure 6).[9] Forming almost a third of *Métal*'s material, images of Dutch industry dominate much of the book.

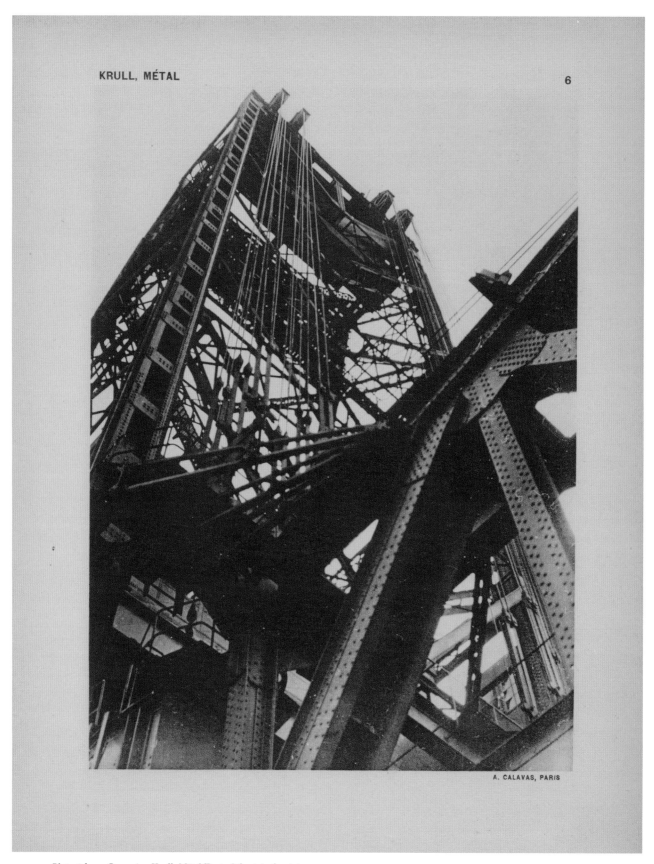

A. CALAVAS, PARIS

FIGURE 5 Plate 6 from Germaine Krull, *Métal* (Paris: Librairie des Arts Décoratifs, 1928). Collotype, sheet: 11½ × 8¾ in. (29 × 22.5 cm).

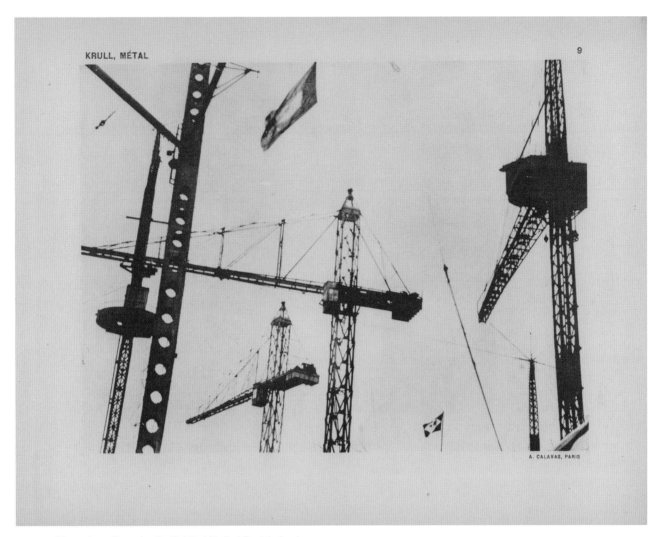

FIGURE 6 Plate 9 from Germaine Krull, *Métal* (Paris: Librairie des Arts Décoratifs, 1928). Collotype, sheet: 8¾ × 11½ in. (22.5 × 29 cm).

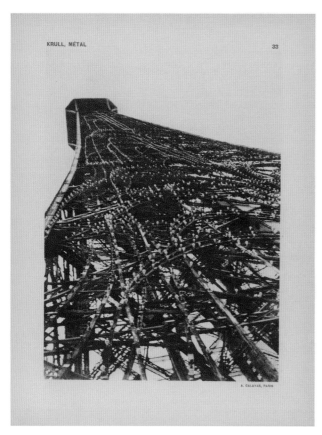

FIGURE 7 Plate 33 from Germaine Krull, *Métal* (Paris: Librairie des Arts Décoratifs, 1928). Collotype, sheet: 11½ × 8¾ in. (29 × 22.5 cm).

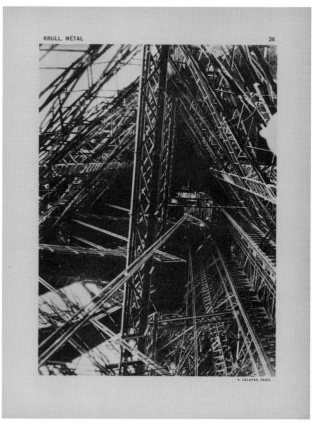

FIGURE 8 Plate 26 from Germaine Krull, *Métal* (Paris: Librairie des Arts Décoratifs, 1928). Collotype, sheet: 11½ × 8¾ in. (29 × 22.5 cm).

The Eiffel Tower is the other major anonymous subject in *Métal,* and it forms the abstracted subject not only of the cover but also of eleven images (plates 2, 11, 19, 26, 28, 33, 37, 50, 54, 57, and 62). Upon close examination, the tower's defining features (its height and its curlicues) can be seen only in two images. Plate 57 displays the signature curved-iron forms of the lower section, and plate 33 highlights the diagonal narrowing of the tower as it moves from midsection to top (figure 7). Most of the other Eiffel Tower views might just as well be other industrial structures; it takes a long and close look to identify the Parisian monument (figures 8, 9). As we will see later, these images tie the book to the popular picture press, where Krull published similar views of the Eiffel Tower on May 4, 1928, in the eleventh issue of *VU* magazine, but they also provide a second connection to Florent Fels, who wrote the *VU* article accompanying the pictures as well as the preface to *Métal*.[10]

The final link in Krull's brief introduction is her oblique reference to her voluminous commercial and industrial work; like other photographers in this period, she did not hierarchize or separate her fine-art subjects from her commercial work. The twenty images Krull made for Citroën, the electrical company of Saint-Ouen, and other industries such as the watchmaking firm Gustave Sandoz are given equal weight in *Métal* and constitute fully one-third of the book's images (figure 10). These industrial clients were firmly modernist and forward-looking, and included Citroën's burgeoning car company (Citroën advertised with electric lights on the Eiffel Tower during these years) and the Compagnie Parisienne de la Distribution d'Électricité in the northern suburb of Saint-Ouen—since 1913 the most modern electrical plant in France. It is difficult to identify specific factories, since, aside from the Sandoz image, Krull deliberately obscures any signage, but machines and machine parts are visible in more than a dozen plates. Cogs, centrifugal speed governors, flywheels, stamping press drive gears, drive belts, furnace flues, gears, clockwork, and generators can be seen, but their larger purpose within their factories is impossible to decipher—and that was Krull's intention. In 1978, fifty years after the book's

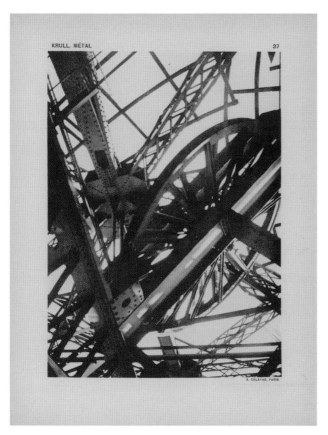

FIGURE 9 Plate 37 from Germaine Krull, *Métal* (Paris: Librairie des Arts Décoratifs, 1928). Collotype, sheet: 11½ × 8¾ in. (29 × 22.5 cm).

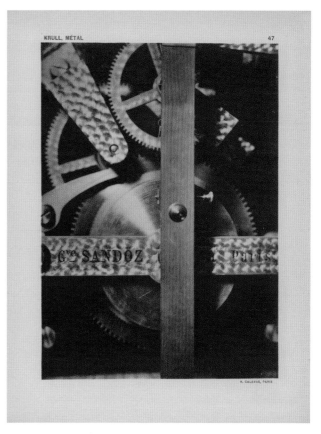

FIGURE 10 Plate 47 from Germaine Krull, *Métal* (Paris: Librairie des Arts Décoratifs, 1928). Collotype, sheet: 11½ × 8¾ in. (29 × 22.5 cm).

publication, Krull identified a number of these plates as part of her work for Citroën (including plates 35, 29, 42, 44, and 59), and others as "Electricité France Paris 1927" (plates 3, 8, 23, 51, 61; figure 11).[11] This is, however, impossible to tell from the images themselves. Some of these twenty images were certainly used in advertising or publicity campaigns, although published views of these specific images have not yet surfaced.

The subjects of Krull's photographs in *Métal*, therefore, can be identified, more or less, with a lot of effort. But in the volume itself, as it was meant to be seen, the photographs refuse to participate in a narrative about either De Hef Bridge in Rotterdam, the Eiffel Tower, or any particular industrial site. They also deny any logical reading of easily identified classifications, so that if she had meant it to be a learning dictionary or taxonomy of "machine parts," the book would have been a failure. Instead, Krull opts for cacophony: *Métal*'s plates form a dizzying, abstract pattern of diagonals, verticals, horizontals, and overlapping images. Two of the photographs, plates 22 and 51, are multiple exposures, but these are

rare exceptions; Krull usually found abstraction within straight views of industrial details from extraordinary vantage points. Since the book is clearly not readable as a list of industrial history or as a taxonomy, the multiple exposures can, however, help to form a methodology for looking at the entire album. One image from the electric company is even more confusing, as it is printed horizontally in the book, as are twelve of the sixty-four plates (plate 51; see figure 11). To solidify the author's intention, the captions "Krull, Métal" and plate numbers are printed on the horizontal sides of these plates. The reader must remove the loose page and turn it, adding to the simultaneously overlapping images in the haptic experience of freely moving pages in space; this effect removes any lingering sense of a proper direction or reading order. Three unidentified generators march across this page, framed inside a factory, and a faint double exposure is printed at a different angle, forming an echo both of movement (as in the Futurist photographs of Anton Bragaglia), and, by extension, of the sound of the factory at work. The second multiple exposure shows various bicycle factory parts

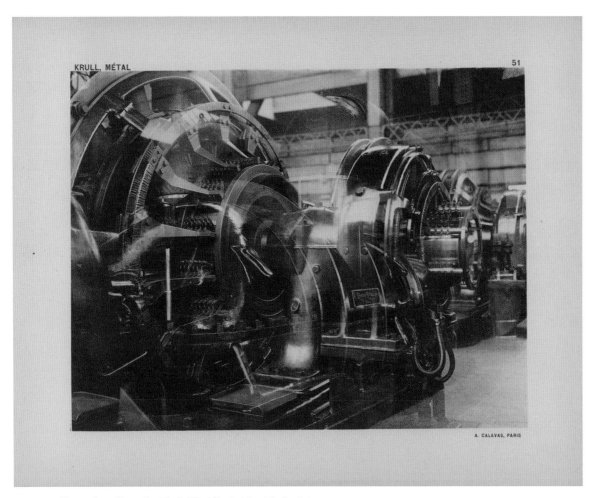

FIGURE 11 Plate 51 from Germaine Krull, *Métal* (Paris: Librairie des Arts Décoratifs, 1928). Collotype, sheet: 8¾ × 11½ in. (22.5 × 29 cm).

(plate 22; figure 12). The background seems to be a series of columns, probably at the entrance to a building in Paris. We can identify a silhouetted view of handlebars, seat, and wheel. Two more wheels are superimposed over this, and a series of wheel shadows overlaps the shadows cast by the columns. Site, subject, and identity are obscured. Instead, Krull highlights movement, modernity, and the thrillingly fast pace of spinning wheels in the city. One of *Métal*'s reviewers, Daniel Rops, singled out this image as a symbol of industrial simultaneity, writing: "Movement itself expresses itself: the photographed dynamo seems to recreate the mysterious halo that it surrounds with its vertiginous rotation."[12] These two multiple exposures are metaphors of industry, not illustrations of particular sites. As such, they, and the other plates in *Métal*, form an important part of the photographic discourse of the Machine Age in the 1920s. Although Krull occasionally used multiple exposures and photomontages to express the simultaneity of modern life, this was a rare occurrence in *Métal*.

The final textual clue for *Métal* is Florent Fels's brief introduction. Although Krull herself credits Lucien Vogel, the editor of *VU*, for introducing her to the Eiffel Tower as a subject after admiring her Dutch industrial views, Fels was a firm supporter in many ways. A major art critic in interwar Paris, Fels founded the review *Action*, was editor of the important art journal *L'art vivant*, wrote art criticism for *Vogue*, and worked for and wrote art criticism at *VU* from 1928 to 1930; he later became editor-in-chief at another similar picture magazine, *Voilà*. In *VU*, just two months after the magazine was introduced, he wrote the text for an article highlighting Krull's images of the Eiffel Tower.[13] He was also a co-organizer of the Salon de l'Escalier, and included in its exhibition thirteen of Krull's photographs, among them three Eiffel Tower images, three from Rotterdam, and one of the port of Saint-Malo.

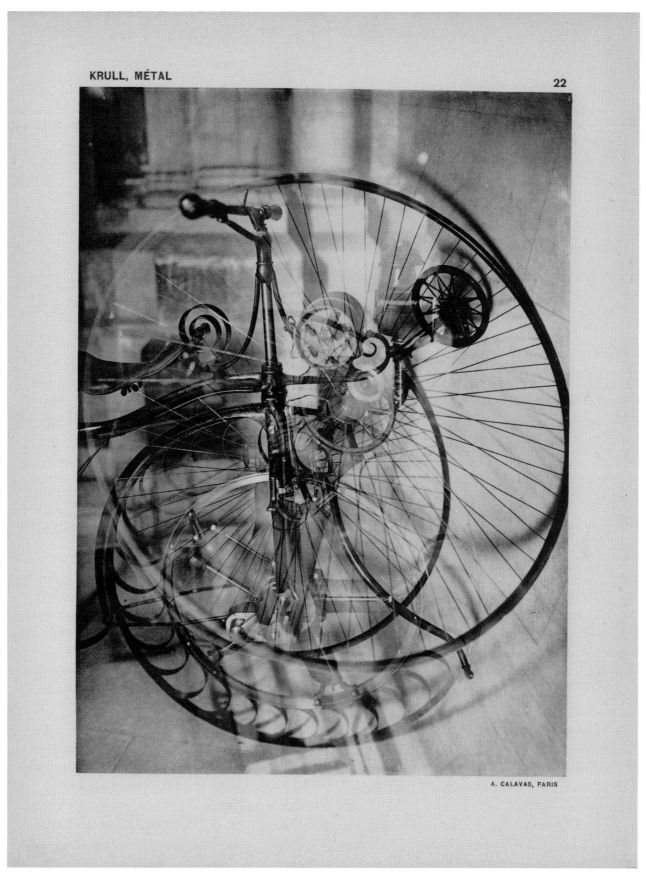

A. CALAVAS, PARIS

FIGURE 12 Plate 22 from Germaine Krull, *Métal* (Paris: Librairie des Arts
Décoratifs, 1928). Collotype, sheet: 11½ × 8¾ in. (29 × 22.5 cm).

Therefore, in 1928, Krull's *Métal* photographs simultaneously populated three overlapping worlds: the avant-garde art exhibition, the popular picture press, and the commercial art-book market in Paris.

In his text for *Métal,* Fels supplies the symbolic and lyrical counterpoint for these images of steel and iron. He hints at the postwar reinvention of modernity, and argues that industry replaces historical architecture in representing the era: "The great cities of Europe strike us as dilapidated and anachronistic. . . . Meanwhile, the lyricism of our time puts its name down in streams of cement, in cathedrals of steel." He clearly sees Krull as the muse to comment on this shift: "Steel is transforming our landscapes. Forests of pylons replace age-old trees. Blast furnaces supplant hills. Of this new look of the world, here are a few elements caught in fine photographs, specimens of a new romanticism. Germaine Krull is the Desbordes-Valmore of this lyricism: her photographs are sonnets with sharp and luminous rhymes. What an orchid, this Farcot engine, and what disturbing insects these regulator mechanisms!"[14]

Fels's equation of industry with a twentieth-century history could not be clearer, and he positions Krull as the romantic poet of this new form, although the early nineteenth-century lyric poet of nature, Marceline Desbordes-Valmore, is an odd comparison to this thoroughly twentieth-century industrial lyricism; perhaps Fels found a parallel in the older poet's independent lifestyle and emotional intensity.[15] His view of *Métal* is dynamic, not static: "In the halo surrounding them the powerful dynamos, silent and tranquil in their action, seem to send forth luminous vibrations; and what trumpet calls are shot into the air by the smokestacks, these new god-herms that rise along our roads! Mechanical bridges burrow into space. Trains with their clattery uproar shatter the horizon line. They leave the earth, and in the inexorable advance of progress, glide on the ether, transporting marveling living creatures toward astral railway stations." Acknowledging the tower's role as a radio transmitter, Fels labels the Eiffel Tower the "steeple of sound waves." He honors Krull's photograph of André Citroën's lighting of the tower with thousands of electric lights (plate 33; see figure 7): "What that giantess lacked was a crown of starry hair: she has been given one. Industry inscribes its luminous progress at full length along the Tower's nighttime spine." Fels concludes by placing the tower as the "supreme symbol of modern times," noting that

"Lindbergh kept [it] in his sights so as to hit the mark of Paris, in the sentimental heart of the world."[16]

MÉTAL'S CRITICAL RECEPTION

Krull's *Métal,* and the individual images from the series that were published and reproduced elsewhere in the popular and fine-art press, received major press coverage. Her Eiffel Tower photographs were first reproduced in *UHU,* a German periodical, in December 1927, in an article by a German engineer.[17] However, several of the organizers of the Salon de l'Escalier—Florent Fels, Lucien Vogel, and Jean Prévost—were clearly early and important champions for the work.

Fels promoted Krull in multiple ways. In addition to including Krull in the Salon de l'Escalier, and the fact that he wrote the preface for *Métal,* he had been actively supporting her work for months before. The editor of the arts journal *L'art vivant,* he wrote a review of the Salon de l'Escalier in its June 1928 issue, famously calling Krull "the Valkyrie of photographic film." Although Krull had a revolutionary past, she was no warrior. This reference may have more to do with the fact that, though born in Germany, she had recently been living in the Netherlands, so she was variously identified in the press as "Northern European" or "Nordic" or "Dutch." Or perhaps Fels perceived her subject of industrial ironwork as especially muscular. In a later essay, "Acier" for *Jazz,* in mid-1929, Fels seems to move past the lyricism of the essay in *Métal.* He appears to have been convinced of the power of the machine, "psychological, physiological and aesthetic."[18] Scorning the machine-phobia manifested in Fritz Lang's 1927 German film *Metropolis,* he sees a more positive industrial culture at work. In this essay, accompanied by Krull's double exposure of the generators (plate 51; see figure 11) as well as some fly governors and machine parts (plates 7, 15, and 16), Fels writes that machine gestures are replacing human ones, and that steel represents the highest modern virtue, the newest symbol of power.

According to French photography historian Michel Frizot, Fels may have even suggested the idea for *Métal* through a different spread titled "Acier" in the third issue of *VU* in April 1928, although this book goes far beyond the images in that article. As mentioned above, Fels wrote the text for the publication of Krull's Eiffel Tower photographs in *VU* in May 1928. In "Acier," in *Jazz* in April 1929 (discussed above), he reproduced four more Krull *Métal* images. Finally, in June 1929, he published Jean Gallotti's

monographic article on Krull as an art photographer, fifth in an ongoing series that included Eugène Atget, Laure Albin-Guillot, Man Ray, André Kertész, Eli Lotar, Alban, and Maurice Tabard. When Krull published her second book, *100 x Paris*, in 1929, Fels wrote the preface for that as well.[19]

Lucien Vogel, another Salon de l'Escalier organizer and the founding publisher of *VU*, also directly supported Krull. An Alsatian and the founder of the *Gazette du bon ton* in 1912, he directed *Jardin des modes* and worked at *Vogue*. On March 21, 1928, he published the first edition of *VU*, and he directed all facets of the periodical from March 1928 until 1936, when he was removed for his left-wing sympathies and the publication of a special issue on the Spanish Civil War. Like Fels, Vogel had many overlapping activities, and he also organized exhibitions (the Salon de l'Araignée as well as the Salon de l'Escalier). *VU* was published in rotogravure (called "héliogravure" in French), and the high quality of the photographic images was vastly more effective than halftone printing had been.

Vogel hired the best photographers he could find, including Krull, Kertész, Lotar, Man Ray, and others. He first hired Krull when he commissioned the Eiffel Tower images for *VU* from Krull after seeing her Dutch images, and published them in May 1928. As I have detailed in earlier writings on Krull, the photographer first met Vogel before the first publication of *VU*, and her autobiography recalls his admiration for her work. Krull's memoirs recount his reaction: "This is what I want for my first issue. Go and photograph the Eiffel Tower, Germaine. Photograph it as you really see it, and make sure that you don't bring me a postcard view." Krull was reportedly unenthusiastic at first, writing:

> The Eiffel Tower—all that enormous, lifeless, black iron—had never interested me. I found an angle here, an angle there, but it was not exciting. How was I to make photographs that resembled my *Métal* pictures out of this old black and inert thing? Finally, I found a small door at the very top to a staircase that no one uses and no one knows. I climbed and descended, and suddenly there was the magic of iron, those great wheels that turned the elevators, those crowns of iron, the lace work of small ironwork that served as decoration, seen against the sky like huge spiders. When I brought my harvest of pictures back to Lucien Vogel, he embraced me and said: "Our first issue is set."[20]

FIGURE 13 Florent Fels, "Dans toute sa force," *VU*, no. 11 (May 30, 1928). Photographs by Germaine Krull. Rotogravure, 14¾ × 11 in. (37.5 × 28 cm).

This tale is somewhat exaggerated—the tower pictures did not appear until *VU*'s issue number eleven on May 30 (figure 13). However, Vogel was certainly a major patron for Krull, particularly in the years from 1928 to 1930: her photographs appeared in the first four numbers of *VU*, and she published almost three hundred photographs in about sixty issues of the magazine from 1938 to 1934.[21]

A third organizer of the Salon de l'Escalier also promoted Krull's imagery. Jean Prévost, the editor of the literary journal *Le navire d'argent*, reproduced four Eiffel Tower images in his book *Eiffel*, published in 1929 to celebrate the fortieth anniversary of the tower. His wife, Marcelle Auclair, published a large spread of Krull's Eiffel Tower images in Fels's journal *L'art vivant*, including that issue's cover image.[22] In addition to promoting her husband's book, Auclair paid graceful compliments to Krull and to the well-known film *Paris qui dort*, released in 1924 by another organizer of the Salon de l'Escalier, the

filmmaker René Clair, who will be discussed below.

Krull soon became well known outside her immediate circle as well. One of the earliest reviews by Pierre Bost—writing in *Jazz* in January of 1929, just after the book appeared—marvels at the beauty of the images: "Few photographers have known how to put so much intelligence and taste into photographs like these. In this black and white, in these wheels, these labyrinths of tubes and pillars, we see all the grandeur of modern spectacles whose utility has long hidden their beauty." Bost continues to comment on the revolutionary quality of these images: "If we are not yet perfectly ready to understand this modern beauty, we are already starting to feel it very intensely, and Mme. Krull's book will be one of the best guides to this new aesthetic. Those who love the present day should know these plates." Michel Frizot sees Bost's response as somewhat unsettled, but Bost seems ready to adopt the new style and celebrate it.[23]

Charles Saunier, writing in *L'art vivant* in May 1929, had despaired of finding a Machine-Age aesthetic response to the vertiginous and tumbling energy in Piranesi's 1750 *Carceri d'invenzioni*. He finds the solution in Krull's *Métal,* and he admires "a suite of superhuman visions that seize the spirit, so that when one leafs through this album one is enthralled." He appreciates both the individual images, but more importantly the dizzying quality of reading the album in its totality, writing that as he leafed through the album, some plates "give the reader vertigo from tumbling from the sky into a deep pit, where another elicits a desire to fly into the ether." Saunier feels that the author of this revelation is "a camera disciplined by an expert hand controlled by an intelligent eye." It is the collaboration of images in the album that creates the dynamism for him—large forms next to small ones. In agreement with the lyrical evaluation by Fels, Saunier concludes that Krull thus creates "beautiful formal poems."[24]

The following month, Jean Gallotti wrote an article on Krull in his multipart series in *L'art vivant,* "La photographie est-elle un art?" Here he concentrates solely on Krull's *Métal,* and he, too, agrees with Fels that these industrial forms present the "pure beauty of the modern world." He notes that Krull gives a charm to these "cold, dry and dead subjects." He invokes the armchair traveler when he writes that on a couch in a heated apartment, ironwork looks better than when outside, but gives credit to the unaccustomed points of view made possible by the camera. Gallotti writes vividly of Krull's views that the camera can easily extract, that would cause "vertigo and a stiff neck" if seen in person. He admires Krull's versions. In recent scholarship, Michel Frizot goes even further than Gallotti, and sees in the magazine's layout of images—prominently displaying her name—an overtly politicizing cultural comment: "The German surname and very French given name were far from neutral in a context of industrial growth driven by iron and steel that, as Fels wrote, had 'rehabilitated steel' after the cataclysm of artillery and barbed wire."[25]

One of the most insightful writers about photography in this decade is Pierre Mac Orlan, a novelist and critic who wrote the text for the monographic book on Krull published in 1931, three years after *Métal* appeared. *Germaine Krull: Photographes nouveaux* is the only published volume in a planned series of monographs on photography titled *Photographes nouveaux.* The book is the same format and size as a Gallimard series, *Les peintres nouveaux.* An important critic whose notion of the "social fantastic" became one of the most important lenses for viewing the work of modern photography, Mac Orlan celebrates the lyricism and disorientation of *Métal.* He writes, "Among the works of all those who have been the lyrical and meticulous witnesses of the social fantastic since 1918, I particularly like those of Mme. Germaine Krull. . . . This adroit and self-confident artist who is a great reporter and a poet of everyday life, closely associates her personality with all the elements of steel and flesh that form and later serve to formulate the picturesque and the social fantastic of the contemporary period."[26]

In an implicit acknowledgment of the concept of the "city-symphony" film, Mac Orlan sees that she "transposes a machine-scape into a kind of stunning symphony," and he further presents her as a literary poet when he concludes: "Germaine Krull is lettered. She too can 'throw a fresh rose' into a hall where giant milling machines are making engine blocks."[27] Mac Orlan's writings infuse a note of lyricism into the Machine-Age admiration of the other critics.

TAXONOMIES AND PHYSIOGNOMIES

Krull's works soon gained international recognition. Walter Benjamin, the German critic then writing in Paris, included Krull in one of his famous essays, "A Short History of Photography," published in 1931 just three years after *Métal*'s publication. Benjamin was a personal friend

of Krull's for several decades.[28] In his essay, he groups Karl Blossfeldt, August Sander, and Krull (along with Eugène Atget) as activist photographers whom he admires. The first three may seem like an odd combination for the German critic, but these photographers created what can be seen as active, rather than deadening, modernist taxonomies of interwar Europe.

In his thoughtful overview of Benjamin's essay, the German art historian Herbert Molderings finds a common ground between French and German projects; he writes that Benjamin read László Moholy-Nagy's writings in the middle and late 1920s, and he sees Benjamin's essay as an "attempt at fusing two extremes: the vulgar materialism of the cultural policy of the Communist Party of Germany (KPD) . . . with the radical aestheticism of avant-garde art and photography." Molderings argues that Benjamin grouped Blossfeldt, Sander, and Atget, all of whose work began in the pre–World War I period, so that "their sober, objective approach to their subject matter only just anticipated the form and content of the modern photography that was yet to come."[29]

Despite his comments on the backward-looking facets of Blossfeldt, Sander, and Atget, Benjamin also appreciates their joint fascination with the details of the modern world—a fascination Krull also shared. For Benjamin, all four—including Krull—avoid what he castigates as fashion, or reifying beauty (like Renger-Patzsch), or—worst of all—"creativity." Benjamin famously names them specifically as having avoided that trap: "When photography has extracted itself from the connections that a Sander, a Germaine Krull, a Blossfeldt gave it, when it has emancipated itself from physiognomic, political, scientific interests—that is when it becomes 'creative.'" Blossfeldt with his plants, Sander with his portraits, and Krull with her machine parts are somehow reaching what Benjamin terms the unconscious physiognomic level of photographic depiction. He writes, "Photography, however, with its time lapses, enlargements, etc. makes such knowledge possible. Through these methods one first learns of this optical unconscious, just as one learns of the drives of the unconscious through psychoanalysis. . . . Photography opens up in this material the physiognomic aspects of the world of images, which reside in the smallest details, clear yet hidden enough to have found shelter in daydreams."[30]

For Benjamin, Sander's portraits in his project *Menschen der 20. Jahrhunderts,* begun in 1910, transcend portraiture, and "allow the education and sharpening of the physiognomic conception into a vital necessity"; Benjamin also tells us "Sander's work is more than a book of pictures: it is a book of exercises." In analyzing the "optical unconscious," the German critic cites Blossfeldt who, "with his astonishing photographs of plants, brought out the forms of ancient columns in horsetails, the bishop's staff in a bunch of flowers, totem poles in chestnut and acorn sprouts enlarged ten times, gothic tracery in teasel plants" (figure 14).[31] Blossfeldt, in his 120 abstractions of plant forms, creates a strange but evocative compendium of forms; they are not divided into botanical types, but rather into forms that resemble cultural artifacts. Although Krull's images are more vertiginous, the effect of removing forms from their natural settings and inserting them into an unsettling modern format resembles Blossfeldt's project.

Daniel Magilow's study of German photobooks specifically concentrates on these taxonomies and physiognomies that buttress German identity while simultaneously highlighting nationalistic destabilization. He argues that

FIGURE 14 Plate 13, *Aesculus parviflora,* from Karl Blossfeldt, *La plante* (Paris: Librairie des Arts Décoratifs, 1929). Gravure, page: 12½ × 10 in. (30 × 25.2 cm).

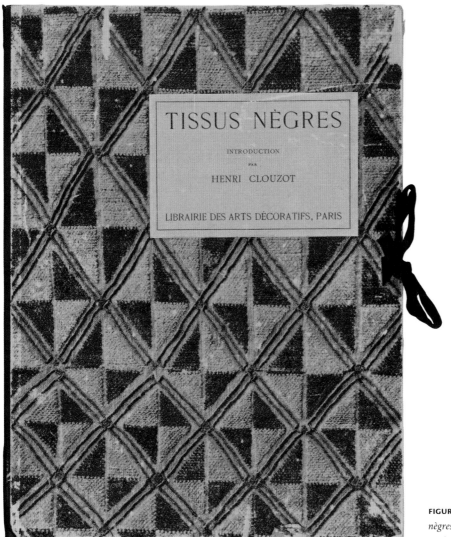

FIGURE 15 Cover of Henri Clouzot, *Tissus nègres* (Paris: Librairie des Arts Décoratifs, 1921). Collotype, 13 × 10 in. (33.1 × 25.7 cm).

the German "physiognomic revival offered thinkers and photographers a powerful means by which to probe the roots of the chaos lurking beneath Weimar Germany's fragile façade of stability." For instance, Magilow discusses another plant taxonomy, Paul Dobe's *Wilde Blumen der deutschen Flora*, arguing that "the book considers nature a source of national culture," and directs "the German gaze toward German soil and its natural products." In contrast, he sees disruptive narrative transitions from image to image within Renger-Patzsch's *Die Welt ist Schön*.[32] Krull's book, in contrast, constructs a French taxonomy that embraces destabilization as a celebration rather than a critique of modernity.

If the pairing of Krull and Blossfeldt seems unlikely, there is a physical Parisian link between the volumes: the Librairie des Arts Décoratifs, publisher of *Métal,* also

published *La plante*, the French edition of Blossfeldt's 1928 *Urformen der Kunst*, the next year, in 1929. The books were roughly the same size (quarto, or large sizes), although Blossfeldt's book was bound, not in portfolio format. The French Blossfeldt edition is identical to the German one except for the translated text, and the printing technique and size relate them physically. Moreover, Blossfeldt "made strange" the forms of plants he photographed in detail.[33]

Other books by the Librairie des Arts Décoratifs, A. Calavas, had strikingly similar formats to Krull's, and also present taxonomies of different sorts. As Michel Frizot has noted, this references Antoine Roche's three portfolios titled *Paris* (1928, 1929, 1930).[34] Roche's 1928 books present color plates of contemporary graphic design and decorative arts from designers such as Man

FIGURE 16 Title page of Germaine Krull, *Études de nu* (Paris: Librairie des Arts Décoratifs, 1930). Gravure, sheet: 8¾ × 6½ in. (22.3 × 16.2 cm).

FIGURE 17 Plate 4 from Germaine Krull, *Études de nu* (Paris: Librairie des Arts Décoratifs, 1930). Gravure, sheet: 8¾ × 6½ in. (22.3 × 16.2 cm).

Ray, Cassandre, Sonia Delaunay-Terk, Raoul Dufy, Giorgio de Chirico, Pavel Tchelitchew, and Jean Cocteau from those years, and the 1929 edition of *Paris* includes images by Krull and Eli Lotar. However, beyond these three portfolios, the publisher had been presenting taxonomies in folios in this format since at least 1920. Like *Métal*, all had unbound plates and a short introduction and were encased in a portfolio with cloth ties, but they were conventional selected portfolios of multiple works, not a monographic, abstract riff on one subject. One of the earliest of these portfolio publications by the publisher, and perhaps the visually closest to Krull's *Métal*, is Henri Clouzot's 1921 *Tissus nègres*, with a very similar cover and a similar collection of African geometric textile fragments (figure 15).[35] By equating *Métal* or Blossfeldt's book with other collections of images such as *Tissus nègres, La décoration primitive: Afrique* (1922, with works from the Musée d'Ethnographie), or *Hebraica* (1930), the publisher inserts modern steel into a colonialist taxonomy similar to collections of primitive or ethnographic specimens. The most obviously imperialist of these volumes is the gold-leaf

bound album *L'exposition coloniale de Paris* (1931), with fifty-four collotypes by A. Chevojon representing the pavilions and peoples on display at the Colonial Exposition of 1931. As if responding to its own 1928 advertisement of "the dance of the metal nudes," in 1930 the Librairie des Arts Décoratifs published an album of actual nudes by Krull.[36] *Études de nu* is a similar loose-leaf portfolio with twenty-four plates and a modernist typeface, this time highlighting female nude studies with a text by playwright Jean Cocteau, but its compositions (figures 16, 17) are a clear step backward from the formal innovations in *Métal*.

Other French photographers and publishers created kaleidoscopic taxonomies of this sort in the late 1920s and very early 1930s. Another important example is by Laure Albin-Guillot, a fellow participant in the Salon de l'Escalier and *VU* photographer. In 1931 Albin-Guillot published a spiral-bound volume of micro-photographs, *Micrographie décorative*, honoring her scientist husband, Dr. Albin Guillot, who had died that year (figures 18, 19). Although she was best known for her slightly soft-focus Pictorialist imagery and won a gold medal from the

FIGURE 18 Cover of Laure Albin-Guillot, *Micrographie décorative* (Paris: Draeger, 1931). Gravure on metallic paper, 16¾ × 14¼ in. (42.5 × 36.4 cm).

conservative Société Française de Photographie in 1922, Albin-Guillot had been making micro-photographs for her husband's research for thirty years. An early French advocate for micro-photography, she renamed the process "micrographie." The volume has a spiral binding, a silvered stripe on its cover, and silvery letters to mark its title. The photographs are reproduced in an expensive photogravure process that had been popular in the Pictorialist period, most notably in the images in Alfred Stieglitz's journal, *Camera Work*. Eight of Albin-Guillot's twenty photogravures are on metallic paper, and they share Krull's abstraction, although in a more static and decorative pattern. As Delphine Desveaux and Michaël Houlette have written, "Abstraction was not the point of her microscopic investigations, which set out simply to offer a range of ornamental possibilities."[37]

Therefore, it might be tempting to place Krull's *Métal* into a category of collected specimens like those of Blossfeldt and Albin-Guillot. Contemporary critics, however, ignored that possibility and collectively produced a much more dynamic and activist interpretation. Walter Benjamin agrees, and he goes a step further. He notices

more than the transformative, encyclopedic effect of these projects; he sees their strangeness. He may well have taken his concept of social activism from Pierre Mac Orlan's "social picturesque" or "social fantastic," as he specifically references the 1930 Atget monograph for which Mac Orlan wrote the preface (and of course Mac Orlan also wrote the text for Krull's 1931 monograph). In discussing Atget's photographs as the precursors to Surrealist photography, Benjamin lauds him: "He disinfected the sticky atmosphere spread by conventional portrait photography. . . . He began the liberation of the object from the aura."

And he famously concludes his essay by commenting on their strangeness: "Not for nothing were pictures of Atget compared with those of the scene of a crime."[38] That strangeness, or alienating quality, is what makes these projects (Krull's, Atget's, Blossfeldt's) especially powerful in depicting the modernity of interwar Europe. In *Métal*, Krull does not present us with a beautiful, comfortable, static series of machine images like those of Renger-Patzsch. She constructs an activist narrative that goes beyond the formalist patterns or conventional narrative in the montaged stories of contemporary city-symphony

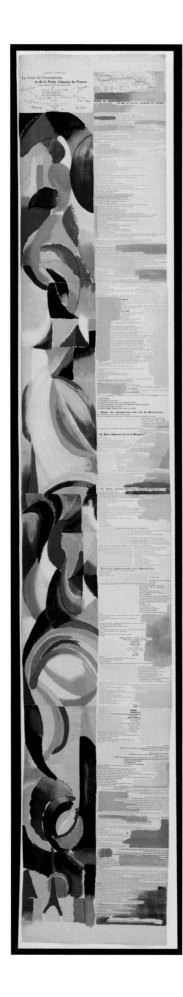

FIGURE 20 Blaise Cendrars and Sonia Delaunay-Terk, *La prose du Transsibérien et de la petite Jehanne de France* (Paris: Des Hommes Nouveaux, 1913). Illustrated book with pochoir and relief print, 78¾ × 14 in. (200 × 35.6 cm).

films such as *De Brug* and *Paris qui dort*. Through narrative techniques that are part taxonomy, part lyrical poem, part vertiginous montage, part Industrial-Age adulation, and by making the whole volume uncomfortable and strange to read, she brings her machine parts to life as they oscillate uneasily throughout the album. The taxonomic idea of the book's layout may well come from ethnographic albums, but the vertiginous movement of the layout and plates requires another explanation.

SIMULTANEITY

Whether in Berlin, Amsterdam, or Paris, Krull had strong ties with the literary and artistic avant-garde. When she arrived in Paris, Robert Delaunay and Sonia Delaunay-Terk were early and supportive friends and patrons. Robert Delaunay, the founder of what poet Guillaume Apollinaire called Orphic Cubism, was an artist obsessed with simultaneity and modern life. Delaunay's simultaneity was a lively poetic language of colors, overlapping volumes, and multiple perspectives that simulated the perception of many movements and emotions at once. Delaunay shared Krull's fascination with modern industry and urban subjects (including the Eiffel Tower, Parisian Ferris wheel, and Louis Blériot's flight from London to Paris). The painter supported Krull after she was rebuffed by the conservative Société Française de Photographie. In what is probably a mythic tale by Krull, he supposedly promised to exhibit her *Métal* photographs alongside his paintings at the Salon d'Automne.[39] A 1926 portrait by Krull depicts Delaunay on a ladder, in the midst of painting one of his aerial views of the Eiffel Tower.

Robert's wife, Sonia Delaunay-Terk, a painter, designer, and clothes designer, hired Krull to make photographs of her fashion designs at this time.[40] One image presents her "simultaneous automobile." Both Delaunays were fascinated with contrasts of form and simultaneous contrasts, even in book forms similar to *Métal*. With the writer Blaise Cendrars, Sonia had published *La prose du Transsibérien et de la petite Jehanne de France* in 1913. Published in an edition of 150 copies, this artist's book is often called the first "simultaneous book" (figure 20).

The format is a "leperello," with one vertical fold and then twenty accordion folds reaching about six and a half feet in length when open. The pages open up into a long, ribbed sheet that mimics the rails and cross ties of the railroad it depicts. Like Krull's metal bridges and towers, this railroad, too, was a new modern arrival—the track that ran all the way across Russia from Saint Petersburg to the Sea of Japan had been completed only in 1905. Cendrars's poem cascades down the right-hand side of the long pages, and Sonia Delaunay-Terk's abstract patterns of color wheels, Cubist forms, and incandescent color dance along the left-hand side and the right margins. Like Krull's *Métal,* this is a dynamic book meant to be read as an active form, rather than in a static fashion. Cendrars's free-verse poem—a memory of a 1904 train trip through Siberia interspersed with sections on his girlfriend—is printed in various typefaces, and the volume ends with the Eiffel Tower and the Ferris wheel, modern urban forms that fascinated both Delaunays and Krull. In fact, Cendrars wrote that "the edition should reach the height of the Eiffel Tower" if fully extended.[41]

The notion of a visually dynamic text, of course, owes much to Apollinaire's *Calligrammes.* Published in 1918, just at the end of Apollinaire's time fighting in World War I, the poet's visually evocative images resonate with those of the Delaunays, whose work Apollinaire championed and labeled "Orphic Cubism" in *Les peintres cubistes.*[42] Apollinaire's visual poems include "La Tour Eiffel," made in 1916 in mid–World War I (figure 21). Cascading letters in the shape of the tower operate as a simultaneous bullhorn to send out his message: "Salut monde dont je suis la langue éloquente que sa bouche O Paris tire et tirera toujours aux allemands." (Claudia Habergham translates this as "Greetings earth of which I am the eloquent tongue which pokes from your mouth O Paris and will poke forever at the Germans.")[43] There are, of course, multiple puns: "lut" is isolated in "salut," so it becomes "to battle" (lutter); "tire et tirera" can be read as "shoots and will always shoot" at the Germans, a natural sentiment for a French soldier in the middle of the war. At any rate, the multiple meanings and the visual form of the letters, fragmented, in active movement, and cascading down the page, seem analogous to Krull's *Métal.* Without asserting that the book's designer intentionally mimicked Apollinaire's form when he designed the letters "K R U L L" to mimic the curve of the tower's curving foot, there is a clear formal analogy here.

FIGURE 21 Guillaume Apollinaire, "La Tour Eiffel," in *Calligrammes: Poèmes de la paix et de la guerre* (Paris: Mercure de France, 1918), 74.

MONTAGE AND FILMIC STRUCTURE

Where Krull's *Métal* photographs owed much to simultaneity and Cubism, further intellectual impetus came from other sources, especially from film, both the work of René Clair and that of Joris Ivens. Clair, who co-organized the Salon de l'Escalier with Fels and Vogel, had premiered his film *Paris qui dort* in 1924. Many of the images that Krull made might well have been inspired by the film, as can be seen in certain screenshots that resonate with Krull's images. In Clair's thirty-four-minute film, the city is paralyzed by a "crazy ray" emitted by a mad professor (*The Crazy Ray* was the film's English title at that time). Only a group of people flying into Paris by airplane, the

FIGURE 22 Screenshot of Eiffel Tower from René Clair, *Paris qui dort* (1924), comparable to Germaine Krull's plate 62 in *Métal* (Paris: Librairie des Arts Décoratifs, 1928).

caretaker living on top of the Eiffel Tower, and a few others escape the paralysis. One of the earliest and most renowned "city-symphony" films of the 1920s, this film has a clear narrative arc: people escape the crazy ray paralyzing Paris below a certain height, roam the city and act out, get bored, rescue the niece of the mad professor who created the ray, and reverse the curse, and all ends well with a romance and a diamond ring. Yet the Eiffel Tower itself plays a major role in the film, and not merely because its caretaker is the film's protagonist. Clair filmed the tower around the time that Krull was first photographing industrial cranes and forms in Holland in 1924, and they share a love of vertiginous angles and a clear sense of humor. In film historian Annette Michelson's groundbreaking article on *Paris qui dort,* she perceives that the industrial infrastructure of French culture—in movement—forms a secondary cast of characters for *Paris qui dort.* First, she observes that "temporality, apprehended as *movement in space,* is the vital current of metropolis." Michelson observes that for Clair, the Eiffel Tower is a camera: "A 'viewfinder,' constantly shifting position, reframing, varying angle and height and distance, making every shot and sequence of action dynamic through the powerful, changing asymmetry of its framing girders. The tower, then, is not only a complex, infinitely stimulating set; it provides a range of low and high-angle positions, a vocabulary of movement, a play of light and shadow, of solid and void, which generate visual tension, a range of kinetic responses. . . . By transforming it [the tower] into

a complex optical instrument, a filmic apparatus, Clair makes it a camera."[44]

This same analysis might apply to Krull's *Métal,* in terms of the Eiffel Tower images she includes. In fact, some Eiffel Tower plates in *Métal* closely parallel Clair's points of view. For instance, both artists are fascinated by the dynamism of the diagonal elevator shafts, as can be seen in Krull's plate 26 (see figure 8) and Clair's elevator shots 22:39 minutes into the film. Moreover, both compose abstracted shots of the radio tower atop the tower; Krull's last plate (plate 62) resembles Clair's view of the radio tower 1:52 minutes into the film (figure 22). As she concludes her analysis of *Paris qui dort,* Michelson zooms out to a more distant metaphorical discussion of the film and argues that "behind the cast of characters there is yet another cast which generates the narrative. . . . These figures—mechanisms all—are the tower, the wireless, the airplane, and that fourth machine, that crazy ray, which is the moving-picture camera." Like Krull, Clair sees the industrial world as a cast of characters moving life forward, and, as Michelson points out, it is a cinematic experience, and "in the sequences of arrest and release, of retard and acceleration, we experience the shock and thrill, the terror and delight" of modernity.[45]

When he saw *Paris qui dort* while visiting Paris in the spring of 1926, Dziga Vertov, maker of what is arguably the best-known city-symphony film, *Man with a Movie Camera* (1929), was strongly affected. Vertov was then formulating some of the most powerful theories of montage

and documentary film.[46] Other canonical city-symphony films include Alberto Cavalcanti's *Rien que les heures* (1926), Walther Ruttmann's *Berlin: die Symphonie der Großstadt* (1927), Joris Ivens's *De Brug* (1928), and Jean Vigo's *À propos de Nice* (1930). Ivens's film, of course, had the most direct impact on Krull, as she was involved in its production.

Germaine Krull first met Joris Ivens in Berlin in 1923, while she had a studio there and Ivens was in training to take over his family's chain of Dutch photographic stores, Capi. They quickly became lovers (they married in 1927). Krull first visited Holland with Ivens in 1924 and moved there in the autumn of 1925, until her move to Paris in mid-1926. Krull's walks around the ports of Rotterdam and Amsterdam first fixed her fascination with industrial forms, and she wrote in her memoirs: "These steel giants revealed something to me that made me love photography again. From this moment onward, I began to SEE things as the eye sees them, and it is at this moment that photography was born for me."[47] Although she was living in Paris after 1926, Krull remained involved with Ivens and with the 1927 founding of the Filmliga movement in Holland, and through it she came to know the Soviet filmmaker Sergei Eisenstein and the theories of Vsevolod Pudovkin (whose film *The Mother* was censored in Holland in 1927). Screenings at the Filmliga included all the major avant-garde filmmakers.

Ivens himself became a major experimental filmmaker, and Krull photographed him several times as he made the film *De Brug*. The film documents the new railroad bridge over Rotterdam's Meuse River, and it premiered on May 5, 1928, in Amsterdam's Centraal Theater. It is more conventional than Krull's album, with an establishing shot of a distant view of the bridge both at the film's start and its end, and a central section of montaged sequences of airplanes, trains, barges, and automobiles. Ivens was concurrently showing films by Eisenstein, Pudovkin, and Vertov at the Filmliga in the Netherlands, and he consciously emulated their ruptured montage compositions. Especially interested in Pudovkin, he had analyzed his films in depth and drew up diagrams before shooting his own film, documenting on paper each frame of the film and its particular camera. The fragmentary design he created clearly disrupted a logical narrative flow of the bridge's activities, but the film ends with the long shot again, retaining a sense of linkage (Pudovkin's term), as opposed to Eisenstein's concept of montage as collision (which is closer to Krull's method).[48]

Like other city-symphony films, Ivens allows us to see—albeit in fragmented fashion—the story of the bridge's function, from the raising of the lifting bridge to a barge passing beneath. He then progresses to the lowering of the bridge afterward to allow a speeding train to pass over. Horses, carts, and pedestrians are also visible. Ivens makes sure to show us the operators of the bridge, men who turn cogs to start the machinery, and those scrambling up and down the stairs. His views of trains, planes, and barges are also anthropomorphized; they puff smoke and steam that often partially obscures the metalwork, much like Alfred Stieglitz's 1910 Pictorialist views of New York, with its buildings and transportation. Ivens is also fascinated with the relations between these modern forms, and he shows us trains crossing above and barges passing below in rapidly alternating sequences, adding in the odd cyclist or horse-drawn cart to humanize the saga. *De Brug* ends with a series of views from the train as it rushes across the newly re-lowered bridge (so that we, as passengers, see glimpses of the city through the metal of the trusswork).

Many of Krull's images in *Métal* closely resemble Ivens's shots. Parallels include Krull's views of the bridge's tower (see figure 5) and Ivens's similarly filmed shot (figure 23). The railroad bed crossing the bridge in Krull's plate 31 contrasts with Ivens's roadbed shot, and Krull's detail of the curved span atop the central section of the bridge looks like Ivens's similar shot, with the addition of puffing smoke. Krull, however, eschews a narrative arc, and she expands on Ivens's storyline for a more

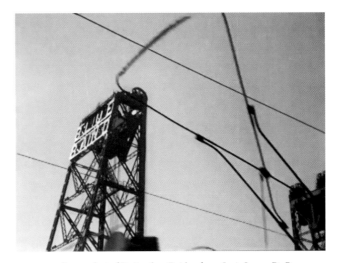

FIGURE 23 Screenshot of Rotterdam Bridge from Joris Ivens, *De Brug* (1928), comparable to Germaine Krull's plate 6 in *Métal* (Paris: Librairie des Arts Décoratifs, 1928).

kaleidoscopic montage effect, closer to Eisenstein's ideas than to Pudovkin's strategy of linkage, which intrigued Ivens. Krull could have photographed the steam and clouds as did Ivens, but she chooses instead to isolate her bridge fragments in a clean, white space. And whereas Ivens shows us a tower after documenting how it is raised or how the wheels work, Krull isolates them from all urban or operational context.

The photographs in *Métal* are arranged in a pattern that is more radically full of interruptions and formal jumps than anything in Ivens's film.[49] Static images are often followed by vertiginous ones. There is no respite between any two images, as can be seen in the progression from swirling bicycle wheel (plate 22; see figure 12) to quiet factory interior (plate 23). We must twist our necks from vertical to horizontal, move from close-up to distant view, or travel unknowingly from Holland to Paris to Marseilles and back again. Eisenstein defines film montage as a language of "visual counterpoint," with conflicts than can be graphic, planar, volumetric, or spatial; these are all formal tools that Krull used. In addition, Eisenstein invokes the use of emotion through montage, writing, "*Emotional* effect begins only with the reconstruction of the event in montage fragments . . . an all-embracing complex of emotional feeling."[50] Although we do not know what Eisenstein thought of *Métal*, he almost certainly saw it—Krull photographed him in 1926 and again in 1930, and he would probably have approved of the emotional kaleidoscope of montaged machine imagery that she constructed.

THE MACHINE AGE

During the years from the end of World War I to the Great Depression, both Europe and the United States participated in an explosion of industry, technical innovation, and large-scale building. Literature, music, and the visual arts both celebrated and critiqued this eruption, and photography was used as a major cultural commentary during these decades. Industrial imagery proliferated internationally both in the fine arts and in the advertising world. In Germany, two camps fought for dominance: that of László Moholy-Nagy, which argued that the true value of the machine lay in its structure, not its external appearance, and that of Albert Renger-Patzsch, a New Objectivity photographer who worshipped the surface, or materiality, of the industrial form. During these years, Renger-Patzsch published his book *Die Welt ist Schön* (1928) with some

FIGURE 24 László Moholy-Nagy, *Dynamik der Gross-stadt*, from *Malerei Photographie Film* (Munich: Albert Langen, 1925), 120. Page: 8¾ × 6¾ in. (22 × 17 cm).

industrial views, and then *Eisen und Stahl* in 1931.[51]

László Moholy-Nagy, teacher of the primary course at the Bauhaus, espoused a very different view, as can be seen in a photograph of the Berlin radio tower in 1928. Moholy-Nagy published his book *Malerei Photographie Film* in 1925, and argued that, in addition to photomontage and photograms (camera-less photographs), straight photography could be invigorated by unusual points of view: bird's-eye views, worm's-eye views, extreme close-ups, and other unusual vantage points. More of a textbook than an independent photography book, *Malerei Photographie Film* includes seventy photographic images (his and others), laid out as double-page spreads, and a fourteen-page storyboard for an experimental film script (figure 24). Although these images were recognizable, they were enlivened by their points of view. Taken individually, Krull's images could be a textbook illustration for *Malerei, Photographie, Film*.[52] We have no direct proof that she saw the book, but they moved in overlapping circles, especially when both published in *iio*, the journal of the Dutch avant-garde film group Filmliga cofounded by Ivens. Like

93

FIGURE 25 Plate 93, Iron Forms for Shoemaking, from Albert Renger-Patzsch, *Die Welt ist Schön* (Munich: Kurt Wolff, 1928). Gravure, page: 11½ × 8¾ in. (29.2 × 22.3 cm).

Moholy-Nagy, Krull utilizes a variety of points of view, and, like his experimental city-symphony project *Dynamik der Gross-Stadt,* published in the book, she assembles them in a montage—although Moholy-Nagy is more didactic, guiding our view with large, graphic arrows and texts inserted into the film. Krull's book is less didactic, and more of a poetic meditation on the kaleidoscopic energy of industry.

Moholy-Nagy's ideas were echoed in the industrial photographs of Aleksandr Rodchenko, dean of metal-working at the Soviet art school VKhUTEMAS from 1922, who first exhibited his photographs in Moscow in 1927 and 1928 and made dramatically angled views of industry in the late 1920s. Rodchenko, who began mak-ing straight photographs in 1924, meant to "renounce shaping a whole and embrace a montage of parts." He photographed industry in tightly compacted narrative groupings. Following his belief that "the most interesting

points of contemporaneity are down from above, and up from below," a year after *Métal's* publication, he created a montage of seven images to illustrate the construction of electric bulbs in *Electrofactory, Let's Give* (1929). His collec-tion of images and texts includes the light bulbs on a table, a slogan for production, the workers making the bulbs, boxed bulbs ready for shipping, and the word "electrofac-tory."[53] Germaine Krull's knowledge of Soviet montage ideas, however, probably stemmed from her acquaintance with Eisenstein, whom she knew through Ivens and the Filmliga.[54]

Krull's position between the clear-cut New Objectivity style of Renger-Patzsch and Moholy-Nagy's more dynamic style (which he dubbed the New Vision) can be seen in *Métal*, where some of the factory interiors have the glossy surfaces and pleasure in material appearance of Renger-Patzsch's photographs in *Die Welt ist Schön* (figure 25). More of the interiors share the "vertiginous rotation"

commented on by Daniel Rops. On balance, Krull represents the side more closely allied with Moholy-Nagy: her photographs celebrate the confusion, speed, and simultaneity of the industrial world. The distinction between Renger-Patzsch's New Objectivity and Moholy-Nagy's New Vision has a political dimension as well as an aesthetic one, and Krull's album lands on the side of the New Vision. A clear view of the dichotomy can be seen in two critical essays from the interwar period. In the introduction to Renger-Patzsch's 1928 book *Die Welt ist Schön*, critic Carl Georg Heise writes, "The head of the snake fits into the coils of its body in such a way that the page seems filled with a decorative pattern of scales, a pattern which the viewer's imagination extends uncannily into infinity. Thus, above and beyond the single snake, the picture presents the entire species."[55]

Krull's images avoid "decorative patterns," and their more dynamic composition resembles closely what Moholy-Nagy, in railing against Renger-Patzsch, suggests: "I would a thousand times rather have exaggeration of objectivity, of sharpness, outlines and details, than a mode of presentation that combines the planes, no matter how skillfully, but omits the details. Objective photography must teach us to see. . . . It must help us to open our eyes."[56] Krull's friend Benjamin politicized these two points of view—surface versus structural/experimental—in his views of Renger-Patzsch, whom he detested as "fashionably perfected." In "The Author as Producer," he castigates Renger-Patzsch, writing: "It goes without saying that photography is unable to say anything about a power station or a cable factory other than this: what a beautiful world! *A Beautiful World*—that is the title of the well-known picture anthology by Renger-Patsch [*sic*], in which we see New Matter-of-Fact photography at its peak. For it has succeeded in transforming even abject poverty, by recording it in a fashionable perfected manner, into an object of enjoyment." Instead, Benjamin has no use for isolated creativity, for "such rigid, isolated things as work, novel, book. It has to insert them into the living social context." As we have seen, Benjamin had far more sympathy for Krull; *Métal* is just such a context—not an overtly political treatise, but an integrated social and cultural commentary on both the vibrancy and the complexity of modernity.[57]

MOÏ VER

Krull was not the only photographer working in Paris to use alienation effects, montage structures, or the idea of making modernity "enstranged," but she was seen as a role model, and *Métal* inspired many of her peers. Krull's fame in the late 1920s made her an object of admiration for many contemporaries, although, perhaps because she left Europe at the start of World War II and contacts with her peers eroded, we have only limited comments from them. Berenice Abbott later recalled, "Germaine Krull was doing some remarkable work and she was sort of the Bourke-White of France." (Margaret Bourke-White frequently published images of industry and Soviet Russia in *Fortune* and, after its inception in 1936, in *Life* magazine.) René Zuber, a slightly younger photographer, commented on how Krull "pointed her camera at the sky and photographed the Eiffel Tower, from bottom to top"; he goes on to state, "Since that day, photographs have set out to discover the world." There was a palpable recognition by these photographers that Krull was doing something remarkable and different with industrial imagery. Among her co-exhibitors at the Salon de l'Escalier, Man Ray supposedly told Krull, "Germaine, you and I are the greatest photographers of our time, I in the old sense you in the modern one."[58]

The Lithuanian-born artist Moï Ver (Moshé Raviv Vorobeichic) published several intellectual offshoots of *Métal* in the years directly after its publication. Moï Ver studied art in Vilnius, at the Bauhaus from 1927 to 1928, and at the École Technique de Photographie et de Cinématographie in Paris. He began photographing at the Bauhaus, inspired by Moholy-Nagy. His first book, in 1931, documented his hometown of Vilnius: *Ein Ghetto in Osten—Wilna*, which he had photographed on a trip home. Although it presents the Jewish ghetto in Vilnius in a series of double exposures and montaged images, it is a conventional travelogue of one place. Its introductory text, in fact, states that the album "shows true Jewish life, and its ethnographic materials make it a handbook for everyone." The book does, however, interrupt logical textual readings because of its bilingual format: it reads from right to left in Hebrew, and from left to right in German.[59] The photographs are relatively conventional multiple exposures, with the first image showing a montage of a worker and a building (figure 26). Another page spread shows a montage in the cut-out shape of an exclamation point.

Also in 1931, three years after *Métal*'s appearance, Moï Ver published his most famous book, *Paris*, with an introduction by Fernand Léger (figure 27). Published

1. The Old Synagogue ‏א. בית מדרש ישן‎

FIGURE 26 Plate 1, *The Old Synagogue*, from Moï Ver, *Ein Ghetto in Osten—Wilna* (Zurich: Orell Füssli, 1931). Offset, page: 7½ × 5 in. (18.7 × 12.5 cm).

by the Parisian Éditions Jeanne Walter in an edition of one thousand copies on expensive, heavy vellum paper, the book (11½ by 8¾ inches) displayed eighty multiple exposures of Paris. It sold for 100 francs, two-thirds of the price of *Métal*. Léger was Moï Ver's instructor in evening classes at the Académie Moderne. Léger's one-and-a-half-page introduction probably made the book more salable, but the painter's language is oddly reactionary and has the tone of a teacher tepidly endorsing his student. Commenting on the new plastic researches that photography undertakes, Léger comments that cinema has opened the path for this development. He comments that "mélange" is in fashion, but dislikes seeing this in photography. Instead, he feels that "surprises are fine for the stage or on the screen but not in photography. That is a minute and patient art. . . . The result should be objective, precise

and striking in its neatness." He then goes on to champion Moholy-Nagy and Lissitzky, who seem to him to be excellent examples of the new art, yet he calls Moï Ver's album merely "interesting."[60]

Paris, oddly, seems to be everything that Léger's introduction is railing against: it is full of cinematic ruptures, surprises, and mixes of images; virtually all its images are multiple exposures. Moï Ver often sandwiched negatives together to achieve his multiple exposures, a technique Krull also used.[61] The cover of the book superimposes a series of smokestacks that strongly resemble Krull's in *Métal*, with a classical colonnade of Corinthian columns and some dramatic clouds (see figure 27). The effect is an obvious equation of modern-day columns and classical columns. The book's first plate begins with a collage of cobblestones and rooftops, followed by a second image

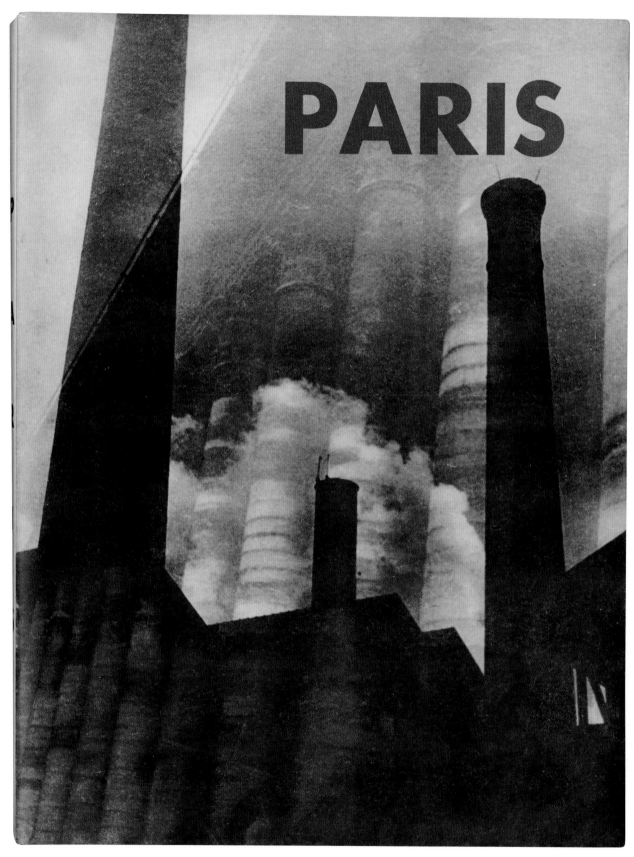

FIGURE 27 Cover of Moï Ver, *Paris* (Paris: Jeanne Walter, 1931).
Collotype, page: 11½ × 8¾ in. (29.2 × 22.4 cm).

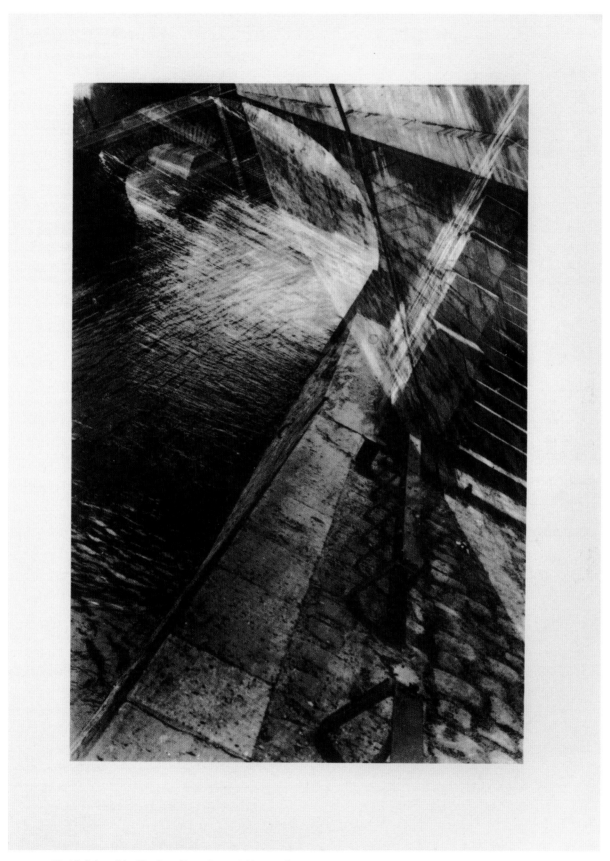

FIGURE 28 Untitled, from Moï Ver, *Paris* (Paris: Jeanne Walter, 1931), n.p.
Collotype, page: 11½ × 8¾ in. (29.2 × 22.4 cm).

of cobbles and automobile wheels. Like Krull's *Métal*, it has no obvious narrative structure, although the multiple exposures seem grouped in street views for the first twenty-five plates or so (figure 28), with more people in the second half (plates 27–43; figure 29). Not only are the angles different in each view, but multiple exposures are piled on top of each other, often from different orientations. Unlike Krull's book, Moï Ver showed all sides of Paris as well as people from all walks of life, and he carried the technique of multiple exposures to an extreme so that all the images are multiple exposures. However, he remains somewhat predictable; people grouped with people, cars superimposed over cars, figures collaged onto a crosswalk. Art historian Andrea Nelson has observed that in his montages, Moï Ver often juxtaposed classical and modern subjects, as well as moving and static subjects: there are many cars, cobblestones, and bicycles.[62] *Paris* was a success, and Moï Ver soon began photographing for *VU* and other journals.

Unlike Krull, Moï Ver's wider reputation did not grow markedly in this period, and there is very little critical reception for this book. *Paris* was advertised in *Arts et métiers graphiques* in 1931, once with a cover shot and once with a full-page image of one page of the book. The book's publication was noted in a biweekly book release journal, in which critic Jean Bullier devastatingly commented, "One, two, three multiple exposures, if they are combined with intelligence and sensibility, can be amusing—eighty-four multiple exposures tire us, bore us, and lose their meaning."[63] In 1932 Moï Ver developed a third project, *Ci-contre*, and began corresponding with Franz Roh about publishing it. He immigrated to Palestine in 1934 and believed that he had lost the book's images, but many years later, the lost negatives were rediscovered in the estate of Roh. Although this volume was Moï Ver's most experimental project, *Ci-contre* was published posthumously, in 2005.[64] Unlike *Paris*, with its clear guidebook subject, Moï Ver structured *Ci-contre* according to much more radical ideas that were purely formalist: light/dark contrasts, wide- or narrow-angle shots, diagonal perspectives, close-ups and long shots. It is decidedly less urban and industrial in form than its precursors. However, since it was not published in his lifetime, it had no public impact on either photographers or bookmaking.

Krull herself had published a tourist book called *100 x Paris* in 1929.[65] With texts in three languages (French, German, and English), it is a far more conventional

overview than Moï Ver's, but it shares the unusual bird's-eye or worm's-eye points of view of her *Métal* images, albeit with commonplace subjects of streets and buildings—modern life in Paris. In the years after World War II, many French publications emulated Krull's and Moï Ver's vertiginous viewpoints, especially in a group of books about the Eiffel Tower that seemed to explicitly pay homage to *Métal*.[66]

AMERICAN COUNTERPARTS

The most famous American photobook, Walker Evans's *American Photographs*, may at first glance have little in common with *Métal* or other experimental photography books in Europe, and few have commented on any links with European modernism. Although he spent only one, somewhat isolated, year in Paris, from April 1926 through May 1927, Evans honed his photographic vision there, and the qualities of simultaneity, Cubist collage, and filmic montage are subtly present in most of his work even after he turned to a more documentary style in the 1930s. In the late 1920s, he was very aware of the European avant-garde, partly from his travels and partly from his friendship from 1929 onward in New York with Berenice Abbott, who had exhibited (along with Krull) in the Salon de l'Escalier, and who was printing the negatives of Eugène Atget that she had brought back from Paris in 1929. Evans's written views on European avant-garde photography are known through a review he wrote of several European photography books, published in *Hound and Horn* in 1931. There he echoes many of Walter Benjamin's ideas, finding Renger-Patzsch's book "exciting to run through in a shop and disappointing to take home," and castigating it as a return to the "middle period of photography," by which he means Pictorialist or art photography. In contrast, he admires Franz Roh's *Photo-Eye*, one of the two books published at the time of the *Film und Foto* exhibition in Stuttgart in 1929, calling it a "nervous and important book. Its editors call the world not only beautiful but exciting, cruel, and weird . . . an anthology of the 'new' photography." Evans's knowledge of specifically French developments is reflected in his remarks on *Photographie*, a 1930 publication by Arts et Métiers Graphiques, with critic Waldemar George's essay "Photographie-vision du monde." Evans finds George's essay valuable "in its French-intellectual way, a respectable statement of the functions and possibilities of photography." In "Photographie: Magie moderne," a subsection of his long essay, George echoes

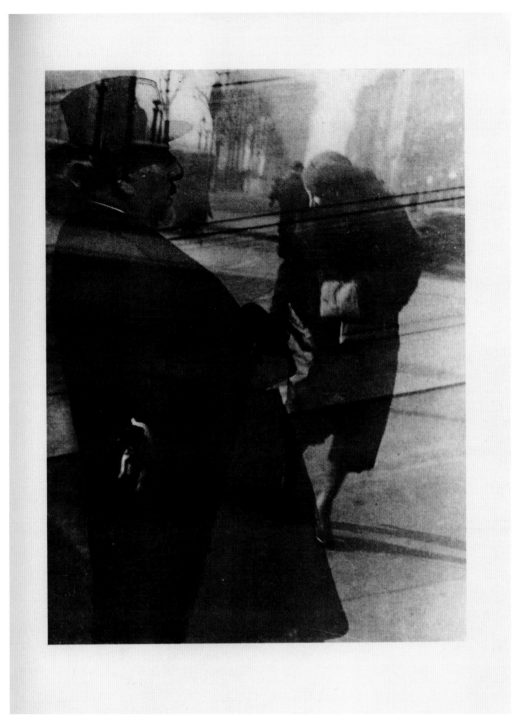

FIGURE 29 Untitled, from Moï Ver, *Paris* (Paris: Jeanne Walter, 1931), n.p. Collotype, page: 11½ × 8¾ in. (29.2 × 22.4 cm).

Florent Fels's lyrical and poetic view of Krull's industrial views: "Germaine Krull photographs the Tower. . . . Photography reveals the metallic constructed architecture, architecture of iron and concrete, that defiance of the laws of equilibrium; these manifestations of the victorious spirit of rebel materials."[67] *Photographie* includes two

Krull industrial images: one on page 74 (the first plate of *Métal;* see figure 3), across from a Charles Sheeler view of New York skyscrapers; and a second on page 89—a Krull view of industrial machinery not included in *Métal.* This second image, too, is placed right before a Sheeler photo of the Ford River Rouge plant. Evans may or may not have

consciously looked at Krull's work, and he may or may not have seen *Métal*, but Krull's vertiginous angles, montage concepts, and uses of simultaneity formed part of his general exposure to the European avant-garde.

Even before this 1931 review, however, Evans had begun experimenting with photographic views that bear a resemblance to Krull's angles, in his depiction of the Brooklyn Bridge, a New York monument that—like the Eiffel Tower—still embodied modernity after its fortieth birthday (the bridge was completed in 1883). Encouraged by a German New Objectivity painter, Hanns Skolle, he and a friend, Paul Grotz, began photographing in New York, and photographed vertiginously angled views of the Chrysler Building and other new construction with a small amateur camera. Two years after *Métal*, three of Evans's New Vision–inspired photographs of the

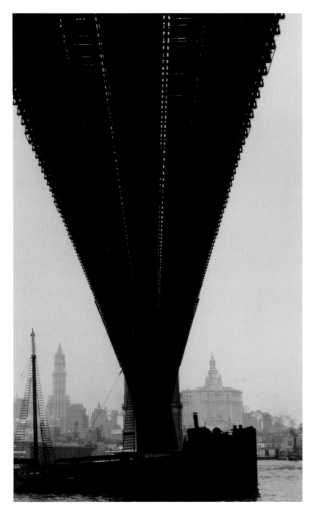

Brooklyn Bridge were published in Paris in 1930 in a Black Sun Press illustrated edition of Hart Crane's *The Bridge*; two different images appeared in slightly later American reprintings the following year. Although not strictly a photographic book, and despite the fact that Crane hoped until fairly late in the process that the painter Joseph Stella would provide the illustrations, this is a true collaboration between poet and photographer, with each image reproduced as a small, jewel-like rendition on a large, empty page.[68] One of these images (figure 30) is a distorting, worm's-eye view of the bottom of the bridge, and bears a striking resemblance to the angled views of Ivens's *De Brug* and to Krull's *Métal*. A second photograph, a diagonally structured view of coal barges, a tugboat, and water from a bird's-eye view (figure 31), bears even more distinct relationships to the New Vision of Evans's European counterparts. A third photograph shows the towers, promenade, and wires of the bridge. Although he soon turned away from these extreme-angled views, both he and Abbott experimented actively with them in 1929 and 1930. Alan Trachtenberg describes these Evans photographs as "constructive visions, unexpected organizations of objects in space: not simply representations of Brooklyn Bridge, but also of the act of seeing."[69]

By 1938 Evans had turned away from a small-format camera and from overtly avant-garde bird's-eye and worm's-eye details of the metropolis, and along with his exhibition at the Museum of Modern Art he published *American Photographs*, a groundbreaking book that would redefine American photography books for the next half century and more. Although the museum installation seemed fairly informal and almost unprofessional, based on installation photographs, with unframed images stuck unevenly on the wall, the book is something else altogether. Evans had been thinking about how to portray the dynamism of city life in book form as early as 1934, writing: "What do I want to do? . . . I know now is the time for picture books. An American city is the best." As Trachtenberg writes, *American Photographs* presents "more than a compilation of individual photographs; rather, a deliberate order of pictures, a discourse of images."[70] Lincoln Kirstein's afterword presents Evans's selections as follows: "Looked at in sequence they are overwhelming in their exhaustiveness of detail, their poetry of contrast, and for those who wish to see it, their moral implication." Kirstein comments on Evans's implicit (as opposed to Krull's explicit) discussion of the Industrial Revolution,

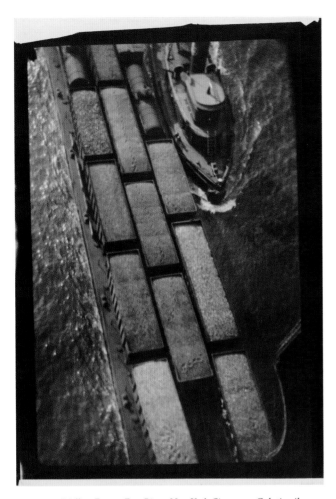

FIGURE 31 Walker Evans, *East River, New York City*, 1930. Gelatin silver print, 9⅛ × 5¹⁵⁄₁₆ in. (23.2 × 15.1 cm). J. Paul Getty Museum, Los Angeles. From Hart Crane, *The Bridge* (Paris: Black Sun, 1930), n.p.

mentioning "the replacement by the machine in all its complexities of the work and art once done by individual hands and hearts, the exploitation of men by machinery and machinery by men."[71] Like Krull, Evans sees both sides of the equation of the effects of the mechanization of the 1920s. But whereas Krull distorts cranes, steelwork, and factories so that they create a poetic montage, Evans's montage is subtler and more embedded in the minutiae of one picture that follows another, and then another. His photographic riff on car culture, for instance, takes him from a car junkyard (plate 7) to a Cubist collage-like view of peeling gas station signage (plate 8), to a view of a food truck with a pastoral hand-painted view of what idyllic car picnics should be (plate 9), and finally to the less-than-happy existence of an actual young couple in their new car (plate 10; figure 32). Their worried faces, not the shiny new car that they inhabit, are the highlight of

the photograph. Although Evans frames a blurred truck (symbolizing modern speed) in the mid-ground, a shiny parked car on the far side, and a long, straight fence mimicking the direction of the road, these two people seem less at ease with modern machinery than the miniaturized, grinning heads that peer down from atop the ship's mast in the first image of *Métal* (see figure 3). As Trachtenberg clarifies, Evans "characteristically thought of his pictures as comprising sequences, forming an order in and of themselves." He reminds us of Evans's first publication of images, "Mr. Evans Records a City's Scene," in *Creative Arts* in 1930, that includes an Apollinaire-like collage of the words "machine, camera, very high speeds, bus hour, speed, Mr. Walker Evans Records a City's Scene."[72]

Where Krull separates her examination of people from her studies of machines, Evans combines them. The format of *American Photographs* itself is the herald of a post–World War II aesthetic: white-framed photos on the right, white pages at the end, captions at the end. Yet Evans's structure of image sequencing is indirectly informed by what he learned in Europe and in his early New York industrial images. Finally, montage and European modernism clearly inspired the layers of certain single images such as plate 1 of *American Photographs*, with deceptively simple signage of photo booths, signs, and fingers all overlapped so that one rickety building becomes a metaphor for a camera and the act of seeing. Krull's heritage is still a celebration of the complexities of the Machine Age; Evans shows us another side, and the unease that he records so effectively leads us back to Pierre Mac Orlan's "social fantastic" observed in daily life, and into a whole series of books that would flourish in the 1930s.

FIGURE 32 Walker Evans, *Parked Car, Small Town, Main Street*, 1932. Gelatin silver print, 5½ × 8¹⁵⁄₁₆ in. (14 × 22.7 cm). Plate 10 from *American Photographs* (New York: Museum of Modern Art, 1938).

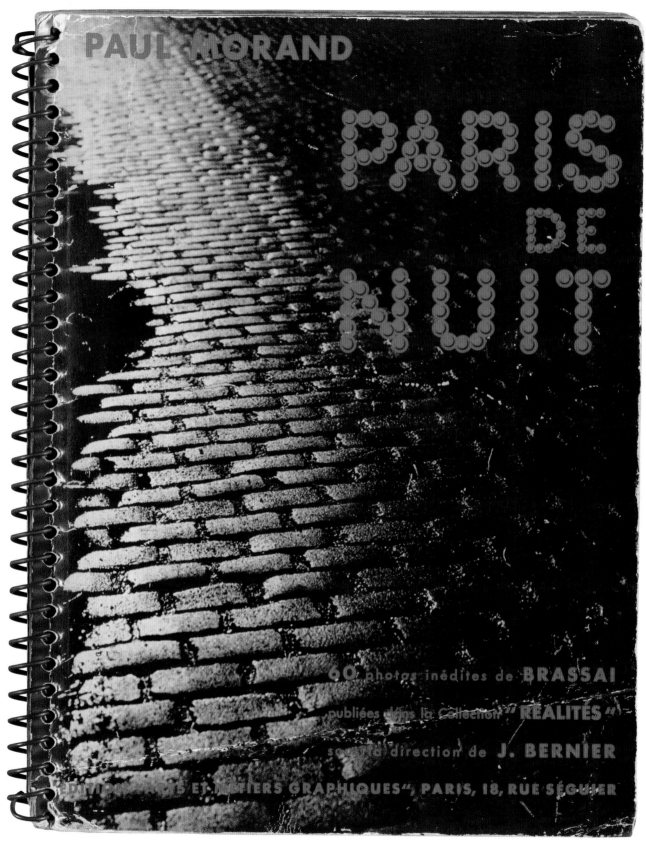

FIGURE 33 Cover of Brassaï, *Paris de nuit* (Paris: Arts et Métiers Graphiques, 1932). Gravure, page: 10 × 7½ in. (25 × 19.3 cm).

2 DREAM DETECTIVES

Brassaï's *Paris de nuit*

In Paris, I led a noctambulist life for six years, and when saturated with the beauty of the Parisian night, I wondered which medium would best capture it, photography and photography alone would do.
—Brassaï

The spring of 1984, fifty-two years after the publication of Brassaï's most famous book, *Paris de nuit* (1932), marked a new detective mission: a hunt for the long-lost negatives of the project that established his career as a seminal photographer and book publisher (figure 33).[1] Brassaï had never recovered his glass negatives from Arts et Métiers Graphiques, the book's publisher, and the press had been sold to another Parisian publishing house, Flammarion. This loss haunted the photographer for his entire life; in fact, each surviving vintage print for *Paris de nuit* bears his handwritten lament on its verso: "Epreuve originale de *Paris de nuit* (le négatif de cette photo a été perdu) Brassaï" ("Original print for *Paris de* nuit [the negative of this image has been lost] Brassaï").[2] After scouring the basement of Flammarion, searching for archives, I unearthed the original prints for *Paris de nuit*'s sister volume, Roger Schall's *Paris de jour* (1937)—also published by Arts et Métiers Graphiques. A next clue was the discovery that old glass negatives were stored in the attic studio of Flammarion's current staff photographer. A long climb up many flights of stairs led to a dusty darkroom, with rows of yellow boxes lining the walls. Faintly visible through the dim light were some boxes labeled "Paris de nuit" on the top shelf,

where Brassaï's glass plates had lain untouched for half a century. I was fortunate in being able to reunite Brassaï, then eighty-four years old, with his long-lost negatives. He died soon afterward, and *Paris de nuit* was republished only after his death, in 1987. Flammarion used the original negatives and same photogravure printing technique, and published the new volume internationally, like the earliest version.[3]

The polarity of these finds, in cellar and attic, highlight the long history of this transformative book from 1932 to the present. Their half-century-long hiding places recall philosopher Gaston Bachelard's use of the house to explore the poetic imagination (his term is the "poetics of space"). That poetic imagination and sense of detective discovery drive *Paris de nuit*. Bachelard's phenomenological study of the meaning of everyday spaces resonates here, as he explores the house as a *"tool for analysis* for the human soul," asking, "How can secret rooms, rooms that have disappeared, become abodes for an unforgettable past?" He continues: "The house shelters daydreaming, the house protects the dreamer, the house allows one to dream in peace." Brassaï's "house" is the city of Paris, and it shelters night-dreaming, whereas Roger Schall's

is a sunlit daydream. It is ironic that Brassaï's negatives of imagery were found in the attic yet resonate with Bachelard's cellar as "the dark entity of the house"; his photographs echo the philosopher's definition of the cellar whose creatures are "slower, less scampering, more mysterious." In contrast, Schall's quotidian images reflect the top of Bachelard's oneiric house, the attic with its "more tranquil solitude."[4]

For a book that was out of print for fifty-four years, *Paris de nuit* has carried a strong after-memory and almost a cult following. Brassaï published many other books about Paris during his career, including *Voluptés de Paris* (1935), a volume he always refused to list in his bibliography, featuring a much seedier underworld than *Paris de nuit,* and *Les Paris secret des années 30* (1976), a nostalgic look backward at his adventures in the 1930s.[5] The many afterlives of *Paris de nuit* give us a clear indication of its international impact and allure, compared to the afterlife of Germaine Krull's *Métal,* which was reprinted only once quite recently, and in a small edition. Nonetheless, Brassaï shows a clear debt to Krull, for the New Vision photographic style she brought to French audiences through her metalwork photographs; for her well-known photo-essays on clochards, the down-and-out citizens of Paris, that she published in *VU* and elsewhere; and for her detective "photo-roman" with Georges Simenon, *La folle d'Itteville.*[6] Brassaï's innovations would build on these ideas, incorporating intuition, mystery, and a dramatic, graphic style that reflected the darker decade of the 1930s.

A close structural analysis of *Paris de nuit* reveals that its subjects, design, and progression of images are closely linked to the intellectual literary world of Paris in the 1930s—both high and low. Brassaï knew André Breton, leader of the Surrealist movement, and made dreamlike images similar to and sometimes published in Breton's Surrealist novels. His dark vision also echoes the dissident Surrealist writer Georges Bataille, whose concept of bassesse (base materialism) was similarly obsessed with the dark and fetid underside of Paris. Many recent writers have explored Brassaï's links to the high culture of Surrealism, including Dawn Ades, Simon Baker, Hal Foster, Rosalind Krauss, and Ian Walker.[7] Less studied is the fact that Brassaï incorporated far more than Surrealism in his project. *Paris de nuit* also echoes the romanticized underworld of other, more popular contemporary novelists such as Francis Carco, Louis-Ferdinand Céline, Eugène Dabit, Léon-Paul Fargue, Paul Morand, Pierre Mac Orlan, and Henry Miller. Miller, Brassaï's good friend, labeled his vision an "insatiable eye."[8] Furthermore, *Paris de nuit* reveals a contemporary fascination with vernacular culture, especially the detective fiction of the time, with its petty crimes and nocturnal wanderings—Simenon's fictional detective, Inspecteur Maigret, first appeared in 1930 in a Parisian journal, *Détective.* All these middlebrow or lower-brow contacts coalesce to produce a photographic book that builds on uneasiness—the stock in trade of the French critic and author Mac Orlan, with his influential concept of the "social fantastic." For Mac Orlan, the quotidian trumps the intellectual; observed reality becomes a transgressive poetic realism; and his "social fantastic" blends with Paris as an embodiment of Bachelard's later idea of a space that "shelters dreams." A visual counterpart to these literary trends, Brassaï's densely black, graphic style combined factuality and intuition; it would become a powerful visual metaphor for periods of unrest, both in 1930s Paris and after the war.

The ideas that Brassaï explored in *Paris de nuit* resonated strongly in the Depression era. France was reeling after the financial crash and yearning not only for a "simpler" nineteenth century but also for the lost prosperity of the 1920s and the forward-looking "Machine Age" celebrated by Krull half a decade earlier. The years from 1926 to 1931 had been a calm "Indian summer," with postwar rebuilding completed and German reparations payments arriving on time. The Depression hit France late, in 1931, and in some ways less severely than in other countries, with no banking crisis and unemployment reaching only 5 percent. Nevertheless, it was still the worst economic downturn in a century, and its devastating effects lasted until 1935. Tellingly, the psychic wounds of World War I reemerged in these years, and the war's longer-term effects made the 1930s a complicated and troubled time in France. France lost 1.4 million young men on the battlefields of World War I, and 4 million more were wounded or disabled. As historian Eugen Weber writes, "The 1930s began in August 1914."[9] Caught between traumatic World War I memories and increasing anxieties about the ominous political situation in Germany, the French expressed these worries not only in Surrealism, but in a widespread fascination with detective fiction, and in the popular press's taste for scandal, xenophobia, and anti-Semitism.

Brassaï's photographs project the turbulent French political culture of the 1930s, when radically different

left-wing and right-wing political factions battled while economic development stalled. His work includes both the innovations of the avant-garde inherited from the 1920s and a more right-wing reactionism, *retour à l'homme.* Brassaï's work has often been seen in the context of an art-historical poetic realism, especially in his postwar publications, and his later involvement with French humanist photography reflects the more nostalgic and conservative side of France's cultural equation—an important development that has been under-studied in recent years.[10] But *Paris de nuit* also introduces a more literary, more unsettling, and politically blacker worldview. The photographer's combination of these two viewpoints resonated deeply with its audience. He achieved this effect with a photographic method that contradictorily champions both reportage and intuition. As novelist Lawrence Durrell writes, "Brassaï does not 'interpret' but allows the subject to interpret itself on his film." Yet at the same time, as the photographer himself explains, "For me the photograph must suggest rather than insist or explain. . . . I should be able, by photographing it in a certain way to render completely tangible the hidden life behind."[11] Secretive hints, contradictions, and mystery: Brassaï skillfully used the cultural tools of his decade in constructing his book.

Paris de nuit hit the newsstands in December 1932—a spiral-bound softcover book of sixty-two views of Paris, printed in photogravure, and, including its first print run of four thousand that month, twelve thousand copies were sold by the end of 1933. Considerably smaller than *Métal,* measuring 10 by 7½ inches, it also cost one third of *Métal*'s price—45 francs in Paris bookshops. The following year, an English edition, *Paris after Dark,* was published in London by Batsford Press. After five years as a journalist, Brassaï had begun to photograph in 1929, and in late 1931 he convinced the prestigious art publisher Arts et Métiers Graphiques to publish a book of his nocturnal views. The volume presents a collaborative effort among Brassaï, who provided the images, press director Charles Peignot, series editor and caption writer Jean Bernier, and Paul Morand, the popular novelist who wrote the text. Although Brassaï closely monitored the final narrowing down of images for the volume, Peignot and Bernier probably laid out the book. Morand may well have written his essay before the final image selection was made.[12]

Morand, the book's essayist, had slightly different interests from Brassaï's, and *Paris de nuit* demonstrates an odd slippage between his more elitist biases and Brassaï's keen interest in the lower classes, further complicated by the more genteel images demanded by Peignot as publisher. The series editor and author of the captions, Bernier, knew Bataille well and had a fourth, politically leftist, view of the world.[13] In contrast to Morand's more conventional text, which moves from dusk to dawn like a good Paris noctambulist tourist account, Brassaï's images often subvert conventional views of the places they portray. His camera records the fashionable nightspots of the Étoile and the Opéra, but unusual compositions redefine the sites in Brassaï's terms. Often shot from below, they reveal his own attitudes and his preferences for the underworld as opposed to the leisure classes. This occurs both in sequencing and in composition.

Despite the competing interests of its multiple authors, the book resonated widely and continues to do so today. Its impact spread as far as Japan as early as 1933, when *Asahi Camera* published an eight-page spread of the photographs soon after the book's release.[14] Many books overtly emulated it in the same size and approximate number of images: the publisher commissioned Schall for *Paris de jour* in 1937, and in 1938 Bill Brandt published *Londres de nuit* (*A Night in London*), with Arts et Métiers Graphiques publishing the French edition. After World War II, Brassaï's emotional intensity, his deep and gritty black tone, and the book's startling layout, with its lack of white borders, were seen as an effective language for urban books as varied as William Klein's *Life Is Good and Good for You in New York: Trance Witness Revels* (1956) and the Japanese protest photobooks of the turbulent 1960s and 1970s.

PARIS DE NUIT

The cover of *Paris de nuit* shows a series of cobblestone streets, whose gritty reality vividly recalls the seamy street corners of popular film and crime fiction (see figure 33). A gleaming, wet, cobblestone gutter moves into the book's binding from bottom right to top left. A black puddle dominates the left edge, and the title appears as a group of bright-red traffic light–shaped circles, which Sylvie Aubenas equates to "a neon dance-hall or night club sign."[15] (The 1933 English edition added *Paris after Dark* in green-light circles below the red French title.) Despite its association with school notebooks today, the metal spiral binding represented the height of avant-garde technique at the time—as we have seen, Peignot's annual publication,

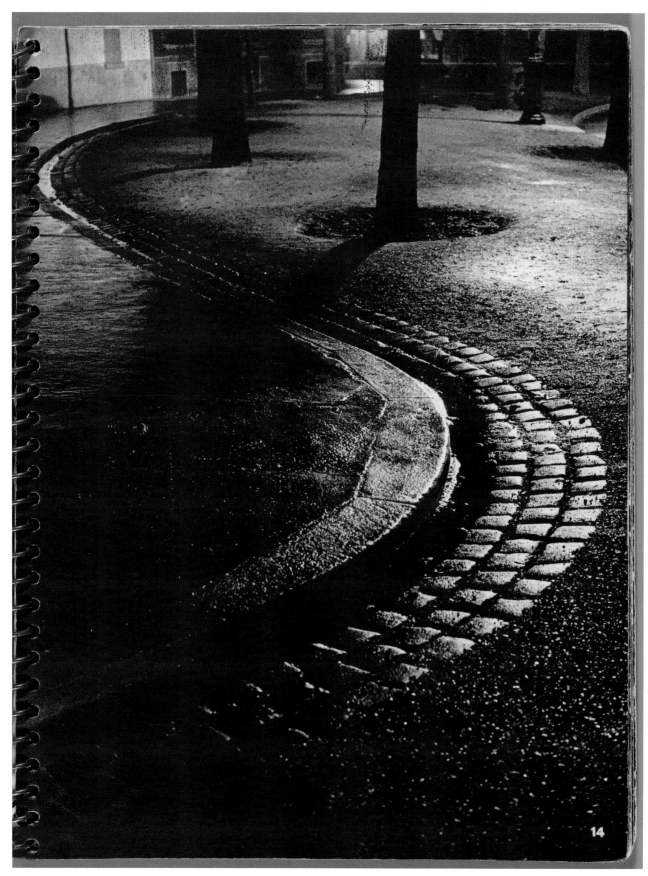

FIGURE 34 Plate 14, Open Gutter, from Brassaï, *Paris de nuit* (Paris: Arts et Métiers Graphiques, 1932). Gravure, page: 10 × 7½ in. (25 × 19.3 cm).

Photographie, and Laure Albin-Guillot's *Micrographie décorative* had similar spiral bindings. This binding allows one to lay the book completely flat when reading it, and lets the right and left pages blend. It punctures and then sutures the pages themselves, simultaneously injuring the urban depictions and stitching them together in odd juxtapositions. Brassaï's black images literally bleed off the page's edge, saturating the view with black ink and obscuring all white pages. Because the book is printed in inky, luxurious photogravure, the deep, velvety blacks rub off onto your fingers when you touch the page.

The two-page spread inside the front and back covers continues the cobblestone motif of the cover (see figure 1). Two crescent cobblestone patterns butt up against each other at the wire spine yet form a continuous pattern. Undulating from left to right, from light to dark, and from top left toward center right, they create a stone wave landscape with no sky, no ground, and no human scale. These continuous patterns suggest a dreamscape rather than a peopled space. In fact, Brassaï's *Paris de nuit* becomes a metaphor for a dream city not dissimilar to that in André Breton's novels *Nadja* and *L'amour fou.*[16] The black ink in another undulating gutter suggests blood—the blood of dreams rather than physical violence (plate 14; figure 34). Thus, the book's elegant layout also has a visceral side. Brassaï knew of Georges Bataille's writings on *bassesse* and had published photographs in *Minotaure* that have direct references to Bataille's fascination with exploring blood, gore, dirt, feces, and the visceral world to bring down art to a level of base materialism. Bataille's concepts of *bassesse* and the *informe* (formlessness) formed a cruder, more visceral, nightmarish counterpart to Breton's more polite dream imagery. Brassaï's images fit into this pattern, and his gutter (see figure 34) recalls the "abbatoir" photographs of Krull's colleague Eli Lotar; his rows of disembodied cow hocks lined up outside the slaughterhouse door in a similar pattern illustrate Bataille's "dictionary" definition of "abattoir" in *Documents* (1929).[17]

Each page spread in *Paris de nuit* stitches together two black images side-by-side, and the page spreads often make a social commentary. For instance, plates 17 and 18 present both graphic and social comparisons: in a juxtaposition of two compositions with large semicircular forms, the Place de la Concorde, with its elegant statues lit beneath a curving water spout, lies adjacent to a black bridge whose arched base frames clochards around a fire (figure 35). At times the editor tips over into lighthearted

humor in the pairings: plate 23 depicts two cats and plate 24 displays two lovers. But some juxtapositions are trenchantly social: plate 27 frames prostitutes' hotels advertising rooms-by-the-hour, while the facing plate 28 portrays the bicycle police who patrol these neighborhoods. Even the book's upper-class images toward the end of the book present deliberate pairings, as in the metallic skirts of the Eiffel Tower juxtaposed with the long dresses of women entering the Hôtel de Crillon on the facing page.

Paris de nuit, like the city-symphony films discussed in the previous chapter, follows the roughly hourly timetable that Morand lays out in the introduction; we begin at 10:20 p.m. on the Place de l'Étoile and end with the morning milk truck (plate 2; figure 36, and plate 62; figure 37). Within that large structural framework, however, Brassaï's photographs can be separated into two distinct groups of more transgressive images: the oneiric redefinition of nighttime monuments and streets, and the refiguration of Paris with his powerful yet troubling figure studies. A list of the sites conforms to a tourist's path: Luxembourg Gardens, Notre Dame, Place de la Concorde, Arc de Triomphe, Tuileries, Folies Bergère. Yet the composition of each photograph subverts a merely touristic definition. The subtle process redefines nocturnal Paris into a blacker, more mysterious city than Morand's more conventional one.

Not content with disturbing views of Parisian sites, Brassaï also distorts the standard picturesque traditions of Paris people—figure studies constitute almost half (twenty-five) of the plates in *Paris de nuit.* In his book, he collects more than twenty "types" of Paris, evincing nostalgia for a passing way of life and for manual labor—there are few electricians or trolley drivers here. In *Paris de nuit,* Brassaï shows us men exiting from urinals, three views of clochards, lovers, men visiting brothels (discreetly seen from the outside), two pages of policemen, septic tank pumpers, flower girls, sleeping vegetable vendors at Les Halles, worksite watchmen, newspaper printers, bakers, prostitutes, newsstand vendors, three different groups of dance hall girls, dustbin/rag pickers,

OVERLEAF

FIGURE 35 Plates 17 and 18, Place de la Concorde and Under the Bridges of Paris, from Brassaï, *Paris de nuit* (Paris: Arts et Métiers Graphiques, 1932). Gravure, page: 10 × 7½ in. (25 × 19.3 cm).

17

FIGURE 36 Plate 2, Vegetable Train, Place de l'Étoile, from Brassaï, *Paris de nuit* (Paris: Arts et Métiers Graphiques, 1932). Gravure, page: 10 × 7½ in. (25 × 19.3 cm).

and milkmen. Many of these figures have their own tradition in the print history of the *petits métiers* (small trades). Yet the photographs, with their trace of reality, deny the overt romanticism of prints, and the gritty inky quality of Brassaï's pictures portrays specific individuals at a particular time in history, as he trespasses visually, invading the space of the actual people. Like the meticulously described figures in detective stories, their detailed and tactile representation erodes the viewer's safe distance from this underworld and provides a frisson of reaction.

Brassaï (born Gyula Halász) was a Hungarian-born artist and journalist who arrived in Paris (via Berlin) in February 1924.[18] He sold articles to the German press, especially to the *Kölnische Illustrierte* and *Münchner Illustrierte,* and purchased photographs for those articles, sometimes acting as a photographic agent (he sold images by André Kertész, among others). By 1928 Brassaï had

moved to the Montparnasse area; he lived at the Hotel des Terrasses (74, rue de la Glacière) until 1940, when he briefly left Paris during World War II. Hungarian friends such as the painter Lajos Tihanyi and the filmmaker Vincent Korda also lived there, as did the Belgian painter Michel Seuphor, the French writer Raymond Queneau, and Henry Miller's agent, Frank Dobo. Brassaï met Miller at a nearby Montparnasse gathering place, the Café du Dôme, around 1930.

Brassaï began taking photographs by March 1930 and actively turned to night photography when he faced diminishing demand from his Berlin publisher, Mauritius Verlag, after the financial crash of 1929. He credits Kertész with teaching him: "My friend André Kertész helped me; he gave me advice and I imitated some of the things he did." An extensive and escalating war of words ensued between the two photographers over who was

FIGURE 37 Plate 62, Morning Milk Truck, from Brassaï, *Paris de nuit* (Paris: Arts et Métiers Graphiques, 1932). Gravure, page: 10 × 7½ in. (25 × 19.3 cm).

more innovative and how much Kertész taught Brassaï, but clearly Kertész taught him some basics and Brassaï developed a particularly powerful night photography language from that beginning.[19] Whereas Kertész remained a humanistic photographer throughout his career, in these pre–World War II years, Brassaï's vision was far more transgressive. Brassaï's extensive output can be seen from his archive of contact prints housed at the Musée National d'Art Moderne in Paris, and curator Quentin Bajac has explained that of Brassaï's forty-seven boxes of contact prints, four and a half boxes are filled with nighttime images, mostly taken in the 1930s (Brassaï developed different interests after the war). These nocturnal views were divided into "Night" and "Pleasures," with a third group of unpublished images of the Exposition Internationale in 1937.[20]

Most scholars have tiptoed carefully around the more venal and quasi-pornographic images Brassaï made during this period, careful to honor his self-constructed persona as a photographer neatly balanced between art, literature, and the documentary mode. This follows the artist's own self-identification as an artist, and also whitewashes his early commercial work, although there is ample evidence of his commercial ambition in his early letters to his parents. In fact, Brassaï has written so much about his own experiences that it is sometimes difficult to separate his 1970s voice from his 1930s life.[21] In addition, Brassaï's wife, Gilberte Brassaï, who lived until 2005, continued to have a strong and somewhat gentrifying voice in the presentation of her late husband's work. In the 1930s, however, Brassaï had no such qualms; he openly, even gleefully, moved back and forth between working-class and venal worlds in Paris, photographing copiously for pornographic journals such as *Paris-Magazine* and

sensationalist photo magazines such as *Détective* and *Voilà* while negotiating with Peignot for the most elegant art book. The disquiet in his work resonated strongly with the underworld and continues to reverberate even now.

Brassaï's frequent letters to his parents give important contemporary accounts of his aspirations, plans, and frustrations as a young artist in Paris. In the early 1930s, he recounts many details of the actual process of publishing *Paris de nuit*, although we must realize that he would have been unlikely to share his more erotic, dangerous, or criminal adventures with his parents back in Brassó (Brasov), Romania. In November 1931 he first wrote to his parents about his project to publish a book of Parisian night photographs, boasting that "the best French art publishing house has decided to publish my collection of photographs taken of Paris by night." This letter relates that Lucien Vogel, *VU*'s editor and a member of Arts et Métiers Graphiques' board, introduced him to Charles Peignot in mid-October 1931. He describes Peignot's periodical, *Arts et métiers graphiques*, as "the most beautiful and expensive periodical in France," and writes of Peignot's offer to publish his book. Even discounting the positive tone any son would take in telling his parents about a coup, Brassaï is anything but modest and exaggerates the details, including the price of the book, which was 45 francs:: "The price of the book will be one hundred francs, a few exclusive copies will cost 500 and 1,000 francs, and the first edition will have a print run of five thousand copies. . . . I am convinced that it will sell, though. I'm going to ask for 12.5 percent of the first edition and 6 thousand in advance. . . . This is a colossal achievement for me; I've managed, with my first book, to grab the best publishing house. . . . This book will be the first in a series and will be followed by several other publications for which I'm also likely to receive a commission." A later letter, in December, reflects Brassaï's growing hubris: "It seems that I did not overstate the extent of my success; on the contrary, it will be greater than I thought. Paul Morand, the famous writer, is going to write a foreword for the book."[22]

Brassaï's triumphal project progressed less smoothly than he might have liked; in April 1932 Peignot asked other photographers to contribute night photographs, which Brassaï deemed inferior to his own. He fought back, "I had to take energetic measures, and I told Peignot that while I was in no position to prevent him from commissioning others, I had to insist, in accordance with our contract, that only my pictures be included in the book. . . . Peignot

was forced to admit that in me he had found the only suitable person." However, he did make some concessions for the publisher; the same letter explains that two empty slots were left for springtime photographs that were to be taken later, including a springtime shot of chestnut trees in bloom (plate 54). After a summer and fall traveling and working for Sándor Korda on his film *La dame de chez Maxim,* in early November he sent his parents a Sunday full-page announcement for his book in *L'intransigeant.* The book came out on December 2, 1932, and in a letter home two days later, he trumpeted: "The major bookstores have filled entire windows with displays of the book. There are phenomenal crowds everywhere. Many people have bought it. A lot of bookstores sold all their copies the very first day."[23] Although we have no way of knowing how much filial exaggeration this letter demonstrates (Brassaï was a renowned and colorful raconteur), the book certainly reached a wide audience and was well received.[24] By the end of 1933, Brassaï was actively planning his next book, which he then called *Paris intime,* writing to his parents: "I have the feeling that it will be at least as good as *Paris de nuit.* Possibly even better."[25]

Brassaï clearly valued the literary genealogy of Arts et Métiers Graphiques when he called it "the best French publishing house." The Deberny type foundry had been founded in the late eighteenth century, with French writer Honoré de Balzac as an early partner. In 1923 it merged with a rival, Peignot et Cie, to become Deberny et Peignot. Its new director, Charles Peignot, joined the Union des Artistes Modernes, whose members included Le Corbusier, Sonia Delaunay-Terk, André Gide, and Jean Cocteau. Peignot became immersed in modern art, developed new Art Deco typefaces, and commissioned the renowned designer A.M. Cassandre to work for his foundry. Cassandre created three modernist typefaces for him: the Art Deco–influenced "Bifur" (1929); a second typeface reflecting the era's fascination with the Machine Age—titled "Acier" or "Steel" (1930); and a final design called "Peignot" in 1937.[26]

In 1927 Peignot founded a large-format journal, *Arts et métiers graphiques,* which he intended to be the most luxurious art journal available. Between 1930 and 1940 he also published special annual issues of the journal, titled *Photographie.* With its spiral binding—the latest in avant-garde presentation, invented in 1924—*Photographie* opened flat, so that photographs could be printed to the edge of the page with no diminution in clarity. The large-format

annual was intended for a wealthy audience and included full-page advertisements for Rolls-Royce, Christofle, Louis Vuitton, and expensive fine-art publishers. In 1930 *Photographie* included a nighttime photograph by André Kertész (page 49), an early example of Peignot's appreciation for the dramatic and graphic qualities of nighttime photography. Including Brassaï's book, Arts et Métiers Graphiques also published eight photography books between 1930 and World War II.[27]

Both *Photographie* and *Paris de nuit* were printed in the photogravure (or héliogravure) process.[28] The dark, inky quality of these prints allowed for a wide range of tonalities from light to dark. The darks were particularly sensuous, as Peignot and Brassaï showed with dramatic effect in *Paris de nuit*. *Paris de nuit* also makes use of another edgy, modern Arts et Métiers innovation, Cassandre's 1929 Art Deco "Bifur" typeface (figure 38). As we begin to read the essay by Morand, highly decorated letters weave sinuously above and below the text in a coiling pattern that recalls the curves of the cobblestones on the endpapers; the letters themselves act as Art Deco cobblestones, sutured together by the binding's metallic spiral. These pages are white, unlike the other pages of almost-black photographs.

The name of the editor, Jean Bernier, appeared on the book's cover, just under Brassaï's name (both names appeared in smaller type than Paul Morand, who got top billing). An active combatant in World War I, Bernier joined the foreign ministry, wrote an autobiographical novel about his war experiences, and had remained "an active figure of the extreme left since just after the war."

Fascinated by Marxism and Freud, he was drawn to the Surrealists from the beginning of the movement and had an early impact on André Breton. Bernier belonged to the Cercle Communiste Démocratique throughout the 1930s; he knew Georges Bataille and collaborated closely with him in essays for the far-left-wing organization "Contre-Attaque": Union de lutte des intellectuels révolutionnaires. Bernier's captions for the book show a slightly more leftist reaction to the photographs than Morand's mainstream, lyrical essay. Barely a month after *Paris de nuit* appeared, Bernier published an essay, "Paris de nuit," in *VU*. Although clearly a promotional text, it gives a sense of the editor's priorities. He writes of "the pleasures and the fears born in Paris at night," and of subjects ranging "from the raw to the louche." He also talks of a "fantastic reality" that "pokes you as you turn, and glues you to the wall."[29]

Paul Morand, a French diplomat and author, achieved fame for both his reporting and his fiction. In 1932, when Brassaï's and Bernier's names would still have been little known, Morand moved in the circles of Jean Cocteau and the arts cabaret Le Boeuf sur le Toit. Among the most lauded writers in interwar France, he counted as admirers Marcel Proust, Jean Cocteau, and Louis-Ferdinand Céline—who famously wrote that in 2000 only he and Morand would still be read. Morand joined the right-wing Action Française in 1933 and allied himself with the Vichy government during World War II, for which he was later villainized. In the early 1930s, however, his prominent position in the avant-garde literary world and his authorship of the popular books *Ouvert la nuit* (1922) and *Fermé*

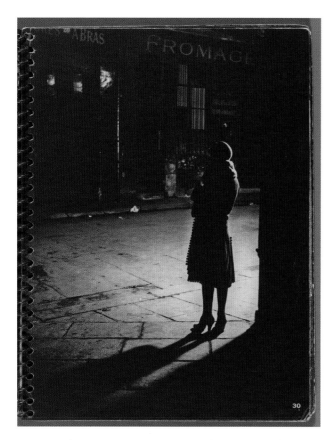

FIGURE 39 Plate 30, Prostitute, near Boulevard de Sebastopol, from Brassaï, *Paris de nuit* (Paris: Arts et Métiers Graphiques, 1932). Gravure, page: 10 × 7½ in. (25 × 19.3 cm).

la nuit (1923) made him a natural choice for Brassaï's book. Morand's two books feature vignettes of sexualized urban encounters that are constructed as cinematic events with fast transitions between scenes—*Ouvert la nuit* with six stories of women in different cities, and *Fermé la nuit* as its male counterpart, with tales of four men and their adventures. In the preface of *Ouvert la nuit*, Morand presages the elitist, racist, and anti-Semitic opinions he would hold through his life: Morand set himself up as a wandering Jew "arriving in a neat and tidy nation with that ghastly reek of people who have traveled all night." In the 1920s and 1930s, Morand also wrote colorful and witty vignettes of London, New York, and Bucharest.[30] His text for *Paris de nuit* would follow firmly in a centuries-long tradition of lighthearted commentaries about Paris at night, echoing the combination of urban terror and pleasure that would be a hallmark of the 1930s:[31]

> Night is not the negative of day; black surfaces and white are not merely transposed, as on a photographic plate, but another picture altogether emerges

at nightfall. At that hour a twilight world comes into being, a world of shifting forms, of false perspectives, phantom planes. There is something eerie, even disconcerting, about the process—although the obvious epithet "diabolical" does not necessarily apply. Paris, metropolis of the mind and city of light, can no more than other capitals escape the dark contagion. Indeed, a furtive menace pervades the Paris night; its darkness teems with unseen presences, the restless souls of the Parisians escaping through sleep bound lips.

The writer continues on to comment that "the Frenchman, so conservative by day, goes revolutionary in his dreams," and claims that Paris "can be uncannier at night than any 'haunted woodland,' more alarming than the underworlds of London, Chicago or Berlin." With words such as "eerie," "disconcerting," "contagion," "menace," and "restless souls," Morand presents us a nightmarish beginning. His essay continues with references to the brooding melancholy of Julien Green's novels: "life that is a parody of death," a night that "dons its panoply of shadows and a malefic alchemy transmutes the texture of the visible world," rivers that burn with "a metallic sheen . . . amid the odour of death that hovers on the water." Inexplicably, after this powerful introduction, which echoes the edginess of Brassaï's photographs, Morand retreats from his terrifying vision, commenting that after reading Green he "has little relish for a lonely walk by night in Paris," and proposing instead to "escort you, rather, to the safe precincts of the city lights. Better avoid the haunts of solitude and shadow, peopled with a cloud of phantoms, and cultivate our neighbors' company."[32]

The remainder of Morand's essay follows the safe, conventional path of a "Paris by night" tour from dusk to dawn—he even mentions the night tour buses with their German, Italian, and English signs. Like the authors of so many other Paris albums, city-symphony films, and Paris novels, Morand takes us on a verbal tour of the city. He begins: "Midnight had not yet struck when I stepped forth into the street, but already the nightshifts were up and about, moving like phantoms towards another spell of toil." Morand clearly looked at Brassaï's photographs—or a selection of them—as he wrote. He directly describes many of the photographic images: "At each street corner prostitutes were on the watch" (plate 30; figure 39), "plainclothes policemen prowled the pavements" (plate 28; figure 40), and "down-and-outs are strewn around the

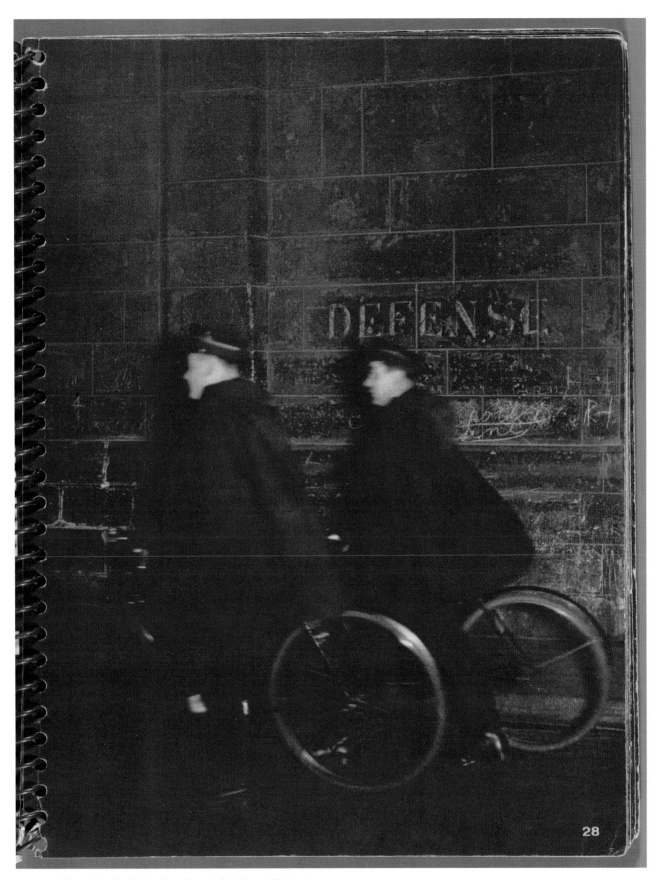

FIGURE 40 Plate 28, Cyclist Police, from Brassaï, *Paris de nuit* (Paris: Arts et Métiers Graphiques, 1932). Gravure, page: 10 × 7½ in. (25 × 19.3 cm).

square, their heads pillowed on nerveless arms" (an image of sleeping clochards waiting for work at Les Halles). As dawn nears, "there is a rattle of milk-cans," which is parallel to the last image of the book (see figure 37).[33] Like earlier "Paris by night" books, the sequence follows the tradition of flâneurs from Charles Baudelaire to André Breton. Morand follows that pattern, but Brassaï's photographs are more transgressive.

Morand does comment on the city's troubling strangeness. Paris no longer reflects the rational, "realist" city of light of the nineteenth century, he notes; it has become dangerous. The Surrealists courted danger, too, but Morand's reference to the troubled souls of the Parisians implies a more generalized political and literary position, which Morand terms "the subconscious mind of the French race." As we shall see, detective writers, Surrealists, and photographers joined in exploiting and creatively using this popular urban definition of danger. Morand shared the general anxiety after the devastations of World War I, and amid renewed Depression-era worries, but he voiced his worries in a poeticized language more conventional than Brassaï's.[34]

Despite Morand's reputation, some critics quickly recognized that Brassaï's images were more groundbreaking than Morand's words. Writing for the *Chicago Daily Tribune* in March 1933, Waverley Lewis Root noted the "large letters [for] the name of Paul Morand, who contributes to this book eight pages of more or less routine text. . . . In smaller type, hidden away with the name of the publisher, one finds the name of Brassaï," and Root goes on to state that "Brassaï's name will still be known when Morand's has been forgotten."[35]

NIGHT PHOTOGRAPHY

Night photography had begun long before the 1920s and 1930s. Nadar first used magnesium flash for his extraordinary views of the catacombs and sewers of Paris in 1861. Photographic agencies with "Old Paris" views collected night views of Les Halles and other areas of Paris from about 1910 onward. Some of these images have a force and power surprisingly similar to the later images of Paris by night. Smaller cameras and faster films, however, made night photography possible on a larger scale, and in the 1920s Parisian nighttime pictures gained popularity in the picture magazines.[36]

Once *Paris de nuit* appeared, Brassaï's photographs

illustrated many manuals about night photography in the 1930s. He published an essay on night photography in Peignot's journal *Arts et métiers graphiques* in January 1933, the month after the book appeared.[37] Brassaï's text and book illustrate his newly acquired technical mastery of the problems of night photography, and served as an example to many other photographers. Examples from *Paris de nuit* illustrate different problems of night imagery. Brassaï identifies two opposing hazards—artificial light and the natural blackness of night. Since the night lamps, gas lamps, and other sources of illumination cannot be dislodged, the photographer must move around them. Comparing his method to the use of *nègres* (cinematic screens) that shield unwelcome lights in filmmaking, he writes of using trees and walls as natural screens. Glare can be diffused in a distant view when the atmosphere, or even fog or rain, spreads the light more evenly.

Instead of lengthy technical methods, he suggests using weather to lend atmosphere to the photographs, street fixtures (both electric and gas) to light his scenes, and naturally occurring structures to create shadows. He explains his calculation of exposure times in his usual colorful prose: "I explained to them that I had several exposure times—the 'Gauloise exposure,' in other words the time it took to smoke a Gauloise, and the 'Boyard exposure,' which was about twice as long."[38] (Boyard cigarettes are thicker than Gauloises.) When a scene he wanted to create lacked the appropriate figure, he sometimes enlisted his friends and occasionally used himself to stand in for the subjects; true reportorial exactitude mattered less to him than the story he planned to tell. Especially for vexed subjects such as prostitution, he often used stand-ins; his assistant Gabriel Kiss posed as the client in the "Chez Suzy" brothel series.[39]

Brassaï's interpretive understanding of the meaning of night photography, however, marks his real contribution. Although he experienced severe technical restrictions, he creatively used the limitations of artificial light; much of the charm of his night photographs lies in their uneven lighting. Seen as a group of isolated, scantily lit fragments, Paris cannot be conceived as a whole. Nor can a detective's unsolved mystery; both photographer and fictional detective construct whole solutions from skimpy evidence. Light, the symbol of nineteenth-century Paris, remains the symbol of 1930s Paris, but Brassaï records it *in situ*, consciously selecting the elements he stumbles upon in

the city. This is a good metaphor for Parisian night vision: photographers find their subjects at random, but execute a conscious choice in their mode of representation.

THE MODERN-DAY FLÂNEUR

Contemporary critics of *Paris de nuit* noted its strange combination of poetry and reportage, and the book's advertisements described "a tour de force that fixes each stop with the power of an etching." The photographer had studied literature deeply, remaining a devotee of Goethe and a great admirer of Marcel Proust—about whom he wrote a book late in his life. He also admired Denis Diderot, Gérard de Nerval, Restif de la Bretonne, and Charles Baudelaire.[40] Brassaï wrote of his admiration for the artist Constantin Guys, Baudelaire's model for the flâneur—an educated, idle, and well-dressed dandy who strolls the city street coolly observing life passing him by. We see few flâneurs in *Paris de nuit,* however; instead, most of his figures belong to the lower class. Here his taste paralleled that of contemporary writers of the 1920s and 1930s, as well as the popular detective novels of the time. Nightwalkers included both Surrealist writers such as Breton and Louis Aragon, and non-Surrealists such as Céline, Mac Orlan, and others. Brassaï's many literary friends tended to be fellow night wanderers less interested in the polite world of the dandy than in the working class. They included Henry Miller and Léon-Paul Fargue—both frequent companions on his nighttime walks, as well as Jacques Prévert and Raymond Queneau.

Like Fargue's and Miller's writings, Brassaï's photographs of monuments subvert the flâneur's upper-class experience. For example, plate 2 records a standard monument of seemingly middle-class, western Paris, the Arc de Triomphe (see figure 36). Yet instead of viewing the arch traditionally from the Champs Élysées, Brassaï has photographed the monument from an unusual, jutting angle, and highlights the side arch, blocked and fragmented by the witchlike fingers of a tree's black branches. He contrasts the arch with the vegetable train from Saint-Germain-en-Laye to Les Halles. The train obscures the lower part of the arch and provides a physical reminder of working-class Paris, a satirical comment on the vast gulf between the large apartments of the sixteenth arrondissement and the crowded, dirty eastern markets. Bernier's caption reads: "Every night at 10.20 the miniature train that brings in vegetables from Saint-Germain-en-Laye

snorts noisily around the Étoile on its way to the central market. Here the camera records, for the first time, this nightly rendezvous of dignity and impudence—the shining splendor of the Arc de Triomphe and the grimy little locomotive."[41] Morand must have seen this print, but he comments only on a "shining" arch and ignores both the shadowy cracks in its façade and presence of the train.

Brassaï's other revisions of major monuments, including views of Notre Dame and the Eiffel Tower, often anthropomorphize them, endowing them with a disturbing life. Instead of the traditional frontal postcard view, we see Notre Dame Cathedral (plate 7) from the back, its buttresses splayed like the limbs of a giant spider or a whalebone-supported petticoat. It looms starkly out of a dense blackness. The Eiffel Tower, on the other hand, displays all the jeweled decoration of a thousand electric light bulbs (plate 57; figure 41). Standing silhouetted through an open gateway on the Trocadero, it assumes the stance of a two-legged living creature. Its jewels date it as one of Brassaï's earliest night photographs; the tower's lights

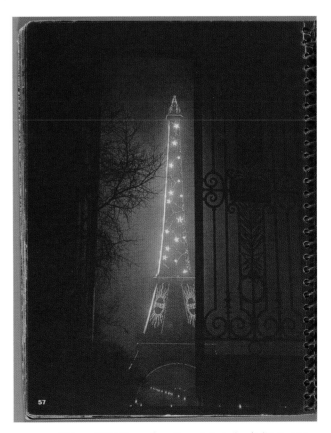

FIGURE 41 Plate 57, Eiffel Tower, from Brassaï, *Paris de nuit* (Paris: Arts et Métiers Graphiques, 1932). Gravure, page: 10 × 7½ in. (25 × 19.3 cm).

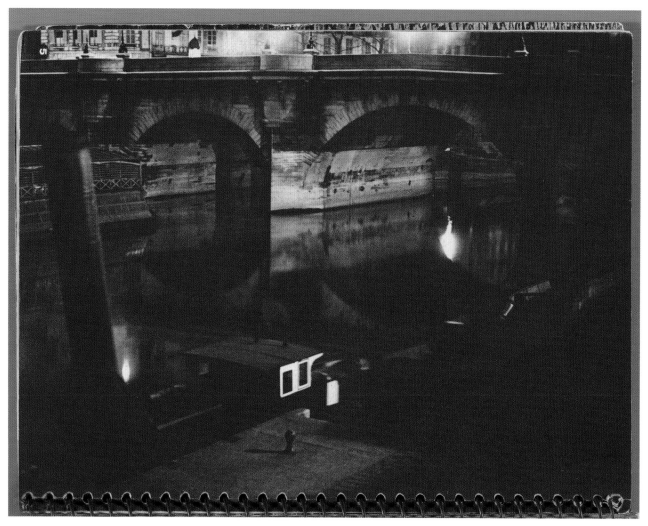

FIGURE 42 Plate 5, Near the Pont Neuf, from Brassaï, *Paris de nuit* (Paris: Arts et Métiers Graphiques, 1932). Gravure, page: 7½ × 10 in. (19.3 × 25 cm).

herald its fortieth birthday with 1889 on one leg and 1929 on another.[42]

Another early plate in the book, plate 5, humanizes a monument in a more political and abstract manner (figure 42). The Pont Neuf (the oldest bridge in Paris) represents another famous symbol of daytime, rational Paris. Yet instead of recording the bridge from street level, Brassaï has photographed it from the barge-cluttered quayside below. He divides the view into horizontal layers that have specific class references as well as literary and historical ones. The top layer includes the conventional lights, houses, and streets of the bourgeois city, but this wealthy sector has been cropped out and reduced to a thin, glimmering line. Brassaï clearly turns away from this Paris to train his camera on the underside of the bridge and, metaphorically, of the city. Reflected in the water,

the bridge's two black arches form two round eyes and a nose, humanizing the bridge and recalling Brassaï's graffiti photographs of faces.[43] A study of the original negative and the printed page reveals that Brassaï cannily and specifically composed his images to cut out all the elegant Parisian houses that appear above the bridge in the original negative. Creating a more politically charged and complex view than his full negative, Brassaï condenses and hones an anthropomorphic image.

Paris de nuit, however, does not concentrate exclusively on the underworld; its universal sympathies also emerge from oblique views of tourist spots. Elegant spots such as the Hôtel de Crillon and the Opéra are also present (possibly at the behest of Peignot), although Brassaï distances himself formally from the glittering nightlife, and these photographs (often near the end of the book)

may satisfy Peignot's requirements rather than Brassaï's primary interests.

PIERRE MAC ORLAN AND THE "SOCIAL FANTASTIC"

The novels and criticism of Pierre Mac Orlan come closer to Brassaï's ideas than those of any other writer. Although he wrote about almost every other major photographer in interwar France, including penning the text for Krull's monograph with Gallimard in 1930, Mac Orlan never wrote about Brassaï specifically, although as the photographer planned his second book, he wrote to his parents, "I would like Pierre Mac Orlan to write the accompanying text."[44] That collaboration never happened. Mac Orlan frankly reveled in the Parisian demimonde and underworld, and used these subjects to reflect his turbulent era, differing from Miller's frank vulgarity or Fargue's nostalgia. His ideas are enormously important for understanding the blend of nostalgia, poetry, detective imagery, and disquiet that Brassaï embodied, and that became the hallmark of French photography during the 1930s. While Brassaï's Surrealist links are well-known, Mac Orlan's impact has been less explored.

The French art historian Clément Chéroux, who recently republished all of Mac Orlan's writings on photography, notes that between 1928 and the late 1930s the critic wrote about fifteen articles, prefaces, and essays on photography, more than Walter Benjamin and Siegfried Kracauer combined. Mac Orlan's photographic criticism, though less known today, defined French photography in the interwar period. He published several seminal essays in the late 1920s (in such major journals as *Les nouvelles littéraires, Les annales politiques et littéraires,* and *L'art vivant*). He also wrote important texts for photographic monographs on Eugène Atget, Claude Cahun, Germaine Krull, Willy Ronis, Otto Steinert, and André Kertész.[45] His particular interests, like those of Walter Benjamin, lay not in art photography but in popular street photography, the illustrated press, documentary photography, and the margins of society.

Mac Orlan's essays make several important points that resonate particularly for Brassaï. First, he calls photography a "literary art," equating photography and the act of writing with their ability to delve into the quotidian poetry of small corners of daily life, as visceral acts that painting cannot equal; similarly, Brassaï was a serious writer for his entire life as well as a photographer. Mac Orlan concentrates (several years before Benjamin) on

what he terms the "graphismes"—phonograph, cinematograph, photograph—modern media that he finds most suited to portraying the contemporary world. In particular, he writes that photography finds its inspiration in what he terms the *fantastique social,* or "social fantastic." In an early essay in *Le crapouillot,* he defines the "social fantastic," often seen through imagery of blood or death, as a concept that "is not some artist's interpretation of a fact, nor an image that offers the equivalent of reality." For Mac Orlan, photography easily reveals the social fantastic as "an instinctive art." In a passage that could describe Brassaï's images directly, he writes that the photograph (in his article, an anonymous crime scene) acts as a witness that penetrates "into the fantastic domain of shadow. Light, for it is no more than a means to explore shadows, to reveal its cerebral appearances, its dangers."[46]

Mac Orlan sees the urban world as full of *"inquiétude,"* or anxiety, a symptom of the modern state as "an almost always indefinable embellishment of the atmosphere and of picturesque elements that act on us as on a barometer." His fictional writings highlight pirates and outcasts, Bohemian bistros, sailors' bars, and mysterious prostitutes. He explores these concepts in his novels (*Quai des brumes, La tradition de minuit,* and so on) as well as his volumes of essays (*Villes*) and his criticism.[47] The "social fantastic" manifests itself best in the margins of society: vagabonds, demobilized soldiers, prostitutes, port cities, sailors' bars, train stations, dark alleys, at night, under neon lights, in the fog, wind, or rain. In prose that uncannily precedes Roland Barthes by a half century, he writes: "It is thanks to this incomparable power of photography to create a sudden death, and to lend to objects and people the popular mystery that gives death its romantic power."[48]

Brassaï's night world teems with Mac Orlan's favorite subjects, and his images strikingly parallel Mac Orlan's "social fantastic." In *Paris de nuit,* the underworld recurs often, as in his photographs of the Paris police (plates 28 and 40). Brassaï identified strongly with criminality, and his more intuitive interpretations carry it beyond his colleagues' sensationalist or reportorial images. For instance, plate 28 isolates two police officers (see figure 40). Bernier's caption reads: "Stealthily the cyclist police patrol the empty streets. Their capes float after them like wings and they blow their whistles on the least provocation; hence the nickname 'swallows' which the populace has given them."[49] Thus the text romanticizes the furtive quality not only of criminals but also of the police as they

move through the nighttime city. Brassaï's photograph, a long exposure taken while the policemen move slowly past a wall, has a more complicated and literary meaning. He blurs the faces of the law, rendering them ghostlike, and making their rear bicycle wheels indistinct as well, suggesting a haunting, silent progression through the city. The caption's reference to winged capes conjures up notions of angels, but these black figures with their shadowy white faces seem more like characters who could have stepped right out of Mac Orlan's novel *Quai des brumes.*

In this image Brassaï also crafts a literary pun, playing word against image. On the wall behind the policemen we read the word *"défense,"* probably a portion of the "post no bills" regulation *"défense d'afficher, loi du 29 juillet 1881"* so prominently painted on many Paris walls.[50] The police should defend the urban centers, yet transgressive graffiti surrounds the wall's faded word "défense." The photographic doubling continues, contrasting the orderly stencil against the hand-drawn graffiti below it. Thus, Brassaï celebrates insubordination, both political and pictorial. "Défense" itself has a double meaning: military defense and "the forbidden." With that second meaning, Brassaï's photograph itself becomes a kind of political graffito. During these years, Brassaï also began documenting the graffiti he found around Paris; he published the first suite of such images in *Minotaure* in 1933 and produced a book of graffiti images in 1960.[51]

Brassaï's books clearly echo Mac Orlan's taste for indigents and criminals. *Paris de nuit* boasts a comparable threat of oneiric violence in its physical construction and printing technique, its subjects, and its narrative passage of imagery. It owes much to Mac Orlan's "social fantastic" of emotion, viscerality, and humanity.

THE DETECTIVE

Brassaï's fascination with the seedy underground and mysteries of the night parallels the decade's obsession with detective fiction. The genre gained enormous popularity in the 1930s in France, offering both an escape from the depressed times and an apt metaphor for its bleakness. Both detective novels and Brassaï's Paris books record the small corners, objects, and places in a beloved Paris, and use them as evidence for crimes. The criminal, whether he be Volpe in Philippe Soupault's Surrealist *Les dernières nuits de Paris,* a clochard in Brassaï's photograph, or Marcel Allain's popular culture villain Fantômas,

represents a fictional hero in a disaffected society that feels no qualms about taking sides with the villain.[52]

Walter Benjamin, writing in 1931 about an earlier Paris documenter, Eugène Atget, famously comments on the political message carried in urban details. His thoughts apply to Brassaï as well: "These are the sorts of effects with which Surrealist photography established a healthy alienation between environment and man, opening the field for politically educated sight, in the face of which all intimacies fall in favor of the illumination of details." Like Mac Orlan, Benjamin celebrates the connection between photography and criminality, writing, "Not for nothing were pictures of Atget compared with those of a scene of a crime. But is not every spot of our cities the scene of a crime? Every passerby a perpetrator? Does not the photographer . . . uncover guilt in his pictures?"[53]

Brassaï made many photographs for detective magazines (*Détective, Voilà, Paris Magazine,* and others) and novels; the idiosyncratic path of the fictional detective provides a strong analogy for his approach to the city. The detective, like the noctambulist photographer, traverses the city after dark. His main constituents, consisting of the underworld and the criminal class, often emerge at night. Similarly, Brassaï writes that during the 1920s and 1930s his life approximated that of the criminal: he slept during the day and entered the city streets at night. Like the photographer, the detective uncovers random pieces of information and has the knowledge or instinct to determine which one signifies most, and which one will fit into the jigsaw puzzle of criminal evidence to create a whole picture. Criminal society enthralled Brassaï, too, and he particularly appreciated its rich literary heritage. In the introduction to *Les Paris secret des années 30,* he writes of his affection for literary outcasts in the writings of Stendhal, Dostoevsky, and Nietzsche: "Enthralled by outlaws living outside the conventions, the rules, they admired their pride, their strength, their courage, their disdain for death. . . . And let there be no mistake. The admiration expressed by the author of *Crime and Punishment* was not for revolutionary intellectuals or for political prisoners, but for real criminals: thieves, murderers, convicts—his own prison companions."[54]

During the 1920s, much French criticism of detective fiction had a pseudoscientific slant. French critic Régis Messac writes that the detective story is "a narrative dedicated above all to methodical and gradual discovery of a mysterious event, by rational methods and exact

FIGURE 43 Cover of Germaine Krull and Georges Simenon, *La folle d'Itteville* (Paris: Jacques Haumont, 1931). Offset, 7 × 5¼ in. (18 × 13.5 cm). Museum of Modern Art Library, New York.

circumstances."[55] Popular detective fiction, however, often concentrated on intuitive solutions to crimes in the city. Georges Simenon, its major exponent, created a hero, Inspecteur Maigret, whose instinct triumphed over reason and science. Brassaï's photographs employ both a scientific technique and an instinctive interpretation akin to Maigret's.

The earlier Fantômas stories, written by Marcel Allain and Pierre Souvestre, were equally popular in the 1930s, and represent another contribution of the detective novel to the photographic depiction of nocturnal Paris. This series, like Edgar Allan Poe's nineteenth-century Parisian mystery stories, owes much to its serialization in the popular press. Its influence lies in its mass appeal, even more than Simenon's, and it appeared in the intellectual press only briefly, in a series of covers reproduced in Bataille's *Documents*.[56] Simenon's Maigret remains firmly in the working or middle classes; Fantômas leaps the barriers. A sensationalist element enters into play here: Fantômas,

the elusive and despicable criminal, always eludes his pursuer, the magistrate Juve. An element of the hunt always enriches these descriptions of Paris; Fantômas, in his many disguises, crosses all social boundaries, from high society to the depths of the underworld. As crime fiction cuts across class barriers, mocking bourgeois attitudes of the previous century, so does photographic depiction. Brassaï, the photographic detective, explores his city in a similar way, leaping from clochard to operagoer, creating order only through the structure imposed by his imagination.

Finally, and most importantly, the successful fictional detective solves the case and reorders the city because of the ingenious and idiosyncratic way he fits together concrete details. Simenon's method closely parallels photographic attitudes. In fact, in 1931 he published an early novella as a photo-novel, with photographs by Germaine Krull (figure 43).[57] Krull's photographs for this inexpensive book have all the lurid attraction of Brassaï's underworld

FIGURE 44 Cover by Eli Lotar for *Détective* (December 6, 1928). Rotogravure, 17¾ × 12 in. (45 × 30.5 cm).

1940, and edited by Georges Kessel, the brother of novelist Joseph Kessel. Krull and Eli Lotar were among its main photographers in its early years, contributing photographs of nighttime hearses, railway waiting rooms, and other illustrations of lurid stories (figure 44). Krull published photographs for Joseph Kessel's "Paris la nuit" in *Détective* as early as November 15, 1928. A sensationalist cousin to *VU, Détective* specialized in "lurid reports of crime, investigations into the underworld, and reports on the seamier side of Paris," and became so notorious that the police banned posters advertising it within city limits in 1932.[60] Contributing authors included Francis Carco, Pierre Mac Orlan, and Georges Simenon, and dozens of photographers published there regularly.

SURREALISM

As a more highbrow analogy to detective fiction, the Surrealists also wandered the city at night, and in their tales of dreamlike walks they often recount encounters with marginally criminal or otherwise disturbing Parisian figures. Many of them frequented the same sectors of Paris favored by Brassaï, concentrating on the older, crowded, center of the city: Les Halles, the Tour Saint-Jacques, the Canal Saint Martin, the quays of the Seine. Brassaï's *Paris de nuit* begins with a distinctly dreamlike frontispiece (plate 1; figure 45). In this first image, Bernier, the editor, clearly refers to Surrealism's "gridwork of dreams." In the Jardin du Luxembourg, a slightly larger-than-life-sized statue of the druid Velleda greets us from behind the garden's Boulevard Saint-Michel gates. For Brassaï, she acts as a ghostly tour guide—framed behind a grid of shadows stretching from the gate into the garden. The shadows create an abstract pattern—proving that Brassaï could proficiently use Cubism and geometric abstraction. Unlike Krull's celebration of metal, however, this ironwork fence is not visible: Brassaï's picture subverts the solidity and monumentality of stone and iron. The druid herself leans against a sculpted tree trunk with crossed arms, and in Brassaï's patchy shadow-work she seems to beckon us into her dark realm. Bernier's caption reinforces this oneiric impression: "The shadows of the Luxembourg gates trace a phantasmal chequerwork of shadow on the forsaken garden-walks."[61]

Brassaï has often been connected to the Surrealist movement.[62] He first met Picasso in 1932 when the painter moved on the edge of the Surrealist circle, and his photographs of Picasso's sculpture in the first issue of *Minotaure*

imagery. Thomas Narcejac defines the particular nature of Simenon's logic: "Maigret is not a detective but a hunter who wishes to capture alive a beast whose reactions are unknown. He noses out his habitat and tries to learn his habits and his routines by mimicking them."[58] He solves his cases by highly trained instinct, coming to a solution only after thoroughly imbibing the character of the neighborhoods where the crime occurred.

The link between detective fiction and photography extends beyond Brassaï and Krull. Little has been written about the appeal of the lurid popular press, except in Robin Walz's *Pulp Surrealism,* with its micro-histories of Aragon's *Le paysan de Paris,* the Fantômas novels, a mass murderer named Henri Désiré Landru, and the cult of suicide.[59] Many more photographers contributed regularly to the popular press, especially to *Détective,* the sixteen-page weekly with a circulation of three hundred thousand to one million copies published by Gallimard from 1928 to

FIGURE 45 Plate 1, Railings, Jardin du Luxembourg, from Brassaï, *Paris de nuit* (Paris: Arts et Métiers Graphiques, 1932). Gravure, page: 10 × 7½ in. (25 × 19.3 cm).

catapulted Brassaï into the group of artists and writers around the publishers Albert Skira and Tériade. Through Picasso, Brassaï worked closely with Salvador Dalí, with whom he photographed a series of detritus picked from the gutter—*"sculptures involontaires."*[63] Nevertheless, he did not regard himself as a member of the group. In response to a question about his connections to Surrealism, he replied: "In effect, but only since 1932–1933, the two most important years of my life, when I met Picasso, published *Paris de nuit* and collaborated on the magazine *Minotaure*. Breton wanted me to join the group, but I did not completely agree with their doctrine." Brassaï found certain viewpoints of the movement too disturbing, and despite his admiration for Breton's mind, he found the Surrealist leader too dogmatic: "He took his doctrine, his work, and each of his actions too seriously to admit the possibility of humor."[64]

Nonetheless, Brassaï occasionally did collaborate with Breton, who wrote his celebrated Surrealist novel *Nadja* in 1928. In *Nadja*, Breton sets forth the themes of wandering through the city, often during the night, and culling experiences and people in semi-automatic fashion to fabricate a Surrealist experience. Both Brassaï and Miller admired the book's accounts of noctambulist wanderings. They shared with the Surrealist novelists a deep affinity for the same congested older neighborhoods of central Paris—the meat and vegetable markets, cafés, prostitutes' haunts, and shabby buildings. Miller wrote about them and Brassaï photographed them for *Paris de nuit* and other publications. Brassaï supplied three photographs of the Paris night for "La nuit du tournesol"—the 1934 essay for *Minotaure* that would later be published as the central section of Breton's third novel, *L'amour fou*, in 1937. He recalls, "Breton asked me for a photograph of Les Halles at night, another of the Flower Market, and a third of the Saint-Jacques Tower. . . . But, contrary to what Breton believed at the time, these photographs were not taken specially for him. I had already had them for some time, even the Saint-Jacques Tower 'under its pale veil of scaffolding.'"[65]

Rosalind Krauss, in her important articles on photography and Surrealism, has written about these images in Breton's novels, noting that the internal spacing and doubling in Brassaï's photograph certainly illustrate Breton's Surrealist notion of "convulsive beauty." Despite the parallels, Brassaï clarifies the differences between Breton's view and his own approach, arguing that his own images remain firmly tied to reportage. "But it was a

misunderstanding. They found my photographs 'surrealist' because they revealed a Paris that was ghostly, unreal, drowning in the night and the fog. That is why André Breton wanted to publish my photographs with his texts 'La nuit du tournesol' and 'La beauté sera convulsive.' But the 'surrealism' of my images was nothing but reality rendered fantastic by my vision. . . . My ambition was always to show a view of the everyday city as if it were being discovered for the first time. That is what separates me from the Surrealists."[66]

For Brassaï the surreal existed only if it could be uncovered in everyday life. Normality, not abnormality, constitutes the marvelous for Brassaï, whose eyes were always open and trained on the exterior world, whereas the Surrealists' were turned inward in search of a greater knowledge of the unconscious. Brassaï's most effective contributions to the Surrealist journal *Minotaure* are the most pedestrian—the images of "found objects," graffiti that he published there and continued to photograph for many years, finally publishing them as *Graffiti* in 1960.[67]

Brassaï had less direct contact with Georges Bataille and with *Documents*, but his images reflect Bataille's fascination with the physical and psychological mud, corporeality, and filth of the Parisian underworld. Bernier's links with Bataille appear in the tone of some of the captions, and the seedy subjects he photographed reflect bassesse, although they are more often featured in *Voluptés de Paris* than in *Paris de nuit*.

NOCTAMBULISM: BRASSAÏ AND HENRY MILLER

Brassaï's closest noctambulist friend, Henry Miller, was far too visceral and obscene for the more sedate Breton. Miller's Paris experiences offer a telling insight into Brassaï's experience of Paris in these years. Both men had suffered a reversal of fortune after 1929; Miller's first trip to Paris in 1928 differed vastly from his return in 1930, when he found a much less sparkling city. Brassaï clearly describes this general economic history and its effect in *Henry Miller: The Paris Years:* "Paris had changed between 1928 and 1930, between Miller's first trip and his second. . . . Black Thursday—October 24, 1929—had rocked the world. . . . The full impact of the crisis reached France nearly at about the moment Miller did. He had timed his second arrival to coincide perfectly with the end of the *années folles*—that crazy ten-year period between the Armistice and the Crash—and the beginning of a lean age of bankruptcy, misery, unemployment."[68]

The two men soon became nighttime companions in their wanderings through the city. Miller's *Tropic of Cancer* appeared—in English—in Paris in 1934, a year after *Paris de nuit*. It sold only 1,300 copies the first year, in contrast to *Paris de nuit*'s sales of twelve thousand volumes.[69] A photographer modeled on Brassaï appears briefly in the pages of *Tropic of Cancer*, where Miller writes, "He was a good companion, the photographer. He knew the city inside out, the walls particularly. . . . Our favorite resting places were lugubrious little spots such as the Place Nationale, Place des Peupliers, Place de la Contrescarpe, Place Paul-Verlaine. Many of these places were already familiar to me, but all of them I now saw in a different light owing to the rare flavor of his conversation." Miller also wrote a longer essay on Brassaï, "The Eye of Paris," describing Brassaï's gaze as "the insatiable eye." In an insightful admiration of Brassaï's eye and its skill in isolating the Surrealist notion of the uncanny among the details of the streets, he writes, "Brassaï strikes at the accidental modulations, the illogical syntax, the mythical juxtaposition of things. . . . What is most familiar to the eye, what has become stale and commonplace, acquires through a flick of his magic lens the properties of the unique." When Miller first saw Brassaï's photographs, he found a clear analogy for his own writing: "When one day the door was finally thrust open I beheld to my astonishment a thousand replicas of all the scenes, all the streets, all the walls, all the fragments of that Paris wherein I died and was born again. There on his bed, in myriad pieces and arrangements."[70]

In return, Brassaï eventually wrote two books about Miller, *Henry Miller: Rocher heureux* and *Henry Miller: Grandeur nature*. In describing the writings of his friend (after World War II), Brassaï writes, "His prose was diffuse, baroque, dreamlike. A bizarre mix of novel, essay, diary, poetry, journal, philosophy, obscenity, esthetic, theology—everything pell-mell in arranged disorder." The graphic rigor of Brassaï's *Paris de nuit* lies at a distance from Miller's sprawling prose, and Brassaï's poor English did not allow him to read Miller's book when they first met. But *Paris de nuit* offers a mélange of novel, newspaper, reportage, and philosophy similar to *Tropic of Cancer*, and a similar fascination with elements of Parisian venality.[71] Nevertheless, Brassaï appreciated Miller's need to experience the underworld: "It was disguised as a clochard that he simultaneously discovered the city and his talent as a writer. I was in the midst of photographing the

underground Paris that he loved so much. . . . There is undoubtedly an affinity between his writing and my photographs of this period."[72]

A stone statue invites us to enter the book in plate 1 (see figure 45). However, single living figures do not appear before the tenth and eleventh plates of *Paris de nuit*, and throughout the book, Miller-esque marginal figures, prostitutes, and clochards far outnumber the middle class. Plate 11 depicts a man exiting a public urinal (figure 46). Brassaï, never afraid to stage a photograph if he could not find it in natural form, posed as the figure himself.[73] Bernier's caption highlights its romanticism: "The concealed lighting and the surrounding darkness, the soft hiss of a gas-jet and the gentle plash of running water combine to lend a bizarre, imponderable charm to the stark ugliness of this *vespasienne*." In addition to the urinal's obviously suggestive shape and its fascination for the Surrealist writers, Brassaï's 1976 book, *Les Paris secret des années 30*, demonstrates that he was acutely aware that these were gathering spots for homosexuals in Paris.[74]

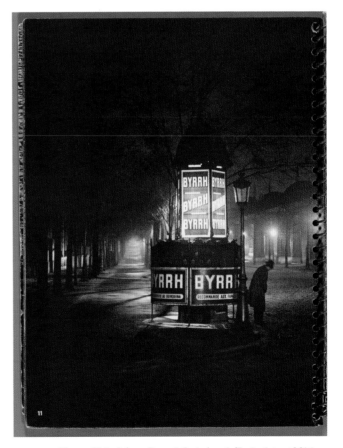

FIGURE 46 Plate 11, Urinal, from Brassaï, *Paris de nuit* (Paris: Arts et Métiers Graphiques, 1932). Gravure, page: 10 × 7½ in. (25 × 19.3 cm).

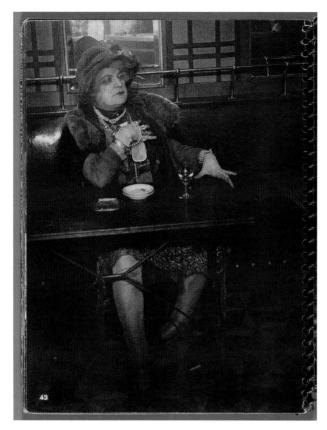

FIGURE 47 Plate 43, Bijou, from Brassaï, *Paris de nuit* (Paris: Arts et Métiers Graphiques, 1932). Gravure, page: 10 × 7½ in. (25 × 19.3 cm).

The photograph hints at the invisible happenings inside.

Prostitutes are another Miller-esque group much in evidence in *Paris de nuit.* Brassaï's imagery in *Voluptés de Paris* and his work for the pornographic publisher Vidal in *Paris Magazine* provide clear visual evidence that his photographic eye did wander below the line of polite behavior, even if—as he insisted—he never actually patronized brothels with Miller. *Paris de nuit* contains only one photograph of conventional lovers on a park bench, with Frank Dobo and Janet Fukushima posed as the lovers. Instead, Brassaï concentrates on the commercial love industry.[75]

Like the other working-class figures in *Paris de nuit,* prostitutes lived in central Paris and often frequented the areas around Les Halles. In a Brassaï image taken on the corner of the rue Quincampoix near the Boulevard de Sébastapol, we see a woman in stark silhouette (plate 30; see figure 39). We can pick out all the idiosyncrasies of her garb and posture: her exaggerated heels, the trim of her coat silhouetted against the light, her curved back as she clasps her bag. She stands straight and free of any support, reinforcing Brassaï's depiction of her as a strong, solid,

independent figure: lonely perhaps, but neither titillating nor pitiful like her earlier counterparts. Her placement under a cheese shop sign reading "fromage" humorously and obscenely equates her profession with the other trades of the market quarter, all concerned with bodily needs, the *ravitaillement de Paris* (belly of Paris).[76] The long shadow cast by her silhouette, running parallel to the impenetrable black shadow of the wall, recalls the lurid shadows cast in Josef von Sternberg's 1930 film, *Der blaue Engel,* starring Marlene Dietrich.[77]

The most famous prostitute in *Paris de nuit* is Bijou, the seventy-year-old Montmartre prostitute who seems like a character right out of *Tropic of Cancer* (plate 43; figure 47). The original negative allows us to see how skillfully Brassaï cropped his plate: he isolates her by excluding the empty seat that might allow us to imagine a companion for her. He also crops out the large mirrors that show one front-facing man and one profiled man behind her.[78] The caption places Bijou safely in an unreal literary realm "out of one of Baudelaire's most night-marish pages." Bijou, however, was a real person, and Brassaï's photograph captures her physical presence with uncompromising attention to all her physical detail. As she sits at a café table, we see her varicose-veined legs under the table, bound into tight shoes and bordered by the spangled hem of her dress. Multiple veils surround her grotesquely powdered face; her neck, wrists, and fingers are overloaded with flashy jewelry. Yet for all her grotesque trappings, Bijou retains a heroic stance, which Brassaï emphasizes in his portrait.[79]

Brassaï also studied a different member of the Parisian underworld, the clochard, one whom the Surrealists ignored but Miller celebrated with gusto. In plate 18, we see a group under a bridge (see figure 35, right). The caption reads, "Under one of the Seine bridges some of the city's down-and-outs sit by an al-fresco fireside."[80] This caption reflects the picturesque petits métiers tradition that includes hobos and beggars, and the French words refer to the popular song "Sous les ponts de Paris." Brassaï's photographic portrait, however, presents a much darker and less picturesque statement. Only the bridge's black arches are visible; the street and quays are blocked out. But the trash can fire (the *feu de fortune*) warming the three clochards glows brightly white—Brassaï suggests a metaphor for Heaven and Hell. He clearly prefers the Inferno: the bridge's arch encloses the figures like a domed stage set, and the trees on the right create bars like a balcony

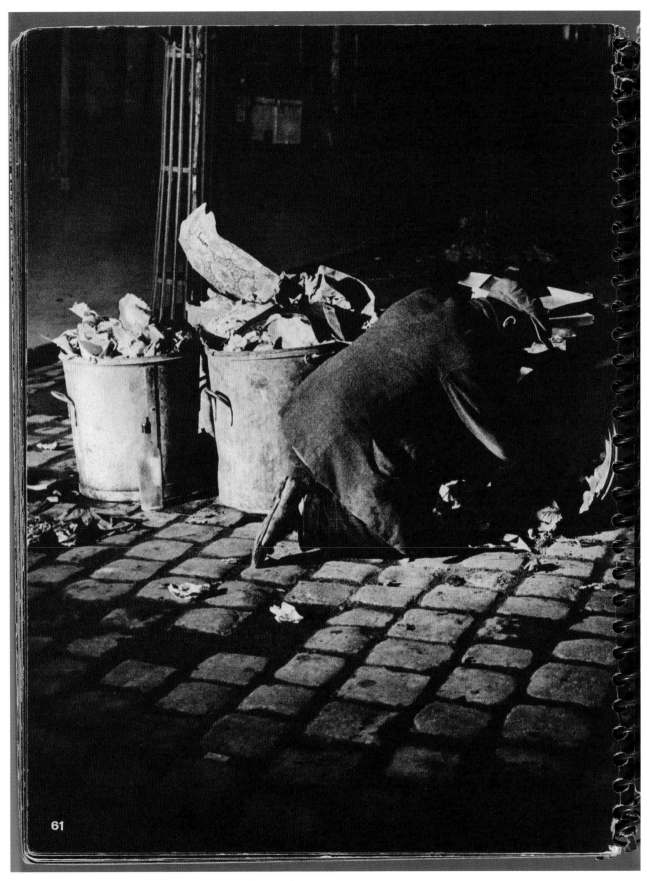

FIGURE 48 Plate 61, Ragpicker, from Brassaï, *Paris de nuit* (Paris: Arts et
Métiers Graphiques, 1932). Gravure, page: 10 × 7½ in. (25 × 19.3 cm).

(or a prison). Here, as in many other photographs in the book, Brassaï's radical cropping has enhanced the image's power. The original negative shows two bays of the bridge, two lamps, an expanse of sky above, and the bright lights of a neon-lit retail store on the opposite bank.[81] The book crops out this second arch completely and makes a stronger statement about the power of the clochard.

Clochards reappear several times in *Paris de nuit;* they were both a fixture in 1930s Paris and the press's mythical symbol for a supposed freedom (a way for the press to whitewash their homelessness). Brassaï participated in this journalistic myth, but his compositions also hint at the clochards' implied danger to society. In a photograph taken at 2:00 a.m. near Les Halles, they sleep on straw in rows under the columns of the Bourse. The caption romantically describes them as "modern counterparts of the medieval *truands,*" or as bandits and free criminals. In plate 32 a woman in rags occupies a quayside bench, preserving, according to the caption, a vestige of grandeur. Finally, in one of the last images of the book, a *chiffonnier* (ragpicker) digs through the garbage, looking for something to sell, his cap set jauntily on his head despite his distasteful task (plate 61; figure 48). Instead of a more conventional image, he and the milkman, the subject of the last photograph in the book, become the closing symbols of Paris in this pictorial voyage through the urban night (plate 62; see figure 37).

LÉON-PAUL FARGUE, ROGER PARRY, AND *BANALITÉ*

Another writer, Léon-Paul Fargue, also accompanied Brassaï on his nighttime walks. Fargue formed part of a wider circle of noctambulist writers working in Paris in the 1920s and 1930s (Francis Carco, Eugène Dabit, André Warnod, Jacques Prévert, and others). A master of Paris poetry and prose, he wrote about everything from high life to small bistros and forgotten streets and suburbs. He published his most famous book, *Piéton de Paris,* in 1939, and a series of stories and poems, *Banalité,* in 1928.[82] *Banalité* concentrates on childhood memories, beginning with his earliest memory of the 1878 Paris Exposition Universelle, and recounting others, from the wind knocking at his bedroom window to the billboards in his neighborhood to the family's outings on the Champs Élysées. The book ends with a postscript poem echoing the poetic melancholy of the streets. After evoking night boats about to depart and lost lovers, it closes with the lines: "All will be consumed, all pardoned. The pain will be fresh and the forest new,

and maybe one day, for new friends, God will bestow the happiness he promised to us."[83] Brassaï's work lacks Fargue's melancholy tone, but they share a love for details of urban nightlife.

In 1930 Gallimard reissued *Banalité* in an oversized, photographically illustrated format that directly preceded *Paris de nuit.* The author André Malraux was just beginning to be known in the literary world and had recently been appointed Gallimard's new artistic director.[84] Roger Parry, a young student of the photographer Maurice Tabard and a staff photographer at Arts et Métiers Graphiques, also worked off and on with the publishing house Gallimard. Malraux asked Parry and his friend Fabien Loris to illustrate a new, deluxe edition of *Banalité,* a daring choice to pair an unknown graphic assistant at the press with a much more famous author. *Banalité* was just one of a series of luxury publications Malraux oversaw at Gallimard. Printed on February 15, 1930, the photographically illustrated edition was still bound in Gallimard's trademark yellow cardboard but much larger in size (15¼ by 11¼ inches). Despite its softcover binding, this new edition of Fargue's melancholic tale was clearly a fine-art publication—printed in a small edition of 332 copies on fine paper.[85] Man Ray's development of the photogram technique, his combinations of unexpected pairings, and his quasi-violent subjects such as one image of a gun and a key were a clear inspiration to Parry and Loris.[86]

The sixteen images in *Banalité* echoed Fargue's fascination with dream and reality, past and present, and included five photograms (provided with the help of Parry's friend Loris), photomontages, multiple exposures, solarized views, and negative prints. Fargue's text reveled in the fragmentary memory of the past, with poems, snippets of prose, and long letters. Parry and Loris contributed images to intersect with these. Despite the fact that the photographers respect the meaning of the text, they create an unmistakable sense of unrest in each, highlighting Parry's Surrealist leanings, and critics appreciated his ability to transform the everyday into the poetic. The images describe Fargue's prose and also refer to his sense of traumatic absence.[87]

The illustrated edition of *Banalité* predated *Paris de nuit* by two years, but its images parallel Brassaï's concerns. Its most compelling plate graphically depicts the "scene of a crime," in Benjamin's words (figure 49). A photographic portrait has fallen off the wall to land upside down on the floor, and a rope and mysterious debris sit

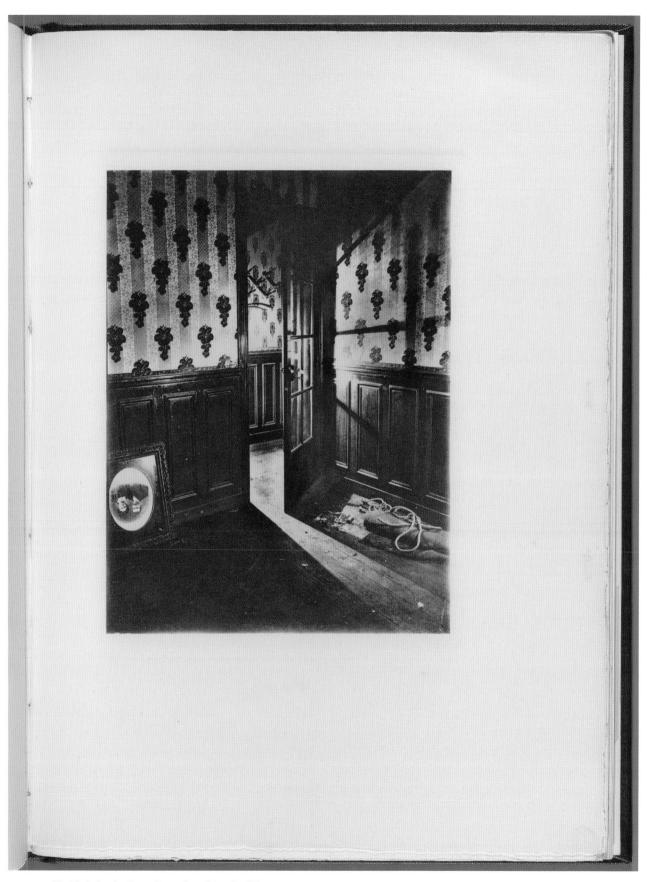

FIGURE 49 Untitled plate by Roger Parry, from Léon-Paul Fargue,
Banalité (Paris: NRF/Gallimard, 1930), following page 68. Gravure,
page: 15¼ × 11¼ in. (39 × 28.5 cm).

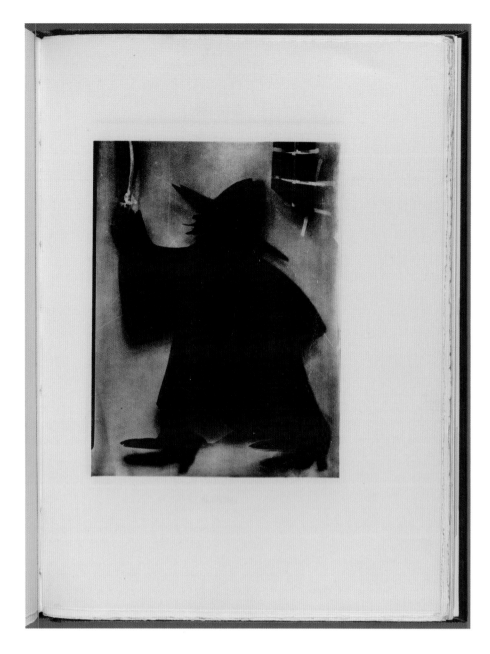

FIGURE 50 Untitled plate by Roger Parry, from Léon-Paul Fargue, *Banalité* (Paris: NRF/Gallimard, 1930), facing page 60. Gravure, page: 15¼ × 11¼ in. (39 × 28.5 cm).

just inside an open door of a deserted room. We are not told what the mystery depicts but are clearly meant to experience a frisson of horror at the possibilities. Other images have similarly mysterious clues—a box of dice and pearls, some broken beakers and wineglasses, and a photogram of a witch brandishing some sort of weapon, cut out of paper (figure 50). In other images, a supine body lies on the floor with a pistol by its hand, an abandoned merry-go-round horse sits forlornly in a vacuum, and a negative image of a locomotive charges right at us; all are presented in this beautifully printed volume. Parry has caught the trauma of Fargue's night walking with uncanny effect.

Although Parry's photographs for *Banalité* are his best-known work, they gained him an immediate clientele as a designer of detective-story book covers. After the publication of *Banalité*, he produced a large number of photographic covers for detective stories, and his output reflects the wide fascination with detective literature of all sorts in interwar Paris. Not only did he provide posters for André Malraux's renowned novel *La condition humaine* in 1933, but he made numerous photographic covers for Gallimard's "Détective" collection, including Raymond Fauchet's *La boutique sanglante* (1934), Edgar Wallace's *L'homme du Maroc* (1934), Sidney Fairway's *La vipère jaune* (1933), and S. S. van Dine's *Le chien mort* (1934).[88]

FROM CRIME TO SIN: BRASSAÏ'S OTHER NIGHT BOOKS

Voluptés de Paris, Brassaï's second volume, which finally appeared in 1935 with forty-six images, is the clearly transgressive twin to *Paris de nuit;* it more closely resembles *Détective* than it does André Breton's Surrealist novel *L'amour fou.* It fully explores the criminality and venality of the era. It appeared without approval from Brassaï, although he had signed a contract for 12,000 francs. Its publisher, Victor Vidal, owned Paris-Publications as well as a soft-core pornographic magazine (*Paris Magazine*), an erotic bookshop (Librairie de la Lune), and an erotica company (Diana Slip).[89] *Voluptés de Paris* sold for 40 francs and targeted the sensation-seeking audience of *Détective* readers. With its orange cover and plastic-ring binding (figure 51), it certainly presents a less elegant appearance than *Paris de nuit.* Although its format similarly allows the pages to lie flat, it has none of the graphic innovation of Brassaï's previous volume in either printing technique or layout. Its subjects have few overlaps with the first book, concentrating instead on peep shows, street fairs, music halls, brothels, homosexual clubs, and illicit encounters (figure 52). But both books share a fascination with the underbelly of Paris. In addition, although he never acknowledged them in his bibliographies, Brassaï published many photographs in Vidal's *Paris Magazine.* This had an estimated circulation of 150,000, so these Brassaï images, too, reached a very wide audience, although certainly not a highbrow one.[90]

Instead of a literary introduction by Mac Orlan, as Brassaï had hoped, *Voluptés de Paris* begins with a brief and frankly vulgar two-and-a-half-page introduction. The anonymous text begins: "Paris, city of delights and sweet diversions, paradise of our desires" and ends in a carnival busker's exhortation: "Help yourselves, Ladies and Gentlemen! There's something for everyone in the *Voluptés de Paris* grand bazaar." It came out in two editions, a first uncensored one for overseas sales, and a second one that deleted eight presumably censored images, including a view of a couple dressing in a brothel, a view in an opium den, a photographer recording a half-nude prostitute, and a couple embracing on the ground outside the city walls, in the *zone* (see figure 52). Mac Orlan owned a copy of the censored version, but it never reached a wide audience.[91] The subjects are frankly sexual and much

FIGURE 51 Cover of Brassaï, *Voluptés de Paris* (Paris: Paris, 1935). Cover: 10⅝ × 8¼ in. (27 × 21 cm).

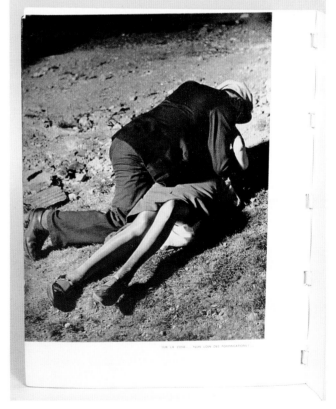

FIGURE 52 *Sur la Zone . . . non loin des fortifications!,* from Brassaï, *Voluptés de Paris* (Paris: Paris, 1935), n.p. Page: 10⅝ × 8¼ in. (27 × 21 cm).

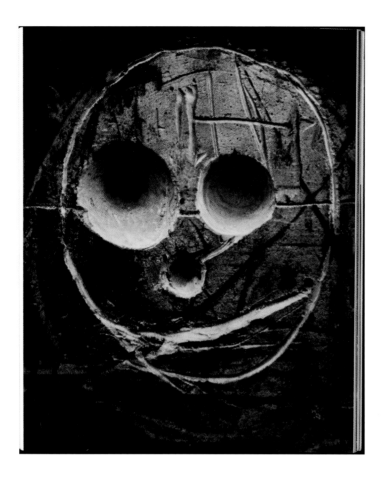

FIGURE 53 Graffiti from Brassaï, *Graffiti: Zwei Gespräche mit Picasso* (Stuttgart: Belser, 1960), n.p. Page: 13⅜ × 7⅞ in. (34 × 20 cm).

more explicit than the underworld images Brassaï later published in *Les Paris secret des années 30* in 1976. Vidal chose images that were titillating and explicit.

When Brassaï published tamer variants of them forty years later, with a nostalgic and romanticized prose to accompany them, this underworld had died out; in 1935 it represented a living, and dangerous, part of Paris. Brassaï laid out *Les Paris secret des années 30* in a complete hand-drawn maquette. The sketches of images on each page spread show the compositional effects he found most compellingly salacious. For instance, his sketch of "Conchita ou Eros à la fête foraine" highlights the black band across the eyes of the three women, and his sketch of the famed billiard player exaggerates her splayed fingers on the cue stick. In 1976 the artworld audience traveled to see the show at Marlborough Gallery on New York's fashionable Fifty-Seventh Street; Vidal's 1935 audience bought books wrapped in brown paper. Perhaps the 1935 book's censorship spooked Brassaï away from further pursuing such edgy topics; he certainly never did so again. But from 1930 to 1935 he was undeniably fascinated by the sordid and lurid underworld, photographically documenting the world that Henry Miller wrote about, as much

as Brassaï denied it later. (His postwar writings about Miller, too, are whitewashed to exclude the writer's more pornographic imagery.)

Brassaï's *Paris de nuit*, with its dark and borderless formats, had another lasting legacy after the war. Brassaï began making photographs of the rough graffiti carved illegally into Paris walls in the early 1930s and first published them in *Minotaure* in 1933. He finally published these images in book form only in 1960 (figure 53), a postwar echo of the impact of *Paris de nuit*. The book reprises the format of bleeding most images to the edge of the page, so that we enter into the actual carvings in the urban stone quite directly. In his early essay, he writes, "The following graffiti images were collected in Paris, found by chance on several walks." He concentrates on their anthropomorphic charm: "How hard is the stone, how rudimentary the instruments! No matter! . . . These succinct signs are nothing less than the origin of writing, these animals and monsters, demons and heroes, phallic gods, nothing less than the elements of mythology."[92] He constructs eight image categories, including the birth of mankind, faces, animals, love, and death, making it clear that he sees the city as teeming with anthropomorphic forms—much as

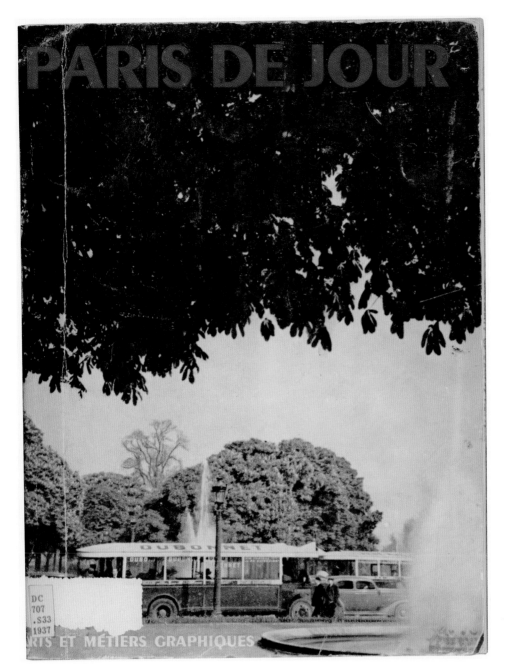

FIGURE 54 Cover of Roger Schall, *Paris de jour* (Paris: Arts et Métiers Graphiques, 1937). Gravure, 10 × 7½ in. (25 × 19.3 cm).

he did in the Pont Neuf image in *Paris de nuit*.

In addition to his own work, Brassaï's graphic design elements have taken on a life of their own in the work of other photographers. Very black tones and the printing technique of bleeding all the images off of the edges of the book page have sometimes become an aesthetic choice, and often an overtly political one to express danger or outrage.[93] More than a formal affectation, bleeding creates a particularly filmic and continuous kind of design that erases distance and draws us into the interior of the subjects it depicts. As illustrations bleed off the edge of

the paper, they create a visceral quality as well; the black ink seems to become a literary form of real blood, or the blood of dreams rather than physical violence.

PARIS DE JOUR AND LONDRES DE NUIT

Arts et Métiers Graphiques reprised the successful format of *Paris de nuit* immediately, in Roger Schall's *Paris de jour* (1937) (figure 54). Correspondence between the publisher and the printer, Hélio-Cachan, clarifies that they intentionally meant to copy the format of *Paris de nuit*. H. Jonquières writes: "I am attaching a blue print

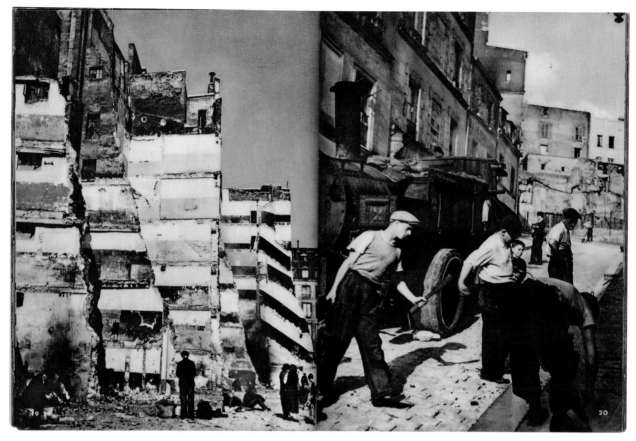

FIGURE 55 Plates 19 and 20, *Rue Beaubourg* and *Belleville,* from Roger Schall, *Paris de jour* (Paris: Arts et Métiers Graphiques, 1937). Gravure, page: 10 × 7½ in. (25 × 19.3 cm).

and compared to *Paris de nuit* it will give you the path to follow."[94] Published in a very comparable format, with sixty-two plates but lacking *Paris de nuit*'s spiral binding, this volume has a preface by the artist and writer Jean Cocteau. Its images lack the mystery of Brassaï's, and though they are printed in inky héliogravure like *Paris de nuit,* the tones of Schall's daytime photographs are much less rich or deep than Brassaï's. Although a counterpart to the first volume about Paris by night, it is, in comparison, an undistinguished, quotidian volume. Its cover lacks either an author or photographer's name, listing "Paris de jour" in undistinguished green letters across the top; we see a bus parked beneath a tree at the Rond-Point des Champs-Élysées (see figure 54). Cocteau's introduction, however, is set in the press's newest typeface, "Peignot," designed that year. Cocteau's text, unlike Schall's photographs, clearly follows in the literary detective tradition set by *Paris de nuit.* He writes: "Among the numerous and beautiful images in this album, you will not see the Eiffel

Tower. However, it remains at the center of this mysterious capital where Rocambole, Fantômas and Balzac's Trompe-la-Mort stirred up their intrigues." Cocteau comments on the quotidian Paris depicted by Schall: "Instead, it is the pastoral side of our city—the naïve and simple side—that these very beautiful photographs highlight and render very new."[95] The frontispiece shows a view of a horse-drawn cart with cyclists in the background, a scene that could date from 1937 or 1897. More bourgeois in tone than Brassaï's images, Schall's photographs show us the main tourist sites, along with an emphasis on people walking and working in working-class neighborhoods. For example, plates 19 and 20 depict a demolished neighborhood near the Quartier Beaubourg in central Paris and street pavers in the northern suburb of Belleville, each printed in rich gravure tones and with no margins shown for the photographs (figure 55). Nonetheless, despite the rich blacks, beautiful printing, and images bled to the edge of the page, the book lacks the excitement of Brassaï's.

In the following year, 1938, while still copying the general format of its bestseller, Arts et Métiers Graphiques copublished a London counterpart to *Paris de nuit. Londres de nuit (A Night in London)* was produced by Arts et Métiers Graphiques in Paris, by Batsford in London, and by Charles Scribner's Sons in New York (figure 56). Its photographer, Bill Brandt, was born in Hamburg and raised in Germany by an English father and German mother during World War I. He spent three months in 1929 working for Man Ray in Paris, then moved to England. He was another "outsider" like Brassaï—their complicated national status helped them to observe the societies they recorded. Brandt published *The English at Home* in 1936, and *Londres de nuit* in 1938. Expanding upon his early examination of the higher and lower classes from his first book, Brandt includes both sides of society in this later book. Batsford Press in London and Arts et Métiers Graphiques joined in publishing *Londres de nuit*, much as they had collaborated on the English edition of Brassaï's book in 1932. A comparison of the two books clarifies Brassaï's more edgy and literary imagery, despite Brandt's rich, deep blacks and full overview of society. Brandt celebrated all ranks of life, from society to working class, taking an equal interest in the parlor maid and the countess, in what Sarah Meister calls a "distinctively neutral sensibility." When he photographed edgier subjects, he posed his family members or other friends for the images, less interested than Brassaï in venturing into the streets in search of subjects (plates 6 and 7; figure 57). These photographs share a certain mystery in their tone, however, and Diane Arbus much appreciated the work of both photographers. She explained: "Brassaï taught me something about obscurity, because for years I've been hipped on clarity. Lately it's been striking me how I really love what I can't see in a photograph. In Brassaï, in Bill Brandt, there is the element of actual physical darkness and it's very thrilling to see darkness again."[96]

IN JAPAN

As early as 1933, the Japanese photographic journal *Asahi Camera* reviewed Brassaï's *Paris de nuit* in a portfolio with a full translation of Morand's introduction. This eight-page spread appeared just ten months after the book's publication in Paris and includes text samples showing the "Bifur" typeface, the front and end papers with cobblestones, and sixteen images. It is among the biggest portfolios the journal ever published and its only non-Japanese

portfolio in that period. Only a handful of non-Japanese single images appeared at all in *Asahi Camera* that year; most were Japanese Pictorialist photographs interspersed with a very few machine images. Although we do not know who chose to publish these images, they had a major impact in Japan. The scholar Eiko Imahashi notes that the modernist Japanese photographer Yasui Nakaji admired Brassaï in the 1930s, and that the poet Takiguchi Shuzo also saw Brassaï's photographs in *Minotaure* in the 1930s. Imahashi argues that Brassaï's core principles were "the imaginative power of transmutation" and "the poetic imagination of stone," a phrase he takes from Gaston Bachelard.[97] He finds the graffiti images to be Brassaï's most central work, but his continuing scholarship on Brassaï, based on analyses of sixteen separate images, shows Brassaï's enduring importance in Japan even today. Brassaï and William Klein are probably the most important Western photographers to impact postwar Japanese photography: both share graphically strong print qualities and disruptive depictions of urban life that clearly resonated in Japan.

Nakaji's photographs influenced Daido Moriyama, and Moriyama's renowned photobook, a supposed farewell to photography titled *Shashin Yo Sayonara* (1972), represents perhaps the most direct Japanese offshoot of *Paris de nuit*. As will be seen in the conclusion to this book, the work of Moriyama and other Japanese photographers of the 1960s and 1970s echoes not only Klein, whose grainy views were hugely popular in postwar Japan, but also the black quality of Brassaï's prints and printing techniques with no white edges. In the 1960s and 1970s *Asahi Camera* reproduced photographs with no white edges, and Moriyama liked this printing technique for its difference from the orderly white borders that mimicked gallery walls.[98] In 1960s Japan, Kikuji Kawada's *Chizu* also echoes Brassaï's turbulence. First published on the twentieth anniversary of the bombing of Hiroshima and representing a symbolic map, it, too, is completely black, with no borders, a photographic metaphor for atomic total destruction. Its leaves fold out to make an interactive experience far more radical than Brassaï's spiral binding, but the bombed fragments, torn letters and uniforms, billboards, and other fragments recall his interests in graffiti and the urban underworld. Kawada echoes Brassaï's aims of using blackness for emotional expression, and of combining reality and intuition: "With the rich and chaotic nature of monochrome, . . . I tried to find my early style within the illusion

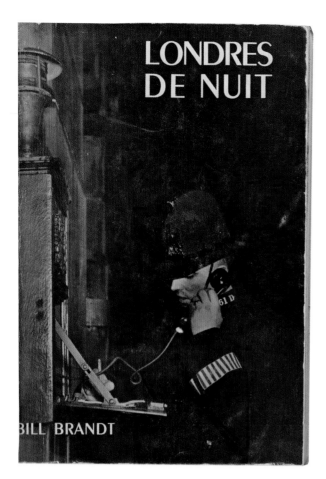

FIGURE 56 Cover of Bill Brandt, *Londres de nuit* (Paris: Arts et Métiers Graphiques, 1938). Gravure, 10 × 7¼ in. (25.4 × 18.5 cm).

FIGURE 57 Plates 6 and 7, *Streets in Bermondsey* and *Working-Class Family at Home,* from Bill Brandt, *Londres de nuit* (Paris: Arts et Métiers Graphiques, 1938). Gravure, page: 10 × 7¼ in. (25.4 × 18.5 cm).

of reality by abstracting the phenomenon."[99] Although Brassaï's oneiric map of nighttime Paris is hardly a post-nuclear witness document, its underlying inquietude (Mac Orlan's social fantastic) forms the logical precursor to Kawada's stunning pictorial language and book.

POSTWAR AMERICA

If black, borderless images continued to connote a certain political effect, metal spiral binding, the second mark of avant-garde publishing for Brassaï, completely changed its meaning by the postwar period. Now denoting a school or science notebook, it still was sometimes used for photography books, but now imbued them with an anti-art or pseudoscientific meaning. Several decades later, Martha

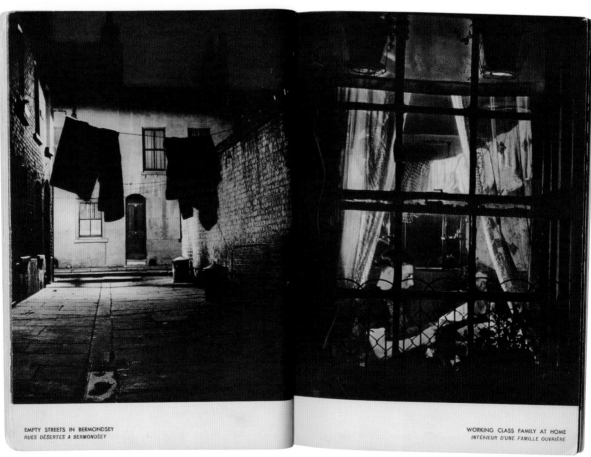

EMPTY STREETS IN BERMONDSEY
RUES DÉSERTES A BERMONDSEY

WORKING CLASS FAMILY AT HOME
INTÉRIEUR D'UNE FAMILLE OUVRIÈRE

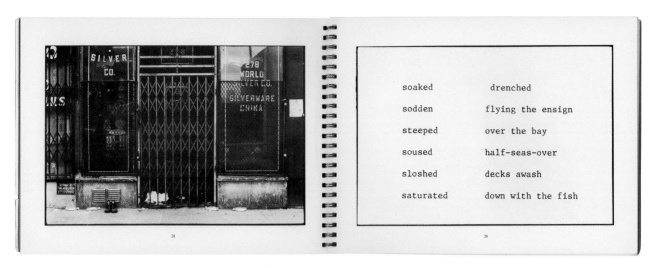

soaked	drenched
sodden	flying the ensign
steeped	over the bay
soused	half-seas-over
sloshed	decks awash
saturated	down with the fish

FIGURE 58 *The Bowery, in Two Inadequate Descriptive Systems,* from Martha Rosler, *Three Works* (Halifax: Nova Scotia College of Art and Design, 1981), 28–29. Offset, page: 8 × 10¾ in. (20.3 × 27.3 cm).

Rosler returned to a spiral-bound format and to Brassaï's subject of the urban underworld in her 1981 book *Three Works.* With a first section on Chile, a second presenting her important 1974–75 project, *The Bowery, in Two Inadequate Descriptive Systems,* and a third section with her essay "In, Around, and Afterthoughts (on Documentary Photography)," she comments on the inadequacy of photographs to represent documentary issues. Although she was specifically addressing American documentary photography, the project seems to deny the very premise of Brassaï's project, just at the moment when he was writing his nostalgic and romanticized text for *Les Paris secret des années 30* (1976). The Bowery section, in particular, contrasts words and images as mutually exclusive and equally inadequate systems for describing the true misery of life on the streets of the Bowery (figure 58). Rosler relates a similar urban impetus to that of Brassaï in Paris: "I'm a native New Yorker, and I spent a lot of time walking on the Bowery and thinking about how the people who spent most of their lives out on the Bowery were represented photographically." She continues to explain that she wanted to counteract what she eloquently calls "the find a bum school of photography," a reference that could easily apply to Brassaï and his noctambulist wanderings, as well as to his later New York counterpart, Weegee. Rosler explicitly rebuts the idea of photographers finding a picturesque scene of a bum, snapping a picture, signing it, and displaying it—also a direct rebuttal to Brassaï's project: his clochards were on view in 1977 at the very upscale Marlborough Gallery in New York while Rosler was at work downtown. Rosler's twenty-one grainy photographs, echoing Brassaï's dark tones, are entirely free of figures. She uses language (twenty-four text panels) as a counterpart, giving readers the raw tools to reconstruct what she calls "the poetics of drunkenness."[100] Rosler critiques the poetics of urban down-and-out life romanticized by Brassaï in views such as his police photograph in *Paris de nuit.*

To return to the 1930s, the dreamlike, fragmented, and scattered clues that Brassaï first gives us to construct a troubled city portend an even blacker time, the period when Paris endured German occupation in World War II. The language of isolated clues, anthropomorphized buildings and monuments, vagrants and prostitutes, and all the restiveness that they emit reflect Mac Orlan's "social fantastic" in the 1930s. By the 1940s, however, the fantastic took on a nightmarish quality, no longer lighthearted or lyrical in its poetry. The Germans invaded Paris in June 1940. Under the Nazis, photographic book publishing took a whole new turn, but just after the liberation of Paris, a few photographic books transformed the language of modern forms, quotidian details, and urban clues to comment on that dark period in French history. As we will see in the next chapter, Jean Eparvier and Roger Schall's *À Paris sous la botte des Nazis* (November 1944) and Pierre Jahan's *La mort et les statues* (1946) signal another shift, transforming a long tradition of war books into a new format.

15

FIGURE 59 Plate 15, *Rome capitule*, from Pierre Jahan, *La mort et les statues*
(Paris: du Compas, 1946). Gravure, page: 13¼ × 10¼ in. (33.7 × 25.8 cm).

3 ELEGY

Pierre Jahan's *La mort et les statues*

"It's the end. Rome capitulates."[1] Jean Cocteau's poetic caption, illustrating Pierre Jahan's 1941 wartime photograph of Parisian statues being melted down for German ammunition, pulls no punches (plate 15; figure 59). The image is immediate and anguished: two bronze alligators rear up and out of the frame—jaws agape, forked tongues extended, claws bared. Piled atop each other, they seem to rip their way out of a morass of machinery whose pulleys and wheels dominate the top right of the image. The "republic" is dead. In fact, the French Third Republic *was* dead, its seventy-year-long period of stability fractured by the German invasion of Paris in June 1940. Another image gives us its tombstone, in the form of a foot and a toppled plinth whose base is inscribed with those very words: *"république"* (plate 3; figure 60). These alligators are two of sculptor Georges Gardet's five sea monsters—added in 1908 to Jules Dalou's 1899 *Triumph of the Republic* monument in the Place de la Nation. Fittingly, the beasts were originally meant to represent the enemies of the republic.[2] After their removal, the alligators were stored in a warehouse along with other bronze statues, awaiting their fiery death in the smelter on their way to becoming German bullets. In situ, they had adorned a monument whose center was Dalou's figure of the republican heroine Marianne, with her Phrygian cap, surrounded by her attendants Justice, Work, and Peace (figure 61). Marianne and her nymphs escaped demolition, their subjects deemed too central to French identity to destroy. Interestingly, these universal symbols of liberty since the eighteenth century and the French Revolution—Marianne and her Phrygian cap—are completely absent in Pierre Jahan and Jean Cocteau's 1946 book, *La mort et les statues.*

Jahan clearly found the alligators from the Place de la Nation very moving: five of the twenty images in *La mort et les statues* depict their snarling death amidst the debris of the warehouse (plates 12 through 16). Cocteau, in his turn, was inspired by their symbolism and clearly saw them as representatives of the republic. For plate 12 (figure 62), he writes: "Here the alligators of the Place de la Nation revolt. Liberated. Freed from their chains. They participate on the barricades. From their abominably entangled shapes, they form their own barricade." But by plate 16 (figure 63), showing a tangle of serpents among the other metal debris, he writes of their ultimate demise: "Cleopatra's soldiers return to the mud of the Nile."[3]

Pierre Jahan made these images surreptitiously on a

FIGURE 60 Plate 3, *Botte blanche,* from Pierre Jahan, *La mort et les statues*
(Paris: du Compas, 1946). Gravure, page: 13¼ × 10¼ in. (33.7 × 25.8 cm).

FIGURE 61 J. H., Postcard of Jules Dalou, *Triumph of the Republic*, Place de la Nation.

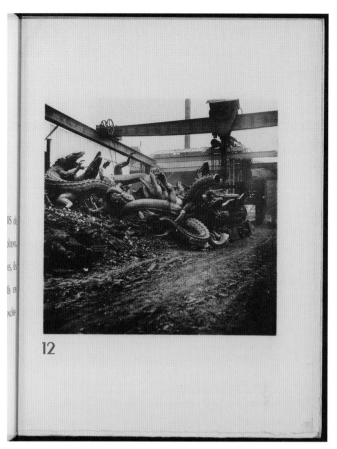

FIGURE 62 Plate 12, *Alligators*, from Pierre Jahan, *La mort et les statues* (Paris: du Compas, 1946). Gravure, page: 13¼ × 10¼ in. (33.7 × 25.8 cm).

predawn morning in December 1941, the same year he first met Jean Cocteau. When Cocteau saw the photographs at the war's end, he penned poetic reactions to a group of twenty images and helped Jahan find an editor. *La mort et les statues* was published in 1946 with twenty photogravure plates and a reproduced handwritten letter by Cocteau, stating, "This book was composed during the occupation" and praising Jahan for "an example of the kind of beauty that one single man can create out of an impossibly ugly spectacle."[4] These photographs and their companions are a cri de coeur for French liberty. The anguish of the French people, the loss of the alligators of the "Republic" monument, the sense of being eaten alive by a voracious enemy, and the hopelessness of the early years of the German occupation are all packed into this image and its short caption—along with an undeniable sense of menace and violence. *La mort et les statues* is a particularly French and especially potent commentary against war, one that uses the languages of reportage, of Surrealism, and of poetry in book form. Brassaï's detective-clue and Surrealist commentary on the cultural and political tumult of the 1930s is replaced by a full-out cry of despair as the war arrived in France. *La mort et les statues* is relatively little known, and at the time when it was published it lacked the widespread dissemination of other books in this study. Among a larger group of French books from 1945 and 1946 about the occupation and the war, it has, however, stood the test of time, and—unlike most of its contemporaries—it has been republished twice in recent years. *La mort et les statues* is unique among these French war books, and it encompasses many universal expressions of

anguish. Its combination of photographic exactitude and poetic license would be repeated in many future volumes. Simultaneously, it raises universal questions about both the power and the morality of depicting trauma and war.

La mort et les statues comments on the loss of French liberty on several symbolic levels, and in each case public monuments stand in for traumas too complex or horrific to depict in straight documentary photography. First, the complicated subject of French wartime collaboration and resistance dominates this book, both of whose authors could be labeled (often at the same moment) as cultural collaborators with Germany, but also as resistance commentators. Second, the use of melting statuary acts as a powerful symbol for the loss of French liberty during World War II. Third, in its concentration on late nineteenth-century statuary being melted down, *La mort et les statues* forms a national commentary on the failure of the Third Republic, which lasted from 1870 to 1940. This dialogue looks all the way back to the previous occupation of Paris by the Germans, in 1870.

Finally, when it was published in 1946, five years after the images were first made in 1941, the book accrued a more generalized postwar meaning. It became a more universal commentary about war, one that uses bronze statues as acceptable stand-ins for the anguish of human death. With Cocteau's subtle commentary and the power of Jahan's compositions, *La mort et les statues* is a symbolic lament not only for the French and other military deaths in World War II, but for the all-too-real civilian bodies that had been burned in German concentration camps and by the atomic bombs in Hiroshima and Nagasaki. In their book, Jahan and Cocteau frame the statues waiting to be melted down as symbolic images. The French had a singular relationship with these horrors, since they deported Jews to Germany through the Drancy transit camp just to the northeast of Paris. Drancy opened in August 1941, after a roundup of four thousand French Jews. The statues would be toppled just a few months later.

Several commentators on this project equate *La mort et les statues* with historian Pierre Nora's *lieux de mémoire*. Nora defines a lieu de mémoire, a site symbolizing French national identity, as follows: "There are *lieux de mémoire*, sites of memory, because there are no longer *milieux de mémoire*, real environments of memory." Nora sees, in the diminution of classical historical archives (the church, the state, and great families) a need for a new kind of memory. His lieux de mémoire are "simple and ambiguous, natural and artificial, at once immediately available in concrete sensual experience and susceptible to the most abstract elaboration," operating as *lieux* in three ways: "material, symbolic, and functional." Cocteau's and Jahan's partnership creates just such a memory—a functional memory of lost statues, a symbolic memory of lost liberties and people, and an abstract metaphor for a larger dialogue between nineteenth-century history, World War II, and its aftermath. Nora sums this up succinctly when he writes, "Reflecting on *lieux de mémoire* transforms historical criticism into critical history—and not only in its methods; it allows history a secondary, purely transferential existence, even a kind of reawakening."[5]

Using a particularly French combination of Surrealism, lyricism, and abstraction, *La mort et les statues* stands alongside Paul Éluard's famous 1941 poem "Liberté" and Pablo Picasso's *Guernica* as one of the most eloquent mid-twentieth-century elegies of war. Despite Theodor Adorno's belief that after World War II "neutralized and ready-made, traditional culture has become

worthless today. . . . To write poetry after Auschwitz is barbaric"; lyric poetry in this volume is actually the language of a heartfelt, patriotic grief. Lisa Saltzman, in her study of Adorno and Anselm Kiefer, examines the problem of how to represent the unrepresentable, and suggests that Adorno's views on art can reflect "both the Hebraic ethics of unrepresentability and a Hebraic ethics of bearing witness." Unlike Adorno, Jahan and Cocteau are not Jewish, yet their book also bears witness yet refuses to directly depict the horrors of war. Almost no books in the immediate afterwar period developed a way to pictorially address the atrocities of the war. Instead, in their commentary on war, poet and photographer construct one of Nora's lieux de mémoire.[6]

PUBLISHING IN OCCUPIED PARIS

Any attempt to write about French wartime photography books in the 1940s runs into an inevitable snag: France was under Nazi control from the moment when the Germans invaded Paris on June 14, 1940, until the Free French and American troops led by General Jacques-Philippe Leclerc liberated the city on August 25, 1944. In 1940 the Free French press was exiled to London, where *La France libre* was produced by Charles de Gaulle's exiled government, and to Brazzaville, French Equatorial Africa, where the Free French Radio Brazzaville broadcasts originated. Les Éditions de Minuit, an underground press established in 1941, published a few books, but a gradual reemergence of independent French publishing resumed only with the liberation of Paris. Cultural activity did not stop in occupied Paris, but it became very problematic, and the full extent of activities is only now becoming known, thanks to the scholarship of figures such as Catherine Tambrun and Françoise Denoyelle.[7]

The most simplistic cultural analyses of this period separate the collaborationists, those who worked within the German-controlled Vichy government structure, from the resistance, those who fought in the underground movement against the Germans. In fact, daily life in Paris was far more complicated than that, and French citizens walked an uneasy path that often simultaneously encompassed both positions. Actions as simple as buying food and as complex as continuing to live a creative life fell into this murky middle ground. Any analysis of photography books both during and directly after the war must approach this reality carefully.

Naturally, few books were published during the

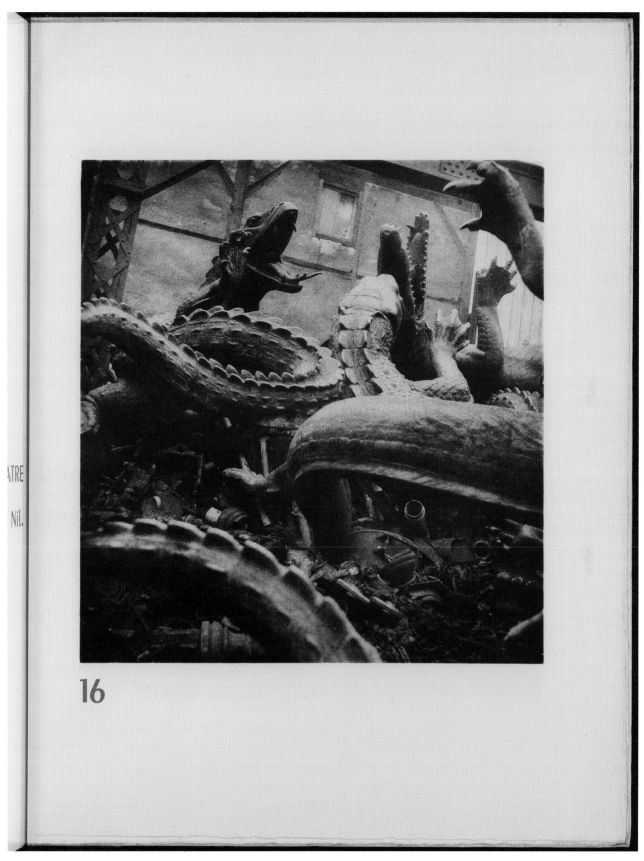

16

FIGURE 63 Plate 16, *Soldats de Cléopâtre*, from Pierre Jahan, *La mort et les statues* (Paris: du Compas, 1946). Gravure, 13¼ × 10¼ in. (33.7 × 25.8 cm).

occupation itself, but there were projects started, many of which were published just a few months after the liberation of Paris.[8] Most focused on the liberation itself, and, as historian Catherine Clark has recounted, a major exhibition on the liberation opened at the Musée Carnavalet in November 1944 and more than a dozen liberation-themed books were published in 1944, sixteen in 1945, and another dozen in 1946; most of them mythologized the liberation of Paris as "the iconic battle of the war, the founding myth of the postwar nation." Clark contends that between 1944 and 1946 more people "would witness the liberation as a spectacle of images than had experienced it firsthand."[9] In most of these books, the liberation of Paris was presented as an independent French effort, as if no Allied troops had fought their way from the beaches of Normandy and Saint-Tropez to liberate the city, and as if the filth of war were not present. Although Roger Schall's three books published from 1944 through 1946 had a wider circulation at the time, Pierre Jahan's and Jean Cocteau's *La mort et les statues* is the most beautiful of this outpouring of publications once the German censorship was lifted, and it has a different message from its peers.[10] Jahan secretly made the photographs for *La mort et les statues* during the darkest days of the occupation, not at the moment of France's liberation. His images are a clear cry against the occupying forces, yet he continued to work professionally in Paris during the occupation; he was the head photographer for the magazine *Plaisir de France* from 1934 until 1974. Although Jahan was a practicing photographer even during these occupation years, he did not then publish the body of images in this chapter, or his many other images of Paris under the occupation.[11]

La mort et les statues operates on a larger scale than the liberation myth, presenting instead a multigenerational response to the war and to war in general. The book was produced on October 30, 1946, in a deluxe edition of 450 copies, and it was not well known until its republication in 1977 and again in 2008. The 2008 edition reproduces all the images that Jahan took in 1941, including ones excluded from the 1946 book. A final issue for this book is its resurrection in later editions. The 1977 and 2008 editions accomplish two goals: they give an afterlife to the book itself, and to the photographer who would otherwise be forgotten. But they also re-sculpt the public monuments themselves, giving them a "rich second life" long after their physical removal. The republication dates may not resonate politically, but it is also possible that

1977 and 2008 were cultural times when the more universal message of loss, resurrection, and anguish about the loss of national pride echoed particularly strongly.[12] *Métal* and *Paris de nuit* have been republished primarily due to the pull of the art market and of the photographic book market; it is possible that this book has a more political resonance in its afterlives.

Pierre Jahan was a photojournalist working in Paris in the 1930s and still active during the occupation. Born in 1909 in Amboise, in the Indre-et-Loire region, he became a professional photographer in 1933, on the advice of another photographer, Emmanuel Sougez. From 1934 to 1974 Jahan worked for *Plaisir de France*, a journal that began in October 1934 and was purchased in 1974 by *Connaissance des arts*. Jahan joined the group Le Rectangle, founded in 1937 by Sougez with the intention of promoting a specifically French national style of photography. The group was in hiatus during the war and re-formed in 1946 under the name Groupe des XV, with a similarly nationalist bent.[13] As part of this group, the images from *La mort et les statues* were exhibited at Square du Roule in Paris in 1949. Among Jahan's colleagues were Robert Doisneau, Willy Ronis, and René-Jacques; all these photographers valued and documented quotidian street scenes and French traditional life and were important links to the larger French humanist photography movement.

Jahan published images in two books before *La mort et les statues*—*Dévot Christ de la Cathédrale Saint-Jean de Perpignan* (1934), and *Mer* (1935)—and after the war continued to make a large number of books documenting cathedrals, churches, and ecclesiastical sculpture around France.[14] In all of these works, including *La mort et les statues,* he manifests a real appreciation for the tactile allure of sculptural forms, rendering them in loving and almost three-dimensional imagery. For the majority of his career, he worked actively as an advertising photographer and photo reporter, producing photojournalistic projects on the 1937 World's Fair for *L'illustration* and postwar advertising campaigns for Citröen, Renault, Daum crystal, Porcelaine de Paris, and other companies. During the war, he justified his continued work for *Plaisir de France* because it "had no direct contact with the occupiers." Directly after the war, he documented the repatriation of artwork to the Louvre. Jahan also experimented with a series of photographs that regroup disembodied plastic doll limbs, torsos, and heads; these images echo

the Surrealist fascination with fetishizing bodies and desire, although nowhere near as disturbingly as Hans Bellmer's work in the 1930s. In 1937 Jahan gave a talk called "Surrealist Photography in Publicity." After the war, Jahan continued to work for *Plaisir de France* and made many travel and art photographs, including studies of Baroque art in 1960, and of Spain, the Canal du Midi, Switzerland, Holland, Austria, and other places in the 1960s and 1970s. He died in 2003.[15] Unlike many photographers of the interwar period, he never achieved an international reputation; the photographs he made surreptitiously during World War II remain among his most important works.

In December 1941, three and a half years before the liberation of Paris and a year and a half into the occupation, Jahan received a tip about odd activities in the twelfth arrondissement. In a 1974 article in the *Gazette des beaux-arts,* Jahan remembers that a painter friend, Suzanne Tourte, who lived on the Avenue Michel Bizot, told him that in a factory courtyard near her were "bronze statues that the Germans had condemned to be melted down." Tourte informed him that the courtyard door was empty and unlocked at seven o'clock in the morning. Jahan recounts that he photographed at dawn, using flash, and then used the sunlight to light the rest. The photographer remembers that he was reluctant to present these images publicly after the war ended, feeling them to be an "abstract and surrealist horror [that] paled in comparison to what we now knew about the concentration camps."[16] By chance, he showed them to Cocteau, who immediately became very enthusiastic and wrote the text and captions. Cocteau's text, in fact, reads more like a series of haiku about the pictures than a strictly documentary project. Jahan admitted that the book had a very limited audience, due to the small print run.

Jahan writes he learned later that the Germans meant to use the bronze collected that day to commission a monument to the Third Reich by German sculptor Arno Breker. Breker did use thirty tons of French bronze for an exhibition at the Orangerie in May 1942, and rumors abounded that there was a direct connection. Recently, several art historians have also suggested a direct connection similar to Jahan's assertion, but it is impossible to prove what melted bronze was used for military purposes and what was used by Breker. Jahan's grandson, Olivier Lacroix, has collected some of his grandfather's recollections that reinforce a political meaning to whose statue was melted down and for what purpose.

Commenting on Marshal Philippe Pétain's decree of October 11, 1941, to send monuments to be melted down, he suggests that the first victims of this destruction were nineteenth-century public and political figures, whereas Jeanne d'Arc was spared. Lacroix also provides more memories of the speed with which his grandfather executed this project in the early morning hours: the workers—supposedly heartsick over their task—accepted that he would make this report.[17]

In his introduction for the 1946 edition (five years after the photographs were made), Cocteau wrote a poetic introduction that both acknowledges the creative reimagining of the Parisian monumental statuary and the transformative role of photography itself in its redefinition. Explicitly using the term "estranged," he writes:

> The poet's métier cannot be learned. It consists of placing objects of the visible world—objects that have become invisible through the murk of familiarity—into an estranged position that reflects the soul and gives it a tragic outlook.
>
> This is a case of compromising reality, of taking it out of context, unexpectedly drenching it in light, and obliging it to reveal what it is hiding.
>
> Pierre Jahan gives us a vivid preview. He secretly photographed the warehouse where the Germans crushed, broke and melted down our statues. The result, thanks to the angles of his images, is that the most mediocre statues find grandeur and a solitary drama. I honor him for that.
>
> A camera is a third eye for the man who uses it. Therefore, Jahan's album is a poetic album. These are admirable poems whose crimes show even more clearly among the rubble.[18]

Cocteau's prose is overblown, but he captures the essence of Jahan's project, calling it a poetry that renders an invisible habitual world visible, and paying homage to the dramatic tragedy that Jahan creates. He also acknowledges photography's role in using light to illuminate things that otherwise remain hidden—a sentiment similar to Brassaï's—and credits Jahan not only for photographing the destruction of these monuments, but for giving otherwise mediocre urban statuary a new grandeur and heroism. In calling the camera man's "third eye," he labels Jahan a poet, and, in the path of Pierre Mac Orlan's "social fantastic" of the 1930s, lauds the imagery of rubble that

exposes the crimes committed when "Germany crushed, broke and melted our statues." Of course, neither the imagery, the statues, the politics, nor the melting down of the statues is as simple as Cocteau suggests. A trenchant view of the war and its aftermath emerges from the intentional pairing of Cocteau's text with Jahan's images in the book's physical construction.

Cocteau is better known for his personality and Parisian presence than for his writing and visual art, but his lifelong fascination with classicism, theatricality, and the contrast between good and evil is very apparent in this small book. His early works such as the ballet *Parade* (1917) (produced by Serge Diaghilev, music by Erik Satie, sets by Picasso, libretto by Guillaume Apollinaire) introduce his interest in theater, and dance would be a key interest for his life; in his captions for *La mort et les statues* he makes the bronze statues dance. If, as Wallace Fowlie suggests, there are two "principal schools of French style"—the Latin rhetorical style, and the Greek tradition "where the sentence is brief, concise, sculptured"—Cocteau falls into the Greek tradition. Fowlie identifies a selection of key figures that recur throughout Cocteau's work: sailors, angels, cyclists, statues, marble, mirrors, snowballs, horses, and so on.[19] The 1926 play *Orphée* presents Orpheus and the Angel Heurtebise, and *Les enfants terribles,* a 1929 novel, presents a dark psychological look at adolescence (simultaneously angelic and evil) during the freewheeling 1920s. In his journals, Cocteau writes of the impact of Marcel Proust, of Apollinaire, of André Gide, of his young muse Raymond Radiguet, of Cubism, and of the Surrealists. He describes Cubism as "classicism opposing the romanticism of the Fauves," and classicism haunts his writings for decades.[20]

Cocteau's film *Le sang d'un poète* (1930) extends the imagery of angels and of classical figures as living statuary where the poet "writes with his own blood." As Kathryn Brown argues, his statues in *Le sang d'un poète* are "not merely commemorative symbols or relics of antiquity, but beings possessed of an independent existence on the boundary between physical frailty and immortality." Death is a metaphor in this film, as it would be in his discussion of Jahan's photographs. In this film Cocteau continues his identification with Orpheus, the nonviolent god of poetry. Most importantly for *La mort et les statues,* the film features a Pygmalion-like classical statue come to life—in the transcendently beautiful figure of the photographer Lee Miller—that is then smashed into ruin at the

film's end (figures 64, 65). Brown sees Cocteau's further exploration of the theme of statues in his wartime poem "Léone," in which the narrator meets statues wandering through time and urban space—a reflection of his view from his Parisian apartment in the Palais-Royal during the occupation.[21] In Cocteau's commentary and captions for *La mort et les statues,* he finds all his favorite themes of classical imagery, of living statuary, and of a blending of innocence and evil (this time World War II evil).

Jahan's images of the alligators writhing would have certainly triggered for Cocteau a memory of a story from Virgil's *Aeneid:* Laocoön, the Trojan priest of Apollo, and his sons were crushed by sea serpents as punishment for warning the Trojans about the wooden horse. In perhaps the most famous sculpture of anguish in the history of art, the Hellenistic statue in the Vatican Museums depicts their agony and struggle. In Gotthold Lessing's renowned 1766 essay on the Laocoön, he writes, "A cry is the natural expression of physical pain," and lauds classical Greek humanity in allowing sufferers to feel pain and injury "in the expression of this feeling by cries, tears, or invectives."[22] The alligators from the Place de la République are hardly as masterful as the work of the three Rhodian sculptors who created the Laocoön, but, piled as debris in the smelting yard, their anguish is palpable.

Any study of Cocteau during the war years must address his role in wartime Paris. Cocteau is a famously problematic case, both revered as an original voice in the arts and reviled for perceived collaborationist efforts. His wartime experiences are complicated at best.[23] He enthusiastically welcomed the "excitement" of the Nazi arrival and sought an official license to continue presenting his plays. Most notoriously, he published an article, "Salut à Breker," praising a 1942 exhibition of Arno Breker's sculptures in Paris. Not only did it appear on the first page of *Comoedia,* the major cultural weekly publication during the occupation, but its language was uncomfortably analogous to German rhetoric. He explicitly writes: "I salute you, Breker. I salute you from the great homeland [*patrie*] of poets, a homeland where countries do not exist, except in the sense that each one brings treasure to the national project. . . . Because in the high homeland in which we are compatriots, you speak to me of France."[24] The timing of this article is especially important for *La mort et les statues,* as it was published in spring 1942, just after the wave of smeltings that included Jahan's images—and Jahan imagined that Breker would use the bronze to fabricate

FIGURE 64 Film still of Lee Miller as statue, from Jean Cocteau, *Le sang d'un poète* (1930).

FIGURE 65 Film still of broken statue, from Jean Cocteau, *Le sang d'un poète* (1930).

a Nazi monument, even if we do not know Cocteau's knowledge of this rumor. Further instances of Cocteau's active involvement are his catalogue essays for the Galerie Charpentier, one of the main galleries arguing that French art (now excluding any Jewish participants) represented the "harmonious continuity of French art since the era of Romanticism." Cocteau, clearly fitting in with Aristide Maillol, Raoul Dufy, Georges Rouault, and Henri Matisse as a French artist acceptable to the Germans, had a one-man exhibition at the Galerie Carré in May 1941.[25]

Yet histories of occupied Paris are seldom one-dimensional. At the same time as his support for Breker, Cocteau's play *Les parents terribles* was listed as "immoral" by the Vichy government, and he was seriously harassed during its run. Cocteau was brought before the purification tribunals after 1944, but "exonerated of any serious misconduct." As a further complication of a simplistic portrayal of Cocteau as simply collaborationist, his drawing of Marianne wearing the French Resistance rosette became a stamp in the Fourth French Republic.[26]

Therefore, when Cocteau writes in his letter at the start of *La mort et les statues* that Jahan finds "an example of the beauty that one man can find in the unnamable spectacle of ugliness," we can see him attempting to redeem himself in countering his own earlier support for Breker. In 1946 alone, among many other projects, he produced the film *La belle et la bête*, wrote the commentary for Jahan's book, and also narrated *L'amitié noire*, François Villiers's and Germaine Krull's patriotic and ethnographic film about the Free French War effort in Africa.[27] All combine

classicism, a kind of "social fantastic" found in reality, and theatricality. Brown suggests that Cocteau finds in *La mort et les statues* a new language for expressing the disasters of World War II, quite aware that traditional representations had lost their meaning. In anthropomorphizing the statues, he is able to mourn their "death" in a classicizing and universal fashion. As she writes, "The viewer does not simply 'bear witness' to an act of industrial destruction that occurred during the occupation, but rather rehearses the experience of pain inflicted on individuals during those years." She places the anthropomorphism in a political context as well, and notes that in the introduction "Cocteau's texts cast the photographs as crime scenes," with the Germans as the "criminals."[28]

The publisher for *La mort et les statues*, Les Éditions du Compas, was founded by a fellow photographer and a member of the photographers' group Alliance Photo. Its director, René Zuber, produced a volume on the liberation of Paris in 1945, with photographs by Robert Doisneau, Pierre Jahan, and Zuber. However, the press is best known for *La mort et les statues*.[29] Reflecting the exigencies of postwar Paris, this is a softcover book, although the editors use Cassandre's elegant new Peignot typeface from Arts et Métiers Graphiques. Cocteau and Jahan receive equal billing on the cover, and the title, "Statues," is separated into two word fragments so that "mort" and "tues" both suggest death and killing. The Peignot typeface is creatively used throughout the book. The first letters of several words on the cover, title page, and contents page are in red, green, and blue, and the plates are variously

LA MORT ET LES STATUES

Texte de Jean Cocteau

Photos de Pierre Jahan

FIGURE 66 Cover of Pierre Jahan, *La mort et les statues* (Paris: du Compas, 1946). Gravure, page: 13¼ × 10¼ in. (33.7 × 25.8 cm).

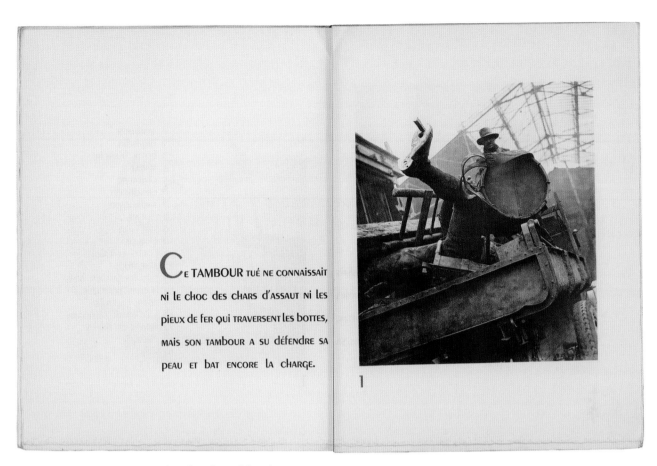

Cᴇ TAMBOUR ᴛᴜᴇ́ ɴᴇ ᴄᴏɴɴᴀɪssᴀɪᴛ ɴɪ ʟᴇ ᴄʜᴏᴄ ᴅᴇs ᴄʜᴀʀs ᴅ'ᴀssᴀᴜᴛ ɴɪ ʟᴇs ᴘɪᴇᴜx ᴅᴇ ғᴇʀ ǫᴜɪ ᴛʀᴀᴠᴇʀsᴇɴᴛ ʟᴇs ʙᴏᴛᴛᴇs, ᴍᴀɪs sᴏɴ ᴛᴀᴍʙᴏᴜʀ ᴀ sᴜ ᴅᴇ́ғᴇɴᴅʀᴇ sᴀ ᴘᴇᴀᴜ ᴇᴛ ʙᴀᴛ ᴇɴᴄᴏʀᴇ ʟᴀ ᴄʜᴀʀɢᴇ.

1

FIGURE 67 Plate 1 and caption, *Tambour*, from Pierre Jahan, *La mort et les statues* (Paris: du Compas, 1946). Gravure, page: 13¼ × 10¼ in. (33.7 × 25.8 cm).

numbered in the same colors. The captions are printed in large Peignot type on the facing pages to each image (cover and plate 1; figures 66, 67). Despite its paper binding, and in defiance of the paper shortages that plagued Paris at the end of the war, it is a beautiful object, with elegant gravure plates and a combination of multicolored, innovative graphic design and photography that jumps off the page, even though the book is encased in a modest housing.

The images themselves present an interesting collection of eighteenth- and nineteenth- century luminaries—the monument to the French painter Auguste Raffet, the monument to the universal suffrage activist Alexandre Ledru-Rollin, two images of the French Revolution hero Jean-Paul Marat, one of the mathematician and revolution Girondist the Marquis de Condorcet, one of Claude Chappe (the inventor of the aerial telegraph), and two images of Adolphe Thiers (a prime minister in 1836, 1840, and 1848, opponent of Emperor Napoleon III, and suppressor of the revolutionary Paris Commune of 1871, as

well as president of France from 1873 to 1875). In addition, there are the five images of the alligators surrounding Dalou's *Triumph of the Republic* at the Place de la Nation and several anonymous images.[30] Cocteau's titles are abstracting: "Tambour," "Orphelin," "Botte blanche," "Marat," "Centaure," "Condorcet," "Androgyne," "Enigme," "Jardinier," "Chappe," "L'ours et l'aigle," "Alligators," "Gueles jambes bras," "Homme politique," "Rome capitule," "Soldats de Cléopâtre," "Monsieur Thiers," "Mirages," "Vide," and "Style."

The primary subject of *La mort et les statues* is the loss of French liberty during the German occupation, and the alligators are only some of the book's most poignant symbolic images. Jahan and Cocteau make a powerful statement about liberty in the first three images of the book—a one-two-three punch that enhances the visual leap of these broken sculptures off of the page and into our space. The first plate is of a drummer, crushed by the machinery of other metal in the wrecking yard (see figure

67). We see only a booted foot and leg, and the large drum itself; the rest of the sculpture is hidden by debris and an industrial truck that hauls it away. A workman's head peers above the drum, cunningly providing a disembodied and anatomically impossible reconstructed body. Cocteau suggests that the drum is the still-beating heart of an unnamed French combatant: "This murdered drummer did not know the shock of battle or stakes through his boots. But his drum knew how to defend his flesh and still beats the charge."[31]

The book's second plate, "Orphelin," continues the analogy of an innocent combatant. A winsome sculpture of a young boy sits atop a metal beam, surrounded by disembodied hands, urns, and chains, against an industrial backdrop. His nose is broken (plate 2; figure 68). Cocteau exaggerates his losses in a philosophical lament: "This young orphan of the exodus has not just lost his family and his home. He has lost his époque. On this railway tie he refuses to look at a universe of machines that he cannot comprehend at all. He does not wish for powder or bullets. He has a thorn in his foot."[32] In referring to a lost époque, Cocteau references two intertwined losses—the loss of the French culture that has been swept away by the German occupation, and the loss of the Machine Age of the 1920s, which this young figure can no longer even fathom (it would have been so long ago, before the dark decade of the 1930s, that this metaphorical young boy would not have been born yet). Whether or not this sculpture actually has a thorn, it refers to *Spinario*, or *Il Fedele* (Boy with Thorn), a Hellenistic bronze of about 100 BCE much copied in the Renaissance and after. Not only the pose but the allegorical story depicted are relevant here. The title *Il Fidele* refers to a popular but invented anecdote meant to give the sculpture a civic message: supposedly it commemorated the loyal service of a small boy who ran to deliver a message to the Roman Senate and stopped to pull out a thorn from his foot only after its delivery. Napoleon confiscated this bronze from the Capitoline Museums, and it was later returned to Rome—another reference to the French international exchange of culture and power during wars, though Cocteau may not have meant to carry the analogy as far as this.

The writer, however, was not shy in invoking Roman analogies to refer to the loss of the French Republic. Plate 3 depicts a toppled statue of which we see only a boot and the bottom of the plinth with the word "république" (see figure 60). The foreground is dominated by a disembodied boot rendered white by ash, corrosion, or the patina of age; presumably the rest of this figure has been buried or crushed. In the background, on the rails, we see a blurry sculptural group of workers wrestling a bull, all frozen in place on their bronze plinth. Cocteau's caption returns to Rome: "White boot. Is it a pedestal or a coffin? A Roman soldier guards the rails from which a white boot bears witness to great atomic catastrophes."[33] For Cocteau, catastrophe has a double meaning, the loss of the republic—at the very introduction of the book—and a secondary catastrophe of the atomic bombs, which will be addressed later.

FROM "STATUOMANIA" TO SMELTER

A second major theme of *La mort et les statues* is the fate of the actual statues themselves, which is a much more complicated story than it first appears. These statues are important symbols of the French Republic, but they also carry the loaded shadows of an enormous efflorescence of late nineteenth-century municipal sculpture that was both lauded and reviled as "statuomania." A critic writing for the *Gazette des beaux-arts* in 1974 tells us that Paris had only eleven statues of "great men" in 1870. They multiplied over the next thirty years: thirty-four statues (including Voltaire, Charlemagne, and Jeanne d'Arc) from 1870 to 1890, twenty-three from 1880 to 1890, thirty-four from 1890 to 1900, and fifty-one more from 1900 to 1910.[34] Most of the statues melted down in 1941 and 1942 were these late nineteenth-century additions to the public art of Paris.

In a shift from the Enlightenment ideals of the eighteenth century, these new monuments presented figures who seemed to have an affinity for what historian Daniel Sherman has called "the superior progress of an unshackled, newly free people, in which the talents of the individual reflected the liberty of all, not the glory of a ruler or a dynasty." New monuments were erected to scientists, doctors, composers, philosophers, and French Revolutionary figures such as the Marquis de Condorcet and Jean-Paul Marat, as well as figures from the Third Republic (Léon Gambetta, Victor Hugo, and others). Symbolic homages to the republic included Jules Dalou's *Triumph of the Republic* in the Place de la Nation and Léopold Morice's *République*, among others. Many in the press complained that these new statues were of lesser quality than earlier public art, and "statuomania" was widely ridiculed: the painter Edgar

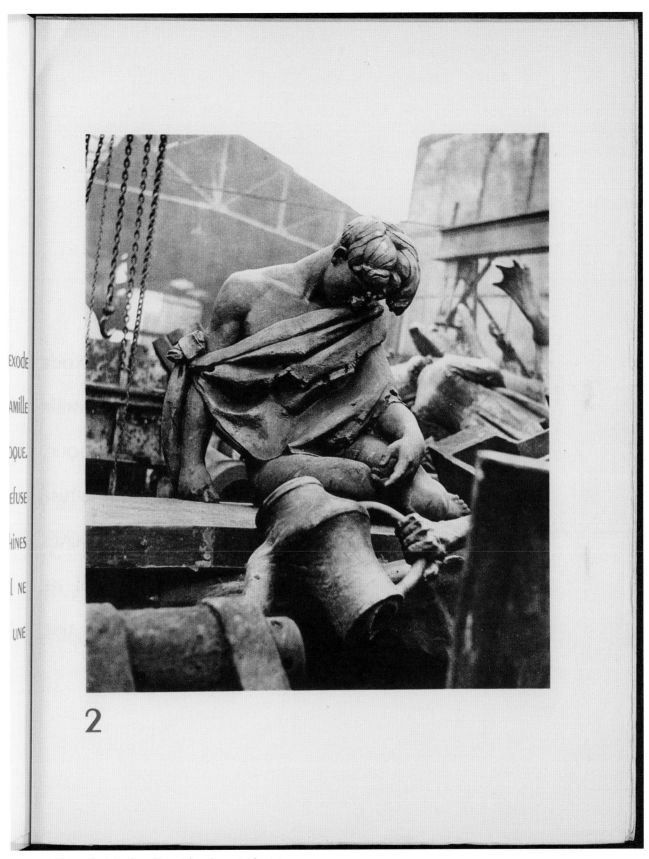

2

FIGURE 68 Plate 2, *Orphelin,* from Pierre Jahan, *La mort et les statues*
(Paris: du Compas, 1946). Gravure, page: 13¼ × 10¼ in. (33.7 × 25.8 cm).

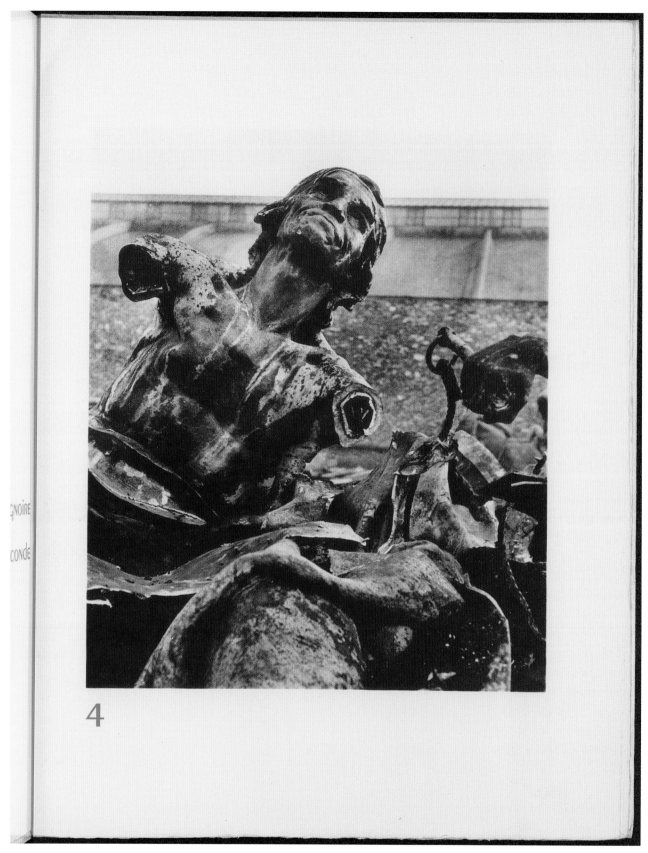

FIGURE 69 Plate 4, *Marat,* from Pierre Jahan, *La mort et les statues* (Paris: du Compas, 1946). Gravure, page: 13¼ × 10¼ in. (33.7 × 25.8 cm).

Degas had written, "We should put iron spikes around the lawns of the squares so that sculptors cannot leave their work there."[35]

Opposition to the statues grew even more after World War I. Therefore, the wartime removal of this statuary was seen in some quarters as a corrective to this exuberance. When the statues were removed, there was relatively little public outcry, even in the pages of *Beaux-arts* magazine, where one critic applauded the actions as a "fortunate coincidence" to rid the city of the statues that "dishonor our public spaces," and another trumpeted, "Sus aux navets!" ("Down with bad art [turnips]!"). The commission established in Paris to determine which statues were to be melted down was seen by the collaborationist press as embodying a "revenge of taste" against the previous century's statuomania.[36] The statues that Jahan photographed, however—perhaps fortuitously because they happened to be in the wrecking yard, or perhaps his deliberate choice among the debris—reflect the symbols of the French Revolution and its first engagement with democratic liberty.

Marat and Condorcet, in particular, represent the revolution and the first instance of republican government in France, whereas Adolphe Thiers represents the previous battle with Germany in the Franco-Prussian War of 1870. Marat appears in plate 4, directly after the introductory images (figure 69). Marat, a radical theorist in the French Revolution's Reign of Terror, was famously murdered in his bath in 1793 by Charlotte Corday, a young Girondist sympathizer. Until 1795 he was viewed nationally as a famous martyr (Le Havre was temporarily renamed Le Havre-de-Marat), but during the French Republic his extreme views were increasingly viewed with suspicion. His fluctuating political fortunes were reflected in the 1883 sculpture by Jean-Eugène Baffier: it was first erected as a monument, then stored away in a warehouse in 1891 by right-wing councilors, then moved to the Parc des Buttes Chaumont in 1906.[37] In Baffier's original sculpture, he sits in a bath with a bronze cloth over his knees; the rendition is more pitiful or comical than Jacques-Louis David's heroic Neoclassicist painting. As the statue was being destroyed, Jahan's photograph renders him heroic again. Marat suffered from a debilitating skin condition and bathed often to soothe his sores; the painter David placed Marat in his bathtub in his famous painting *The Death of Marat*, but replaced his suppurating skin with a smooth, white marbled surface. The Baffier statue follows David's convention of a bathtub, but in Jahan's view his skin is blistered anew, this time by metal corrosion and bird droppings. Jahan frames his image so that he gazes, agonized, at the sky, both arms amputated by the demolition crew so that he truly resembles a *mutilé de guerre*. Here Marat is not only a revolutionary of the terror, but also a symbol of the French Resistance, and of every man who was wounded in battle fighting for France in World War I or World War II. Cocteau's caption clearly reinforces Jahan's interpretation when he writes, "Lying in his bath, Marat meets death a second time." Another facet of the French Revolution is represented in plate 6, in the crushed statue of the Marquis de Condorcet, a politician who spoke against the king but was named a traitor anyway and died in 1794 (figure 70). As a man widely respected in France, his crushed metallic body represents martyrdom not only to the French Revolution, but to the recent battles.

The melting down of French bronze statues in 1941 is popularly blamed on the German occupation, but the

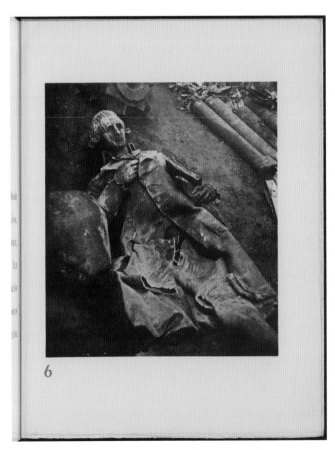

FIGURE 70 Plate 6, *Condorcet,* from Pierre Jahan, *La mort et les statues* (Paris: du Compas, 1946). Gravure, page: 13¼ × 10¼ in. (33.7 × 25.8 cm).

history is more complicated than a simple enemy action. Historian Kirrily Freeman presents one common French view that the Vichy regime "assaulted the memorials to what had become a discredited Republic." Another view (promoted by Maurice Agulhon, among others) is that the Germans themselves promoted the annihilation of these forms as part of the cultural as well as physical invasion of France.[38] In fact, the Germans only destroyed two monuments (upon the first invasion of Paris in 1940), one to Edith Cavell and one to General Charles Mangin, who used colonial troops on the Western Front. France was obliged to deliver raw materials to Germany, but as Pascal Ory writes, "It exercised a particularly subtle form of censorship, eliminating hundreds of republican totems at the same time."[39] Between 1941 and 1944, somewhere between 1,527 and 1,750 statues were destroyed, in two phases—from October 1941 to May 1942, and from summer 1942 to August 1944. French authorities were much more involved and complicit with the actions than the simplistic history of German strong-arm tactics would suggest, and the French administered the removal programs with relative independence.

The melting of the bronzes reflected Vichy's collaboration policies toward the Germans. In August 1941 French Admiral François Darlan (Pétain's second-in-command) wrote of a campaign to capture a source of metal "in the form of monuments and statues in bronze that adorn numerous public spaces." The goal was to find copper, for munitions and navigational equipment. In October 1941 commissions (including the departmental president, a curator, a curator of antiquities, an architectural historian, and the industrial production inspector general) were formed in all French departments, with the job of inventorying the statues.[40]

Parisian monuments, once removed, were sent to yards on the edge of the city. Documents show that they were exported to Germany. One of these was the site that Jahan documented one morning in December 1941.[41] His record constitutes one of the few pictorial records of these events. But, like the entire project of reclamation of metal from municipal monuments, Jahan's photographs have both a historical and a political story. Not surprisingly, they were not published until after the war's end, and they have an equally complicated cultural and political tale to recount, both in their mode of publication and in the presentation of the photographs in the book itself.

La mort et les statues is a contemporary response to the violence done to this collective memory and space. Cocteau and Jahan have, in fact, argued that poetry can honor those spaces where collective and individual memories are mixed. The book does not attempt to present a documentary overview of the events of that day in December, but instead creates a lyric construction that mourns the loss of culture, of soldiers, and of public spaces. The year 1946 was a difficult time for this kind of statement: De Gaulle was briefly in power, attempting to reconstruct a unified notion of nationalism. The ex-Vichy government was busy reinventing itself as republican and French once again, and the French people themselves were violently divided between labels of collaborators and resistance fighters. As a fine-art book, Cocteau's and Jahan's collaboration could hardly have addressed the mass upheavals as France embarked on its postwar republic, but many of these threads were present, and it is important to see it in the context of these warring points of view.

POETRY AND WAR

The expression of war's trauma is a difficult task, and Jahan and Cocteau share a strategy of romanticizing and softening its impact through allegorical and symbolic illusion. As James Anderson Winn writes, "War and poetry are fundamentally different activities. War dismembers bodies, scattering limb from limb. Poetry re-members those bodies and the people who lived in them, making whole in verse what was destroyed on the battlefield." Winn argues that war often attracts poets as an "instance of the sublime," but in this case, as is true for many British World War I poets, the horror of the war comes first, and can only be expressed by the sublime. Cocteau infused the metaphor of poetry into all his wide-ranging output—and *La mort et les statues* is no exception. He called all his works "poetry, poetry of the novel, poetry of the theatre, critical poetry, graphic poetry, cinematographic poetry, and plastic poetry [sculpture]."[42]

Although it has no photographs, another wartime publication mirrors Jahan's and Cocteau's combination of poetry and national memory. In 1941, around the time that Jahan was photographing his mangled statues, the Surrealist poet Paul Éluard penned a poem, supposedly a love story to his wife. He soon renamed it "Liberté" and it became perhaps the best-known French war poem. It begins by visualizing the poet writing the name "Liberté" on his school notebook, on his desk, and on landscape

features such as sand, snow, and trees, and continues for almost two dozen stanzas. After twenty-one stanzas, including "on refuge that crumbles," "on danger dwindling," and "on hope without remembrance," Éluard concludes: "And by the power of a word / My life returns to me / I am born again to know you / And to name you / LIBERTY."[43] An elegiac and poetic cry for liberty in the depths of German oppression, "Liberté" was given a print run of 150,000 copies (in French) and dropped over the French countryside by British Royal Air Force pilots, along with other propaganda and supplies. It may seem ironic that a Surrealist poet's words could become a patriotic battle cry, since the Surrealists railed against bourgeois French life throughout the 1930s, but poetic humanism, both in poetry and in photographs like those in *La mort et les statues,* had become a particularly powerful French language.

SURREALISM

La mort et les statues encompasses many of the issues most central to Surrealism—dream images, found objects, chance encounters, and the uncanny. Brassaï, too, had incorporated these ideas into his imagery for *Paris de nuit*—although he had a closer, if complicated, relationship with André Breton, as has been discussed in the previous chapter. Jahan's tendencies echo the popular reuse of much Surrealist popular imagery in the mainstream press. Jahan found these dismantled statues by chance, so that they are "found objects" encountered in the city—analogous to Breton's finding items in the flea markets and inserting them into his novels. These photographs reflect a "chance encounter" as well.

The lyrical yet subtly violent intertwining of industrial forms and figurative sculptures in a wrecking yard is an almost literal illustration of one of the Surrealists' favorite lines by the Comte de Lautréamont: "As handsome as . . . the chance juxtaposition of a sewing machine and an umbrella on a dissecting table." Jahan's photographs include the gender punning, implicit violence, and odd juxtapositions of Lautréamont's words, and Cocteau certainly thought consciously of them when he penned his responses to the photographs. The Surrealist use of this phrase is commonly linked to sexuality and the Freudian unconscious, but, as Amy Lyford writes, for post–World War I readers it also evoked warfare's grisly memories of young French soldiers who were gassed and lost their limbs in trench warfare. Sewing machines and dissecting

tables also suggest medical and psychological efforts to heal the wounded and reconstruct lost masculinity. In 1946 Jahan and Cocteau reinvoke this imagery for a new world war, perhaps echoing the end of *Les chants de Maldoror,* where, as Lyford reminds us, its tortured protagonist, Maldoror, hung dead from the roof of the Panthéon in Paris.[44] Lautréamont equates his death with the place where France's most famous politicians were buried; Cocteau may have drawn a parallel here too, in lauding the bronze statues that had been maimed, destroyed, and symbolically dismembered.

Hal Foster suggests that the Surrealist "uncanny"—through the marvelous, the use of objective chance, and convulsive beauty—explores the reframing of familiar objects through repression, all of which is very similar to how Jahan's crumpled statues function. They are familiar yet disturbing, recognizable yet destroyed, and the strange juxtapositions of their forms convulse in a metallic death throe. In this way, the mangled figures echo Breton's notion of "convulsive beauty," as implicitly violent and explosive as Man Ray's photograph of an exploding Flamenco dancer at the end of Breton's first Surrealist novel, *Nadja.* Breton ended his novel with the words, "Beauty will be convulsive or it will not be."[45] Although Jahan is not central to the Surrealist group of artists and writers, this book is a work of convulsive beauty.

For instance, there are three separate views of a statue of Adolphe Thiers. A symbol of moderation and resistance to Germany, his busts and his statue had been erected widely through the Third Republic. In plate 17, we see Thiers's statue suspended from crane by a block and tackle, flying over an industrial rooftop (figure 71). The image is a chance encounter of found objects on several levels—his bourgeois, suit-clad, seated figure and his upholstered armchair are rendered in bronze; he seems to be flying through the air like a man in a hot-air balloon's basket; and another unidentified bust seems to be embracing his knees. Cocteau's caption, "In '70, Gambetta left Paris in a captive balloon. Watch the journey of M. Theirs," acknowledges the balloon reference and makes a punning comparison to another statesman, Léon Gambetta, who escaped Paris by balloon in the Franco-Prussian War. In a second image, Thiers is about to be dumped into a morass of tangled bodies as contorted as the Laocoön sculpture, in the midst of industrial metal machine parts (plate 18; figure 72). Cocteau's caption for this image suggests the apocalypse: "All killing machines are dangerous. A bomb

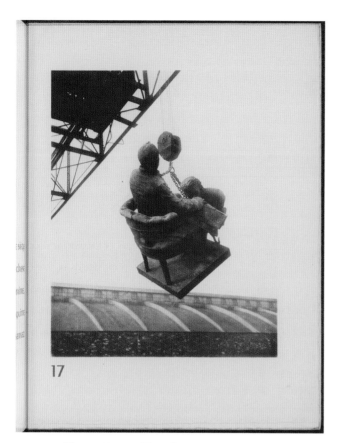

FIGURE 71 Plate 17, *Monsieur Thiers*, from Pierre Jahan, *La mort et les statues* (Paris: du Compas, 1946). Gravure, page: 13¼ × 10¼ in. (33.7 × 25.8 cm).

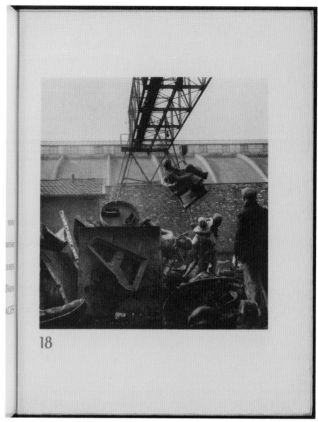

FIGURE 72 Plate 18, *Mirages*, from Pierre Jahan, *La mort et les statues* (Paris: du Compas, 1946). Gravure, page: 13¼ × 10¼ in. (33.7 × 25.8 cm).

from the future can thwart the passage of time and pulverize everything. M. Thiers is the victim of one of these deadly visions."[46] Breton's "convulsive beauty" has become deadly, as it has been in most of the images in this book.

Jahan's photographs also allow Cocteau to explore the notion of the *merveilleux* (fantastic), and in this Cocteau parallels the "social fantastic" of Pierre Mac Orlan and the convulsive beauty of the Surrealists. Street life, with its melted-down statuary, is stranger than the wildest fantasy, and Cocteau's captions honor both the classical forms and the nightmarish configurations that they create in the book. In his work, death is a constant fascination, and the link between life and death is fluid—a trait explored in *La mort et les statues* as well. Cocteau specifically defines the fantastic in terms of film, and the definition applies for Jahan's photographs as well: "The fantastic is very much discussed today. . . . If I had to define it, I would say that it is what separates us from the limitations within which we have to live and that is like fatigue stretching outside of us to the bed of our birth and death." Like Mac Orlan and

Breton, he believes it must arrive by surprise: "The Fantastic and Poetry do not concern me. They must attack me by ambush. My itinerary must not take them into account."[47]

In plate 10, another sculpted figure embodies the Surrealist notion of the fantastic and the chance juxtaposition of images, both denoting impending death (figure 73). In 1792 Claude Chappe invented the semaphore telegraph system that was widely used by Napoleon and throughout Europe. A statue honoring him, by the sculptor E. Damé, was installed in 1893 and stood at the corner of the Boulevard Saint-Germain and Boulevard Raspail, in the middle of the Left Bank. Before its destruction, it was one of the more peculiar sculptures in Paris—depicting Chappe on a Neoclassical plinth with a nymph and presenting the invisible notion of telegraphic communication though his billowing cloak and semaphores waving above his head. He held a telescope. In Jahan's photograph, that is all that remains of his modern machinery; Chappe is seen as a corpse with a wrecking ball about to descend

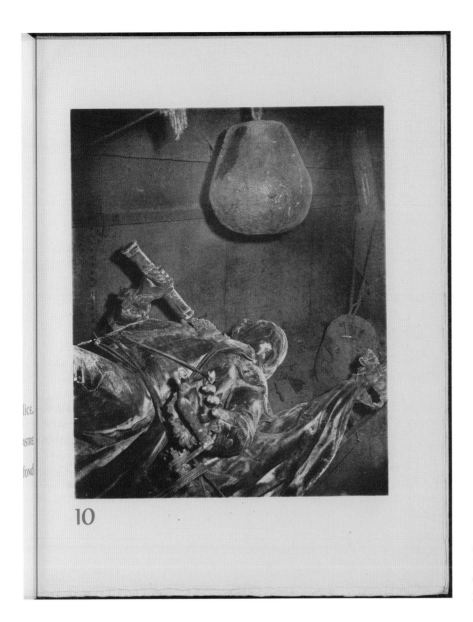

on his head. Cocteau's caption riffs on telegraphic com-
munication and his demise: "Chappe waits for his torture.
With his telescope did he see the metal star that crossed
the centuries to annihilate him?" A 1974 article in the
Gazette des beaux-arts presents the un-mutilated statue,
and in old postcard views we can also see it intact.[48]

Cocteau was not the only one to see a Surrealist
absurdity in this image of Chappe; Jacques-André
Boiffard included this urban sculpture as an example of
the city's most ludicrous monuments in the Surrealist
journal *Documents* (figure 74). In fact, *Documents* pub-
lished an entire series of "the most ridiculous monu-
ments in Paris" with images by photographer Boiffard
and an essay, "Pygmalion et le Sphinx," by Surrealist
poet Robert Desnos.[49] During the Surrealist period in

the 1930s, references to these statues appeared in other
Surrealist publications as well, notably the novels of
André Breton (including a Boiffard photograph of the
statue of Étienne Dolet in *Nadja*), Philippe Soupault's *Les
dernières nuits de Paris*, and Louis Aragon's *Le paysan de
Paris*. All of these writers and artists valued the oneiric
mystery of these statues more than their artistry or their
public commemorations.

TRAUMA

Using a combination of poetic and Surrealist-inspired
visual and verbal language, Jahan's photographs carried a
particularly urgent message in 1945 and 1946. *La mort et les
statues* transcends the particulars of the French loss of lib-
erty and the specifics of the demise of nineteenth-century

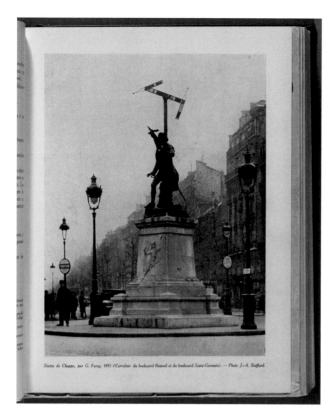

FIGURE 74 Jacques-André Boiffard, *Statue de Chappe*, in Robert Desnos, "Pygmalion et le Sphinx," *Documents* 1 (January 1930), n.p. Page: 10⅝ × 7⅞ in. (27 × 20 cm).

"statuomania" in the smelters to become a more universal lament. Unlike the work of the Surrealists, this is not an ironic imagery of statuary. In remembering or memorializing or honoring trauma, photography holds a special place among the media. As Susan Sontag writes in *Regarding the Pain of Others*, "When it comes to remembering the photograph has the deeper bite. Memory freeze-frames; its basic unit is the single unit." For her, as for many others, Robert Capa's photograph of a falling republican soldier during the Spanish Civil War is the quintessential war image. Deemed an authentic image after a long debate about whether or not it was staged, it captures the moment of a man falling from gunshot, a quintessential expression of the agony of death and the hopelessness of a lost cause. (Franco's armies would all too soon claim victory over the republicans and usher in the longest fascist government in Europe.) Sontag equates the shock value of Capa's photograph with Breton's "convulsive beauty." She also pinpoints why photographers found it such a powerful medium for this purpose, writing, "Their credentials of objectivity were inbuilt. Yet they always had, necessarily, a point of view."[50] Capa's photograph

expresses the universal horror of war as effectively as does Picasso's *Guernica,* painted in *grisaille* (the black and white emulating photographic tonalities) for a mural for the Spanish Pavilion at the Paris 1937 Exposition des Arts et Techniques dans la Vie Moderne—a mere four years before Jahan took his photographs. Like Picasso's mural or Capa's photograph, *La mort et les statues* addresses the universal trauma of war and suffering.

Ulrich Baer attempts to come to terms with this through his writing on photography and trauma. He employs the Greek philosopher Democritus's model of history as "occurring in bursts and explosions" rather than a continuous river, as Heraclitus defined it. Applying this sense of history to move away from a continuous narrative, he reads photographs "from *within* the illusion of an isolated moment." He states clearly that he reads photographs "not as the parceling-out and preservation of time but as an access to another kind of experience that is explosive, instantaneous, distinct—a chance to see in a photograph not narrative, not history, but possibly trauma." Through this method, he argues, photographs can "provide special access to experiences that have remained unremembered yet cannot be forgotten."[51] The Holocaust, of course, is neither unremembered nor forgotten, but the particular images in this book offer a new access to their expression of collective trauma—Baer calls this "explosive," but one could easily read them as a politicized version of Breton's "convulsive beauty."

The first clue of this comes as early as plate 3, with Cocteau's discussion of the white boot of a supposed Roman soldier. Cocteau includes in his caption a reference to a white boot that "bears witness to great atomic catastrophes" (see figure 60).[52] The boot in the foreground appears to be dusted with white ash, as if it had been incinerated. Jahan framed his view with this central boot as a clear reference to the smelting activities in that work yard, but after the war it takes on the shadow of the atomic bomb of the previous year, and, without specifically mentioning it, of the recently photographed and publicized concentration camps, first photographed for the public only in the spring of 1945. The boot doubly signifies the dead French soldier, a metaphor for the loss of the French Republic under Vichy, and also recalls the phrase "under the Nazi boot."

The universal metaphor for war continues. We see two views of a classical youth, whose forever-smiling features in plate 7 are being strangled by a wire garrote—the

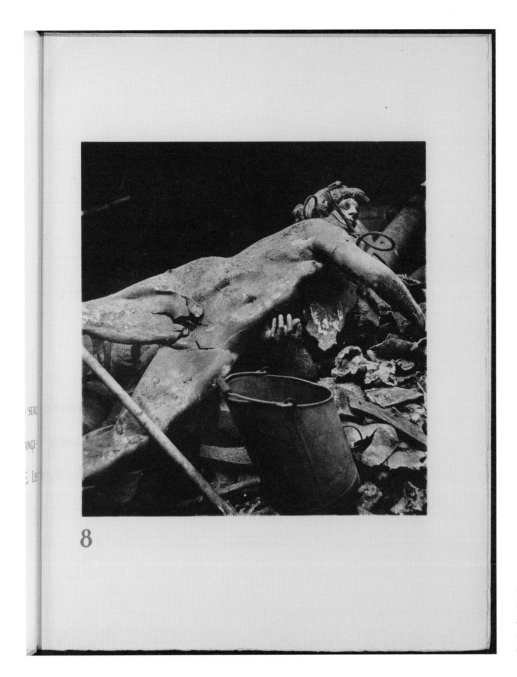

8

FIGURE 75 Plate 8, *Énigme*, from Pierre Jahan, *La mort et les statues* (Paris: du Compas, 1946). Gravure, page: 13¼ × 10¼ in. (33.7 × 25.8 cm).

thick wire rope that might have pulled him down and still encircles his neck. His body is twisted in an impossible angle, and in plate 8 his loins are crushed by a wrecking ball—an image with all the nightmarish symbols of wartime slaughter, torture, and death that anyone might imagine, encapsulating much of the German nightmare. Jahan captures all of this in his image, and Cocteau builds upon the sense of violation in his captions. He writes, "Androgyne. When the police arrive no trace of a rape remains. What was this androgynous youth doing in this mansard? Who had an interest in losing him? In crushing his breasts. His thighs. In disemboweling even his soul?"

In the second image, which Cocteau titles "Énigme," he writes "Signs of conviction—a bucket. A broom. A tool for emptying—adding to the enigma. The research continues" (plate 8; figure 75).[53]

These images comment on being "under the Nazi boot," a common French reference to German occupation that was the title of the 1944 book *À Paris sous la botte des Nazis* about Paris under occupation. This book will be discussed later, but it does include one kind of image absent in *La mort et les statues:* the actual dead bodies of the war, in a two-page spread titled "Le charnier de Romainville" (figure 76).[54] Here, in a press photo by Presse Libération,

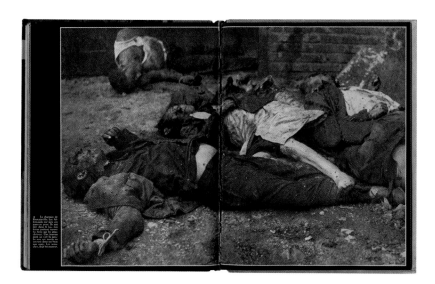

FIGURE 76 Agence Presse Libération, *Le charnier de Romainville*, from Roger Schall, ed., *À Paris sous la botte des Nazis* (Paris: Raymond Schall, 1944), n.p. Gravure, spread: 10⅝ × 17¼ in. (27 × 43.8 cm).

dead bodies covered with flies are strewn on the ground with the same lack of care as Jahan's metal bodies. In contrast, in *La mort et les statues*, the imagery and texts remain metaphorical, not literal.

The final image of *La mort et les statues* returns to this motif of universal postwar anguish. In plate 20 we encounter another disembodied leg and foot, resting on the ground (figure 77). Cocteau's caption encapsulates a metaphorical summing up of war that is not just German atrocity or atomic carnage, but a more universal condemnation. "A Leg. A nude foot. A style. This is all that is left of the kings' feast. Syphilis puts all of this lovely world on the run."[55] Through their complex isolating of events, their poetic eulogizing of grief, and their very French response to the events of World War II, Jahan's photographs operate as "lieux de mémoire," in Pierre Nora's term introduced at the beginning of this chapter.

In these images, *La mort et les statues* clearly presents a more universal lament than the specifics of Paris in 1941. Through its romanticized poetic language, and by deliberately aestheticizing these ruined statues, it is able to make political statements that would be impossible with photographs of real bodies. This, however, raises the question about the aestheticizing of suffering, a topic particularly significant after the Holocaust. Sontag argues that "for the photography of atrocity, people want the weight of witnessing without the taint of artistry, which is equated with insincerity or mere contrivance."[56] She is writing after September 11, 2001, and, as mentioned earlier, a similar philosophy had been articulated by Theodor Adorno after the end of World War II. Any attempt to represent

suffering seemed naïve. In 1966 Adorno amended that idea, writing, "The enduring suffering has as much right to expression as does the tortured man to scream; therefore, it may have been wrong that after Auschwitz poetry could no longer be written." As Liliane Weissberg suggests, "He envisioned an art that would . . . parallel a scream. To save art, Adorno severed its ties with beauty, and introduced instead an aesthetics of pain." Weisberg asks, "Is one permitted to feel aesthetic satisfaction in viewing a work of art about the Holocaust?," but goes on to say that despite Adorno, whose "call for the end of poetry was never heeded, not even by himself," art and poetry are "alive and well."[57] In her book *The Body in Pain*, Elaine Scarry argues that imagination is a tool that can transform the suffering body into a voice.[58] For *La mort et les statues*, the mangled statues such as the disembodied foot in plate 20 become just such an imaginative voice for anguish, although they do not directly comment on individual deaths or atrocities.

Jahan and Cocteau faced exactly this dilemma. Although they did not photograph concentration camps directly, the images taken by Allied photographers in April and May 1945, when soldiers and press corps discovered camp after camp, had burned an indelible memory into the collective unconscious. On one level, the book can be read as an imaginative representation of that suffering, as another layering of meaning on top of the patriotic one and the historical sculpture overview. In Barbie Zelizer's magisterial book, *Holocaust Memory through the Camera's Eye*, she writes about certain collective memories that "vibrate," in a "graphing of the past as it is woven into the

present and future." Photographers who recorded the Allied discoveries of Buchenwald, Bergen-Belsen, and Dachau in April and May 1945 bore witness with their images, and they were disbursed throughout the press, but the question of *how* to bear witness was complicated and changed many of these photographers forever. Many numbed themselves to record the atrocities, but that, too, caused problems. For instance, British photographer George Rodger photographed the women's camp at Bergen-Belsen when it was liberated and discovered to his horror that in his viewfinder he was "subconsciously arranging groups and bodies on the ground into artistic compositions . . . treating this pitiful human flotsam as if

it were some gigantic still-life."[59] He temporarily ceased being a photojournalist.

This brings us back to the question of using beauty to address suffering on a universal or a particular scale. Jahan and Cocteau choose a stand-in for atrocity, and because of that the idea of creating "a gigantic still-life" is not a moral decision but a metaphorical choice. And the images can resonate for us today in a kind of post-memory, a concept that Marianne Hirsch calls "the response of the second generation to the trauma of the first." Its continuing resonance is evoked as post-memory too, not only for children of the Holocaust, but more generally, "linked specifically to cultural or collective trauma."[60]

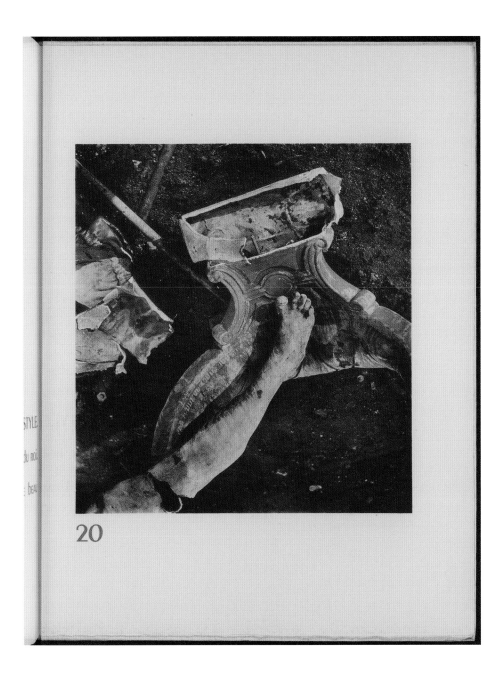

FIGURE 77 Plate 20, *Style*, from Pierre Jahan, *La mort et les statues* (Paris: du Compas, 1946). Gravure, page: 13¼ × 10¼ in. (33.7 × 25.8 cm).

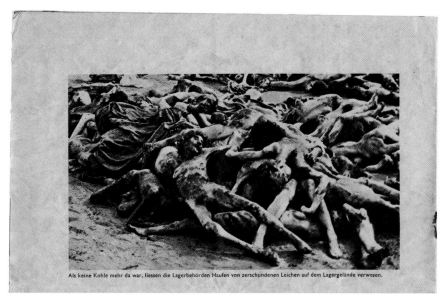

Als keine Kohle mehr da war, liessen die Lagerbehörden Haufen von zerschundenen Leichen auf dem Lagergelände verwesen.

FIGURE 78 U.S. Office of War Information, *Belsen*, from *KZ: Bildbericht aud fünf Konzentrationslagern* (Washington, D.C.: American War Information Unit, 1945), n.p. Page: 8½ × 10½ in. (22 × 27 cm).

ATROCITY PHOTOGRAPHIC BOOKS

After World War I, Ernst Friedrich tried to use photography to express the horrors of that war, following the belief that the shock value of viewing atrocities might prevent their recurrence. Published in 1924, ten years after the war ended, *Krieg dem Kriege!* presents 180 photographs of war atrocities; in addition to trench corpses, its most distressing images are close-up views of soldiers "with huge facial wounds." As Sontag recounts, this book had ten editions by 1930, and many translations, but it did not prevent another war.[61]

Another wartime photography book, *KZ,* is not a French production; it was produced by the American War Information Unit in 1945 and consisted of thirty-two pages with forty-four horrifying photographs of the concentration camps. Produced in 1945, it was meant to force the German population to view the atrocities that had occurred during the war, and showed images from Buchenwald, Belsen, Gardelegen, Nordhausen, and Ohrdruf. The images of corpses and survivors printed in graphic starkness bear eerie analogies to the mangled statues of Jahan. Jahan and Cocteau strove for a metaphoric and poetic commentary on the horrors of war; this is a literal documentary view, designed with a view to maximum political impact. Perhaps no book better illustrates Sontag's comment that "memory freeze-frames" trauma.

In spring 1945, the U.S. Army took these photographs to "bear witness," documenting the German concentration camps in the weeks after the Allies discovered them in spring 1945. As Tessa Hite has discussed, the Office of War Information and Supreme Headquarters Allied Expeditionary Force (SHAEF) gave clear directions to the Signal Corps photographers in commissioning images: they were to present impartial witness documents to the atrocities, and at the same time to avoid any sympathetic imagery of the Germans that might soften German reception of the images.[62] The images that the U.S. Signal Corps took for *KZ* were meant to be immediate propaganda in the days and weeks after the concentration camps were liberated by the Americans and British, in April and May 1945. Éluard's poem had been dropped by the Allies over occupied France several years earlier to boost morale. In contrast, this book—actually more of a leaflet, with its newsprint pages—was dropped by air over the German countryside to "educate" the German population about the horrors they had ignored. The photographs are deliberately un-aesthetic, as are the captions. *KZ*'s caption for a group of human corpses states, "As there was no more coal, the camp authorities let the pile of battered corpses rot on the camp's grounds" (figure 78).[63] Yet even with the newsprint pages and unadorned format, the images sometimes hover on the edge of aestheticism. In this image a pile of skeletons is intertwined in a pile that recalls the mangled alligators or destroyed bronze bodies in Jahan's book. In contrast to Adorno's edict, they are no less horrifyingly effective for that graceful arabesque of forms.

Aside from *KZ,* few immediate postwar books

addressed the atrocities of the war, or even its bloodiest battlefields. These images were widely reproduced in the popular press, a more immediate medium that allowed viewers to bear witness to current events, but they were excluded or otherwise not incorporated into book-length studies. Sharon Sliwinski explores this conundrum of seeing yet not yet comprehending: "How could the Nazi camps be widely photographed, indeed widely *seen* in 1945, yet the significance of these sins and the crime that they embodied take several decades to enter into public discourse and thought?"[64]

In understanding the power of atrocity photographs, the historical starting point is in the 1860s, when Felice A. Beato photographed for the British the ruins at Lucknow after the Indian Mutiny, and China's Taku Forts when the British overran them during the Opium Wars. In

the United States, battlefield photographs of the Civil War first were published in book form when Alexander Gardner published his two-volume *Gardner's Photographic Sketch Book of the War* in 1866, with a total of one hundred images. Only six represented dead bodies, partly due to the difficulties of making, exposing, and developing wet-collodion negatives on the battlefield and partly due to the literal "fog of war"—cannon smoke. The most haunting are *A Harvest of Death* (plate 36; figure 79) and *Field Where General Reynolds Fell, Battlefield of Gettysburg,* both in the first volume. Photographed by Timothy H. O'Sullivan, these two images depict rain-bloated bodies strewn across the battlefield—three days after the end of the battle. Unlike Adorno's dictum to avoid poetry to depict barbarity, these are beautifully composed images, taken from ground level so we view the scene from below the corpses.

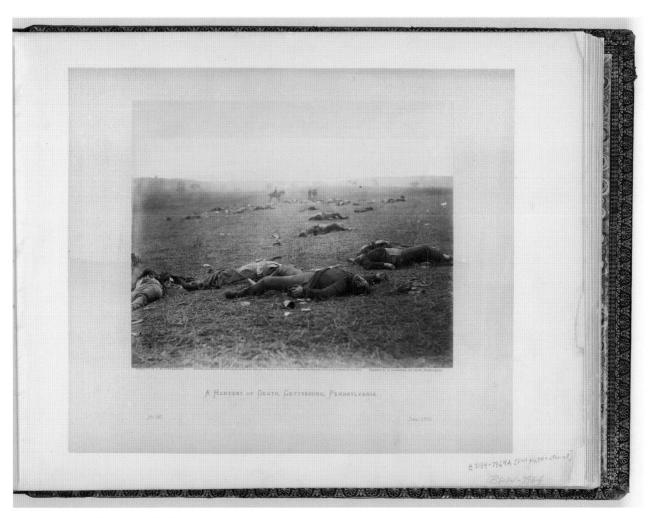

FIGURE 79 Plate 36, Timothy H. O'Sullivan, *A Harvest of Death, Gettysburg, Pennsylvania,* from Alexander Gardner, *Gardner's Photographic Sketch Book of the War* (Washington, D.C.: Philip and Solomons, 1866). Albumen print, page: 12 × 16 in. (30.6 × 42 cm).

The bodies lie in horizontal lines across the barren field, and Gardner's accompanying texts analyze the power of photography of atrocity better than any later critics.

> Slowly, over the misty fields of Gettysburg—as all reluctant to expose their ghastly horrors to the light—came the sunless morn, after the retreat by Lee's broken army. Through the shadowy vapors, it was, indeed, a "harvest of death" that was presented. . . . A battle has often been the subject of elaborate description; but it can be described in one simple word, *devilish!* . . . Such a picture conveys a useful moral: It shows the blank horror and reality of war, in opposition to its pageantry. Here are the dreadful details! Let them aid in preventing another such calamity falling upon the nation.[65]

O'Sullivan's image does indeed show us the "dreadful details," but he also aestheticizes them to make them bearable to view. This book was priced at $150, a huge amount in the nineteenth century. No more than two hundred copies were made, and it was published after the war's end.[66] It was only a modest success, due partly to its inflated price tag and luxury presentation, and partly to its disjunctive storytelling style that moves chronologically from Manassas to Yorktown to Antietam to Gettysburg, but offers only isolated vignettes rather than a narrative overview of the war. For instance, O'Sullivan's famous image, *A Harvest of Death*, is a cinematic shot of bloated Confederate corpses—the result of violence, rather than its heroic justification.

Art historian Anthony Lee argues that the *Sketch Book* is the first photographic book to tell a story of war; rather than an overview, he argues that Gardner "found something in photography's values that could match the disruptive, disjointed, and retrospective experience of war." Lee finds it a clearly modern work—with photographs that were "cleaved, piecemeal, and self-conscious of their means." In a remarkable parallel to the larger issues posed eighty years later by Cocteau and Jahan, Gardner seems to ask, "What is war?," and Lee suggests that Gardner's answer is that the book is "full of digressive and disconnecting musings that spoke to the personal experience."[67] Like those in Gardner's *Sketch Book*, Jahan's images were photographed during the war, but published only afterward. The *Sketch Book* defined the American Civil War visually for generations and continues to this day to be the best-known visual record of that war. Jahan's book is less celebrated, but it, too, compellingly reflects France during World War II.

PIERRE JAHAN'S OTHER WAR PROJECTS

During the occupation, Pierre Jahan made other war-related reportages that were not published then but that are accessible now. There are several groups of World War II images, and they demonstrate the complicated attitudes of people living and surviving in Paris under the occupation, whatever their political sympathies. One group includes six 1941 images of the German occupation, including a silhouette of a German officer at the Palais de Chaillot looking toward the Eiffel Tower, and a handful of images of Pétain supporters, including one image of four men holding handwritten placards reading "Vive," "Pétain," "Et le," and "Pays." Along with an image of a German officer buying lilies of the valley on the first of May, they are more conciliatory toward the Germans than confrontational. A second group of thirty-three images documents the liberation of Paris on August 25, 1944. On his website, Jahan wrote that he was mobilized as a member of the underground press committee on August 20, 1944, and

FIGURE 80 Pierre Jahan, *Devant la Barricade*, from Roger Schall, ed., *À Paris sous la botte des Nazis* (Paris: Raymond Schall, 1944), n.p. Gravure, image: 9 × 8 in. (23 × 20 cm); on page: 10⅝ × 8⅝ in. (27 × 21.7 cm).

FIGURE 81 Pierre Jahan, Return of the *Victory of Samothrace* at the Louvre Museum, after the war, Paris, 1945. Gelatin silver print.

told, "You should go everywhere that there is gunfire; an easy task because there was gunfire on all sides."[68] These images resemble those of Robert Capa in their renditions of pedestrians cringing under sniper fire, Allied troops being welcomed, and some interesting images of the symbolically important but strategically useless barricades being constructed around the city (figure 80), as well as citizens reading the new posters covering the Vichy posters on August 25, 1944, the day of the liberation of Paris.[69]

A final, unpublished project of thirteen Jahan images presents the postwar return of artworks to the Louvre. Jahan recalls that René Huyghe, chief curator of paintings at the Musée du Louvre, called him to tell him of the return of works that had been stored in the provinces for safety. "If I wanted to photograph this event I should get myself to the Louvre's Porte Denon on this day at this time. Of course, I went!" Two images depict the return of Leonardo da Vinci's *Mona Lisa,* and the careful unpacking of her face from the layers of protective cloth is a strong symbol of the care given to the nation's greatest masterpieces during and after the war. Five images show the painstaking return of the *Victory of Samothrace* to her home in the grand staircase of the Louvre, moving from the carefully swaddled sculpture in its crate to its positioning on the staircase (figure 81). In the final image, the interaction of workmen, scaffolding, and sculpture

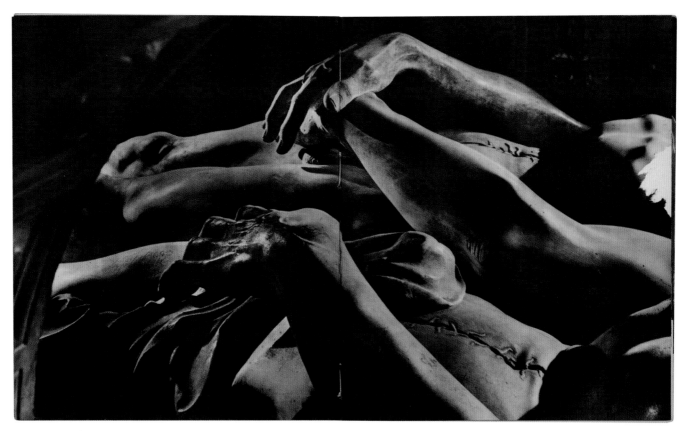

FIGURE 82 Plate XIX, *Louis XII and Anne de Bretagne,* from Pierre Jahan, *Les gisants* (Paris: Paul Morihien, 1949). Gravure, spread: 11 × 18⅞ in. (28 × 48 cm).

allows us to imagine the sculpture flying to its home in the stairwell, in a highly symbolic photograph. Jahan himself underscores this patriotic reading in his autobiography, when he writes, "There is an odd effect of discovering her without wings: with these placed to the side, she truly becomes once again Victory, a symbol of our own recent hard-won victory."[70]

Jahan's photographs of outdoor sculptures being crushed in 1941, for *La mort et les statues,* must be seen in the context of these other wartime projects, and also in connection with his pastoral images of regions of France and various medieval churches during the same period. Most of these bodies of photographs share the multi-layered symbolisms, the complicated politics, and the interspersing of popularized Surrealism and quotidian reportage techniques of the wartime era in France.

Three years after the publication of *La mort et les statues,* Jahan again anthropomorphized figural sculptures in another book, *Les gisants,* on the ecclesiastical tomb sculptures at Abbot Suger's twelfth-century

basilica, Saint-Denis.[71] Coauthored with Jahan's friend Jean-François Noël, and published by Paul Morihien in Paris, it shares with *La mort et les statues* a fascination with three-dimensional forms emulating living historical events. This overview of French royal tomb sculptures is an art-historical text, but it shares some of the formal effects and lifelike portrait techniques of the earlier book. Unlike the treatment in the earlier volume, detailed archaeological and historical notes on each of the twenty-five views are published at the back of the book. The images for this book present eerie views of the tomb sculptures, showing the marks of time on the stone and metalwork. In a detail of *Louis XII and Anne de Bretagne,* we see only hands, arms, knees, and the stitched bodices that resemble autopsy stitching; these sculptures enter a very uncomfortable dream world (plate XIX; figure 82). Even in a more conventional portrait, of the tomb of Isabelle d'Aragon, the stone of her nose is chipped to create a semblance of violence; breaking the stone equals breaking the body. Although these are less overtly political

than the images in *La mort et les statues,* the kings and queens of France are broken symbols of a French nationalism—broken not only by the guillotines of the French Revolution, but by time and by his dreamlike lens.

In his autobiography, *Objectif,* Jahan cites a text that Cocteau wrote for *Les gisants,* but that does not appear in the published volume. In it Cocteau continues his theme of seeing in statuary a kind of Surrealist life, and presents these kings and queens of France in a dreamlike state outside of history: "The dead seem to wander hand in hand on a quiet stream. . . . The royal couple . . . glides, invulnerable to regicides and crimes of jealousy."[72] However, the published preface by Roger Lannes—an author who wrote biographies of Cocteau and the poet Paul Valéry—refers both to Valéry's poetry and to the recent war, rather than to medieval history primarily. He exhorts us to see these funerary sculptures not only as art but also as history, and as symbols of the redemption of the flesh (as opposed to Egyptian mummies with no notion of reincarnation). Lannes's essay for *Les gisants* is firmly placed in the twentieth century with an odd reference to the spiritual depth of these figures, in contrast to what he calls the two extremities of death in the twentieth century: the "atrocious puppet that Lenin became" and the "pulverization and dispersion" of "that other seigneur of the twentieth century: Adolf Hitler."[73] The notion of "les gisants" also plays on the multiple meanings of the word itself; as a noun it means "recumbent statue," but as an adjective it is often used to denote lifelessness, as in the depiction of dead soldiers. These stone figures, in fact, are related to the lifeless metal corpses of Condorcet or Marat in *La mort et les statues;* they, too, are "les gisants."

WOMEN AND WAR BOOKS

Because of the difficulty of publishing during the occupation, few French-sponsored wartime books appeared between June 1940 and the autumn of 1944. Furthermore, to document battles, one had to be outside of occupied Paris. One of the earliest books to appear after the liberation was a short paperback book published by Jacques Haumont, who had been a publisher and colleague of Germaine Krull's before the war. In 1945 Haumont published *La bataille d'Alsace,* a modest paperback book by two war correspondents for SHAEF—Roger Vailland was a war correspondent and Krull, the author of *Métal,* was serving as the photographer attached to the unit (figure 83). Printed on newsprint, it recounts in journalistic prose and

military photographs the bloody battles to retake Alsace in November and December 1944; the overall effect is of an enlarged news story. It is notable, however, for what it omits; in an overview of soldiers' experiences and the slogging advance of the Allied armies, it avoids imagery of the concentration camps and horrors of war, although Krull did see the camps.

In England, Lee Miller, who had previously lived in Paris and studied photography with Man Ray, also made photographs and eventually a book about the war. She had acted as the statue in Cocteau's *Le sang d'un poète* (1930). Cocteau recalled, "The statue was Lee Miller, a friend of Man Ray. She had never been in a film before and has never been in a film since. We saw her again in uniform in 1945." She had returned to England before the war and was a military photographer. As a correspondent for *Vogue,* Miller soon became one of the most active women photographers of the front line and photographed the liberation of Buchenwald and Dachau in searing images that show shocked Allied soldiers confronted with masses of corpses. These images were published in *Vogue* in the spring of 1945. These photographs bear witness, in the most immediate sense, to these events, but, as Sharon Sliwinski writes, "The public bore witness in 1945, but they did not yet know what they had seen." Miller echoes this view, writing to *Vogue,* "I don't take pictures of these things usually as I know you won't use them. . . . I would be very proud of *Vogue* if they would run a picture of some of the ghastliness. . . . I would like *Vogue* to be on record as believing." The immediate popular press could share the news photographs, but these images were certainly not yet intelligible in book form.[74]

Aside from *KZ,* no French or English book recorded the atrocities of the war in these early years. In 1945 Miller published a more contemplative sort of war book, *Wrens in Camera,* a documentary overview of the role of the Women's Royal Naval Service (WRNS). Although the layout and structure of the book are strictly documentary (boat crews in training, signals, orders and observations, housekeepers, supply and demand, technicians, transport, and recreation), starting with the Duchess of Windsor in uniform and ending with a ship's cat, the lengthy, fifteen-page central "technicians" section with thirty-four photographs is one of the fullest documents of women in the war effort (figure 84). Miller planned to include French WRNS in her book, but the publishers refused to wait for the images to arrive before going to press.[75] Its texts are strictly military,

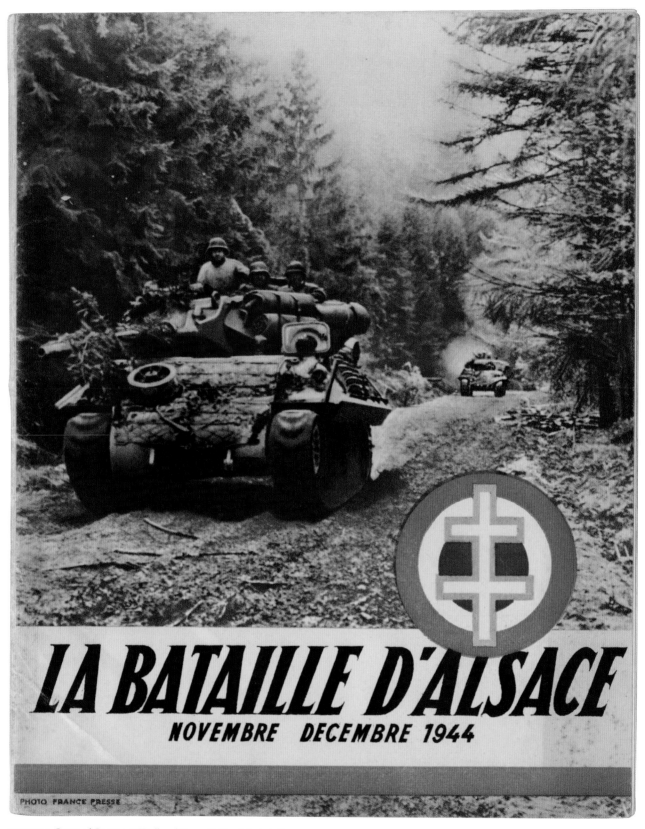

FIGURE 83 Cover of Germaine Krull and Roger Vailland, *La bataille d'Alsace* (Paris: Jacques Haumont, 1945). Gravure, cover: 7⅜ × 5⅞ in. (18.6 × 15 cm).

and its images documentary, demonstrating none of the Surrealist photographic techniques she learned from Man Ray. (Miller discovered the solarization technique, among other things.) Overall, the book remains a straight journalistic enterprise, with none of the poetry, creativity, or complex layering of meanings that are found in *La mort et les statues.* Its relevance is limited as a wartime document, instead of a universal lament.

À PARIS SOUS LA BOTTE DES NAZIS

Perhaps only two other photography books published at the end of the war carry as strong message as *La mort et les statues. KZ* had been almost too horrifying to view and was more conventionally documentary in its approach. The second book, *À Paris sous la botte des Nazis,* was published in fall 1944, two months after the liberation of Paris, with a text by Jean Eparvier and 225 photographs by Roger Schall and others.[76] Jahan contributed three images to this book, a view of citizens hitting the ground under

sniper fire, a view of the still-standing statue of Strasbourg through a hole in a ministry building on the Place de la Concorde, and the previously discussed reconnaissance vehicle stopped by a barricade so its drivers could enter a café (see figure 80). They are just a few of the hundreds of photographs Schall reproduced in this book. Schall, like other photographers, was required to register with the Germans, but hid a number of negatives. He and his brother started working on this book in May 1944, before the liberation, so that it was quickly ready for release in November. In addition to Schall's own photographs, they collected images from other French photographers who had been photographing throughout the war, sometimes innocuous images and sometimes transgressive ones. A best seller in 1944, it went through five editions and at one point it sold one thousand copies a day.[77] With references back to *Paris de nuit* and Schall's own *Paris de jour* (1938), it has a cover with bright-yellow bands highlighting the title, and Schall's striking diagonal composition of the

FIGURE 84 Lee Miller, *Wrens in Camera* (London: Hollis and Carter, 1945), 46–47. Spread: 9¼ × 14 in. (23.6 × 32 cm).

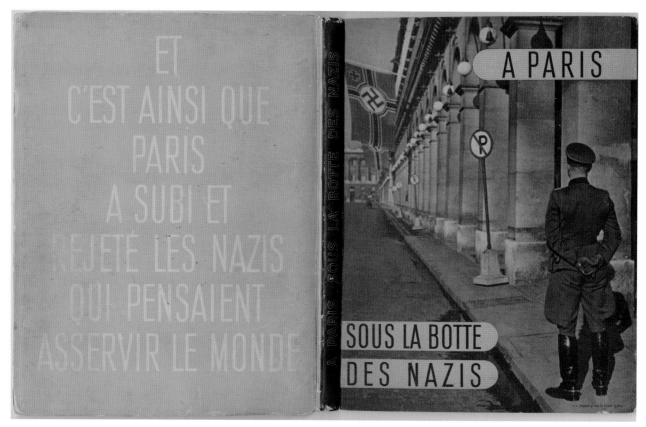

FIGURE 85 Cover and back cover of Roger Schall, ed., *À Paris sous la botte des Nazis* (Paris: Raymond Schall, 1944). Gravure, 10⅝ × 8⅝ in. (27 × 21.7 cm).

Rue de Rivoli with swastikas flying and a German officer looking down the street—an ominous view (figure 85). It was designed by Jean-Louis Babelay. The bright-yellow back of the book states—in large capital letters—"This is how Paris submitted and rejected the Nazis who thought to enslave the world." The inside endpaper presents Marianne's Phrygian helmet symbolizing the French Revolution; it is drawn in white against an orange background, and the colophon opposite echoes the sculptural shape of her helmet, as it states that the work was conceived under Nazi occupation, during the previous "four years of shame," and that design had begun in May 1944.[78]

Eparvier's text follows chronologically from the occupation to the liberation of Paris, and the images begin with German troops marching past the Arc de Triomphe in June 1940 and being paraded, hands up in surrender, by Allied troops in 1944. The images follow the same chronological path. An early photograph in the book, by Roger Parry, shows the statues being collected for smelting—a more pedestrian image than Jahan's—and another marvelously ironic one of four men struggling to load the bronze

"balloon" from the sculpture commemorating the Balloon Corps of the 1871 Siege of Paris (figure 86).

Images of bicycle culture, black market food, and daily life are juxtaposed with page spreads contrasting one Schall photograph of a topless dancer in front of Germans in a bar with another of women rummaging in the gutter for scraps of vegetables from Les Halles. There are similar juxtapositions of Germans holding baguettes and Frenchmen in food lines—a castigating editorial voice by way of the layout and juxtapositions, if not in each individual image. One searing series shows the assassination of French patriots by the Germans; the German who took these images gave them to an Amiens photographer, M. Caron, to develop, and he made doubles of the prints in secret. Another full-page spread shows the carnage in Romainville, where Germans shot a group of people who lie, covered with flies, on the ground (see figure 76). *À Paris sous la botte des Nazis* ends with the liberation of Paris in August 1944, complete with images of celebrations and snipers on the Place de la Concorde. A powerful documentary overview, this book lacks the poetic

FIGURE 86 Roger Parry, *Le ballon des Ternes*, from Roger Schall, ed., *À Paris sous la botte des Nazis* (Paris: Raymond Schall, 1944), n.p. Gravure, image: 3⅛ × 2⅞ in. (7.8 × 7.2 cm); on page: 10⅝ × 8⅝ in. (27 × 21.7 cm).

imagination of Jahan's and Cocteau's work, but it is the most immediate record we have of the occupation in Paris and constructs a powerful myth of resistance—one of the clear origins of the fiction that all French opposed the Germans.[79] This book is one of a group of four post-war photography books published by Raymond Schall, including *Un an* (October 1946), depicting the liberation and European life until October 1945, *Victoires des Français en Italie*, and *Les hommes verts*, a satire against the Germans. *À Paris sous la botte des Nazis* shows the uneasy coexistence between the Germans and French, but in later years its honest assessment was less well received by French audiences. Schall had actively photographed during the German occupation, and even his postwar books did not completely rehabilitate his reputation; he was not included in the postwar exhibitions around Paris.[80] Jahan's *La mort et les statues* avoided this political quagmire, and the poetic yet metallic demeanor of its subjects—rather than flesh-and-blood people—allowed its

popularity to grow over time as a metaphor for the occupation, with reprintings in 1977 and 2008.

POSTWAR WAR ELEGY BOOKS

La mort et les statues and *À Paris sous la botte des Nazis* may have been the best-known photography books to document wartime Paris, but they did not reach a large international audience, either during the war or after its end. They are now known as a part of the photographic book movement, but did not have a critical reception as pronounced as that of Krull's or Brassaï's books. What has endured, in an indirect way, is the concept of creating one of Pierre Nora's lieux de mémoire, or of following Ulrich Baer's concept of a moment in history that resonates, or of creating a poetic elegy to war or trauma, in a general sense.

In the years after the war, universal laments and large issues became increasingly problematic to address in photographic book format; there were too many

immediate crises, which created another kind of book, not under discussion here. But at the time of the American bicentennial, Lee Friedlander published a volume that addressed the larger questions of memory and loss, this time in an American context. He, too, enlisted the words of a poet—in this case, Walt Whitman. In Friedlander's bicentennial book, *The American Monument* (1976), as in *La mort et les statues,* he imbues his monuments with a host of historical, cultural, and moral attributes that stand in for human reactions. Friedlander published *The American Monument* in a fine-art edition published by the Eakins Press Foundation and supported by a grant from the National Endowment for the Arts.[81]

Friedlander cites the lines from Whitman's *Leaves of Grass:* "All doctrines, all politics and civilization, exurge from you; All sculpture and monuments, and anything inscribed anywhere, are tallied in you."[82] Like Jahan, he invokes a poet's voice to give a universal meaning to very particular views. The book has a ledger-like cloth cover and is held together with metal screws, so that the pages can be disbound like Krull's *Métal,* yet reflect an industrial binding device like Brassaï's *Paris de nuit.* These 213 photographs of small, often neglected monuments in small towns show the marks of time and history, albeit in a gentler form than Jahan's tortured metallic statues. The book begins with "Liberty," as does Jahan's, but this time it is a lonely-looking view of "Liberty, with French, Indian, Highlander, and Green Mountain Soldiers, Ticonderoga, New York." Instead of the greatest American monuments such as the Statue of Liberty in New York Harbor, Friedlander honors the smaller, forgotten replicas funded by the Boy Scouts of America in the immediate postwar years of 1949–51, such as one image in Wichita, Kansas, with a cracked set of steps leading to it (plate 201; figure 87).

Friedlander probably did not know Jahan's book, but his volume is close in size to *Gardner's Photographic Sketch Book of the War,* and he knew Paris well and was a great admirer of Eugène Atget's photographs of cracked and worn statuary in Versailles photographed in the first quarter of the twentieth century. Like the interwar French photographers, he used the book format as his greatest creative tool, producing a number of wordless and non-narrative tales.[83] In *Letters from the People,* he reprises Brassaï's *Graffiti* in a series of alphabetized random recordings of the creative graffiti found in his travels around the United States. More importantly, in

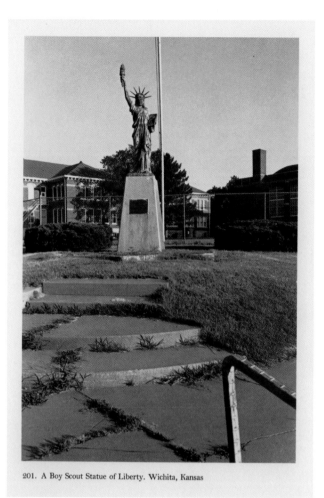

201. A Boy Scout Statue of Liberty. Wichita, Kansas

FIGURE 87 Plate 201, *A Boy Scout Statue of Liberty, Wichita, Kansas,* from Lee Friedlander, *The American Monument* (New York: Eakins, 1976). Image: 6 × 4 in. (15.2 × 10 cm); on sheet: 11½ × 16½ in. (30 × 42 cm).

The American Monument, Friedlander's humorous yet insightful commentary on statues and their frequently awkward afterlives is an intellectual compatriot to *La mort et les statues.* These commemorative statues in small towns were not part of a national outcry about "statuomania," as occurred in France, nor were they melted down for ammunition. But Friedlander shares with Jahan the recuperation of lost monuments that commemorate both lost lives and forgotten cultural icons. Both were published at moments of great stress to national identity: Jahan's book at the start of the Fourth French Republic after World War II, and *The American Monument* born in the tortured intersection of the bicentennial, Watergate, and the end of the Vietnam War in the United States. Both are poetic commentaries on nationalism, patriotism, and their complex identities.

FIGURE 88 *Library of Dust 157* (2005), from David Maisel, *Library of Dust* (San Francisco: Chronicle, 2008). Page: 17 × 13½ in. (43 × 33½ cm).

A more recent elegy can be found in David Maisel's 2008 book *Library of Dust.* In some ways this book is closer to *KZ* than to *La mort et les statues;* it depicts actual remains—the copper canisters holding the unclaimed remains of anonymous mental institution patients who died between 1883 and the 1970s at the Oregon State Insane Asylum. There are 3,500 copper canisters, each corroded in a different way, so that "the vestiges of paper labels with the names of the dead, the etching of the copper, and the intensely hued colors of the blooming minerals combine to individuate the canisters." These canisters are disturbingly beautiful, with hues that recall photographs of Earth from outer space, and the book itself is an oversized, transcendent object (figure 88). Like the subjects in Brassaï's *Paris de nuit,* they float in completely black pages, so that there is no context for human scale. Maisel is quite conscious of the ethical issues of representing trauma and death through extremely beautiful forms; he writes of his concerns about

"the crises of representation that derive from attempts to index or archive the evidence of trauma; the uncanny ability of objects to portray such trauma; and the revelatory possibilities inherent in images of such traumatic disturbances."[84]

Friedlander's and Maisel's books have little direct connection with Jahan's *La mort et les statues,* but they share a universal commentary on loss in a metaphorical language rather than one that is only documentary. They mark the end point in a line of war books that starts with *Gardner's Photographic Sketch Book of the Civil War,* and Jahan's text is an important marker in that progression. It is important both as a universal elegy on loss and as a particular moment in French history, at a turning point in the midtwentieth century. The avant-garde languages of Cubism, Surrealism, and poetic realism would transform yet again in the 1950s, when photographic books exploded in numbers and yet reflected an oddly nostalgic longing for the world that the war had left behind.

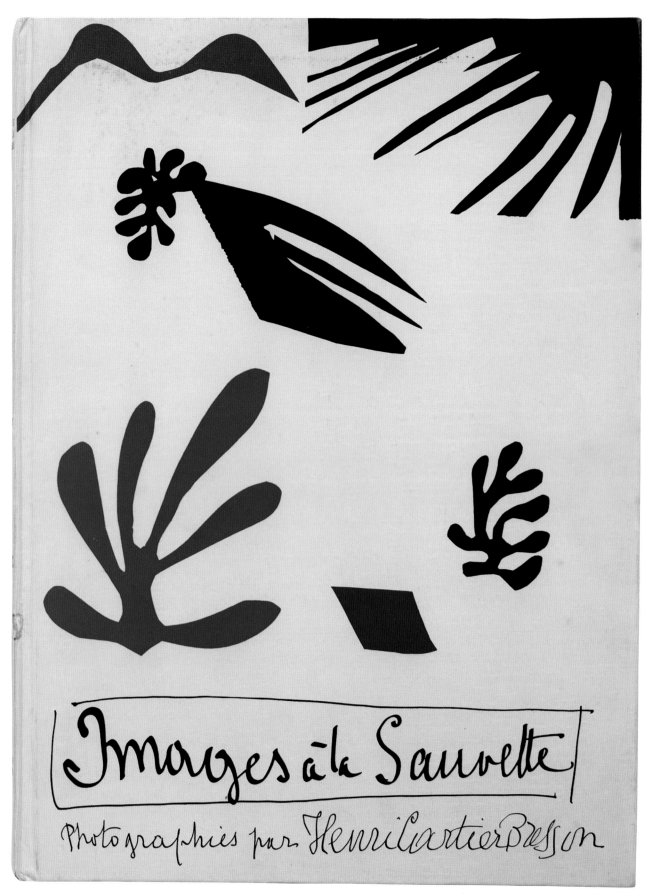

FIGURE 89 Cover by Henri Matisse of Henri Cartier-Bresson, *Images à la sauvette* (Paris: Verve, 1952). Gravure, 14½ × 10¾ in. (37 × 27.4 cm).

4 NOSTALGIA

The Photobooks of Henri Cartier-Bresson

Henri Cartier-Bresson's 1952 book, *Images à la sauvette,* copublished in English as *The Decisive Moment,* is divided into two sections, labeled "Occident" and "Orient" in the American edition (figures 89, 90). The first image of each section encapsulates many of the themes of the book and, by extension, of postwar French photography and culture. Interestingly, Cartier-Bresson's words presented before the first plate both belie and reveal part of the message of the book: "These photographs taken at random by a wandering camera," he writes, "do not in any way attempt to give a general picture of any of the countries in which that camera has been at large."[1] But despite the photographer's assertion, the images *do* give a cultural picture, on many levels, and his term "at large" can be read as a metaphorical reference to an escaped prisoner; Cartier-Bresson had broken free from a German prisoner-of-war camp during World War II, on his third attempt, and was now free to frame the world through the lens of a newly liberated democratic French Republic.

The photographer re-encapsulates democratic Europeanism and also reconceptualizes the term "making strange" for the postwar period. Formally, he consciously moves away from the interwar uses of montage and Surrealism, which he had explored in his work of the 1930s. Culturally, his books reflect the nostalgic humanist affection for quotidian events in a France recently liberated from German occupation. On a larger platform, his books form part of the important cultural work of redefining France in a decade rent by the new independence of its vast colonial empire and the rise of the Cold War. (In 1939 the French empire had numbered about 110 million people; by 1962 it had shrunk to not much more than the 46 million people living in France itself.) Cartier-Bresson's books construct Asia and the rest of the world as a visually framed and contained "other," crafting a Eurocentric view of non-Western governments newly emerging from colonialism into independence or transitioning into communism. This clear division between nostalgia for European mores and a reifying yet beautiful framing of politically transitioning Asian countries is a particularly French approach to the turbulent postwar transition from earlier imperialism to the rise of independence; notably, none of France's soon-to-be-former colonies such as French Indochina, Tunisia, West Africa, and Algeria are included in *Images à la sauvette.* Therefore, Cartier-Bresson is commenting on global changes, as a Magnum agent in Asia,

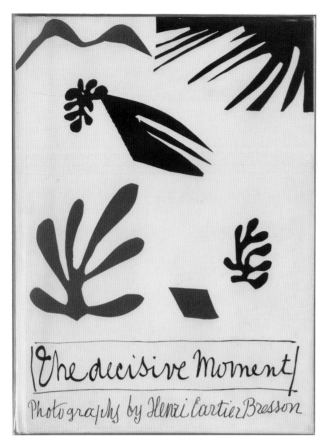

FIGURE 90 Cover by Henri Matisse of Henri Cartier-Bresson, *The Decisive Moment* (New York: Simon and Schuster, 1952). Gravure, 14½ × 10¾ in. (37 × 27.4 cm).

but, by its conspicuous absence in his great book, he is also commenting on the demise of French imperialism. In a decade of crisis for French national identity, the photographer places French culture at the center of the world.

The first image in the book is, indeed, about as quintessentially French as it could be, captioned "Joinville-le-Pont, near Paris, 1938. A bridal pair at a café on the Marne which is part bistro, part garden. The two were here for the entire afternoon with a full wedding party which included uncles, aunts, and small children of the family" (plate 1; figure 91).[2] The viewer is immediately lifted up by the diagonal rise of the bride's swing, her joyous laugh, and the corresponding smile on her groom's face. Against this moment and the freedom of her body in space we sense the solidity of family members in the background. Taken together, the individuality, joy, and communal family structure of this couple reaffirm French independence after the war through the language of French humanist photography, for which Cartier-Bresson is the most prominent spokesman. More than that, the image

displays both his compositional balance and his spontaneity, marking him as a master of photographic style, and the photograph introduces us to the grand themes that Cartier-Bresson will address in this book.

The photograph has a larger cultural meaning, as well. It is aggressively European, as befits the first section of this book, with its concentration on European ("Occidental") culture. By opening with an image from 1938, taken just before the war, he reminds us of the French *liberté, égalité,* and *fraternité* that had been lost during the four years of the occupation, and reinforces the power of its recovery after the war's end and at a time when French colonies were becoming independent. We assume a Catholic ceremony from the bride's white dress, and we participate actively in the scene, almost getting ready to push her back on the swing. In 1938, at the time the photo was taken, this bride did not yet have the right to vote in France, but by the book's 1952 publication, she would have become a full active member of French society (women's suffrage was granted in France in 1944, after the liberation of Paris). The first half of *Images à la sauvette* is all about "us," the European and French "us" that had been under siege during the war and was now liberated to express its freedom and democratic vision. As we will see, the progression of the images in this half of the book continues to explore these themes.

The second half of *Images à la sauvette,* the "Oriental" half, begins with a similar image of two women, but although they are likewise clad in white, these woman are faceless, the photo joyless and static (plate 64; figure 92). Captioned "Western Pakistan, 1948. Two ladies in purdah at a bazaar where war surplus parachutes are being sold for clothing material," the photo frames the women from the back, rendering them doubly faceless by the back view and the fact that they are hidden in head-to-toe coverings. This is opposite in spirit and style to the white wedding gown and appealing, laughing face in the European photo. The Pakistani women are surrounded on either side by long, white lengths of knotted parachute cloth, a wartime material that physically recalls the recent strife. In fact, Cartier-Bresson has framed four "ladies in purdah," two standing and two hanging from hooks in the market. The turbaned market vendor is half-hidden behind the platform; he does not interact with us or with his two female customers, and visually he seems to have four bolts of white cloth for sale, the lines and weight of each dragging downward.

FIGURE 91 Plate 1, *Joinville-le-Pont, near Paris, 1938,* from Henri Cartier-Bresson,
Images à la sauvette (Paris: Verve, 1952). Gravure, page: 14¼ × 10½ in. (36.2 × 26.7 cm).

FIGURE 92 Plate 64, *Western Pakistan, 1948*, from Henri Cartier-Bresson,
Images à la sauvette (Paris: Verve, 1952). Gravure, page: 14¼ × 10½ in.
(36.2 × 26.7 cm).

Importantly, this photo of veiled women reflects as much of Cartier-Bresson's idea of postwar Asia as the Joinville-le-Pont photo captures his view of interwar France, and in doing so, it embraces the many opposites that Cartier-Bresson worked with as a journalist and artist. Like most of the images in the second half of *Images à la sauvette*, the photo was taken after the war and presents Asia as "other"—a continent rendered static, timeless, and completely opposite to European "normalcy." This view persisted despite the fact that his first wife, Ratna, was Javanese, and even as Cartier-Bresson spent years in Asia and acted as the Asian correspondent for Magnum, the photographic agency that he helped found, sympathetically photographing many of the world's conflicts between 1947 and 1952, and publishing many of these reportages in *Life.* He had a front-row seat at many of the changes in Asia, as China became a communist regime in 1949, India achieved democratic independence (and partition with Pakistan) in 1947, and the Soviet Union began to engage in the Cold War with the West around 1949, continuing a repressive regime even after Stalin's death. But *Images à la sauvette* deliberately edits out individuals or formally generalizes the political events Cartier-Bresson depicts, to create a sense of universal "otherness." If Cartier-Bresson's journalism is concerned with the here and now, this second image clearly celebrates an artistic yet equally politicized subject: otherness and stasis. The dialogue between these images constructs a new kind of postwar "making strange"—one that departs from fragmenting montage or detective-clue techniques. Cartier-Bresson is sensitive to his era's reworking of Orientalist tropes at a moment when the settled patterns of European imperialism in Asia and Africa were undergoing profound shifts. Nostalgia here has a more geopolitical meaning than between the wars, and non-European cultures are being visually compressed or otherwise forced into static frames—although French Indochina, Morocco, Algeria, and other French colonies do not appear in Cartier-Bresson's books. Thus, the book embodies a dialogue between several kinds of opposites—not only East and West, but also art and journalism, classicism and instantaneity.

As we will see later in this chapter, Cartier-Bresson did publish monographs on China and Moscow during these years, but they do not seriously challenge the imperialist European view of an Orientalist culture that is crafted in *Images à la sauvette. Images à la sauvette* is one of four books that Cartier-Bresson published between 1952 and 1955—all with multiple editions in several languages. Two of them, *Images à la sauvette* (*The Decisive Moment*) (1952) and *Les Européens* (*The Europeans*) (1955), were clearly presented as monographs. Two others, *D'une Chine à l'autre* (1954) (published as *From One China to the Other* in 1956) and *Moscou vu par Henri Cartier-Bresson* (*The People of Moscow*, 1955), were more topical, dealing with the global upheavals of the 1950s. In some sense, all four must be considered together to understand the impact of *Images à la sauvette*, the most famous of the group. The four books together also show the tensions between prewar formal experimentation and his postwar journalism. Before his imperialist commentary is addressed, however, Cartier-Bresson needs to be understood within the French tradition of humanistic photography.

FRENCH HUMANISTIC POSTWAR PHOTOGRAPHY

After the end of World War II and after four years of German occupation, France held a different political and cultural position than in previous years. Existentialism had replaced prewar nationalist patriotism in the world-view of many French intellectuals, and, in concentrating on quotidian events rather than global tragedies, postwar photography was seen as helping to create a balm for the wounds of recent French history. The result, often called humanistic photography, is both graphically powerful and culturally conservative. Although humanistic photography, with its concentration on the pleasures of daily life, had been a facet of French photography since 1930, and one can possibly include *Paris de nuit* and *La mort et les statues* among the books that reflect it, it took on a particularly resonant and even political role in the postwar period. It offers a nostalgic look back at a moment when Europe was redefining itself and its relationship with the world in the aftermath of World War II, when France's and England's colonies gained independence, and when Soviet, Chinese, and Southeast Asian communism both enticed and repelled European cultural and political thinkers. *Images à la sauvette* reflects on all these larger issues: it is the most renowned product of French humanistic photography.

In her thorough overview of French humanist photography, Marie de Thézy writes that a generation of photographers turned away from the urban, industrial New Vision of the 1920s (the kind epitomized in Krull's *Métal*) and toward a photography based on depicting people "found in the *quartiers populaires*" and showing

the poetic beauty hidden in reality.[3] De Thézy defines the word "humanism" in two ways. First, it is a Western harmonizing and realist concept coming out of Christian and Greco-Roman traditions. Second, these images are not merely human-interest stories, but exude a kind of poetic realism that is found in daily life. For her, Brassaï and Cartier-Bresson are among the best exemplars of this photographic movement, and she includes Édouard Boubat, Pierre Boucher, Marcel Bovis, Denise Colomb, Jean Dieuzaide, Robert Doisneau, Gisèle Freund, Izis (Israël Bidermanas), Pierre Jahan, André Kertész, François Kollar, Germaine Krull, Roger Parry, René-Jacques, Marc Riboud, Willy Ronis, Roger Schall, Emmanuel Sougez, René Zuber, and many others. The lifespan of humanist photography was about thirty years, from 1930 to 1960, when a new generation shifted away from humanistic topics. De Thézy sees Otto Steinert's more formalist Subjective photography movement as the beginning of the change; I would argue instead that two French productions, Robert Frank's and William Klein's book projects, opened the door for an edgier and more jaggedly politicized global photographic language to emerge by the late 1950s.

Most images of humanist photography were made as street views of daily life, especially in Paris. De Thézy recognizes that most of these photographers maintained a certain distance from the people they depicted and gave them "the respect they were owed." The photographers achieved an effect of poetic realism by setting their human subjects in their cultural context, rather than formally isolating details or making bird's-eye views like the photographers of the 1920s. People were photographed at eye level, rather than distorted by New Vision angles. The images present "no low-angle shots, no empty looks, but instead living beings who dream, who look at you, interrogate you, speak with you."[4]

De Thézy devotes an entire chapter of her book on French humanism to photography in print, and to picture magazines including the broadly based *VU* (1928–40) and *Marianne*, the sensationalist *Détective*, and the communist *Regards*.[5] *Match* debuted in 1937 and was resurrected in 1949 as *Paris-Match*. Photographic books were also an important language in disseminating the concept of French humanistic photography, combined with utilizing the power of gravure reproductions. Publishers involved in these endeavors included Claude Arthaud; Robert Delpire, with his collections *Huit, Neuf,* and *Dix;* and the

FIGURE 93 Cover of Willy Ronis, *Belleville-Ménilmontant* (Paris: Arthaud, 1954). Gravure, 10½ × 8¾ in. (26.5 × 22 cm).

Greek publisher Tériade, who brought out *Images à la sauvette*.[6] Many of the French humanist photographers published books, especially in the late 1940s and early 1950s; volumes included Robert Doisneau's *La banlieue de Paris* (1949), Izis's *Paris des rêves* (1950) and *Grand bal du printemps* (1951), and Cartier-Bresson's *Images à la sauvette* (1952). Willy Ronis's *Belleville-Ménilmontant* appeared two years later, in 1954 (figure 93).

Prominent authors contributed texts for many of the projects, though not in *Images à la sauvette*. Poet Blaise Cendrars collaborated with Doisneau, and Jacques Prévert worked with Izis. Pierre Mac Orlan, who had been writing about photography since the late 1920s and championed Germaine Krull, discovered that Willy Ronis's project paralleled his own ideas of the social fantastic. Mac Orlan wrote to Ronis to express his support for his project in 1948 and provided the text for his book *Belleville-Ménilmontant*.[7] Ronis has lucidly explained the links between the poetic realism of postwar humanist photography and the political and cultural situation of the early 1950s, articulating his impetus to photograph daily life with such attention:

This atmosphere of what I would call feeling . . . was not simply due to my character and my sensitivity, it was equally present in the ambience of the moment, since we had rediscovered liberty, and we felt very united. There was no longer the fear that existed during the occupation, of not knowing what your neighbor was thinking . . . and then all of a sudden [after the liberation] there was a free press, the occupation forces were gone, it was over and we were all together again. Naturally other problems came up, but they were not problems resulting from war and occupation. That changed everything.

Rather than whitewash his era, Ronis acknowledges that there were plenty of problems that arose after the war. In that light, the cultural situation in France during these years must be understood clearly. About 1.7 million prisoners returned from Germany from 1945 onward, and 1 million people left farm work for the cities in the decade after the war. The city of Paris, however, remained a collection of small neighborhoods, although these were in danger of extinction. Ronis explores one such neighborhood, Belleville-Ménilmontant, a part of northeastern, working-class Paris in the twentieth arrondissement near the Parc des Buttes-Chaumont and Cimetière du Père Lachaise. He said: "I can't remember if I thought that the *quartier* would disappear as soon as it did, but so much of Paris was changing in this period (1947–50) that I wanted to record this way of life before it went forever."[8] This sense of nostalgia for a vanishing French lifestyle marks much of French humanist photography.

ROBERT DOISNEAU'S *LA BANLIEUE DE PARIS*

A more complicated, more ambivalent, and edgier version of humanistic photography can be seen in Robert Doisneau's and Blaise Cendrars's 1949 book, *La banlieue de Paris*.[9] Rather than concentrate on one neighborhood, as Ronis does in his 1954 book on Belleville, Doisneau looks at the positive and negative aspects of all the suburbs of Paris, examining a subject that was consistently overlooked in the French obsession with Paris as the center of all culture. Doisneau celebrates the particular and the quotidian, and the words and images of this book combine to break with the central tenets of poetic humanism, harkening back to the more transgressive points of view of Brassaï's *Paris de nuit* discussed in Chapter 2.

Paris de nuit, in fact, made an indelible impression on Doisneau early in his life. Born in 1912, Doisneau grew up in Gentilly, a southern suburb bordering the thirteenth and fourteenth arrondissements, flanked by Montrouge and Ivry-sur-Seine. As a child he played in the *zone,* the semirural no-man's land between Gentilly and Paris, both of which became long-term topics for his camera. After absorbing Brassaï's *Paris de nuit*, Doisneau wandered throughout the popular working classes of Paris, taking photographs in the early 1930s. In the decades that followed, Doisneau was driven by his communist politics as well as his wish to depict the conditions in the suburbs and to honor those who lived and worked there. As Peter Hamilton has written, Doisneau made New Vision photographs at the very beginning of his career, humanist social realist photographs in the 1940s and 1950s, and montage in the 1960s. He depicted what he saw as the false oppositions in French culture.[10]

The cover of *La banlieue de Paris* makes evident Doisneau's interest in the working classes, exhibited here as a long, zigzagging line of small workers in the "zone," silhouetted against the anonymous apartment buildings of the suburbs, with the Eiffel Tower looming ominously in the background (figure 94)—a far cry from the

FIGURE 94 Cover of Robert Doisneau, *La banlieue de Paris* (Paris: Seghers/La Guilde du Livre, 1949). Gravure, 9¼ × 7 in. (23.3 × 17.2 cm). National Gallery of Art Library, Washington, D.C., David K. E. Bruce Fund.

FIGURE 95 Plate 1, *Gosses,* from Robert Doisneau, *La banlieue de Paris* (Paris: Seghers/La Guilde du Livre, 1949). Gravure, page: 9¼ × 7 in. (23.3 × 17.2 cm).

exuberance of Germaine Krull's dancing tower fragments. In *La banlieue de Paris,* Doisneau's photographs present different categories of street life—children, love, décors, Sundays, leisure, work, "terminus," and habitations. Each image has slightly more bite than Cartier-Bresson's more timeless imagery, and Doisneau's compositions are more contingent than Cartier-Bresson's classical framing. Doisneau's book begins with an image of a young boy from Aubervilliers jumping above the rubble of the "zone" (plate 1; figure 95), in a much rougher and more active moment than the small boy whose portrait ends Cartier-Bresson's *Les Européens* (plate 114; figure 96). In the section "Amour," there are several wedding scenes, all more immediate and less balanced than Cartier-Bresson's opening image for *Images à la sauvette* (see figure 91). On one page, Doisneau juxtaposes a photo of a girl screaming with laughter on a seesaw with an industrial scene

spewing steam or smoke (plate 28; figure 97). Her gleeful smile and widespread legs suggest a less proper and more immediate view than do the sweet smiles of Cartier-Bresson's couple. In contrast to Cartier-Bresson, who never staged his photographs, but similarly to Brassaï, who often did, Doisneau would set up scenes if he wanted a certain point of view, trying to "suggest deeper truths about ordinary life than would have been possible through a purely documentary approach." The image *Wedding in the Bistro* is one such case (plate 21; figure 98). The bride and groom were models from the Joinville film studios, although the dirt-encrusted coal worker next to them walked in by accident.[11]

Even in his images of work, Doisneau is more biting: on one page, he juxtaposes two gas workers in an Aubervilliers factory with two men taking a lunch break outside the Renault factory (Doisneau had worked for

FIGURE 96 Plate 114, *Paris, rue Mouffetard,* from Henri Cartier-Bresson, *Les Européens* (Paris: Verve, 1955). Gravure, page: 14¼ × 10½ in. (36.2 × 26.7 cm).

28

FIGURE 97 Plates 28 and 29, *Bride* and *Décors,* from Robert Doisneau,
La banlieue de Paris (Paris: Seghers/La Guilde du Livre, 1949).
Gravure, page: 9¼ × 7 in. (23.3 × 17.2 cm).

DÉCORS

FIGURE 98 Plate 21, *Wedding in the Bistro—Montrouge*, from Robert Doisneau, *La banlieue de Paris* (Paris: Seghers/La Guilde du Livre, 1949). Gravure, page: 9¼ × 7 in. (23.3 × 17.2 cm).

Renault in 1934 at the beginning of his career) (plates 106 and 107; figure 99). Their indolent poses, as they lie against a bulkhead with cigarettes in hand, suggest a pictorial parallel to being on strike, and this is reinforced by the caption, "The proletariat of the Red Belt is the proudest in the world. After a snack." In the last image of the book, in the section titled "Habitations," Doisneau shows a harried-looking family passing a small grocery store on their way home. The mother pulls a small boy by the hand, and the husband walking in the gutter beside her looks hunched and shrunken. This image, too, is a marked contrast to Cartier-Bresson's gleeful boy with his bottles of wine in the last image of *Les Européens* (see figure 96).

La banlieue de Paris is a true collaboration between Doisneau and Cendrars, who was a close friend of Fernand Léger and traveled widely, writing a mix of realism and imaginary prose he called "Utopie-land."[12] A master of simultaneous poetry in his early years, Cendrars had published the 1913 *Prose du Transsibérien et de la petite Jehanne de France* in collaboration with the Cubist artist Sonia Delaunay-Terk (see figure 20), and just after World War II he published a new book, *L'homme foudroyé*. Doisneau, whose active duty in the army had been curtailed by weak lungs, met Cendrars in 1945, soon after this book came out. Doisneau photographed the writer in Aix-en-Provence, and they quickly became friends. The author inscribed a copy of his novel, "To my friend Doisneau, photographer, *Zone*-dweller, man of the Beauce, who will

FIGURE 99 Plates 106 and 107, *Le gaz de Paris* and *The Proletariat of the Red Belt, after a Snack*, from Robert Doisneau, *La banlieue de Paris* (Paris: Seghers/La Guilde du Livre, 1949). Gravure, page: 9¼ × 7 in. (23.3 × 17.2 cm).

find his Kremlin-Bicêtre and Notre-Dame of Chartres as he turns some pages—and who is the first to whom I write a dedication in a copy of *L'homme foudroyé*."[13] Doisneau returned to his *banlieue* photographs with fresh enthusiasm after reading the book.

Doisneau and Cendrars wrote to each other extensively from 1945 to 1949 as they prepared *La banlieue de Paris*. Cendrars deeply admired Doisneau's photographs and thought they demonstrated the intellectual and material poverty of the suburbs.[14] Cendrars chose the images and sequencing of the 130 photographs that were included in the book and wrote the captions. That text, collected at the front of the book before the images, is divided by the points of the compass: "Sud," "Ouest," "Est," and "Nord." In "Sud," Doisneau's home turf of minor trades and market gardens by the Bièvre River, Cendrars refers directly to Mac Orlan's theories of photography. In describing the *habitations à bon marché* that replaced the demolished

"sinister" fortifications, he had hoped for (in capital letters): "This dream of a sudden opulence transforming the décor of the suburb into a social fantastic." But that dream failed, and Cendrars continues, "Can one imagine anything more disheartening than these apartments of two or three rooms surrounded up to the seventh floor by dozens of doors on endless corridors," continuing that almost nothing seems French in these *îlots,* and that there is "so much ugliness!"[15]

Cendrars notes the wealthier western suburbs with their trains and the working-class eastern suburbs, repeating four times (again in caps), "Long live the paid vacations of August that empty out the workshops!" while describing the camping and picnic expeditions fanning out from the city. He reserves his most vivid prose for the industrial northern suburbs with their large factories, "Drancy, Bobigny, Pantin, La Courneuve, Aubervilliers, Saint-Ouen, Clichy, Gennevilliers," that he describes as "black suburbs

that know only one day of joy each year." Referring to the communist enclaves of Saint-Denis and other northern suburbs through the stories of a *banlieusard,* he draws parallels to the misery of other international cities: London's underworld, New York's Bowery, San Francisco's Chinatown, Los Angeles's Watts, Shanghai's moving suburbs (very topical in the year China became communist), and Moscow, with its abandoned children.[16] In contrast to the more positive poetic realism of other French humanist writers and photographers, Cendrars and Doisneau paint a grimmer picture.

The thinking behind the final product is further revealed by the men's writings to each other. Doisneau writes of his collaborator, "Cendrars said that his vision was darker than mine—he explained, in his own way that to make images you require some light, while he could work in the dark. He also spoke about his social convictions. He imagined me to be a militant communist. To him a factory was a place you got away from as soon as possible." They worked together closely, although they never went out in the streets together. Cendrars pushed Doisneau to include more geographically distributed suburbs than the photographer's own southern banlieue. Doisneau, in turn, felt that Cendrars validated his transgressive vision of the city: "What Cendrars liked about my photos of the banlieue was that they were antiacademic. . . . I tried to disobey, to invent my own rules of the game, and it was perhaps that which Cendrars sensed from our first encounter." Cendrars appreciated the images, finding what Doisneau termed "a sort of popular dynamism," whereas most viewers just saw what the photographer called "picturesque *misérabilisme.*"[17] He did not want to show poverty, but instead the life on the street, but many viewers did not get beyond the poverty.

The writer and photographer had hoped to have Cendrars's publisher, Denoël, produce their joint project, although Cendrars also suggested Charles Peignot, the producer of *Paris de nuit,* if the first publisher should fall through. In the end, the book was copublished by the press of poet Pierre Seghers and the Lausanne Guilde du Livre. Doisneau never saw the layout; Seghers was more concerned with honoring Cendrars. The 140-page *La banlieue de Paris,* measuring 9¼ by 7 inches, was published in an edition of 4,300 copies by Seghers in Paris and the Guilde du Livre in Switzerland.[18] It did not sell well in Paris, and most purchasers were attracted by Cendrars rather than Doisneau. The book's lack of popularity may stem from

its slightly ambivalent or conflicted point of view, or from its addressing issues that were uncomfortable to think about and difficult to sell in 1949, though they would gain traction by the late 1950s. Doisneau and Cendrars were perhaps both behind and ahead of their time: their gritty vision had been championed successfully by Brassaï in the 1930s and would become a powerful photographic language by the end of the 1950s, when a rougher and more ironic view of the city became more valued.

For the next several decades, Doisneau would continue to work for Raymond Grosset's Parisian RAPHO agency, which he had joined in 1946.[19] In expressing how RAPHO was a better fit for him than Cartier-Bresson's Magnum, where Maria Eisner had asked him to come aboard, Doisneau wrote, "Chance played its hand well, because I would have been a bit overwhelmed at Magnum. They sent you on big assignments—India, China, etc. I don't like traveling, I only speak one language, and I photograph best people who are most like me. It's a sort of transposition of my personality into theirs." Or as Cartier-Bresson remembered, Doisneau told him, "If I were to leave Montrouge, I would be lost."[20] This statement sheds light on what makes Doisneau such an incisive commentator on his own local world, in contrast to Cartier-Bresson's more international vision. As a young Frenchman, Cartier-Bresson had traveled more widely than some of his colleagues, including Doisneau, and his prewar work demonstrates these travels—a humanistic photography response not only to Paris, but to a wide variety of places ranging from Spain to Mexico and the United States. Cartier-Bresson's experiences and his membership in the newly formed Magnum agency extend his French humanistic photography to an international arena, but also reflect the complicated postwar discourse about European culture and colonialist attitudes toward the rest of the world, especially as he traveled to the Soviet Union, China, and India in the years after World War II.[21] His work, unlike that of colleagues such as Ronis and Doisneau, helps to craft a conservative French response to geopolitical events such as the rise of communism and the independence of previous colonies.

CARTIER-BRESSON AT THE MUSEUM OF MODERN ART, 1947

Cartier-Bresson enjoyed a wide international reputation that many of his French colleagues lacked. Early in his career, in 1933, he had had a one-man show at New York's Julien Levy Gallery, and in 1946 the Museum of Modern

Art (MoMA) began planning a monographic exhibition of his work. (His first one-man show in France was not until 1955.)[22] Much has been written about Cartier-Bresson's early Surrealist-inspired images, although he published only twice in the context of the movement, once in André Breton's *L'amour fou* (1937) and once in Julien Levy's 1936 New York book on Surrealism. Although Peter Galassi and Ian Walker have written about Cartier-Bresson's links to Surrealism, and Walker parses the differences between Breton's "objective chance" and the "decisive moment," by the 1940s Cartier-Bresson was moving away from this early work or recontextualizing it in a new manner.[23] Cartier-Bresson brought to New York a scrapbook he had assembled that included photographs dating from 1932 onward to enable photography historian and MoMA librarian Beaumont Newhall to choose images for the show. Included in the scrapbook were 346 prints from among his single images and liberation work, the meaning and structure of which Agnès Sire and Michel Frizot have carefully analyzed. Not only did the scrapbook provide the raw material for the show and catalogue, but it is our first indication of how Cartier-Bresson might structure a book, even though these images were probably constructed "chronologically rather than formally." His inclination was to pare down quantity for quality, although the picture magazines he worked for often demanded groups.[24]

Cartier-Bresson's one-man show at MoMA opened on February 4, 1947; other French photographers such as Brassaï, Doisneau, Ronis, and Izis were not exhibited at MoMA until a group show of five French photographers in 1951.[25] Its catalogue, created by Newhall with writer Lincoln Kirstein, serves as a precursor to *Images à la sauvette*: it shows Cartier-Bresson's development and gives us important clues on how his work was negotiating the intersections between photo-reportage and art. Kirstein, who had written the seminal text for Walker Evans's *American Photographs* at MoMA in 1938, explicitly places Cartier-Bresson in the company of an international collection of humanistic photographers that includes not only Europeans such as Brassaï, Bill Brandt, and Robert Doisneau, but also the American photographers Walker Evans, Helen Levitt, Ben Shahn, and (surprisingly) Weegee. Kirstein's essay, "Henri Cartier-Bresson: Documentary Humanist," notes that several of the photographers, notably Cartier-Bresson, Evans, and Brassaï, are painters or draftsmen.[26] Kirstein differentiates Cartier-Bresson from

news photographers because of his concentration on quotidian life rather than politically significant events, drawing a demarcation line between his images and the work of Cartier-Bresson's soon-to-be-partner at Magnum, Robert Capa. This exhibition marks a turning point away from the edgy or contentious images that had had their day in the 1930s and would be powerful cultural comments again in the 1960s. In the late 1940s and early 1950s, however, nostalgia, sentimentality, quotidian events, and human interactions were of supreme importance, bringing a sense of normalcy to those who had suffered through the war.

Indeed, Kirstein and Newhall had originally planned this show as a memorial for Cartier-Bresson when the New York curators thought he had died in a German prisoner-of-war camp, and war's shadow is ever present. In his essay, Kirstein recounts Cartier-Bresson's thirty-five months in prisoner-of-war camps and his escape on his third try, and draws a parallel: "Many American soldiers recall (how faintly now) that rapture of freedom and friendship in overrunning the prison camps for forced workers, prisoners of war, deportees and hostages." Kirstein concentrates on release, not on torture or imprisonment, and presents Cartier-Bresson as an exemplar of this point of view: "Cartier-Bresson, who had been one of them, took their pictures and followed them home, all the interminable way, to the huge centers of repatriation in the vast deserted railway-sheds, and then finally back to their own farms and foyers."[27] In this last phrase lies a clue to Cartier-Bresson's main subject: he is investigating the humanity and home life that had been so nearly extinguished in Nazi Germany and also by American atomic bombs in Japan. In 1947 celebrations of individuality and the simple triumphs of daily life were no small thing, and it is in this context that we must understand French "humanistic photography."

The 1947 MoMA exhibition was itself constructed as an implicit commentary on the recently ended war, but it was less of a national statement of mourning or politics than *La mort et les statues* or *À Paris sous la botte des Nazis*. The photographs are not specifically of war-torn Europe; instead, Newhall and Cartier-Bresson chose images to construct a symbolic commentary on the past seven years. The catalogue begins with two famous 1933 images from Spain: a Valencia child with his eyes shut, playing along a black wall, and a group of boys chasing another child on crutches through a gaping hole in a rubble wall in Seville

FIGURE 100 Plates 12–15, *Valencia, Seville, Madrid,* and *Spanish Morocco,* 1933, from Henri Cartier-Bresson, *Images à la sauvette* (Paris: Verve, 1952). Gravure, page: 14¼ × 10½ in. (36.2 × 26.7 cm).

(both were displayed in large format in the exhibition itself). In 1933, when the pictures were made as formal experiments, the Spanish Civil War (the first instance of fascist military victory in interwar Europe) was still three years away, and World War II was far in the future, but through their inclusion in the 1947 show these images are shadowed by the darkness of recent events. Newhall's choice to begin the 1947 book with these two photographs and to reinvest them with political meaning is no accident. Kirstein explicitly writes: "[Cartier-Bresson's] early shot of children playing in ruins of plaster walls whose holes seem torn out of the paper on which they are printed was prophecy of an imminent decade of disaster. No image since has provided such a powerful report of fused innocence and destruction."[28] These two images would be reproduced once again in *Images à la sauvette,* but their importance is minimized: they are small, quarter-page reproductions well into the body of the book, not the first images, as in the MoMA catalogue (plates 12 and 13; figure 100).

Many images in the MoMA catalogue make more

veiled references to strife; the photos are not obviously connected to a particular historic moment, but evince a general sense of unease. An early Valencia photograph at a bullfight—with a youth exiting a door, a large bull's eye, and an image of a military figure with a monocle—suggests surveillance, or perhaps even World War II spying. A longer series of Mexican and Italian pictures from 1934, reproducing unsettling images of children and seldom reproduced in later books, makes clear metaphorical (if historically anachronistic) reference to refugees, poverty, and hardship. One image on page 27 shows a display of six children's coffins, and plate 29 depicts a small boy in Salerno who stands directly in a cannon's firing line. There are some photographs that demonstrate the height of the "decisive moment," such as the man leaping the puddle at the Gare Saint-Lazare (plate 26; figure 101). Cartier-Bresson's formal picture-making strategies became a public fascination for viewers responding to these uneasy images: *Life* even published an article analyzing his compositions of the Gare Saint-Lazare and boys in Valencia.[29]

FIGURE 101 Plates 26 and 27, *Place de l'Europe, 1932* and *Allée du Prado, Marseille, 1932*, from Henri Cartier-Bresson, *Images à la sauvette* (Paris: Verve, 1952). Gravure, page: 14¼ × 10½ in. (36.2 × 26.7 cm).

But for the most part, the MoMA catalogue presents Cartier-Bresson as a humanist photojournalist, one who comments on politically historical events only through the universal human reactions to them. For instance, there are five consecutive photographs of the coronation of King George. Cartier-Bresson's concentration on the audience, as he turns his back on the main event, is consistent with the humanistic photographic project to celebrate individuality rather than political ceremony. There is also a series of prisoner-of-war repatriation images (plate 34; figure 102), related to his recent film *Le retour,* and the famous single image "exposing a stool-pigeon in a displaced persons camp" in Dessau in 1945—also an important sequence in *Le retour.*[30] Even when the MoMA catalogue turns to New Orleans and to Spain again, there is a concentration on poverty and on children; both become universal metaphors for recent events. A pivot point in the catalogue is the 1938 Parisian image of Cardinal Pacelli with a man kissing his hand. Pacelli became Pope Pius XII in 1939 and oversaw a network that saved eight hundred thousand Jews. Although he was later criticized for not

doing more, at this moment just after the war's end he was highly regarded for his efforts, and this image pivots between prewar and postwar; all 1947 viewers would have recognized the pope, even though we view only the side and back of his head. The MoMA catalogue ends with a series of French intellectual luminaries, beginning with physicists Pierre and Marie Curie and the philosopher Jean-Paul Sartre (who would go on to write the introduction for Cartier-Bresson's 1954 book *D'une Chine à l'autre*) and ending with a series of painters, as if to reaffirm that French culture and art were still alive and vibrant even after the years of occupation.

The clear contextual aim of the MoMA show has been almost erased by later scholarship that concentrates on the photographer's individual images. The show made Cartier-Bresson into an internationally famous artist-photographer, even as he formed the Magnum picture agency at that exact moment (discussions for Magnum's organization occurred at MoMA). In an essay on Cartier-Bresson's MoMA show in the *New York Times* on February 2, 1947, Kirstein elaborates on the division

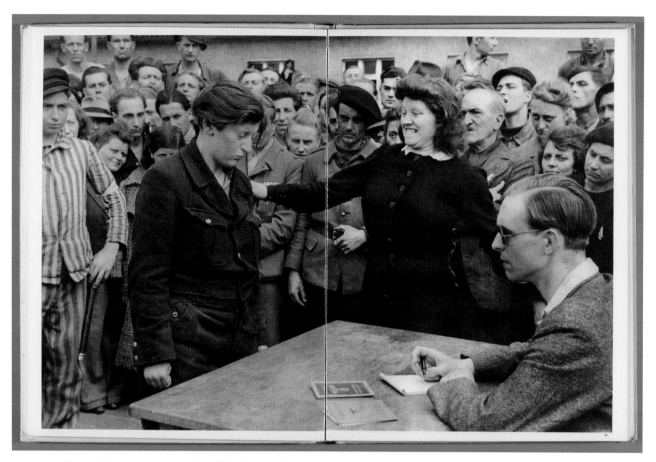

FIGURE 102 Plate 34, *Dessau, Germany, 1945,* from Henri Cartier-Bresson, *Images à la sauvette* (Paris: Verve, 1952). Gravure, spread: 14¼ × 21¼ in. (36.2 × 54 cm).

between picture-making and factuality, finding in them a "triple interest." He writes: "Primarily, they are pictures of human incidents caught during a historical epoch (roughly the last decade), which are so intensely observed and masterfully photographed that they can serve among the chief pictorial symbols of their time. Secondarily, they are beautiful pictures, artfully seized, composed with shrewd characterization—not only in the arrangement of faces, of light, or the balance of elements within a frame, but also within their entire technical formula. . . . Finally, they stimulate, in their impersonal, disciplined integrity, a number of important considerations on the past, present and future uses of photography." In honoring Cartier-Bresson's insightful eye, rather than "indiscriminate journalism" or "purely esthetic ends," Kirstein writes, "As an artist working in our time he has managed to be in places where history was being made. He has taken pictures which are permanent records of this history."[31]

THE MAKING OF *IMAGES À LA SAUVETTE*

By the time *Images à la sauvette* appeared in 1952 with its simultaneous New York edition, *The Decisive Moment,* Cartier-Bresson's double life as a journalistic photographer and a highly lauded artistic photographer had grown apparent for all to see.[32] But between the 1947 MoMA exhibit and the publication of *Images à la sauvette,* two important transformations had taken place. First, Cartier-Bresson spent the late 1940s in Asia photographing for Magnum, and international subjects form the striking second half of *Images à la sauvette.* Second, he had become much more self-conscious about his humanist compositions and his self-image, and he chose not to include many of his Surrealist images from the early 1930s, such as the cyclist at Hyères, the immediate postwar repatriation images, and the most politically topical Magnum Asian photographs he had published in *Life* during these years. Indeed, Cartier-Bresson's book production shows the conflicts between his self-identity as an artist and his journalistic development after the war as a founding member of

the Magnum photography agency. Many magazine articles emerged from his Magnum activities, but Cartier-Bresson also published numerous books, perhaps more than any postwar photographer of the decade.

Cartier-Bresson himself downplayed the importance of sequencing images for a book, writing in 1979, "My intuitive approach to photography and my constant pre-occupation with the single image makes [sic] me a poor designer. I find it difficult to create a harmony among different photos. I leave this to my publisher friends, to art directors and curators, with whom I always discuss the layout." Yet sequencing is a major concern in *Images à la sauvette,* and the overall result is to leach out much of the political meaning the same photographs had in other published contexts. Much like the catalogue of the 1947 MoMA exhibit, *Images à la sauvette* is a permanent exhibition between the two covers, and Cartier-Bresson saw both works as presenting his vision at the expense of the subject itself. As we shall see, this is evident in the way the images are organized, despite his closing idea that "a balance must be established between these two worlds—the one inside us and the one outside us."[33]

Clément Chéroux has identified the dueling roles of photojournalism and art in *Images à la sauvette,* commenting, "Rarely are photography publications so clearly torn between art and reportage." Chéroux sees the first Western European half as more creative, and the second, postwar Asian half as more Magnum-influenced reportage, but in fact there are many elements of artistry that mask the immediate political meanings of even the Magnum imagery. Chéroux's thoughtful and detailed overview of the book's production and reception sheds light not only on Cartier-Bresson's work on the volume but on the collaborative effort of more than fifteen people to create the book, always conceived as a French-English effort. Tériade (Efstratios Eleftheriades) and his imprint, Verve, copublished the book with Richard Simon of Simon and Schuster; Marguerite Lang at Tériade helped with the introduction; a Magnum assistant named Tommy researched images at the agency; Margot Shore, the head of Paris Magnum, translated the preface into English; Pierre Gassmann at Pictorial Service made prints and glass plates for the héliogravures; the Draeger brothers printed the book; and Matisse designed the cover.[34]

Tériade, the artistic director for the Surrealist magazine *Minotaure* since 1932 and editor of *Verve* since 1937, had early on recognized the importance of photography and had published three of Cartier-Bresson's photographs

in the first edition of his luxurious journal, *Verve,* in December 1937.[35] Tériade had even considered the publication of a photography book in the mid-1930s, according to Chéroux, but the book never came to pass.[36] Sounding much like *Paris de nuit,* the planned book would have centered on the marginal underworld of great cities, with photos by Cartier-Bresson, Eli Lotar, Brandt, and Brassaï. Fifteen years later, Tériade helped make *Images à la sauvette* a reality.

Tériade's long association with Matisse was important for *Images à la sauvette.* Tériade had worked with Matisse for several decades by the 1950s, as part of a group of artists he published that included Braque, Picasso, Miró, and Dalí, and Matisse designed the first cover of *Verve* that carried Cartier-Bresson's photos. In 1951, the year before *Images à la sauvette* came out, Tériade published *Matisse parle,* a collection of interviews to accompany a retrospective of the painter's work. Even the choice of English and French titles for the book involved Tériade. In helping to determine the English title, *The Decisive Moment,* Tériade had suggested a quote from the memoirs of Jean-François Paul de Gondi, the Cardinal de Retz, whose memoirs were published in 1717 and reference a "decisive moment" as a term "to describe a diplomatic situation particularly opportune for decision-making or action." The book's French title, *Images à la sauvette,* had been drawn from a list of ideas suggested by Cartier-Bresson's brother-in-law, the film historian Georges Sadoul, with *À pas de loup* and *Images à la sauvette* topping the list.[37] The chosen title signified for Cartier-Bresson "small street vendors ready to flee when asked for their licenses."[38]

The concepts for the front and back covers of Cartier-Bresson's book were generated in a meeting between the photographer, Tériade, and Matisse at Tériade's villa in Saint-Jean-Cap-Ferrat. Matisse's simplified images include a black sun, blue mountains on the horizon, a black bird with folded wings holding a cineraria flower (a plant in the daisy family), and some simple green, black, and blue plants at the bottom (see figure 89). Matisse had made several black suns for *Verve* in 1945, perhaps in reference to Gérard de Nerval's "black sun." The back cover has black spirals emulating the "rhythm of the rotation of the universe." In her overview of Tériade's and Matisse's collaborations, Dominique Szymusiak suggests that the eternal spiral "mixes rigor and poetry, time passed and time dreamed."[39]

The American copublisher, Richard Simon of Simon and Schuster, was brought into the project in March 1952,

and a letter of March 27 from Tériade to Simon explains the project, a dummy of which Tériade had sent to Simon. Tériade describes the book as 128 pages of photographs "reproduced without any text, but with a discreet number referring to the captions, which will be in the middle or end of the book"; he specifies nineteen double pages, seventy-three full pages, and thirty-four half pages, "and, to finish, a text with diagrams on Geometry. There might be a short introduction, but I doubt that it is absolutely necessary." Simon liked Tériade's term "the decisive moment," and it became the English title for the book and Cartier-Bresson's most famous phrase, although the photographer later insisted that he had "nothing to do with it."[40]

Matisse's cover was not as unqualified a success as one might imagine. As late as July 25, 1952, Simon wrote to Louis Sol at Draeger Frères to see if a photographic image by Cartier-Bresson could be substituted as the cover; his salesmen were having a hard time selling the hybrid volume that looked more like an art book than a photography book.[41] Draeger responded that the jacket had already been printed.[42] Simon's concerns were not unfounded: the *New York Times* critic Jacob Deschin found the book's Matisse cover jarring, deeming the cover's self-conscious graphic quality to be at odds with what he saw as Cartier-Bresson's lack of pretension. Deschin worried about the conflicting "worlds" of photography and art: "The book has an attractive jacket by Henri Matisse, which, added to a work already burdened with an excessively 'arty' atmosphere and price, lends an artistic flavor but introduces a distortion of the photographer's unique contribution. . . . However favorable this treatment may be for the distribution of the book, enabling the publisher to straddle both the art and photographic markets, it seems oddly out of place in a book of pictures wholly dedicated to photography in the purest sense and utterly lacking in pretension."[43]

As impressive and beautiful a physical object as *Images à la sauvette (The Decisive Moment)* is, Deschin was right: it is an odd hybrid of photographic book and art book. The volume's very large pages, 14½ by 10½ inches, mimic the large proportions of *Life* magazine at 14 by 10½ inches, and allow reproduction of the biggest possible enlargements of Cartier-Bresson's 24-by-36-centimeter film, either as a spread covering two full pages, or as one vertical image or two horizontal ones on a single page. Printed on Helio Afnor VII paper, the images are reproduced with

as little white space as possible—although they all have white borders, unlike Brassaï's *Paris de nuit*. As Minor White has commented, "The layout is guided by the single principle of darkening all available white space."[44] At about 14½ by 21 inches, the horizontal photographs that span two pages are truly enormous reproductions, similar in scale to some of the enlarged 1947 MoMA exhibition print sizes. As a hardbound volume vastly more outsized than most other photography books, it is too big to hold open on one's lap; it is as big as a large, unfolded newspaper. We seem to be viewing an art portfolio rather than more intimately grasping a book between our hands. One result is that we seem to gaze into the faces of some of the large portrait figures at an uncomfortably close range.

Regarding the book's text, Cartier-Bresson worked on the captions himself, in collaboration with Margot Shore, Magnum's Paris bureau chief. A letter from May 14, 1952, describes their toil: "We worked almost endlessly on the captions. Henri has sent you a copy of the final ones today, and I think that you will find that where the caption says nothing, the picture says everything."[45] But more significantly, Cartier-Bresson wrote an introductory essay that would become his most famous piece of writing, defining his concept of "the decisive moment" and offering the clearest clue to his working method. Notably, this is one of very few photobooks where the photographer wrote the introductory text himself, referencing his image-making process, rather than collaborating with another writer. The essay made an impact even in 1952, causing Walker Evans, in his review of the book for the *New York Times,* to comment on its originality: "for writing of this kind: it is quite devoid of rubbish and ego."[46] Clément Chéroux has carefully analyzed the essay, which is divided into three sections: one a personal introduction, the second, a more technical "reportage" section; and the final, a more personal, reflective conclusion.

In the introduction of the essay, Cartier-Bresson credits the photographs of Atget and films of D. W. Griffith and Eisenstein in the development of his own style, and he tacitly acknowledges the influence of the multiple facets of Cubist simultaneity, filmic montage, and Surrealist strangeness that have been discussed in the previous chapters. An interview with Richard Simon gives us a few more details. Cartier-Bresson recalls being impressed with the photographs of Atget, which he saw at the age of twenty-one, in 1929. When Simon asked him if he read any books on these subjects, he replied that he had not,

but, recognizing Krull's gift of lyric montage, he said, "I remember a woman photographer's work. Her name was Germain [*sic*] Krull. She was something like Berenice Abbott. She was Dutch. She took pictures of harbors and realistic things. It impressed me, with a certain way of picturesque reality."[47]

In his second section, "The Picture-Story," Cartier-Bresson attempts to define what a picture-story is, and sees a "joint operation of the brain, the eye and the heart" that "depict[s] the content of some event which is in the process of unfolding." His commentary, oddly, seems more focused on the single image than the collection of several photographs, and even when he writes, "In shooting a picture-story we must count the points and the rounds, rather like a boxing referee," he is concentrating on individual moments rather than their suturing together. He is, though, eloquent on how to approach his subject—"on tiptoe," with "a velvet hand, a hawk's eye."[48]

Within this second section, he discusses the several components that make up the photograph. When he talks of "The Subject," he notes that "the smallest thing can be a great subject." Discussions about "Composition," "Color," and "Technique" also concentrate on single images, not sequences of pictures. Toward the end of the essay, he refers to "The Customers," writing that the camera is a diary, making a judgment on what is seen. Reading his words, we realize that for a photographer whose work as a photojournalist had made him famous, he has a complicated relationship with the picture magazines, beginning with *VU*. He honors the magazines that "produce for us a public, and introduce us to that public; and they know how to get picture-stories across in the way the photographer intended," but he bemoans the fact that "the photographer runs the risk of letting himself be molded by the taste or the requirements of the magazine." While honoring the layout man and the editor and the "beautiful presentation of a kind which keeps the full import of the story," he emphasizes that "there is a third anguish for a photographer—when he looks for his story in a magazine." He concludes this section of his essay by stating that other paths of photographic communication exist: "exhibitions, for instance; and the book form, which is almost a form of permanent exhibition." Significantly, in the essay's last section, Cartier-Bresson returns to the multivalent meaning of a single image: "A photograph is for me, in the span of a fraction of a second, the simultaneous acknowledgment of the meaning of a fact on one hand, and on the

other, of a rigorous organization of visually perceived forms that express this fact."[49] Chéroux tells us that the end of this sentence comes from a 1951 letter to *Life* picture editor Wilson Hicks.[50] Cartier-Bresson's words cast a long shadow for photographers, but his images are what set *Images à la sauvette* apart from other projects.

OCCIDENT AND ORIENT: IMAGES ON A GLOBAL STAGE

Many French humanist photography books concentrate on Paris and its environs, a topic of local and global interest in the 1950s, when the city was expanding and tourism was returning to Paris. Cartier-Bresson casts a wider net, however, partly due to his travels throughout Europe and in Asia for Magnum. *Images à la sauvette* celebrates daily life and individuality, but also operates on a wider political stage, flattening the world into a division between colonizing and colonized countries, and between European and Asian worlds. The book is divided, with a first section that includes images from 1932 until the war's end, mostly depicting Europe and North America.

The second section of *Images à la sauvette* reflects Cartier-Bresson's Magnum assignments in Asia from 1947 onward. In the English edition, although tellingly not in the French edition, the two sections of the book are titled "Photographs of the Occident" and "Photographs of the Orient." In the same way that humanistic photography reflected a particular cultural moment right after World War II, this division of the book speaks to a particular moment in European imperialism. India gained its independence from Great Britain in 1947, China became a communist country in 1949, Burma (Myanmar) became independent from Great Britain in 1948, and Indonesia finally gained its independence in 1949, after Dutch and Japanese occupation. During his three years living in Asia, Cartier-Bresson was on hand to witness all of these monumental transitions, and his views of their independence indirectly reflect the French colonies' ongoing struggles for independence as well. In French Indochina, Laos and Cambodia became independent in 1953, and the French finally evacuated Vietnam in 1954. The second half of *Images à la sauvette* bears witness to these transitions, but he frames them differently from the lengthy journalistic picture-stories he was publishing on many of these transitional moments in *Life* and other magazines, as well as in his two more journalistic books two and three years later, *D'une Chine à l'autre* (1954) and *Moscou* (1955). *Images à la sauvette* gives a monumentality to the events, partly from

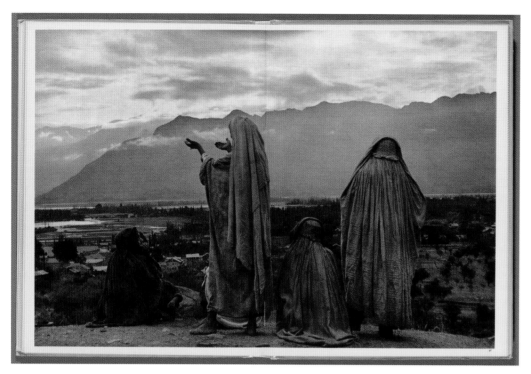

FIGURE 103 Plate 87, *Kashmir, 1948,* from Henri Cartier-Bresson, *Images à la sauvette* (Paris: Verve, 1952). Gravure, spread: 14¼ × 21¼ in. (36.2 × 54 cm).

the size of the book itself and partly from the nonnarrative sequencing and static framing.

"Photographs of the Occident" includes sixty-three photographs from the period up to 1947. They depict France, Italy, Spain (with one Moroccan image), Mexico City, London, and the United States—the places where he traveled from 1933 to 1947. The second half, "Photographs of the Orient," presents another sixty-two images numbered from sixty-four to 126 and dated in rough chronological order from 1947 through 1950. With one exception showing France (plate 108; Blois, France), "Orient" concentrates on Pakistan, India, Indonesia, Singapore, China, and Egypt, with a single image of Iran.[51] These images reflect the years when Cartier-Bresson was the Asian correspondent for Magnum.

In this first section, there are only eight photographs that spread across both pages, each one creating an almost 14-by-21-inch image. Plate 2 shows us an elderly man at a café near the Gare Saint-Lazare, and plate 3 depicts a picnic on the banks of the Marne that seems like a still from Jean Renoir's 1936 film *Partie de compagne*—not a surprise, since Cartier-Bresson worked as second assistant director on that film.[52] There are full pages of a café in Marseille, a boy in Andalusia, two prostitutes in Mexico City, an elderly lady in London's Hyde Park, a

Gestapo informant being identified by a furious citizen, and a group of men lounging on Boston Common during a heat wave. No photograph is remotely topical in subject, with the exception of the German informer image (plate 34; see figure 102), and perhaps plate 35, which shows a reunion between a refugee and his family in New York Harbor. Even when we observe the crowds witnessing King George VI's coronation in two images, Cartier-Bresson's camera is trained on the audience rather than the main event, as was his habit. Politics, recent wars, and economic trouble are absent in the largest and smallest of images, which instead comprise beautiful compositions of peasants, townspeople in markets, and landscapes from all the countries he visited. In contrast, the 1947 MoMA catalogue presented far more pictures forming current picture-stories, although both the catalogue and the "Occident" section end with images of a selection of artists and writers, ranging from Jean-Paul Sartre to Henri Matisse to William Faulkner, Truman Capote, Georges Rouault, and Pierre Bonnard. Clearly, Cartier-Bresson had moved beyond the activist and political concerns of the communist paper *Ce soir* and magazine *Regards* that he had worked for in 1937 and 1938, just as he had turned away from the strongly Surrealist photographs of the early 1930s.[53]

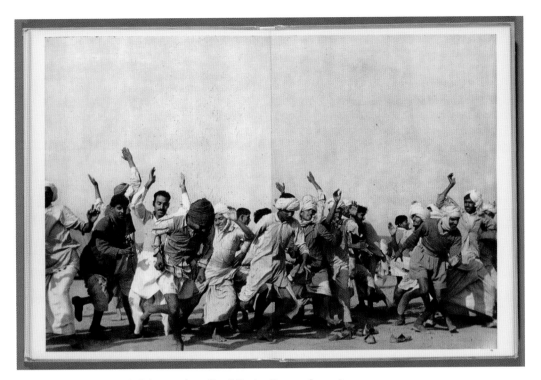

FIGURE 104 Plate 88, *Punjab, India, 1947*, from Henri Cartier-Bresson, *Images à la sauvette* (Paris: Verve, 1952). Gravure, spread: 14¼ × 21¼ in. (36.2 × 54 cm).

In the second half of *Images à la sauvette,* there are eleven more double-page spreads, and, as befits the Magnum Asian correspondent that Cartier-Bresson had become after 1947, they depict a number of geographic and political hot points. Each one, however, is framed in a space that constructs the political or global activity more like a frieze on a stage set than as an historical event with an active entry point for the viewer. These are very beautiful compositions, and they recall the flat depth of field of Cartier-Bresson's best Surrealist photographs of the 1930s, such as the boy catching a ball in Valencia, Spain (see figure 100). But the caught instant, the "decisive moment," is often missing here. Plate 71 shows an old man surrounded by young boys in southern India; plate 79 frames figures and tents in a Punjabi refugee camp against bare trees; and in plate 87 Cartier-Bresson's caption tells us that these are four Muslim women seen from the back, praying to the sun behind the Himalayas (figure 103). Even very active photographs, such as the view of men doing gymnastics to "vent anger" in Punjab, seem to freeze-frame the bodily actions in a shallow space against a flat wall (plate 88; figure 104). Another full plate shows women primping for a dance in Bali, followed by an image of the main canal in Jakarta, Indonesia, where washing and bathing are performed against the peeling cement wall of the canal. Other

full pages show rice fields in Sumatra, a communist youth parade in Shanghai, and a village market in Egypt silhouetted against the distant hills. Even the infamous bank rush in Shanghai in 1948, where ten people were crushed to death, appears as a static stage set against a flat wall and seems more posed than frantic (plate 109; figure 105). Cartier-Bresson would use this image again in *D'une Chine à l'autre,* in 1954. The overall effect of these large, dual-page images is to formally cage and decontextualize the very serious political events that they represent, despite the informative captions that give more political details than the images.

Some of the other images in this "Orient" section, however, are somewhat more topical and journalistic. Cartier-Bresson begins his sequencing with India and Pakistan, presenting images of Pakistani and Punjabi refugee camps. What follows is a powerful series of images of the death of Gandhi that forms one of the few journalistic groups of images in the book. On four pages comprising plates 80 through 84, the photographer presents Gandhi's last fast, his devotees (Cartier-Bresson shot this through a nearby window), crowds trying to climb the train carrying his body to the Ganges, the first flames of his funeral pyre, and Nehru's announcement of his death. This series begins to approximate a picture-story in a magazine

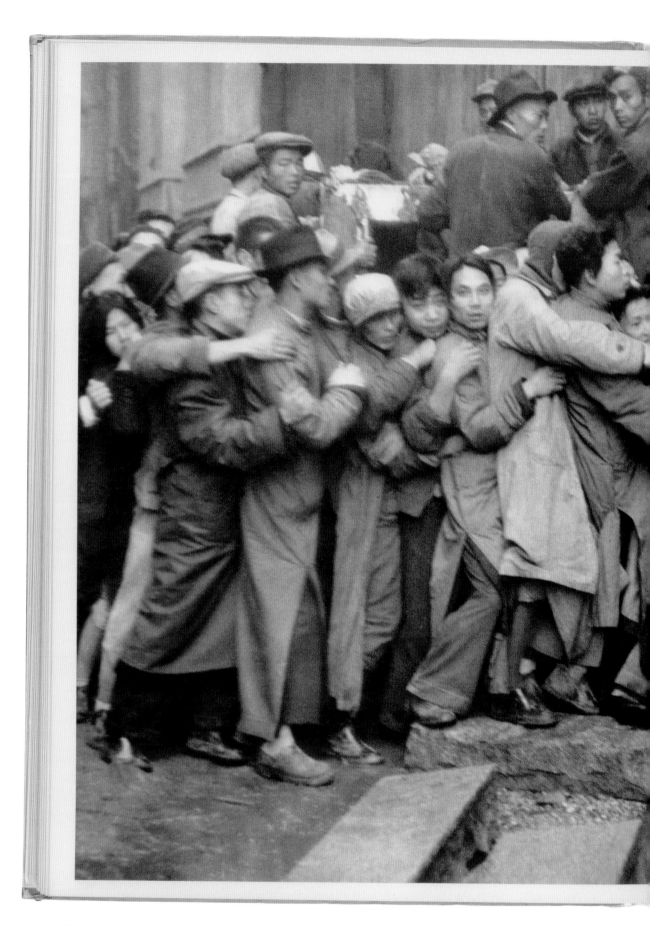

FIGURE 105 Plate 109, *Shanghai, 1948*, from Henri Cartier-Bresson, *Images à la sauvette* (Paris: Verve, 1952). Gravure, spread: 14¼ × 21¼ in. (36.2 × 54 cm).

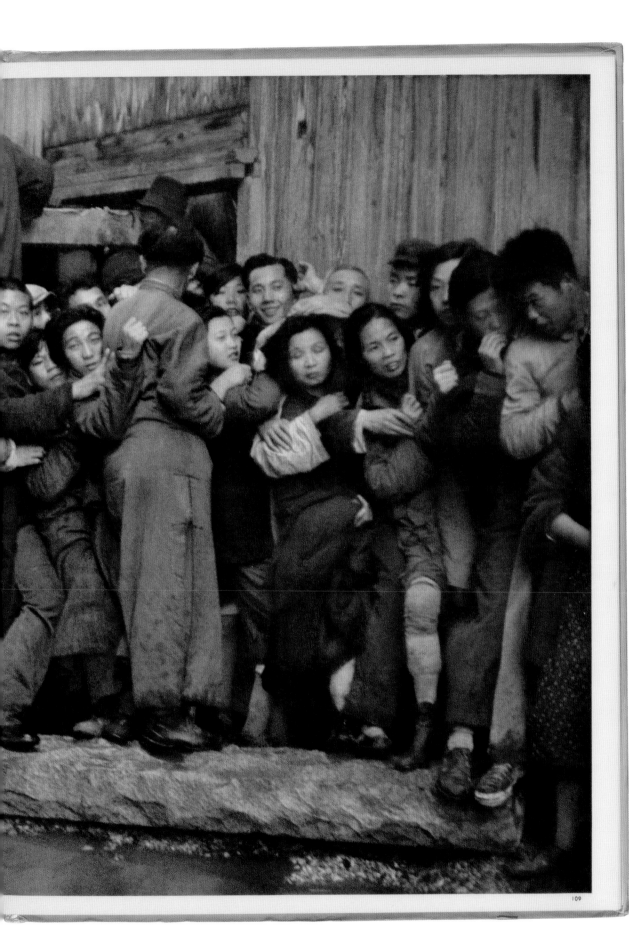

FIGURE 106 Plates 82–84, *Delhi, 1948*, from Henri Cartier-Bresson, *Images à la sauvette* (Paris: Verve, 1952). Gravure, page: 14¼ × 10½ in. (36.2 ×26.7 cm).

(plates 82–84; figure 106). There is also a quieter group of images that shows a Singapore death house, with two images of musicians and people praying, and three more of the upstairs room where people, including a baby, wait to die. A final series shows a group of vignettes of Shanghai at the moment of the communist takeover (plates 110–16). The group of Egyptian images that close out the volume present individual vignettes rather than a linked picture-story like the Gandhi funeral or the Singapore death house.

In the picture magazines, the "layout man" and "editor" would have supplied text and context for the images in the articles, but Cartier-Bresson often distrusted those editors. The photographer kept very extensive notes on his images while traveling, but *Images à la sauvette* deliberately removes all such narrative from these photographs. In his book, the photographer moves us arbitrarily from place to place and year to year, as he presents not a story, but a series of single pictures. Even in multiple-image layouts in the second half of the book, a similar formal stasis occurs. For instance, the second page-spread in the "Orient" section shows this kind of pairing: Cartier-Bresson highlights peacocks on the left side with water carriers on the right, equating the grace and beauty of human and avian figures in their rustic surroundings (plates 65 and 66; figure 107). *Images à la sauvette* becomes a beautiful object, even as many of its pages universalize history in a way that even Krull's deliberately abstract *Métal* images do not.

GEOMETRY

Cartier-Bresson was always interested in geometry, which he used as a tool to give permanence and historical weight to his images, setting them apart from more informal snapshots. In a later essay, "Mind's Eye," he writes that for him "the camera is a sketch book, an instrument of intuition and spontaneity" that nonetheless requires "concentration, a discipline of mind, sensitivity, and a sense of geometry" to achieve his vision. He recognizes geometric patterns in the finished product of his imagery: "You wait and wait, and then finally you press the button—and you depart with the feeling (though you don't know why) that you've really got something. Later, to substantiate this, you can take a print of this picture, trace on it the geometric figures which come up under analysis, and you'll observe that, if the shutter was released at the decisive moment, you have instinctively fixed a geometric pattern without which the photograph would have been both formless and lifeless."[54]

Surrealist photographer Maurice Tabard expands on Cartier-Bresson's words in an unpublished two-page essay, "Cartier-Bresson et geometrie," that was cut from *Images à la sauvette* because of its complexity. A brief look at that essay elucidates the importance of geometry to Cartier-Bresson's work. With highly technical references to the works on geometry and art by Jay Hambidge and Matila Ghyka—whose book Cartier-Bresson kept on his bedside table—Tabard argues that the brilliance, permanence, and balance of Cartier-Bresson's best photographs are due to the use of the Golden Section and the Golden

Ratio. Tabard clarifies Cartier-Bresson's use of Euclidean geometry—whether consciously or unconsciously—in his work by analyzing two images. In his discussion of the first image in *Images à la sauvette*, the marriage scene at Joinville-le-Pont, Tabard demonstrates that even in this dynamic diagonal image, symmetry is preserved because the line of the bride's chin directly intersects the swinging body at the correct proportion (see figure 91). In the second image—the Spanish children framed by a rubble wall's hole—Tabard analyzes the spiral shape of the hole as corresponding to the shape constructed by the Golden Section, and observes that the small boy on crutches is at the exact axis of the "evolution of the spiral" (see figure 100 and figure 108, with Tabard's overdrawing).[55]

Tabard's language is extremely technical and somewhat difficult to understand, and both the publishers and Cartier-Bresson himself decided to omit the essay after conversations about Tabard's excellent ideas and lecturing style, and the difficulties of translating them into clear prose.[56] Despite its omission from the final book, Tabard's essay offers an important clue to the magisterial quality of *Images à la sauvette*. Writing, "I will end this short essay

FIGURE 107 Plates 65 and 66, *Tiruvannamalai, South India, 1948* and *Jaipur, Rajputana, India, 1948*, from Henri Cartier-Bresson, *Images à la sauvette* (Paris: Verve, 1952). Gravure, page: 14¼ × 10½ in. (36.2 × 26.7 cm).

FIGURE 108 Henri Cartier-Bresson, *Seville, Spain, 1933*, with Maurice Tabard's Golden Section line drawings. Series II, Box 12, Richard Leo Simon Papers, Rare Book and Manuscript Library, Columbia University in the City of New York.

with regret because there are many other photographs that deserve to be seen by such an analysis," Tabard recognizes the balance and what Hambidge calls "dynamic symmetry" of Cartier-Bresson's photographs.[57] This lifts them beyond the immediacy of snapshots and quantifies the notion of the "decisive moment" as a purely intuitive technique; Tabard's essay allows us to see what makes Cartier-Bresson's photographs so timeless.

Cartier-Bresson's camera of choice, the Leica, contributed directly to the use of geometry in his images, as suggested by Michel Frizot. The Leica had a frame with the Euclidean "perfect" proportion of 2:3, and in combination with Cartier-Bresson's training with painter André Lhote and knowledge of Purism, discussed below, the Golden Section would have been deeply appreciated. Frizot suggests that Cartier-Bresson set up the geometric frame in the architecture of his scene and then waited for the movement to animate that geometry—"the most fluid interaction between a topological geometry and the random, unpredictable punctuation of the bodies." In close-ups, the figures themselves "become the geometry of the image."[58]

In an interview with Richard Simon, Cartier-Bresson shows his awareness of the rectangle framing allowed by his Leica camera, echoing what Tabard recognized as the Golden Section, and points to his embrace of classicism in his sense of proportion. Cartier-Bresson states, "In Leica there is a game between the horizontal and the vertical," and he shows consciousness of proportion, stating, "Blurred or not, sharp or not, a good picture is a question of proportions, of black and white relations." Even more specifically, he says, "I am not a romantic. I like classicism." His images are taken with a certain preplanning: "When I walk around with my Leica, I always keep it set at from f-11 to f-8 at 1/100th. This is a suitable average, an approximate thing. And for the distance it is set about three metres [10 feet]. Because you never know when you are going to see a picture."[59] But those pictures are partially predetermined by the balanced setting of his camera—not too close, not too far, not too fast, not too slow.

Further in the interview with Simon, Cartier-Bresson expresses his interest in "literature, painting, all fields of the arts," not just photography, and we see that his classicism also comes from his studies as a young man with Lhote, who taught widely, wrote as an art critic for the *Nouvelle revue française,* and moved from Salon d'Or–style Cubism before World War I to a more Purist style in the

1920s, when Cartier-Bresson knew him. From Lhote he may have absorbed not only an interest in geometry but also a sense of classically ordered composition. In the end of his interview, Cartier-Bresson returns to the universality of photography as something "to be reproduced for the masses, not for collectors. For that is part of the strength and validity of photography, that it can be reproduced."[60] Therefore, in addition to spontaneously capturing perfect balance, Cartier-Bresson creates a sense of contemporary classicism.

Whether conscious or a natural outgrowth of the Leica format and his vision, this geometric structuring makes for a book of extraordinary single images rather than storytelling progression with a narrative arc (either representational or abstract in design). Cartier-Bresson himself said that he saw in single images more easily than in series, leaving the ordering of his work to others. However, despite his essay's omission from *Images à la sauvette,* Tabard understood that the balance in these images contributes to what sets it apart as a classic text. Cartier-Bresson's book, as he meant it to be, offers an image of contemporary life as a classical framing, both in subject and in composition. We can see the subjects ourselves, but we owe thanks to Tabard for the comprehension of their dynamic yet classical compositions.

THE RECEPTION OF *IMAGES À LA SAUVETTE*

As the book's reviews make evident, *Images à la sauvette* clearly hit a nerve as a wholly designed object, for its size, its beauty, the richness of its gravure-printed images, and the tactile experience of viewing it. Moreover, tension between the naturalness of photography and the aesthetic construction of the book and cover drew the attention of many critics. In addition, readers regarded images depicting not only "man in his environment," reflecting the French interest in photographing everyday life, as a humanist response to the recent war and its atrocities, but also "in various parts of the world, particularly in the Orient," which were presented with a "remarkable consistency of approach."[61] All together, these features show Cartier-Bresson's universalizing work, the book constructed as being outside of history, outside of specific neighborhood or political contexts. In this it differs markedly from the books of Krull, celebrating the Machine Age; of Brassaï, wandering in the uneasy nocturnal streets of Depression-era Paris; and of Jahan, digging up the imaginary metaphorical bones of war victims. It also departs

from Cartier-Bresson's own work in the 1930s, when he photographed for the communist publications *Le soir* and *Regards,* although a few parallels can be drawn to his political film, *Le retour,* which he made in 1944 and 1945 for the U.S. Office of War Information, depicting the return of prisoners.[62]

Images à la sauvette had a huge immediate impact on photographers. Robert Capa called it "a Bible for photographers." Evans admired the "breathtaking quality" of the printing; William Eggleston later wrote that he marveled at the reproduction quality and observed that "there were no shadow areas that were totally black where you couldn't make out what was in them, and there were no totally white areas." Eggleston, Dennis Hopper, and Larry Fink recalled that this book was the first one that truly affected them as photographers.[63]

The American photography world had received *The Decisive Moment*'s publication with great pleasure. Monroe Wheeler, director of the Museum of Modern Art, wrote to Richard Simon on November 7, 1952: "It is a great book. If I could buy only one picture book in five years, this would be it." Carmel Snow of *Harper's Bazaar* wrote, "I *love* Cartier's book! It is, of course, the best book of photographs ever published—and marvelous in every way." A multiple-page spread, titled "Intruder on Tiptoe," ran in *Harper's Bazaar* in October 1952. Its international impact was immediate as well. Jun Miki at Time-Life's International office in Tokyo wrote, "It will indeed be an inspiration to us here in Japan."[64]

LES EUROPÉENS

Planning for *Les Européens,* simultaneously copublished in English as *The Europeans,* began almost immediately after the publication of *Images à la sauvette;* it was originally meant to be a book about Paris. A letter from Margot Shore in the Magnum Paris office to Richard Simon suggests that Cartier-Bresson had actually been working on it as early May 1952, even before *Images à la sauvette* was published. Correspondence between Simon, Tériade, and Cartier-Bresson confirms that they wanted to build on the popularity of the first book, and variously referred to the new volume as "Sauvette II," "The Indecisive Moment," "The Old World," and "Eternal Europe"; the different suggestions reveal telling details about their intentions for the book. In March 1954 Richard Simon looked forward to seeing the dummy of "The Old World," and suggested yet another title. He wrote, "'The Old World' implies that

here are pictures of Europe as it was in the 18th century or in the 12th century. Since the pictures however, were taken in the 1950s, such an implication—in my opinion—would be neither accurate nor saleable. I'd like to suggest, instead, the title 'Eternal Europe.' People like to feel that, despite two world wars, Europe is and remains eternal." When Cartier-Bresson wrote to Simon on January 5, 1955, he mentioned a "second volume of 'the decisive moment' (no title yet)," and explained that he had "been steadily working on it since the letter of 27 October 53 that poor Capa sent you. Now I just have it here practically in the form Tériade and I wish, and I hope you will also like it." In this letter to Simon, Cartier-Bresson writes, "Have just finished my work on 'The Old World.' It is different from 'The Decisive Moment.'" Finally, later that January, Tériade and Cartier-Bresson decided on *Les Européens* (*The Europeans*). As with *Images à la sauvette,* Simon hoped for a photographic cover for *Les Européens,* selecting an image of two Russian soldiers looking at two women waiting for a street car (plate 26; figure 109).[65] That particular image had been on the cover of *Life* in January 1955, but once

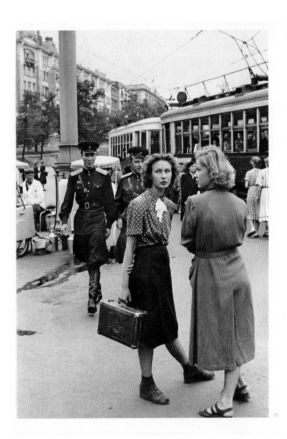

FIGURE 109 Plate 26, *Waiting for the Tram,* from Henri Cartier-Bresson, *Moscou, vu par Henri Cartier-Bresson* (Paris: Delpire, Collection Neuf, 1955). Gravure, page: 10½ × 8¼ in. (26.5 × 21.1 cm).

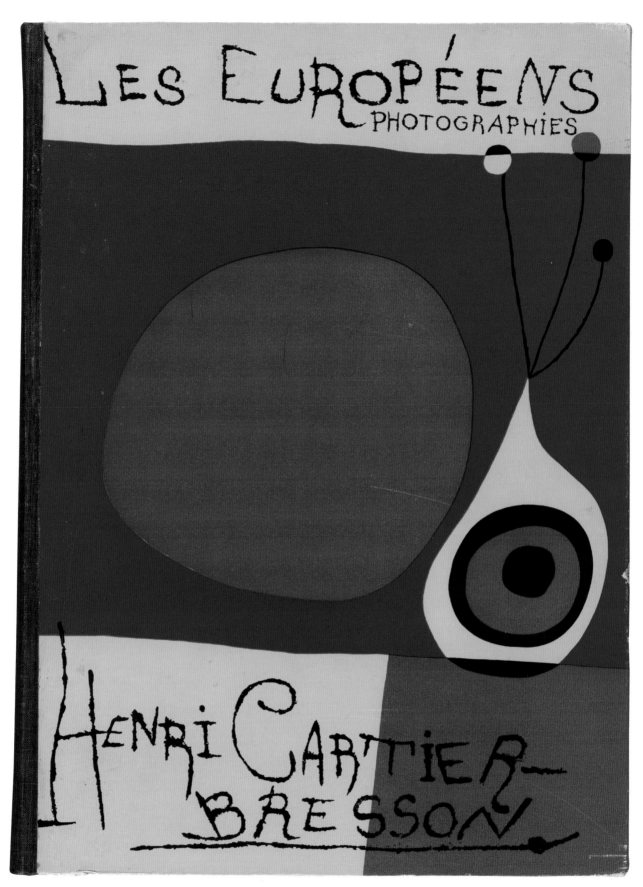

FIGURE 110 Cover by Joan Miró of Henri Cartier-Bresson, *Les Européens* (Paris: Verve, 1955). Gravure, 14½ × 10¾ in. (37 × 27.4 cm).

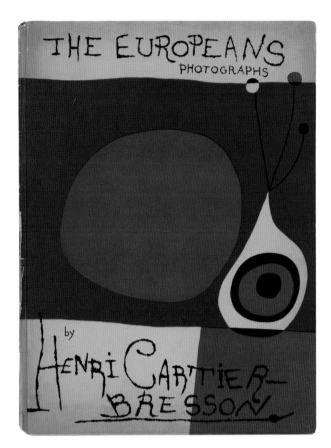

FIGURE 111 Cover by Joan Miró of Henri Cartier-Bresson, *The Europeans* (New York: Simon and Schuster, 1955). Gravure, 14½ × 10¾ in. (37 × 27.4 cm).

again Simon lost out; a work by Miró graced the cover of *Les Européens* (figures 110, 111), and the two women do not appear in *Les Européens* at all.

This second collaboration saw the light of day in 1955, and in it Cartier-Bresson, Tériade, and Simon continue the celebration of everyday life. When the book was published in an edition of seven thousand copies, Thames and Hudson in England added an order for another two thousand copies. Simon sent out a letter publicizing it, and also the English edition of *Moscou, The People of Moscow,* that appeared at the same time. In New York, *The Europeans* was available to subscribing members at $12.50 (list price $15), and *The People of Moscow* at $8.50 (list price $10). Simon describes *The Europeans* as "the result of a five-year itinerary in which this great photographer visited England, France, Spain, Italy, Germany, Austria, Switzerland, Greece, Ireland, and Russia with his Leica. . . . They were perhaps even a little more personal than the ones in the older book. Again, he photographed not

the great or the cliché views that appear in magazines; rather he photographed the everyday people who go about making their living and having fun, in their moments of sadness and joy and everyday life." In another text Simon describes it as follows: "After publication of 'The Decisive Moment,' Cartier-Bresson spent three years all over Europe photographing people at work and at play. To this he has adds some of the magnificent prints there was no room for in 'The Decisive Moment.' The result is this book which may be considered a follow-up of his first volume."[66]

Les Européens begins with an image of Greece, showing the scattered remnants of classical civilization against the industrial smokestacks in the background (plate 1; figure 112). By beginning with the "cradle of civilization," the book presents this image of Eleusis and the Bay of Salamis within a Eurocentric and classicizing vision of the world, following up on *Images à la sauvette* with its clear delineation of "Occident" and "Orient." Cartier-Bresson frames the fragments of statuary and columns in the Eleusis Museum with a walkway, which allows us to circle around the ruins, the site for the Eleusinian Mysteries, the secret initiations for the cult of Demeter and Persephone. As in Brassaï's *Paris de nuit,* a series of statues will be our tour guides. Like Jahan's *La mort et les statues,* however, they are headless and armless, destroyed not by World War II but by two millennia of history. The two smokestacks in the background spew black fumes; reference to Cartier-Bresson's caption reveals the many layers of historical meaning in the photograph. To begin, he views the smokestacks "in the style of the late nineteenth century" as a reference to the Machine Age that grew in late nineteenth-century Europe but was sputtering by the beginning of the Depression. Although it is not visible in the image, his caption makes a more topical reference as well: "Invisible in the picture, but clearly audible at this time when it was taken—the noise of jets at the neighboring airfield."[67] This airfield is a clear reference to the recent Battle of Greece in World War II: the British evacuated their forces from there in 1941 and the Luftwaffe took it over, surrendering the airport only in October 1944. During the war, Eleusis sustained multiple heavy attacks from American bombings.

Only three direct references to the recent war or to war-torn areas are made in *Les Européens.* Plate 22 shows a one-legged man on crutches in Hamburg, with a bombed-out church in the background; Cartier-Bresson tells us

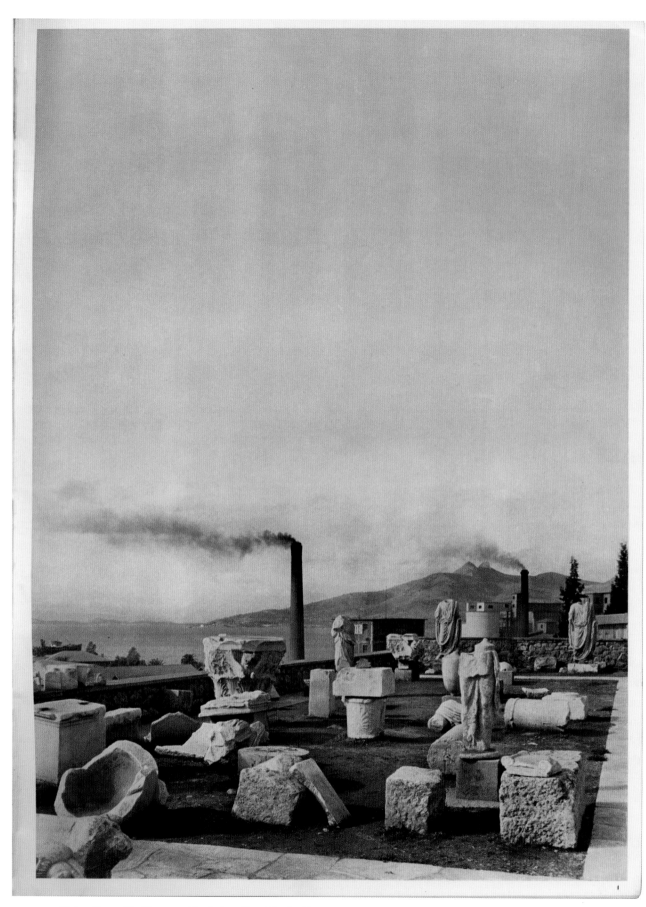

FIGURE 112 Plate 1, *Greece, The Museum at Eleusis,* from Henri Cartier-Bresson, *Les Européens* (Paris: Verve, 1955). Gravure, page: 14¼ × 10½ in. (36.2 × 26.7 cm).

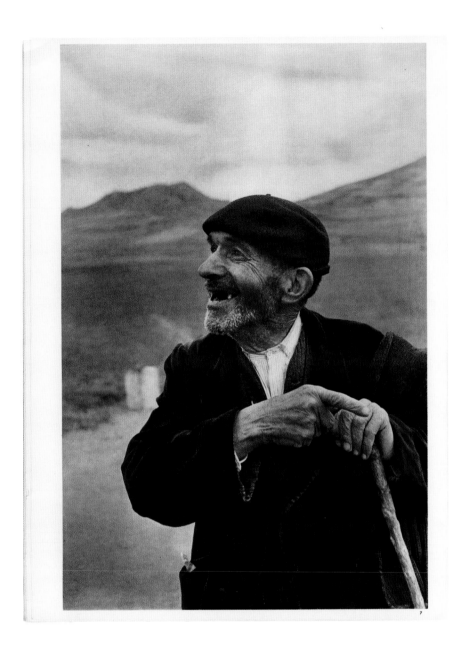

FIGURE 113 Plate 7, *Old Shepherd . . . near Ariza in Castille,* from Henri Cartier-Bresson, *Les Européens* (Paris: Verve, 1955). Gravure, page: 14¼ × 10½ in. (36.2 × 26.7 cm).

that half the city was destroyed by bombs. Plates 26 and 27 show us the ruins of Cologne, and plate 58 depicts the rubble of ruined buildings near the Peterhof, the imperial summer residence in Leningrad. Aside from these photographs, the book's images visually hark back to a "simpler time," with a heavy emphasis on peasants, farming, market scenes, individuals, small commerce, and the joys of daily life. After a visual tour through these countries, the book ends with a timeless image of a small, grinning boy toting two bottles of red wine on a Sunday morning on the rue Mouffetard in Paris (see figure 96).

The essence of *Les Européens* can perhaps be best summarized in one image, an elderly shepherd who, the caption tells us, guards the horses of his landlord in Castille.

Silhouetted against the dramatic, bare Spanish hills, he could be a farmer in any country in the northern hemisphere (plate 7; figure 113). He does not look directly at the photographer or at us, so that we are free to examine all the details of his face and stature—and the large scale of the book means that his head seems almost as large as ours. His gnarled hands clasp his crook, his beret is firmly screwed down over his skull, and his wide, toothless smile exhibits a sense of joy and humor. He is not a broken figure; he stands erect and is about to continue walking. This photograph does not require us to pity, help, or revile him, for it is oddly distanced. Unlike Cartier-Bresson's best compositions of the 1930s, it does not balance on a specific instant when all forms fall into place in a shallow,

theatrical field. Unlike a view of Brussels (1932) from the 1947 MoMA show, for instance, in which two men peer through a burlap wall, eliciting Surrealist dreams of peep shows, this is more of a photojournalistic record of a man in the midst of his life. It is a beautiful image but has none of the political or compositional edginess of Cartier-Bresson's earlier work. Most importantly, this is a Spanish peasant, but it could just as easily be a British farmer, a Soviet worker, or a man from another century entirely; many of the local particularities of topical and national identity have been erased. The shepherd's sense of timelessness is an aura constructed by the book in its entirety. The photographer Philippe Halsman sums this up accurately in a *New York Herald Tribune* book review of the American edition, *The Europeans,* on Christmas Day 1955: "Cartier's brain seems to have become a little wiser, his heart a little sadder as his eye tries to probe deeper. Now he searches less for the startling geometry of a fleeting moment. . . . Work as a reporter has influenced his style. The Fourth dimension of every picture, its meaning, has become more and more important. *The Europeans* is neither travelogue nor reportage. It is a fascinating collection of aphorisms and observations on the state of an outmoded but still attractive continent."[68]

In his brief preface, Cartier-Bresson explicitly defends his focus on Europe: "Nowhere, probably, are as many differences crammed into so little space as in Europe, for reasons geographic and historical." By dividing the book into regions—covering Greece, Spain, Germany, England, Austria, Switzerland, the USSR, Italy, and France, in that order—Cartier-Bresson presents postwar Europe seen as a collection of nations. Yet he also sees a uniform culture that visually begins to heal the divisions between the fascists and the Allies, and in that unification, *Les Européens* bears an odd similarity to Edward Steichen's MoMA exhibition, *The Family of Man,* which had closed just three months before the *Les Européens* was published. In much the same manner that Steichen conflated international cultures, Cartier-Bresson presents individuality, nuclear families, and Eurocentric values as one. Cartier-Bresson even echoes MoMA's mantra of one big, happy, global family when he writes in the introduction, "The yearning of all men for joy and happiness, their cruelty, their every passions are expressed in the countless little facets of daily existence. You are struck at once by their newness and by their familiarity, like something that you are sure you have seen before." Cartier-Bresson does eschew types, writing,

"Geography books used to be illustrated with reproductions of great monuments and drawings of ethnical types. Today, photography has enriched and complicated them with its booty of human elements."[69] Interestingly, Simon had pressed Cartier-Bresson to expand his thinking beyond this brief statement, but the photographer responded that he had nothing more to add, and that the aesthetic principles of *Images à la sauvette* held true for this book too and he felt no need to repeat them.[70]

As for the images themselves, *Les Européens* presents four views of Greece, sixteen of Spain, eighteen of Germany, ten of England, three of Austria, six of Switzerland, sixteen of the USSR, and sixteen of Italy, ending with twenty-five photographs of Cartier-Bresson's home country, France. With only an occasional exception, such as an image of Franco's soldiers in Spain, political differences are erased, and in his avoidance of modernity, Cartier-Bresson almost rivals his fellow Frenchman Eugène Atget, who from 1889 to 1927 managed to ignore any modern or industrial Parisian subject that postdated the French Revolution. Decades later, and after two world wars, Cartier-Bresson gives us timeless marketplaces, farmers, fields, clergymen and manual workers, shop windows, sportsmen, women and children, picnics, and restaurants—a virtual cornucopia of daily life. Sometimes he marks the difference between wealth and the working class, as in plates 37 and 38, where he juxtaposes a German man in white tie toasting the New Year with a chimneysweep in a grimy top hat, or plates 87 and 88, which frame a woman at the fish market in Burano, near Venice, across from a stylish lady inspecting the shiny trinkets in a Florence shop window. In another case, in plates 101 and 102, he juxtaposes a fashionable woman at the Bal des Petits Lits Blancs with a burly market porter from Les Halles. Unlike Brassaï, however, Cartier-Bresson does not evince a clear visual preference for one class over another; his words underscore his preference for all mankind, "man himself, with his joys, his sorrows, his struggles."[71]

In *Les Européens,* as in *Images à la sauvette,* Cartier-Bresson plays with the tension between photography's factuality and its artifice. On one hand, he celebrates the reportorial side of photography in bearing witness to history, as manifested in his work for Magnum from 1947 onward, and he ends his introduction with the words: "Never shall I be able to affirm, 'the characters in this book are purely fictitious' or, 'Any similarity with persons living or dead is entirely coincidental.'" But despite his

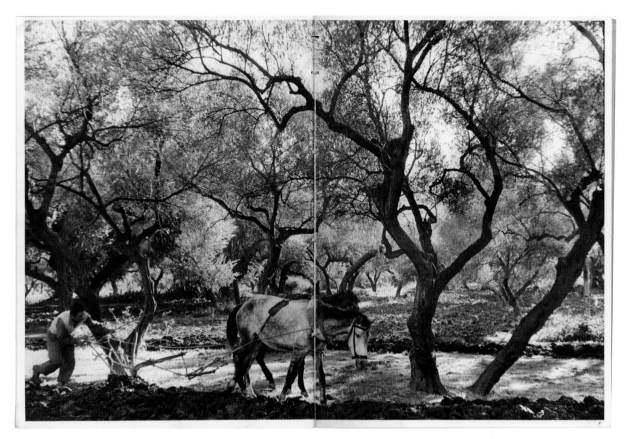

FIGURE 114 Plate 2, *Olive Grove near Aiyion*, from Henri Cartier-Bresson, *Les Européens* (Paris: Verve, 1955). Gravure, spread: 14¼ × 21¼ in. (36.2 × 54 cm).

reaffirmation that "one *makes* a painting, whereas one *takes* a picture," he taps into a deep well of images from the long history of European art: "It is like going through a museum for the first time: certain paintings look strangely familiar, because you have already seen them in reproduction."[72] In Cartier-Bresson's photographs we see clear echoes of Honoré Daumier, of Constantin Guys, of Jean-François Millet, and of Francisco Goya.

Like *Images à la sauvette, Les Européens* is laid out with either one, two, or three pictures per page spread. Full-page spreads, crossing the gutter of the page, are worth noting separately, as they occur only twenty times throughout the book and are oversized, 14¼ by 21¼ inches. Timeless images in each country are shown with little evidence of industrialization, of modernity, or of post-war urban life. The first full two-page spread—only the second image in the book—is of a timeless olive grove in the Peloponnese, featuring a donkey pulling a tiller (plate 2; figure 114). The second, plate 12, shows a group of seminarians walking through the Italian countryside. In Germany, Cartier-Bresson presents a two-page spread

of a view of unemployed workers in a Hamburg shipyard canteen (plate 25; figure 115). In England, Cartier-Bresson frames suburban rooftops (plate 42) and the fishmongers of Billingsgate (plate 43). In Austria, suits of armor line up in a Carinthian castle (plate 51). In Ireland, a horse blocks a rural road in the Dingle peninsula (plate 54), the image followed by one of a man at a horse auction in Curragh; the horse is not chewing a straw, but the man is (plate 57). In the USSR, a woman holds her infant as she stands across the river from the Kremlin (plate 60), a man lounges in a field with his cattle (plate 66), a woman works at her loom in a textile mill (plate 67), and, in plate 71, women workers dance. In Italy, the timeless photograph of an interior of a peasant's home (plate 77) is followed by a rural scene of a field near San Gimignano (plate 79) and by another full plate of a night-lit square in Verona (plate 89). At the end of the book, in its return to France, full plates depict timeless fishmongers in Marseille (plate 98), a political meeting at the Porte de Versailles (plate 103), and a young couple in the Latin Quarter (plate 104). The lack of contemporary details is striking.

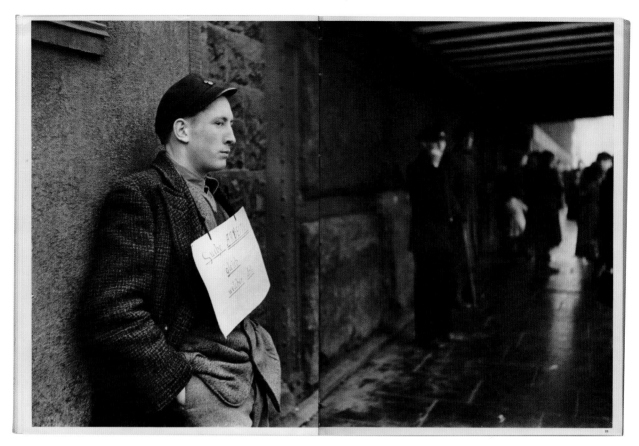

FIGURE 115 Plate 25, *"I am looking for work, any kind,"* from Henri Cartier-Bresson, *Les Européens* (Paris: Verve, 1955). Gravure, spread: 14 ¼ × 21¼ in. (36.2 × 54 cm).

As in *Images à la sauvette*, Draeger's gravure printing process and the book's expensive Helio Afnor VII paper together produce a series of images with rich black, gray, and light tones; these images are far richer, tonally, than the silver prints from which they were made. The result is an extraordinarily beautiful book that removes the images from everyday life with a kind of ahistorical formal elegance. In images such as a young couple in the Latin Quarter, the bodies are so large that they are half-scale reproductions of human size; we seem to interact with them as if with sculptural busts. And the little boy with his wine bottle, the book's last image, seems ready to hand over his heavy bottles to us—they are fully three inches tall on the pages of the book (see figure 96). This is an artifice of the printing process and overly large image size; it is striking but also aestheticizes real life.

When *The Europeans* came out in the United States, a *New York Times* critic praised it but found it slightly less compelling than its predecessor, writing, "Mr. Cartier-Bresson appears to have slightly relaxed the quality of

instantaneous organization, the disciplined 'arrangement' of the frame-finder image in a moment of alert seeing, which marked his earlier work and set a widely imitated pattern. As a result, his compositions now appear to be freer, more spontaneous. One is less conscious of composition, more aware of the essential human content."[73] In recognizing the relaxing of the strict geometric framing that characterized *The Decisive Moment*, the *Times* critic notes the second book's essentializing humanism, but omits mention of the nations covered in this grouping. But in moving on to Cartier-Bresson's other two book projects, we must consider the inclusion of Russia in a new light. In *Les Européens*, Russians are depicted as timeless and apolitical figures, pictorially similar to the French or the Irish and seemingly apart from the Soviet Union. But Cartier-Bresson had been hard at work on simultaneous, more journalistic portrayals of China and of the USSR from behind the Iron Curtain, showing both countries experimenting with forms of government antithetical to humanism.

In contrast to Cartier-Bresson's two formalist, monographic overviews, *Images à la sauvette* and *Les Européens*, two smaller books published at this time reflect his identity as a Magnum photojournalist: *D'une Chine à l'autre* (*From One China to the Other*) (1954 and 1956) and *Moscou* (*The People of Moscow*) (1955). These China and Moscow volumes feature groups of images that are more similar, though not identical, to his magazine picture-stories and that include more context, both books heavy with extensive historical captions. Understandably, the captions themselves reflect Cartier-Bresson's experiences at his picture agency, Magnum, and a letter from fellow Magnum photographer Robert Capa explicitly reminds his friend of "the absolute importance of readable texts and full captions. When you shoot a story get all the details of each picture, and when you finish get yourself a typist and dictate the maximum amount to her."[74] Images join with words to retain elements of the humanistic photographic approach, though the two communist regimes stood opposed to humanism, and Cartier-Bresson expresses a sympathy for the workers. Overall, however, the books present a more tepid political commentary than Doisneau's activist French communist sympathies in *La banlieue de Paris*.

The images in *D'une Chine à l'autre* were printed on November 30, 1954, by Draeger, and the book was published by Robert Delpire as the fourteenth volume in his collection *Neuf*. This collection highlighted photographers such as Brassaï and Robert Frank and included volumes on other countries and cities; Cartier-Bresson's *Moscou* would appear in the same series the following year. The tomes in the *Neuf* series, designed by the renowned book designer Pierre Faucheux, measure only 10½ by 8½ inches, considerably smaller than the 14 by 10½ inch pages of *Images à la sauvette*. Delpire specifically advertises *D'une Chine à l'autre* as a "journal made in images by a reporter-photographer," adding, "it constitutes an astonishing historical document in which both simplistic picturesque imagery and partisan spirit are excluded."[75] The book attempts to distance itself from any particular side of the fight, presenting both old and new regimes, and documenting a transition from the old "Celestial Empire" to the communist government.

In his introduction to *D'une chine à l'autre*, Cartier-Bresson himself writes, "This book is the diary of a journey in China, a diary kept by a photographer-reporter,

for the most part in pictures." By naming himself a "photographer-reporter" in the first sentence of the book, Cartier-Bresson clearly positions himself on the journalist side of his journalism–artist spectrum. He had received a telegram from Magnum on November 25, 1948, stating: "Earliest plane presumably Tuesday November thirty to China to do story called quote the last time we saw Peiping unquote asking for extensive coverage," and asking for specific topics from scholars to merchants to craftsmen to camel train drivers showing "the character of Peiping and expressions of a people."[76] The photographer proceeded to live in China for eleven months, from early December 1948 to late September 1949, on assignment for *Life*.

Cartier-Bresson's first *Life* article about China appeared on January 3, 1949, and *Life* editor Wilson Hicks telegraphed his thanks: "Your Peiping in January Three issue as nine page lead. Thanks and congratulations for superb job."[77] The article depicted a sense of history and tradition despite the political upheavals. Over the next ten months, Cartier-Bresson traveled to the Shantung peninsula to report on the People's Army, and then returned to Shanghai, Hangzhou, and Nanjing, typing hundreds of pages of notes for his images. In Nanking he "witnessed the departure of Chiang K'ai-Shek's last supporters and the arrival of the People's Army," recording the transition from April to July 1949 before returning to Shanghai. He left Beijing on the last plane before the communists arrived in the city. Cartier-Bresson's articles for *Life* at the end of these ten months showed a growing awareness of the contrast between new and old regimes, in images of workers beneath looming posters of communist leaders, as well as energetic views such as the students demonstrating (plate 121; figure 116). Cartier-Bresson clearly saw the long history of China being disrupted, and in a later book, *China*, he described his reaction upon returning a decade later: "What are the Chinese now like? I would answer they are 3000 years old—plus thirteen."[78]

Although Cartier-Bresson's images appeared in *Life* and *Paris-Match* almost immediately after their submittal, publication of a book took time. *D'une Chine à l'autre* was published in France only in 1954, in Germany in 1955, and in Italy and the United States in 1956. In New York, however, Simon and Schuster refused to publish the English edition, finding it too politically sensitive; the 1956 American edition was published by Universe, two full years after the French, as *From One China to the Other*.[79]

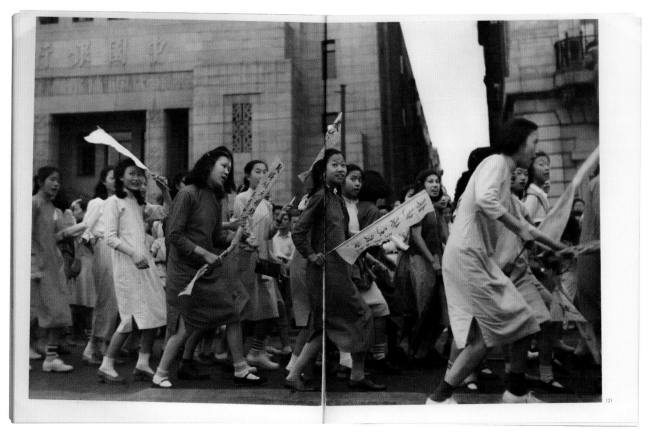

FIGURE 116 Plate 121, *Students Marching against the Black Market,* from Henri Cartier-Bresson, *D'une Chine à l'autre* (Paris: Delpire, Collection Neuf, 1954). Gravure, spread: 10½ × 16⅝ in. (26.5 × 42.2 cm).

Although the texts differ, both French and English editions are divided into the same sections: "The Celestial Empire" (thirty-four images), "From Day to Day" (nineteen images), "The Last Days" (twenty-five images), "The Interregnum" (twenty-seven images), "Celebrations and Planning" (twenty-nine images), and "Departure" (ten images), and the book ends with an outline of Chinese history. Each section has a lengthy descriptive caption that gives both location and political history for the images. Although several photographs are one and a half pages wide, only eight images spread across the gutter to form two-page spreads: plates 2, 15, 50, 56, 57, 61, 85, and 121. The first, plate 2 in "The Celestial Empire" section, presents a solitary pedestrian in the Forbidden City, offering a contemplative view of the woman walking in front of the historical architecture. Plate 50 shows Nanjing with a crowd of peasants hoping to cross the Yangtze River, the first of a series of double-page crowd scenes.

A group of three large images dominates "The Last Days" section, with plates 56 and 57 showing the two scenes of the Shanghai gold rush of December 1948, when ten people were crushed or trampled. The first, plate 56, presents people (including a pregnant woman) waiting patiently in line (figure 117). In contrast, the second, famous image presents the crush of bodies that killed its participants, in a frieze-like, flattened structure of piled-up bodies with a variety of expressions ranging from smiles to grimaces. This second image had already been published in *Images à la sauvette,* with a less politicized caption (see figure 105).

In the section "Celebrations and Planning," plate 121 has a comparable flat structure—the previously mentioned procession of students demonstrates along the Shanghai Bund against the stone backdrop of the powerful Bank of China building (see figure 116). In *Images à la sauvette,* these two last pictures are taken slightly out of context, presented back to back to create a formal dialogue of figures against a frieze-like wall in a shallow space. In this book, they are part of a longer photo-essay about current events in China at a particular time and political moment, as the

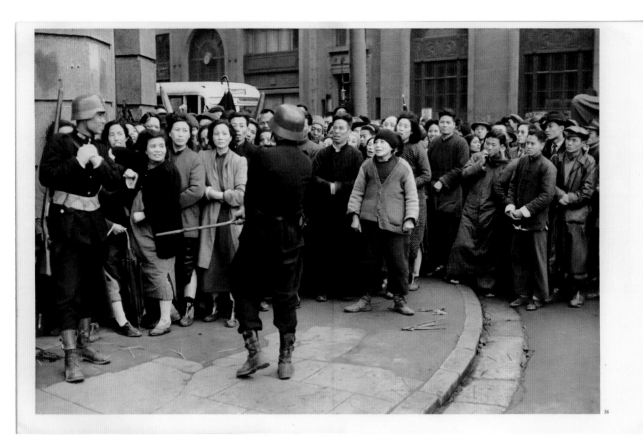

FIGURE 117 Plate 56, *Shanghai, December 1948. The Gold Rush,* from Henri Cartier-Bresson, *D'une Chine à l'autre* (Paris: Delpire, Collection Neuf, 1954). Gravure, spread: 10½ × 16⅝ in. (26.5 × 42.2 cm).

communists took over the Chinese government. The dual uses of the imagery show that Cartier-Bresson's images could serve both his artistic side and his reportorial needs, although the longest afterlife of the images is in *Images à la sauvette,* where he allows the artist to overtake the reporter for a more universal commentary on Western culture and non-European cultures.

Interestingly, many decades later, in 1987, Cartier-Bresson discovered in his archives a lost 1949 maquette for a book that was, as a whole, much more overtly political than *D'une Chine à l'autre.* One image from June 1949 in Shanghai, also reproduced in *D'une Chine à l'autre,* depicts a devastating scene of a mother and child sitting glumly among explosion debris that has reduced their home to a set of matchsticks (plate 96; figure 118). Cartier-Bresson's notes from the time reveal a politically charged reaction: "At the end of June KMT planes were coming over the city. . . . They missed their target by a long distance and they landed in Hutei Road in Chapei on mud and straw huts of a densely populated area. It looked like semi-detached

Christmas cribs torn to pieces by a gale." But this long-lost maquette was never published, and the few images, like this one, that did enter the published work are accompanied by much tamer captions: "The Kuomintang air force bombed Shanghai. The bombs fell in the suburbs and caused numerous casualties among the population who lived crowded in straw huts."[80]

In a more evenhanded approach than his 1949 China maquette or his *Life* articles made the year of the Chinese revolution, *D'une Chine à l'autre* flattens out its history five years after the fact. One image shows a man eating from a bowl in front of a wooden building with another man looking out of a window, a beautifully composed geometric composition of windows, frames, diagonals, circles, and wood that juxtaposes the active act of eating with contemplative thought (plate 15; figure 119). This scene could be from any decade or any century, and offers no clues to current political events in China.

The 1954 French edition of *D'une Chine à l'autre* featured a preface by Jean-Paul Sartre, who contributed an

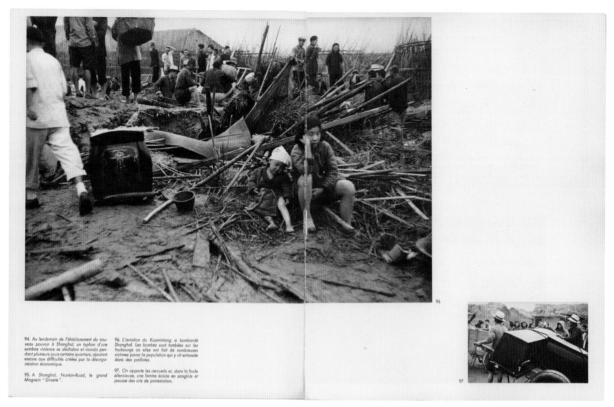

FIGURE 118 Plate 96, *The Kuomintang Air Force Has Bombed Shanghai,*
from Henri Cartier-Bresson, *D'une Chine à l'autre* (Paris: Delpire,
Collection Neuf). Gravure, spread: 10½ × 16⅝ in. (26.5 × 42.2 cm).

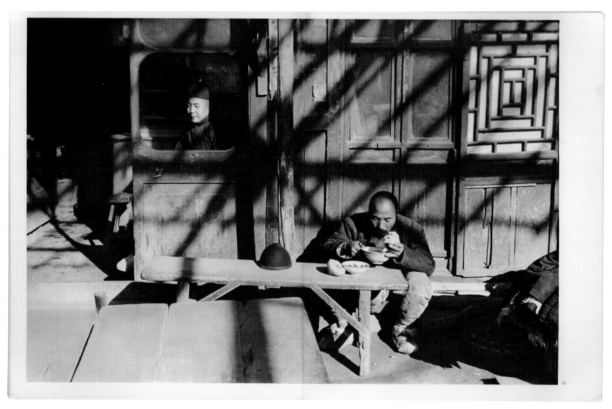

FIGURE 119 Plate 15, *A Peasant Sits to Eat His Meal,* from Henri Cartier-Bresson,
D'une Chine à l'autre (Paris: Delpire, Collection Neuf, 1954). Gravure, spread:
10½ × 16⅝ in. (26.5 × 42.2 cm).

important essay on colonialism here. Sartre, of course, was a famous and Marxist-inspired commentator on colonialism; for him, native subjects are always under the control of colonizers, much as employees are always under the control of the corporation under capitalism.[81] He denounces the picturesque, writing, "The picturesque has its origins in war and a refusal to understand the enemy: our enlightenment about Asia actually came to us first from irritated missionaries and from soldiers." He cites the older European colonialist tropes of noting difference: "I cut my hair, he plaits his; I use a fork, he uses chopsticks. . . . This is called the game of anomalies: if you find another one, if you discover another reason for not understanding, you will be given a prize for sensitivity in your own country." He condemns this in colorful language, noting the trap of overgeneralization. Sartre credits the travel writer Henri Michaux with beginning to demystify the Chinese (*A Barbarian in Asia*, 1933). Then, "a quarter of a century later, Cartier-Bresson's album completes the demystification. . . . Cartier-Bresson's photographs never gossip. . . . His Chinese are disconcerting; most of them never look quite Chinese enough." In other words, "they are human beings." He argues that cultural difference has to be learned, whereas "what unites us can be seen in an instant." Sartre celebrates the new factuality that he sees in Cartier-Bresson: "The picturesque is wiped away, farewell European poetry; what remains is the material truth." The snapshot allows this instantaneous brotherhood. Sartre finds that in Cartier-Bresson's instantaneous snapshots, a universal equality is achieved: "Cartier-Bresson's snapshots catch people at high speeds without giving them time to be superficial; at a hundredth of a second we are all the same, all of us at the heart of our human condition."[82] Therefore, in debunking the picturesque otherness of Orientalizing imagery, Sartre makes a first, although very conflicted, step away from European imperialism toward appreciating the emotional life of all people.

Sartre continues with a specific comparison, and deliberately invokes the Europeanizing notion of the "Other," in order to debunk it: "Consider this Chinese coolie as a grasshopper, and you immediately become a French frog. By getting your models to pose, you allow them to become other. Other than you, other than people, other than themselves." But in stepping away from the cultural definition of cultured Europe in opposition to pagan China, Sartre falls into another trap. When he writes "we are all the same," he risks another kind of simplifying, an erasure of cultural distinctions that makes all citizens a part of what Edward Steichen was calling "the family of man."[83] And *D'une Chine à l'autre* was published within a year of *The Family of Man* exhibition.

In discussing the crowds that Cartier-Bresson frames in his classical, frieze-like compositions, and in sympathizing with the communist takeover, Sartre (somewhat simplistically) finds them comforting. He recalls Parisian occupation by the Germans, and on the last page of his essay, he refers back to June 1940: "Remember June 1940, and those funeral giants who raced across a deserted Paris in their lorries and their tanks? Now that was picturesque; not much voluptuousness, but blood and death, and a lot of pomp. The Germans wanted a ceremonious victory." In contrast, he appreciates these Chinese crowds: "They do not swarm about, or very little, they organize themselves. . . . No one has the right to confuse this swarming with a plague of locusts. Chinese crowds are organized." Even in the crowds of the gold rush in Shanghai that killed several people, "these Chinese multitudes seem neither terrible nor even foreign. They kill but bury the dead within their midst and drink up the blood as blotting paper soaks up ink: gone without a trace. Our crowds are more angry, more cruel."[84] Of course, Chinese crowds are not necessarily more ordered than any others; Cartier-Bresson's geometric compositions create this illusion of an orderly "other" that Europeans can feel comfortable with, in a moment when the threat of communism was expanding rapidly.

Douglas Smith, in his insightful article on *D'une Chine à l'autre*, analyzes the question of whether this book presents a kind of neocolonialist ideology or whether it demystifies it. Susan Sontag has a less diplomatic way of phrasing this thought, wryly writing, "When Cartier-Bresson goes to China he shows that there are people in China, and that they are Chinese." She has little patience for humanistic photography. Smith, on the other hand, looks at the multiple contexts of his images—for instance, the gold-rush crush image in Shanghai—and sees that it was published in one context in the book, in a second context in the first edition of *Paris-Match* in March 1949, and as a more isolated and decontextualized image in Steichen's *The Family of Man*. He overlooks the fact that Cartier-Bresson himself published this image both as a political commentary—in the China book—and as an isolated classical and eternal image in *Images à la sauvette*. In general, however, Smith realizes that *D'une Chine à l'autre*

is "a piece of photojournalism rather than an exercise in art photography." He recognizes that the photographer reordered the chronological sweep of the photographs to allow the book to follow from the fall of nationalist China to rebuilding a communist regime.[85]

The American edition, published two years after the first French edition, is titled *From One China to the Other*, and features a preface by Han Suyin, a pro-communist Eurasian doctor and author who was one of the earliest Chinese-born foreigners to return to communist China, chosen to write because Sartre was far too radical and certainly too Marxist for an American audience. Author of the 1955 autobiographical novel *A Many-Splendoured Thing* (later to become the film *Love Is a Many-Splendored Thing*), Suyin directly addresses possible American discomfort with the new regime. She writes, "I know that many people in the United States will . . . see sullen, driven slave labor, compelled to backbreaking toil, and hating the tyranny that lords over them. They will think of a herded and compliant youth, fanatically imbued with political creed, hastily trained to become cogs in the wheels of a merciless and tyrannical state machine. It is not so. There is a compelling enthusiasm, obvious and too genuine not to move and stir one deeply, however critical of its imperfections one may be."[86] By 1964 Cartier-Bresson had himself grown more optimistic about the Chinese situation, writing, "Having rebelled so often against feudalism in their 3000 years, the Chinese peasant now sees a chance to leave serfdom behind forever. In consequence, China is in full historical renaissance."[87]

MOSCOU

In the summer of 1954, at the height of the Cold War, Cartier-Bresson received a visa to travel in Moscow, and left with his wife on July 8 to spend the next several months photographing behind the Iron Curtain. His photographs were quickly published in two lengthy stories in *Life* in January 1955; one image of two soldiers watching two young women was featured on the cover. *Moscou (The People of Moscow)* included that cover image, and the book was produced by Delpire's Éditions Neuf in 1955, with simultaneous editions in France, the United States, Italy, England, and Germany (see figure 109).[88]

Cartier-Bresson was the first European photographer allowed in the Soviet Union since 1947, and the publication of his images in *Life* (January 17 and 31, 1955) and elsewhere garnered great fanfare.[89] Together with *D'une*

Chine à l'autre, Moscou clearly played a cultural role in the geopolitical jostling between democracy and communism in the Cold War of the mid-1950s. In a letter to John Morris at Magnum in New York, Richard Simon writes, "Henri, like us, hopes this book will be a big success, not only commercially, but that it will also be successful in bringing about an easing of tensions between the Russian people and the American people. Henri's book could bring this about, but there are certain pitfalls that must be avoided, especially in the fields where it seems to the American reader that Soviet propaganda is being crammed down his throat."[90]

Although the transition from magazine to book seemed relatively speedy, finalizing captions was a challenging project, especially in the translation phase. Nina Bourne, aided by Trudy Felieu and Kay Lawson at Magnum, translated them, noting in a letter to Simon that they were in "a pretty fuzzy state." The book's American production also required a certain amount of diplomacy, since Cartier-Bresson was also producing the book on China at the time with the French publisher Delpire—the same book that Simon and Schuster was not willing to publish. The Soviet Union seemed to be a less sensitive subject, and from New York, Simon tried a balancing act, writing to Cartier-Bresson and suggesting that "we bring out the Russian book into an area of minimum hysteria attached to the name of Henri Cartier-Bresson. . . . The Russian book should come first and that a decision about publishing the Chinese book can be made thereafter on the basis of what would be best for the additional great books which you are planning to produce with your camera."[91] Simon and Schuster never did produce the book on China; *From One China to Another* was published in the United States by Universe Books in 1956.

This journalistic glimpse of the Soviet Union behind the Iron Curtain held a wide appeal, and the book's international distribution suggests a far wider distribution than the more rarified art-world publications of *Images à la sauvette* and *Les Européens*. Rather than concentrate on politics, Cartier-Bresson clearly stated in the forward that "my main interest was in people." He wished to "capture a straightforward image of the people of Moscow going about their daily life, to catch them in their ordinary acts and their human relationships. I fully realize how fragmentary that image is, but so much is certain: it represents my visual discovery faithfully." He writes:

I had never been in Russia before and was eager to start working at once. I was not sure, however, if I would have the facilities to photograph as freely as I am accustomed to elsewhere. . . . But in Moscow, I was told that foreigners could photograph everything freely with the exception of certain military objectives, railway centers, panoramic views of cities, and certain public monuments, for which an official authorization was required. I was asked what we would like to see. I explained that my main interest was in people and that I would love to see them in the streets, in shops, as work, at play in every visible aspect of daily life, where enough goes on so that I could approach them on tip-toes and take my photographs without disturbing them.

The reactions he received back in Paris made him realize, as in a rear-view mirror looking back from France, "the distance that lies between us and the country we had just left." He found that many responded with preconceived views but for those asking, "What did you see?," he responded apolitically, "Let my eye speak for me."[92]

Moscou is divided into eleven separate sections, with 163 images separated into groups about the Kremlin (fifteen), the street (fifteen), shops (twenty-four), the subway (ten), museums (nine), religion (eight), Sports Day (sixteen), agricultural exhibitions (ten), entertainment (eighteen), "the shows" (nineteen), and youth (nineteen). Although the book is smaller than *Les Européens,* it features a number of full-page spreads. It is also more documentary in mode, with a clear concentration on contemporary life, rather than the timeless peasantry of *Les Européens.* For instance, we see urban crowds crossing streets and standing in line, and shops that display a variety of customers, such as a girl and her mother before a department store window (plate 37), and a uniformed father holding his baby (plate 41). Displays of youthful and beautiful children and athletes bear a resemblance to Leni Riefenstahl's photographs for the Berlin Olympics, especially in plates 89 and 90, with their views of the fit young athletes at the sports festival (figure 120). Despite Cartier-Bresson's insistence that these images represent people in their everyday life, we see no poverty, no slums, no suffering in these images; the photographs are a deliberately positive view of Russia.

FIGURE 120 Plate 89, *Boxing Society of Moscow,* from Henri Cartier-Bresson, *Moscou vu par Henri Cartier-Bresson* (Paris: Delpire, Collection Neuf, 1955). Gravure, spread: 10½ × 16⅝ in. (26.5 × 42.2 cm).

FIGURE 121 Plate 82, *Vive le Sport!*, from Henri Cartier-Bresson, *Moscou vu par Henri Cartier-Bresson* (Paris: Delpire, Collection Neuf, 1955). Gravure, page: 10½ × 8¼ in. (26.5 × 21.1 cm).

The presentation is distinctly more modern than that of the views of timeless Russians in *Les Européens* published that same year; here we see factories, shops, modern buildings, and industrialization.

Les Européens and *Moscou* include a few duplicate images of Russia, one being a parade of young men with flags on a Sports Day (*Les Européens*, plate 65; *Moscou*, plate 82; figure 121). In *Moscou*, Cartier-Bresson delves further into his subject and surrounds the photographs with other pageantry images from Sports Day, and the caption informs us that the sports clubs parade while they chant, "Hail the Communist Party, Hail the Soviet Government, Hail! Hail! Hail!" In *Les Européens*, in contrast, the caption is more muted: "Every year, in July, Sports Day is celebrated throughout the country. The celebrations are particularly brilliant in Moscow, where delegations from all Soviet Republics convene." Both images somewhat naïvely celebrate the youth and sports culture of the USSR, with little trenchant social commentary. In *Les Européens*, instead of *Moscou*'s whole topical grouping on paramilitary display, this Sports Day image resides in a more ahistorical series of pages, bookended by a guard at a museum on one side and a timeless-looking young cattle-herder lying in a field surrounded by his cattle on the other.

THE FAMILY OF MAN IN PARIS, 1956

As we have seen, the four books that Cartier-Bresson produced between 1952 and 1955 embody important contradictions and emphases that reflect the 1950s: a cool, classical style that depicts a series of topical events; the not-always-seamless juxtaposition of art and photojournalism; an individualistic and even existentialist concentration on the individual in modern life; an awareness of the great debate of the 1950s between capitalism and communism; and a commentary on the end of European colonialism and emerging nation-states in Asia and Africa. Cartier-Bresson's Moscow and China books are more like photojournalism stories, but his most beautiful art books, *Images à la sauvette* and *Les Européens*, do not exist outside history, despite his suggestion that they do. Instead, their deliberately aesthetic and cool tones reflect a cool response to the hot-button issues of the Cold War and the nuclear arms race of the 1950s. On one hand, Cartier-Bresson uses his black-and-white compositions to even out the great historical conflicts he observes—the end of the war, the end of colonialism, and the end of innocence after the Holocaust and atomic bombing of Hiroshima. Although this is an oversimplification, in *Images à la sauvette*, the photographer segregates Asians in the second half of the book; in *Les Européens*, he excludes them altogether; and in his separate books about China and Russia, he isolates non-European cultures into separate categories.

Cartier-Bresson's flattening of history to a universalist human story shares more than a few links to Edward Steichen's *Family of Man* exhibition at the Museum of Modern Art in 1955.[93] The year after *Les Européens* and *Moscou* were published, Steichen's *Family of Man* exhibition traveled to the Musée des Arts Décoratifs in Paris in 1956 as part of its global tour. If we are to consider this exhibition as the apogee of international photographic humanism, Roland Barthes's reaction to the Paris viewing of that show both gives us insight into its reception and shows one of the first cracks in the power of humanistic photography; it would lose its force as a language for cultural expression within the next two years. Poetic realism had its limits, and now a more cynical view of the world was slowly coming into being, one that would be expressed differently in photographic books after 1958.

Close to a dozen Cartier-Bresson images were included in *The Family of Man* exhibition, and there are subtle differences in how Steichen and Cartier-Bresson approached otherness and the concept of grappling with

what Euro-Americans found "strange." Steichen grouped images to collapse international boundaries into global humanist themes such as weddings, the land, eating, worship, uprisings, people in government, and children's joy. For instance, in *The Family of Man,* Cartier-Bresson's women in Kashmir are folded into the universal category of "worship," and his crushed bodies in the Shanghai bank rush form a part of a global collection of "uprisings." Of course, Steichen's solution is to make everything look like a Western democratic family, and Cartier-Bresson's book makes the "other" cultures into static stage sets, safely containing them visually.

Barthes's review is one of a series of essays he wrote in Paris from 1954 to 1956 during a time when he was "trying to reflect regularly on some myths of French daily life" (the essays were later published as *Mythologies*). Unlike Sartre, who seems to have accepted the artifice of Cartier-Bresson's humanistic framing of his subjects, Barthes resented the "'naturalness' with which newspapers, art and common sense constantly dress up a reality which . . . is undoubtedly determined by history. . . . I resented seeing Nature and History confused at every turn." He felt that the "notion of myth" could explain these "examples of the falsely obvious," while understanding that myth, too, is a language of its own. The myth of *The Family of Man* exhibition, for Barthes, shows exoticism in the variations of human forms all brought together: "From this pluralism, a type of unity is magically produced: man is born, works, laughs and dies everywhere in the same way." In a view that was rare in the 1950s, Barthes expresses ultimate scorn for such a universalist notion, writing that all photographs, "however universal, . . . are the signs of an historical writing." He proves this through the exhibition's images of birth, death, and work, arguing that however universal the composition, "it will never be fair to confuse in a purely gestural identity the colonial and the Western worker." He wishes instead for "an entirely historified work which we should be told about, instead of an eternal aesthetics of laborious gestures."[94] Therefore, although he does not specifically address Cartier-Bresson's *Images à la sauvette* or his other three books, Barthes dislikes the idea of universalizing or aestheticizing images, and by extension, the depoliticizing imagery of French humanist photography. Edward Steichen's voice and Henri Cartier-Bresson's vision, both using what Eric Sandeen calls "a positive approach toward human attributes" whose "lasting imprint on the individual viewer was made on

the heart and not the head," were passing out of fashion.[95] *Images à la sauvette,* while immediately compelling, ultimately cast a much shorter shadow on the second half of the twentieth century than did Robert Frank's 1958 book, *Les Américains,* a book that symbolizes a much bleaker and less optimistic photographic voice that was coming to the fore.

Frank's different worldview was already developing during the mid-1950s. He was not a fan of Cartier-Bresson's when *Images à la sauvette* came out, writing, "You never felt that he was moved by something that was happening other than the beauty of it, or just the composition."[96] Frank's less-than-enthusiastic reaction to Cartier-Bresson's book was mirrored in the book's sales records. Compared to *Paris de nuit,* which had sold twelve thousand copies during its first year, *The Decisive Moment* sold only 3,500 copies in the United States.[97] *Images à la sauvette* (*The Decisive Moment*) was not reprinted for more than half a century, and when it was finally republished in 2014 (again in two languages), sixty-two years after its first appearance, it had lost its immediacy. In a 2014 review in the *Guardian,* Sean O'Hagan writes, "For me, what is interesting about the republishing of *The Decisive Moment* is that it has happened too late. The book is now a historical artefact." This is partly because of the advent of color, he writes, but the book's "black and white, acutely observational, meticulously composed, charming" qualities have been supplanted by conceptualism and "deeper, darker narratives."[98]

Although Cartier-Bresson grappled with swirling debates about art and journalism, capitalism and communism, his books, finally, are an indelible mark of their times, the period in the first decade after the war when humanist photography represented a return to a more respectful or universalizing view of individuals. In this period colonized countries in Africa and Asia were just beginning to break their ties with Western Europe, and Cartier-Bresson was a witness to this liminal time. His mix of geometry, classical form, and the instantaneous moment caught on film were a powerful mirror for this moment, an attempt to make sense of the world rather than to change it. In the next few years, and especially in the 1960s, however, photography would become a tool for revolution rather than nostalgia.

CONCLUSION
Transitions: From Paris to New York and Japan

I had used up the single, beautiful image. I was aware that I was living in a different world—that the world wasn't as good as that—that it was a myth that the sky was blue and that all photographs were beautiful.

—Robert Frank

I was fed up with the pretended objectivity and Invisible Camera ethic of the day. I decided to be visible, intervene, and to show it. Shades of Brecht but also a distanciated paparazzi.

—William Klein

As we have seen, a poetic realist voice of photographic humanism reemerged at the end of World War II in an effort, as Jean-Claude Gautrand writes, to "promote hope and encourage dialogue in order to prevent tragic events [from] happening again." Although humanist ideas began in the 1930s and found their most evocative voice in postwar France, other international photographers followed suit in later years, as can be seen in the large range of photographers included in *The Family of Man* exhibition in 1955. Robert Frank's work was included in the exhibition, but his photographs were an uneasy fit for the show; they were a harbinger of a blacker, more sinister vision of the world. Frank overtly disliked the emotional distance he saw in Henri Cartier-Bresson, writing, as mentioned in the last chapter, "He traveled all over the god-damned world, and you never felt that he was moved by something that was happening other than the beauty of it, or just the composition."[1]

CACAPHONY AND DISRUPTION
By the mid-1950s and into the end of the decade, in the midst of the Cold War and the McCarthy era, photography's poetic interest in "the human being" was shifting

to a darker and more ironic stance, best exemplified by Frank's pessimistic views in *The Americans* (first published as *Les Américains* in France in 1958) and by an American-born photographer living in France, William Klein, whose *Life Is Good and Good for You in New York: Trance Witness Revels* appeared in Paris in 1956. These two books mark the end point of Paris as the most innovative center for photographic book publishing and simultaneously point to its successors: New York and Tokyo. Frank and Klein represent a new generation, a quarter-century younger than most photographers discussed in this book—notably, too young to fight in World War II—and their books look forward to a whole generation of 1960s and 1970s photographers who would use chaos and disruption as a creative medium. They continued to employ the earlier formal strategies of montage, dream imagery, elegy, and even a sardonic form of nostalgia, but in an explosive new form of "making strange" that was politically much more pessimistic than the interwar and immediate postwar books. There were significant differences between the two. The beat poet Jack Kerouac saw Frank as a tragic poet, but, according to Raymond Grosset, who ran the RAPHO agency in Paris and who was a strong advocate for the

humanist tradition, Klein was the opposite: he "liked to mock people." Klein was clear that "the accent on [French] humanism was not my thing"; he found it sentimental.[2]

Frank was born in 1924 in Switzerland and spent the war as a student in that neutral country. He lived in Paris from 1949 to 1952 before coming to New York and eventually moving to Canada. Klein was an American born in Brooklyn in 1928 who was old enough to join the Army only in 1946; he was stationed in postwar Germany. Klein enrolled at the Sorbonne in 1948 and has spent the rest of his life in Paris. From their Parisian vantage points, both engaged with New York and with the newly emerging superpower, the United States, in a politically critical dialogue that the previous generation of French photographers had avoided.

Both photographers wrote of the "America" that they saw with some skepticism from their Parisian milieus, although their photographic interpretations varied. Frank acknowledged that what he expected to see "when a European eye looks at the United States" included class distinctions as well as consumer culture: "a town at night, a parking lot, a supermarket, a highway, the man who owns three cars and the man who owns none, the farmer and his children, a new house and a warped clapboard house, the dictation of taste, the dream of grandeur, advertising, neon lights, the faces of the leaders and the faces of the followers, gas tanks and post offices and backyards."[3] Klein, on the other hand, had "left as a kid and now I was coming back in my mid-twenties," and he remembers both politics and popular culture:

> Coming back from Paris, I disembarked right in the heart of the Fabulous Fifties. I don't know whether I realized that America was in the process of inventing post-war culture, colonizing the planet. I do remember I wasn't that impressed. But what was going on? Among other things, McCarthy's Soviet style witch hunts, CIA putsches in Iran and Guatemala, the McDonald brothers opened a hamburger Hut in San Bernardino, the Beatniks were on the road, Elvis made his first recordings, a Little Rock high school was desegregated, Levittowns flourished, so did Marilyn, Brando, H-Bombs, the Pill, Rebels without Causes, shopping centers, electric guitars, space talk, Blackboard Jungles, white Rock & Roll, and above all, in monster wood cabinets, television. So, decidedly, the best of times and the worst of times.[4]

If Cartier-Bresson's two art books and two journalistic books showed the aesthetics and the neocolonial concepts of the early to mid-1950s in France, these two photographers punctured both the bubble of accepted French formal compositional devices and the photojournalistic mantra that drove Cartier-Bresson and Magnum photographers. Klein was self-conscious about this, writing, "I had a peculiar kind of double vision, one eye almost Parisian, the other an incorrigible wise-ass New Yorker."[5] Frank's approach, on the other hand, was more earnest, and he grew dismayed by what he saw. But as the critic Max Kozloff writes, both transplanted photographers "found live and visual metaphors for the bleakness of this Cold War moment and the deadness of things in it. . . . One cannot suppose that the photographers had anything as simple as sympathy for what they saw. It's a question, rather, of their having developed an unlikely poetry as they came of age, to express their awareness of their time."[6] In the grainy quality of their prints and the chaotic organization of their books, that poetry took a formal aspect that can even be seen as a visual physical manifestation of the shards thrown out by the atomic bomb—a language that soon would resonate particularly strongly in Japan.

Both photographers knew from the start that they wished to present their series of images as books. Klein wrote, "Not only was I convinced it would be a book, I intended it to be THE book," and when Frank applied for a Guggenheim fellowship to photograph in the United States, his application specifically refers to a book and magazine publication by Robert Delpire in Paris and to Arnold Kubler, editor of the Swiss magazine *DU*, who planned an entire issue of this material.[7] Tellingly, both books were first published in France, because no American publisher would easily accept their ruptures with earlier modes of depiction—or their less than rosy views of the New World. Even in the transition toward a new era, Paris book publishers were seminal figures and champions of transgressive projects. With their cooperation, Frank created a measured pattern in his book with a slow but syncopated rhythm that paralleled jazz riffs; Klein, on the other hand, intentionally used filmic metaphors, breaks, and compositional devices.

This look at Frank and Klein continues and completes the dual vision of *Making Strange*, which is as much a tale of publishers and presses as it is a story about photographers. We have already seen the impact of the Librairie

NEUF

NUMÉRO 8
CONSACRÉ A ROBERT FRANK
DÉCEMBRE 1952

FIGURE 122 Cover of Robert Frank, *Indiens des hauts-plateaux,* Neuf no. 8 (Paris: Delpire, 1952). Gravure, page: 11 × 8⅝ in. (28 × 22 cm).

des Arts Décoratifs in the 1920s, Charles Peignot's Arts et Métiers Graphiques in the 1930s, small presses like the postwar Éditions du Compas, and Tériade's Verve editions. The end of this list must highlight the important 1950s publishing projects of Robert Delpire, who published Cartier-Bresson's and Frank's books, and of Chris Marker at Éditions du Seuil, publisher of Klein's book.

ROBERT FRANK'S *LES AMÉRICAINS*

To understand *Les Américains* as a product of the French modernist photography world—rather than as the icon of American book publishing that it has become—it is important to study Delpire's 1958 French edition, as opposed to the much better-known American Grove Press edition of 1959. As Michel Frizot writes, *Les Américains* was "not a breakthrough moment, as a mythifying hagiography

would have it," but rather a logical outgrowth of the nearly thirty publications that Delpire had produced by the time he published Frank's book in 1958.[8] Rather than a purely American-centric volume, it formed part of a long series of photographic anthropological studies published by Delpire, including books on Seville, Japan, Bali, the Nuba peoples of Sudan, two volumes on South American Indians, and, of course, Cartier-Bresson's books on China and Moscow discussed in the previous chapter.

Delpire's rise as an influential publisher began in 1950. He was an admirer of Brassaï and a friend of Henri Cartier-Bresson, whose *Images à la sauvette* impressed him greatly. From 1950 to 1953, Delpire published nine issues of *Neuf* (which signifies both "new" and "nine" in French), a journal for the Maison de la Médecine. He then transformed *Neuf* to a book format, with issues on individual

Et il faudra aller ailleurs.

10

Visages d'Extrême–Orient, visages de la sagesse sénile, qui consiste à n'attendre rien.

11

FIGURE 123 Pages 10 and 11, *And They Will Have to Go Elsewhere* and *Faces of the Far East,* from Robert Frank, *Indiens des hauts-plateaux,* Neuf no. 8 (Paris: Delpire, 1952). Gravure, page: 11 × 8⅝ in. (28 × 22 cm).

photographers such as Brassaï, on topics such as the circus (the first Delpire publication to include Frank photographs, along with Cartier-Bresson images), and subjects such as André François and Ylla's photographs of African animals.[9] Cartier-Bresson's 1954 book *D'une Chine à l'autre* was the fourteenth book in the *Neuf* series, and *Moscou* appeared in the same series the next year, in 1955.

Robert Frank's early Peruvian photographs from 1948 form the subject of *Neuf*'s eighth volume, *Indiens des hauts-plateaux* (1952), which includes twenty-six photographs and a text by Georges Arnaud, who had written a popular novel about his three years in the Andes, *The Wages of Fear* (1950). The Peruvian book differs from earlier editions of *Neuf,* whose full-page photographs bleed to the page's edge. Instead, the formats of images in the Peruvian layout vary. As Frizot writes, "This is no longer the space of a book in which you leaf through every picture-page, but the space of the beholder's vision and perception, a space of respirations having its own rhythms variations, pauses, patterns (symmetrical repetition followed

by dissymmetry)." Those rhythms, however, convey a European colonialist message of a hopeless "other." The figures on the cover image spread across the top quadrant of the book, and their well-worn hats echo the ridges and bumps of the Andes Mountains behind them, creating a composition where heads and hilltops are equally timeless and undulating (figure 122). This signals the anthropological bent of the volume: Arnaud's text describes the poverty of Andean mountain culture with little regard for how these people actually lived, framing their existence as hopeless to form an antithesis to European comfort. Arnaud and Frank are Europeans drawn to a very different culture, but careful to shape it in terms of what that period perceived as the have-nots. The interior spreads of the book highlight this even more (figure 123). On the image on the one left-hand page, children move toward the bottom left of the frame, accompanied by the caption "And they will have to go elsewhere"; on the right page, two Andean women wearing European-style hats look sadly away from them toward the opposite corner,

accompanied by Arnaud's shockingly Orientalist caption "Faces of the Far East, faces of senile wisdom, who wait for nothing at all." In these compositions we see not only a preview of Frank's grainy photographic style in *Les Américains,* but also a bleak eye onto other cultures that is also duplicated in his most famous book. Delpire also included more images by Frank in a later *Neuf* title on South America, *Indiens pas morts* (1956).[10]

After the *Neuf* series, Delpire edited a second collection of smaller books that he titled *Huit,* and then moved on to a third series of books, the *Encyclopédie essentielle,* which ran from 1957 to 1968. The aim of this last series of twenty-four volumes was to offer readers "essential" rather than "exhaustive" overviews of encyclopedic subjects. These books cover largely anthropological topics, including Paris, "primitive" art, Arabs, evolution, volcanoes, writing, planes, Germans, Jews, explorers, and insects, among others. With its text by ethnologist Jacques Berque of the Collège de France, *Les Arabes* (1959) has the same format as *Les Américains* from the previous year and includes, among its fifty-two images of art, architecture, and people, three photographs by Cartier-Bresson, two by Brassaï, and five by René Burri. Burri would later be the photographer for *Les Allemands* (1962) in the same series. Frank's project had been planned even before Delpire began this series, and the editor places *Les Américains* among the other groundbreaking design publications of the press.[11] Yet in its French iteration it is largely an anthropological volume, positioning Americans as an ethnographic group among the others studied in the series.

Frank and Delpire, who first met in 1952, had a close relationship. Delpire remembers that Frank came to him in the summer of 1954 asking for support for "a big project on America," for which he was applying for a Guggenheim grant. Frank returned to Delpire three years later not only with the images but with an idea that he wanted just one photograph per double page, saying, "I don't like combining photos." Therefore, Frank deliberately eschewed some of the most innovative discursive design practices often used by Delpire in other books—the positioning of two images across the gutter from each, or a spread that covers two separate pages—favoring instead a purist image alone on a page. They laid out the mock-up on Delpire's floor, in one afternoon, and the publisher recalls, "There are some photographers who do not know how to choose their photos, but he did. . . . As for the sequence, we did it just like that, intuitively." More importantly,

Delpire emphasizes, "We did not feel like we were making a mythical book."[12]

The French book's cover, unlike Frank's photographs inside the book, conveys charm and a humor about American urban life. Frank had wanted a photograph, but Delpire chose a drawing by Saul Steinberg for the cover (figure 124).[13] Delpire had an affinity for humorous drawing: he had already published two volumes of caricatures in the *Neuf* series. This cover is a stark contrast to the New Orleans trolley that so symbolically adorns the cover of the American edition, with its brooding view of white riders at the front and African American riders at the back (figure 125). Three-quarters of the French cover is framed by a piece of graph paper with blue grids, an abstract parallel to the grid of American skyscrapers and city buildings. The title, *Les Américains,* is printed across the grid in bold black about a third of the way down the cover, with a credit, "Photographies de Robert Frank," printed in red, lower and to the right. In his unmistakable drawing style, Steinberg populates the blank bottom and left edge (meant to symbolize a street intersection) with a streetlamp, the curved line of the curb following the façade of the building and around a corner, and an awning as a connection between the graph/grid/building and the curb. Twenty-three scribbled stick figures populate the sidewalk, some hunching forward, some standing at the curb, and some rounding the corner. The back cover has a continuation of the grid and a larger sketch of several brownstones with another awning and more pedestrians, with the authors of the texts listed in red, naming Alain Bosquet as editor.

The graphic effect is far less groundbreaking than Krull's montages, Cartier-Bresson's huge and elegant formatting, or Brassaï's ink-laden pages (although Delpire had paid homage to them in other titles in his *Neuf* series). Frizot suggests the result is a compromise between Frank's wish for a design "without running text" and the normal text and image formula of Delpire's series.[14] Although Delpire included running quotations that filled all the left-hand pages, Frank's images sit alone on their right-hand pages, bordered by white, and in this manner the book's design differs from photographic reproductions in the other *Encyclopédie essentielle* books.

Delpire recalls that his distributor thought other written material about Americans would help to sell the book. In a strategy common for other *Encyclopédie essentiale* volumes, he asked Alain Bosquet—a Russian-born poet and critic who was educated in Belgium, fought

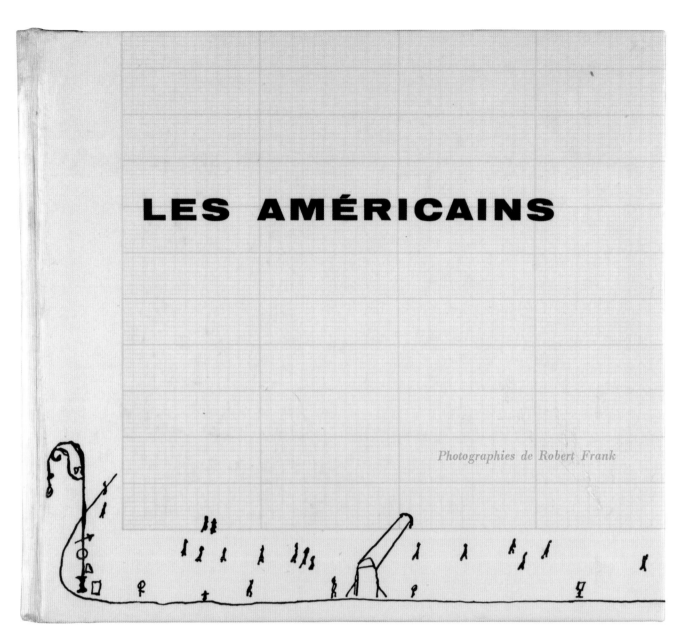

FIGURE 124 Cover by Saul Steinberg of Robert Frank, *Les Américains* (Paris: Robert Delpire, 1958). Gravure, 7¼ × 8¼ in. (18.5 × 21 cm).

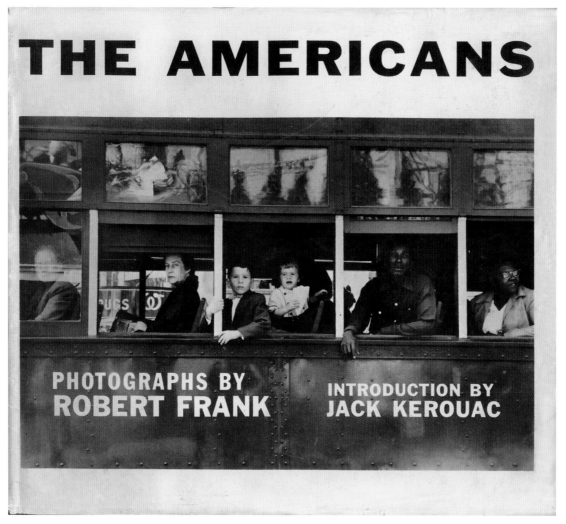

FIGURE 125 Cover of Robert Frank, *The Americans* (New York: Grove, 1959). Gravure, 7¼ × 8¼ in. (18.5 × 21 cm).

with the French and Americans, and settled in Paris in 1951—to "compile an anthology of old or recent texts on America." Frank himself had sent Delpire two introductory texts written by Americans—Jack Kerouac's October 1957 essay later used in the American edition and an earlier introductory text by Walker Evans—but the French edition includes neither of them. Delpire wrote that Kerouac's introduction "could not have sold one additional copy had we used it, because Kerouac was not known in France."[15] Instead, he used Bosquet's chosen texts, a selection of writings by historical and contemporary American and French authors that presents a snapshot of how midcentury French culture defined America. Besides Alexis de Tocqueville and his own writings, Bosquet chose French authors Simone de Beauvoir, F. R. de Chateaubriand, and André Maurois, as well as

American writers Bernard Iddings Bell, John Brown, Erskine Caldwell, Stephen Crane, John Dewey, John Dos Passos, William Faulkner, Benjamin Franklin, Abraham Lincoln, Henry Miller, Franklin D. Roosevelt, Claude Roy, André Siegfried, John Steinbeck, Adlai Stevenson, Harry S. Truman, George Washington, Walt Whitman, and Richard Wright. The resulting historical tone of the book, with the words of so many canonical American writers and its astonishing range from Washington to Miller and Wright, is completely different from Kerouac's poetic and trenchant commentary for the American edition (and all future editions). Frank disliked this formatting, and Delpire agreed that a republication would not include the texts.

Unlike the American edition of Frank's book, which has a clean white page facing each photograph, allowing

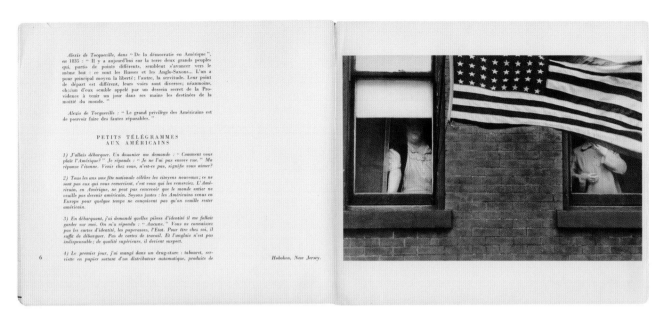

FIGURE 126 Pages 6 and 7, *Hoboken, New Jersey,* from Robert Frank, *Les Américains* (Paris: Robert Delpire, 1958). Gravure, page: 7¼ × 8¼ in. (18.5 × 21 cm).

the images to dictate the narrative, *Les Américains* presents extensive written passages on each left-hand page, filling the pages with small type and a variety of points of view. The immediate visual effect is of an illustrated history book, not a groundbreaking photographic essay, although each right-hand page presents a full-size Frank photograph in the same order of the American edition that we now consider canonical. The text facing the first image, in a far cry from Kerouac's raw essay for the American edition, is by Alexis de Tocqueville, written before the Civil War in 1853 (figure 126). Placing the book in Delpire's *Encyclopédie essentielle* series, the de Tocqueville quote contrasts the Russians and Anglo-Saxons and states "the great privilege of Americans is to make their mistakes reparable."[16] These two quotes from de Tocqueville, citing liberty and the supposed right to make mistakes and correct them as quintessential American traits, sit across from the first image of two women half-hidden inside brick windows and obscured by the flag.

That first left page continues with the beginning of a long list by Bosquet himself, listing twenty American attributes as "small telegrams to the Americans." These include many French tropes of what he perceives to be American traits: he notes that Americans think everyone must want to be American like them, he marvels that no one needs to carry an identity card in the United States, and he remarks

on their rudeness, sneers at menus with photos of the food, expresses scorn at Americans who drink to excess rather than for pleasure, while also evincing respect for American love of learning and lack of snobbery. Bosquet's remarkable list continues uninterrupted for the first six images in the book.

In the French edition, Bosquet's additions create a very different sense from the later American edition: he presents himself as an outsider documenting the ethnographic observations of what it means to be American. Bosquet uses other authors to comment on large themes such as liberty, American Indians, African Americans, and intellectuals, and small ones such as violence, "dollar is king," strip tease, Hollywood, James Dean, simplicity, "a certain niceness," and ending with "moments of nobility." The book's last image, showing Mary Frank in a car on the side of the road in Texas, is faced with a debate comment by Adlai Stevenson in October 1952, when he ran for the presidency against Eisenhower—saying, "I like Ike, too"— and the book closes with Stevenson's address to schoolchildren after he lost the election, on the importance of voting (figure 127). From first to last, Bosquet includes both ethnographic, generalized tropes about Americanness and an appreciation for the liberty and rights of voting the United States represents—a very different message from the photographs themselves. The written materials

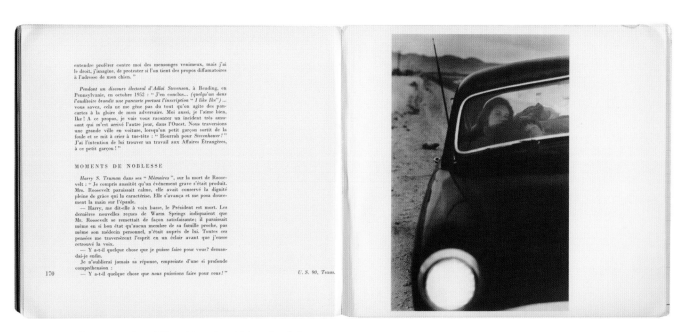

FIGURE 127 Pages 170 and 171, *U.S. 90, Texas,* from Robert Frank, *Les Américains* (Paris: Robert Delpire, 1958). Gravure, page: 7¼ × 8¼ in. (18.5 × 21 cm).

are placed in a series of categories that give a distinctly French overview of American culture. These sections echo conventional, even stereotypical, French views toward America, rather than Frank's own ideas.

Frank had worked hard on the picture layout of his book, as has been examined in the excellent and thorough essays in Sarah Greenough's *Looking In: Robert Frank's The Americans.* Although the texts in the French and English editions differed in content and placement, the image selection did not change. Frank's wish to have single images on the right side of the page, surrounded by white borders, was respected in both editions. Greenough's extraordinary reading of the book's construction gives us important clues about Frank's careful study of books by Bill Brandt: *The English at Home* (1936), *Londres de nuit* (1938), and *Camera in London* (1948). Frank also appreciated the formats of Gotthard Schuh's *50 Photographien* (1942), Jak Tuggener's *Fabrik: Ein Bildepos der Technik* (1943), and Walker Evans's 1938 *American Photographs.* The Swiss photographer admired the Eisenstein-influenced cinematic effects of Tuggener's juxtaposition of industry and workers, juxtapositions that made a critical commentary on industry and workers. These form a contrast to Krull's more celebratory embrace of industry fifteen years earlier. Exposing the societal conflicts of industry, Tuggener had the ability, Frank believed, to be "a stranger in the sense of Camus," seeing his own country "like a visitor," and the image progression as a series of jazz riffs (plates 20 and 21; figure 128).[17] Frank continued the notion of being a stranger in *Les Américains.*

Frank spent several months in 1956 editing and arranging his images for *Les Américains.* He narrowed down the selection from twenty-seven thousand images to a group of about one thousand work prints, and then grouped them by themes of automobiles, religion, race, politics, and media. Eventually, by spring 1957, he had narrowed them down to about a hundred prints and mapped out a rough sequencing, which he then finalized with Delpire in France. Frank made a dummy in 1957 before he traveled to France that summer. The development between Frank's original 1957 sequence and the 1958 maquette is mapped out in Greenough's book. The 1958 maquette of the book is in the collection of the Museum of Fine Arts, Houston, and Andrea Nelson, Greenough, Paul Roth, and Philip Brookman have reconstructed it. In the maquette, there are four distinct sections; the blank pages separating them are absent from the published book.[18] In the final version of the published book, a flag image introduces each of the four sections, but in the maquette, it is missing from the fourth section.

The published French edition, even with its heavy text additions, completely recasts the sequencing of

FIGURE 128 Plates 20 and 21, *Worker* and *Steamwhistle*, from Jak Tuggener, *Fabrik: Ein Bildepos der Technik* (Zurich: Rotapfel, 1943). Gravure, page: 12¼ × 9 in. (31 × 23 cm).

photography books and is a definitive move away from the French-inspired graphic modernism of the books examined in previous chapters. There are, of course, some similarities, such as elements of cinematic montage that are similar to Krull's, a disenfranchised underclass that is comparable to Brassaï's night world, and a gloomy, poetic, and elegiac reading that has affinities to Jahan's book. But its images are deliberately unaesthetic—unlike Cartier-Bresson's—and the book's narrative departs from the magazine-story thematic structure of earlier French books.

Instead, it comprises a new kind of rhythm, as Greenough has insightfully analyzed. She cites Frank's comments that sequencing "mattered a great deal," and his choice to begin each section with a flag image, adding that "the first four or five pictures are of people looking [—] spectators. And then you see what they're [looking at]." Greenough equates the recurring flag imagery to an incantation, similar to Allen Ginsberg's construction of *Howl.* She draws parallels to the book's dialectical juxtapositions and themes: power and powerless, presence and absence of people, and motion and stillness. Indeed, Greenough underscores the emotional journey of this book, alluding to the "sense of insecurity, doubt and alienation that results from a lack of power; the insensitivity, arrogance, and even deceitfulness that grows from its abuse."[19] Masterfully, she studies the first six images of *The Americans,* moving us from one to the next: the "headless" women in their window, the pretentious, top-hatted

politicians, the political performer screaming at his audience, two quiet African Americans, a cowboy, and finally a couple striding toward us. Together, these images present the powerful and the powerless, the rural and the urban, black and white Americans, in a deeply felt but ultimately intrinsically pessimistic view that differs fundamentally from the French modernist books that preceded it. The book ends with the cruel impersonality of the American road, with an image of Frank's wife, Mary, and their children on U.S. Route 90 in Texas.

When *Les Américains* came out in Paris, it was buried among Delpire's dozens of photographic books of the 1950s and received only a lukewarm and muted press response, with reviews in *Carrefour, Le soir,* and *Arts: Lettres, spectacles.*[20] The only American commentary on the French edition was by Minor White, who wrote a less-than-favorable review for *Aperture* in 1960. White notes the panoply of textual authors and wonders why only one photographer accompanies them. He states directly, "He is no Cartier-Bresson," and continues on to say, "Frank has no trace of savoir-faire," but only a grim humor. Although White credits Frank as a social documentarian in the tradition of Walker Evans, he scolds the Swiss photographer overtly: "Is his disgust so great that he is willing to let his pictures spread hatred among nations?"[21]

In 1959 Grove Press, the press that published the first American editions of such contested books as D. H. Lawrence's *Lady Chatterley's Lover* (1959) and Henry

Miller's *Tropic of Cancer* (1961), agreed to publish Frank's book, using the original Draeger Frères plates but including Kerouac's introduction instead of the text medley edited by Bosquet. An edition of 2,600 copies of the book was released in the United States on January 15, 1960 (with a 1959 publication date). Only upon its American publication did the book receive the negative reviews for which it was then notorious and now famed. Only at this point did it become the icon for a "radically new stylistic idiom and a passionate diatribe against American social and political life in the 1950s."[22]

LIFE IS GOOD AND GOOD FOR YOU IN NEW YORK

Although it was published two years before Frank's *Les Américains*, it is Klein's 1956 book, *Life Is Good and Good for You in New York: Trance Witness Revels*, that best pinpoints the end of an era and the transition to a new photographic book form. It, too, was published in Paris, with international editions later that year in Milan and London. Klein's *Life Is Good and Good for You in New York* clearly returns to the abstraction, montage, and film-based principles of Krull's *Métal* and Moï Ver's *Paris*, as well as their kaleidoscopic, simultaneous obsession with modern, urban, industrial life, albeit presented in a more ironic, disturbing, and less lyrical manner. Klein's book is in some ways much more violent than Frank's threatening sullenness, but the violence has a freeing exuberance to it; the book ends up celebrating the wildness of modernity rather than dwelling on its negative factors. It bears almost no formal resemblance to the French humanist tradition, instead creating a volatile mix of montage and celebration of the transgressions of urban life. Klein went on to publish three more city-based photobooks, *Rome* (1959), *Moscow* (1964), and *Tokyo* (1964), the latter two published in Germany but printed in Japan.[23] David Campany calls these four books "great works of journalism, complex records of their time, place, and maker. As the mass-media magazines lost their grip on what counts as a photo essay . . . Klein had found a way to make innovation and rule-breaking serve a deeper documentary impulse."[24] The young American photographer's vision could have not have been more different from that of Cartier-Bresson.

In developing his idiosyncratic eye, Klein combined elements of his postwar training in painting at the Sorbonne, a brief stint as a student of painter Fernand Léger, and a graphic design career working for *Vogue*,

Domus, and other magazines. His paintings were hard-edged abstractions quite different from his street photography, whereas his work at *Vogue*, where he was hired by Alexander Liberman, offered a third language: graphic arts. Klein describes Liberman's patronage as follows: "That financed my book on New York. It was a time when Condé Nast was very generous, and experimental. It was like a government grant!"[25] Klein would continue to work for *Vogue* for years.

Klein's return to New York after several years in Paris was funded by *Vogue*, when he was twenty-three. He spent six months in 1954 exploring simultaneity both of the city and as a camera technique, in the spirit of Dziga Vertov's film *Man with a Movie Camera* (1929). He sometimes pretended to be "The Inquiring Photographer," a tabloid feature of the *New York Daily News*, when asked by bystanders what he was doing in the streets. In developing *Life Is Good and Good for You in New York*, Klein looked to Moholy-Nagy's New Vision books and György Kepes's *The New Landscape*, as he created what Campany calls "a bridge between the pre-war Bauhaus and the graphic arts to come."[26] But the book was too experimental for *Vogue*, and, back in Paris, he showed the maquette to Chris Marker, the filmmaker who was publishing the *Petite planète* series for Seuil and who famously threatened to quit if Klein's book was not published (Klein and his wife would later star in Marker's film *La jetée*). Happily, the book was published by Seuil in 1956, and led naturally to a later career for Klein that included films as well as books.[27]

Elements of the book do look back at earlier publications. Its structure is perhaps the most immediate homage to Brassaï's *Paris de nuit* that we have in European and American photographic literature. There are completely black pages, images that bleed into one another, and an implicit urban unease—if so calm a word can describe Klein's dark energy—expressed in a gritty, dark photographic style. The metaphorical commentary on violence, best seen in Klein's compelling and disturbing photographs of children playing with guns, also echoes Jahan's poetic commentary on war and death, but Klein's war is urban guerrilla violence rather than global war. Finally, *Life Is Good and Good for You in New York*, with its loose thematic chapter structures, echoes Cartier-Bresson's use of the picture-story format to construct his nonlinear tale; both photographers simultaneously worked for the picture press and for their own ends.

But Klein's New York is more crowded, chaotic, and violent than Cartier-Bresson's Europe or Brassaï's nighttime Paris. In capturing children's games of violence, it breaks with the journalistic tenet that war is for a cause, not an outcome of a dysfunctional society. And in its blackness and disjunctive imagery, jarring to view even today, it mimics the chaotic political events that would lead to violence-inspired change in the 1960s. Metaphorically, the book looks ahead to the international demonstrations, antiwar fervor, and civil rights activism of the 1960s, to the 1968 uprisings in Chicago, Paris, and Prague, and to the *Provoke* movement in 1960s Japan.

In expressing this message, the book's format uses practically every transgressive photographic and layout technique available, the only omission being the neat image with a white border on all four sides that epitomizes Frank's *Les Américains.* There are white pages, black pages, images that bleed over two pages with no borders, and every kind of snapshot album layout in between. There are aerial views, close-ups, blurred views, overly grainy views, and photographs of forms and people in motion. There are pages where the images seem to jump right out of the pages, via gestures or framing or pointing or signs held out for us to read.

Together, these tactics are much more violent than the previous books, but at the same time they continue a dialogue with modernist form. As film historian Des O'Rawe comments, these include "the disruption of convenient distinctions (documentary/fiction, observation/participation, vulgarity/sophistication, America/Europe), the incorporation of displacements (chance, spontaneity, random juxtapositions), and the foregrounding of ambiguity." This melding of fact and fiction disrupts the supposed objectivity of both the American documentary mode and the French humanist photography tradition, and Klein's disruptive estrangement effects echo Surrealist chance as well as filmic rupture. O'Rawe argues that Klein's rough street photography, "like Punk, hip-hop, and subway graffiti," eventually became mainstream and even became used in fashion photography.[28] At the time it was published, however, it was highly praised in France, winning the prestigious Prix Nadar in 1957. But Klein's volume was, and continues to be even today, shunned or overlooked in the canon of American photography. By 1962, when John Szarkowski became curator of photography at the Museum of Modern Art, his edict that all

good photographs should have white edges dampened the acceptance of such an experimental format.

When describing his book, in the preface for its reprint in France, Klein cites an earlier text that examines his raw disdain for any rules:

> Before making the book I was doing hard-edged geometric painting in Paris. When I came back to the city in 1954, after eight years away, I decided to keep a photographic diary of my return. These were practically my first "real photographs." I had neither training nor complexes. By necessity and choice, I decided that anything would have to go. A technique of no taboos: blur, grain, contrast, cock-eyed framing, accidents, whatever happens.
>
> As for content: pseudo-ethnography, parody, and Dada.
>
> I was a make-believe ethnograph in search of the straightest of straight documents, the rawest snapshot, the zero degree of photography. I would document the proud New Yorkers in the same way a museum expedition would document the Kikuyus.
>
> Parody: of so-called good photography and news. Photograph a marriage like a riot, and, inversely, a demonstration like a family portrait. Mix the family album with the New York Daily News.
>
> And then Dada: black humor, and absurd. The resulting book went against the grain forty years ago. My approach was not fashionable then, nor is it today.

In that later preface, the "make-believe ethnograph" Klein explains the "tabloid-speak" of the book's subtitle, "Trance Witness Revels," which is also a complicated riff on the reality and fantasy of photography: "Trance + Chance, Witness = Witness, Revels + Reveals." The subtitle connotes things that are celebratory, dreamlike, participatory, but clearly closer to Georges Bataille's bassesse than to André Breton's dream imagery. Klein deliberately denies the anthropological earnestness of Frank's dream of a cross-country road trip—ironically at the same moment when Frank was setting out in his car across the United States. Klein writes, "Almost every American dreams of driving a second-hand car across the country after school, before work, as initiation, to see what's out there, to find out who he is. Me too. But I never did. Instead, I went in the Army and occupation in Europe. And instead of discovering America, my trip was

New York—and photography." Without suggesting that this passage is a rebuke against Frank (who never served in the military, being Swiss, and whose "initiation" trip was a very dour one), Klein sets a tone in the reprint of a more joyous imagery and experience. He is blunt and humorous about the edginess of his work: "Whatever, none of the American editors that I approached would publish the book. Yecch, this isn't photography, they would say, this is shit. This isn't New York, too black, too one-sided, this is a slum. What else did they think New York was?"[29] Remarkably, *Life Is Good and Good for You in New York* was never published in the United States until a San Francisco Museum of Modern Art version in 1995 and the 2010 Errata Editions reprint.

Images of graffiti and signage are prolific in Klein's

photographic images, but the single page of freestanding text, "MANHADOES," appears only on the last pages of the book, first in English and then in French. The second sentence of the text, "Life has always been difficult though exciting on the Island of the Hills," might sum up the ethos of Klein's *Life Is Good and Good for You in New York.* The text gives an abbreviated history of Manhattan from the fifteenth century to the present, with sections on temperature, altitude, industries, transportation, accommodations, annual events, and such points of interest as the Statue of Liberty.[30]

If Frank's book is divided into four flag-bearing groupings, Klein's book is divided into "chapters," each distinguishable only by a single, white dividing page: "Album de famille" (figure 129), "Décor," "Parade," "Merry

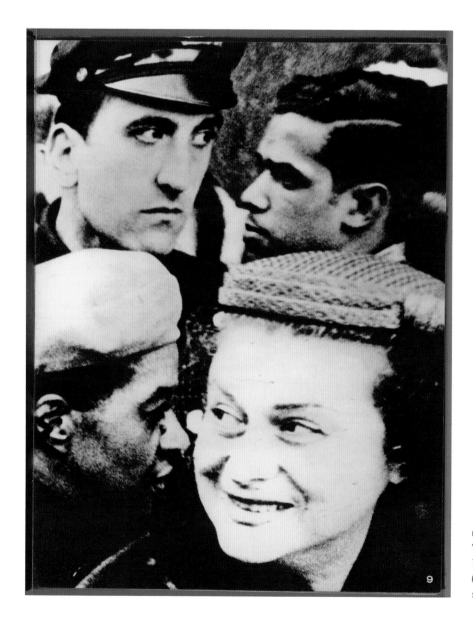

FIGURE 129 Plate 9, *Fifth Avenue,* from William Klein, *Life Is Good and Good for You in New York: Trance Witness Revels* (Paris: du Seuil, 1956). Gravure, page: 10 × 8½ in. (27.5 × 21.5. cm).

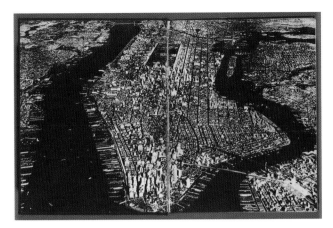

FIGURE 130 Endpapers of William Klein, *Life Is Good and Good for You in New York: Trance Witness Revels* (Paris: du Seuil, 1956). Gravure, spread: 10 × 17 in. (27.5 × 43 cm).

FIGURE 131 Insert pamphlet for William Klein, *Life Is Good and Good for You in New York: Trance Witness Revels* (Paris: du Seuil, 1956).

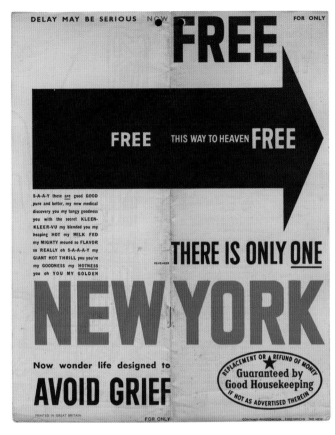

Christmas," "Inhale Exhale," "Gun," "Extase," "? [a question-mark sign painted on a truck]," "A Vital Message," "Dream," and "Paysage." In an uncanny echo of Brassaï's cobble-stones, the book's endpapers show two identical views of Manhattan from the air, spilling into New Jersey and Long Island and bled to the edges of the page (figure 130).

There were no captions in the bound volume of Klein's book, but a fourteen-page folded pamphlet with captions was attached to the book's spine by a piece of baker's string (figure 131). Measuring about five and a half inches tall, it carries the book's only short descriptions or commentaries on the photographs, "verses of free association rattled off in a rapid clip" like Beat poems. The attaching string is short, and to read the caption, the reader must lay the booklet on top of the image, creating a montage effect in keeping with the construction of the book itself.[31] The booklet creates a humorous riff on the advertising industry. Its cover itself assaults us with a layout of words and images that mimic the urgency and energy of an ad: the upper page is dominated by the black, block-lettered word "FREE," below which a large black arrow points outside the page and displays the words "FREE This Way to Heaven FREE" in white letters. The lower section has the block

lettered words "There Is Only One New York," validated by the Good Housekeeping Seal stamped on the lower right. In similar fashion, the pamphlet's interior includes humorously placed advertising images in the left-hand columns (Franco-American Spaghetti, *Mad* magazine, Chiclet gum, Listerine, *Ebony* magazine, "Best Dressed Woman in My Maidenform Bra").

Klein's captions themselves are idiosyncratic and make no acknowledgment of the chapter divisions. He comments on many, but not all, of the images, in anecdotal fashion. The images in the graffiti chapter are also in clear dialogue with other photographers. For instance, "A Vital Message" refers back to Brassaï's graffiti images from the 1930s first published in *Minotaure*, although Brassaï's own graffiti book would not be published until 1960. Future photographers found inspiration in Klein's celebration of the unruly interaction of street writing and urban-scapes: Lee Friedlander would later publish a book, *Letters from the People*, on the topic of graffiti.[32]

Violence is a clear subtext, as can be seen in the chapter "Gun." The entire "Gun" section (pages 95–99) has no commentaries at all in the caption booklet, although it is one of the most compelling parts of the book. Beginning

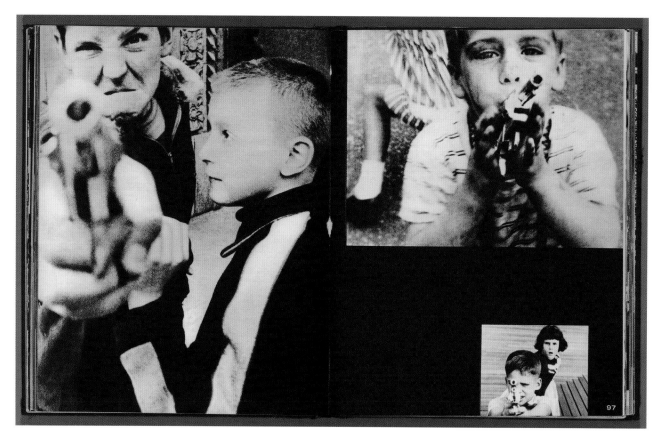

FIGURE 132 Plates 96 and 97, *All Over*, from William Klein, *Life Is Good and Good for You in New York: Trance Witness Revels* (Paris: du Seuil, 1956). Gravure, spread: 10 × 17 in. (27.5 × 43 cm).

with a spread of *Daily News* newspapers with a "Gunman" headline, the chapter includes four pages of children playing with guns (figure 132). One is perhaps the most famous image in the book, of a boy brandishing a gun right at us with a very ugly expression on his face. The gun looms so close to the photographic lens that it is completely out of focus, breaking the realism of the photographic print into a collection of grainy circles and shapes. The presentation fractures both the Renaissance notion of a picture as a window onto the world and the filmic documentary rule of never breaking the fourth wall to expose the filmmaker; this gun is metaphorically pressed to our foreheads. The following six images of boys with guns echo this, with younger and younger children brandishing pistols; one is small enough to still be in a stroller. Taken as a whole, this chapter becomes a wordless commentary on gun violence.

Here a clear comparison can be made to Klein's contemporary, Weegee (Arthur Fellig), the New York news photographer who chased police cars to crime scenes, publishing outrageous pictures of violence in the press.

Photographing crime scenes with his Speed Graphic camera, Weegee published his images not only in the *Daily News*, but also in the *Mirror, PM Daily,* and his book of collected images, *Naked City,* in 1945 (figure 133). Its cover shows dwarfs, policemen, arrests, and body parts, and the cover blurb, written by Nancy Newhall, then acting curator of photography at the Museum of Modern Art, cogently observes: "Through his sense of timing, Weegee turns the commonplaces of a great city into extraordinary psychological documents." Selling for four dollars, *Naked City* had six printings in its first year and "became the most profitable photo-book in the history of American photography."[33] Unlike Klein's chapter headings, Weegee's are frankly sensationalist and include subjects such as "Fires," "Murders," and "Sudden Death." Like Klein, Weegee was born to an Eastern European Jewish family, but Weegee, born in 1899, belongs to the older generation of Brassaï and Germaine Krull. Although Weegee and Klein both used grainy and black images, their aims were quite different. Max Kozloff sums the men up neatly:

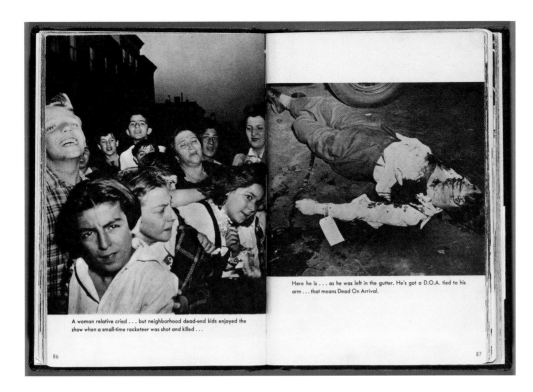

FIGURE 133 Plates 86 and 87, *A Woman Relative Cried* and *Here He Is . . . As He Was Left in the Gutter,* from Weegee, *Naked City* (New York: Essential, 1945). Page: 9½ × 6½ in. (24 × 16 cm).

"One was a primitive putting on airs, while the other was a modernist slumming with jazzy abandon. There is hardly anything like the real-life murder-and-mayhem of the journalist in Klein (only toy guns and charades of violence), and there is nothing of Klein's extreme artistic rawness visually decomposing before your eyes in Weegee."[34]

Other chapters in *Life Is Good and Good for You in New York* are throwbacks to Surrealism, but in a more transgressive fashion. "Extase," with its blurred children in vibrant movement, suggests Man Ray's flamenco dancer in the midst of a movement of Surrealist convulsive beauty or "explosante-fixe," used as one of the images in André Breton's *L'amour fou* (1937). The first image in this section is simply captioned in the booklet "The dance in Brooklyn" and depicts a blurred view of a child who may be executing a dance move, but seems to be disappearing into the sky. Klein appreciates the whimsy of the children shown in this chapter, with a caption that reads, "Now, the very best thing in New York: the marvellous, marvellous children." Klein refers implicitly both to playfulness and whimsy and also to Breton's last line of *Nadja,* defining the Surrealist notion that "beauty will be convulsive, or will not be at all."[35] In another image a little girl and her friend are playing, yet the girl's eyes are transformed into white orbs and her gesture suggests a seizure as easily as a dance (figure 134). The blurred movement Klein captures

parallels the later blurring in the 1960s photographic sequences by Duane Michals, in the last frame of *Death Comes to the Old Lady* (1969).

Like Robert Frank's collaboration with Robert Delpire, Klein's relationship with his French publisher played an essential role in his book's formation. When Klein was unable to find an American publisher for his book, he turned to a friend, Chris Marker, a filmmaker working at Éditions du Seuil. Marker was beginning to edit a series titled *Petite planète* and aimed to create "Not a guidebook, not a history book, not a propaganda brochure, not a traveler's impressions, but instead equivalent to the conversation we would like to have with someone intelligent and well-versed in the country that interests us." The series began with volumes on Austria, Sweden, Italy, and Holland in 1943 and expanded to include nineteen volumes from 1954 to 1958, when Marker ceased his activities as editor.[36] Photographers included Henri Cartier-Bresson, Robert Capa, Elliott Erwitt, Inge Morath, David Seymour, and the filmmaker Agnès Varda. These books featured layouts that combined cinematic montage, differently sized images, and a quality of playfulness. Klein's 1956 book, although not part of the numbered series on separate countries, is labeled "Album Petite Planète 1" on the first page.

Only one New York photographer made a book about

FIGURE 134 Plates 102 and 103, *The Dance in Brooklyn,* from William Klein, *Life Is Good and Good for You in New York: Trance Witness Revels* (Paris: du Seuil, 1956). Gravure, spread: 10 × 17 in. (27.5 × 43 cm).

New York that rivaled the innovations of Klein's *Life Is Good and Good for You in New York,* but in appearance it is the antithesis of Klein's book. Instead of being big and splashy, Roy DeCarava's *The Sweet Flypaper of Life* is small and contemplative and can be held in the palm of one's hand, almost like a diary (figure 135). With a text by poet Langston Hughes, the 1955 book presents images made by DeCarava on a 1952 Guggenheim Fellowship (the first awarded to an African American photographer). If Frank's view of America is that of a disillusioned outsider, and Klein's is an irreverent Dada/Pop riff on New York culture, DeCarava's book is an autobiography. Though Hughes's text about Sister Mary Bradley is fictionalized, it presents a highly personal view of life in Harlem, with its small joys, its ups and downs, and its own rhythms. DeCarava invokes graphic design blackness as a formal poetic language for Harlem, whereas Klein makes it a violent graphic statement.

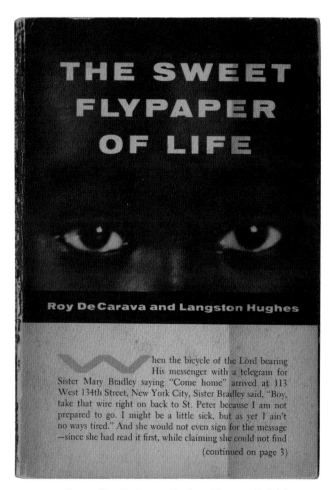

FIGURE 135 Cover of Roy DeCarava, *The Sweet Flypaper of Life* (New York: Simon and Schuster, 1955). Gravure, 7 × 4½ in. (17.5 × 12 cm).

JAPANESE PHOTOBOOKS AND *PROVOKE*

Klein's contributions to photographic book culture are many: the sensation of being in the center of the action, of breaking apart the pictorial and graphic window onto the world, of blurring the image beyond recognition, and of exploding the grain of the photographic print into its constituent parts. The filmic montage, black imagery, and excitement of his images and layout are not just relevant as formal innovations. They also evoke a new, politicized generation of "making strange" volumes—books that echo the violence and vigor of the protest movements of the 1960s that took place around the globe, from Kent State to Prague to Paris to Tokyo. Although Klein's *Life Is Good and Good for You in New York* marks the end point of extreme formal and political innovation in the Paris publishing world, this book and his reputation soon echoed strongly in Japan, where Tokyo replaced Paris as the heart of photobook innovation by the 1960s. Japan had had only minimal contact with European photobooks before the war, although portions of the German *Film und Foto* exhibition had traveled to Tokyo and Osaka in 1931. However, Brassaï's book had been extensively reproduced in *Asahi Camera* in 1933, and a 1932 book of industrial steel abstractions by Masao Horino, *Kamera. Me x tetsu. Kosei* (*Camera: Eye x Steel: Composition*) bears an uncanny resemblance to Krull's *Métal,* although there is no current evidence suggesting a connection. After the war, intersections began between the West and Japan. Klein's 1964 publication of *Tokyo* (plates 116 and 177; figure 136) is an important harbinger of this, as is Robert Frank's Japanese publication of *Lines of My Hand,* published by Yugensha in Tokyo in 1972.[37]

William Klein and Robert Frank had an enormous impact on the Japanese photographers of the 1960s. Klein's book, in particular, affected a whole generation of Japanese photographers. It was even more important than Frank's volume; as curator Simon Baker recounts, "Many people regard Robert Frank's *The Americans* as the pinnacle of photographic book-making, but Frank's *Americans* doesn't have the kind of impact, especially globally as [*Life Is Good and Good for You in New York*]. What Klein's book did for the way people think about photography in Latin America, in Europe and in Japan is probably unparalleled."[38] The radical formal languages developed in Japan became effective conduits to express solidarity with political protests happening in the 1960s all around the world. One result is the *Provoke* movement, a group

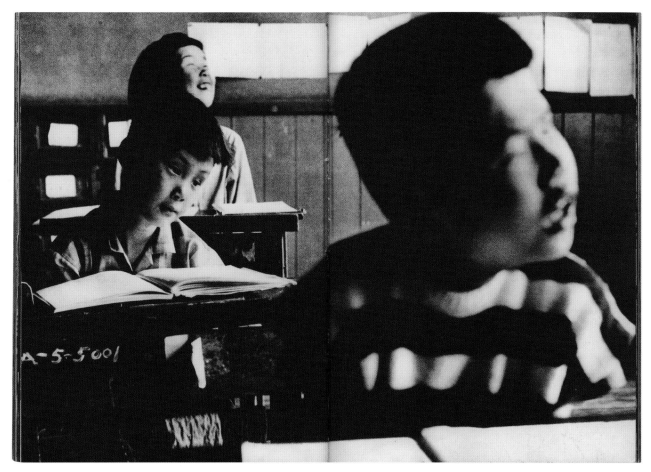

FIGURE 136 Plates 116 and 117, *School for Blind Children,* from William Klein, *Tokio* (Paris: Delpire, 1964). Gravure, spread: 13¾ × 19½ in. (34 × 48 cm).

of magazine/books that highlights cityscapes and that includes the work of Daido Moriyama, Yutaka Takanashi, and Koji Taki. As Martin Parr and Gerry Badger have said, "*Provoke* was Japanese photography's primal scream," marking a radical transition from the immediate postwar Japanese documentary photographs of the war, the atomic bomb, and their aftermath.[39]

Japanese photobooks developed as a distinct and separate medium from gallery prints. As Ivan Vartanian writes, "Through cropping, sequencing, organization of material into chapters or sections, choice of printing techniques, and the introduction of text elements, the [Japanese] photobook became the defining form for photography." These extraordinary Japanese photographic books set a new mode, one that has moved beyond modernism as a language and past the city of Paris as a center of activity.[40] They reflected a large movement of protest photobooks in the 1960s and 1970s, a product of the international counterculture.

Replete with grainy images, deliberately un-documentary picture progression, and out-of-focus aesthetics, these works led to a body of Japanese photographic books of the 1960s and 1970s by Shomei Tomatsu, Kazuo Kitai, and Toshiaki Kanayama, as well as the three best-known *Provoke* movement photographic books, Takuma Nakahira's *Kitanubeki Kotoba no Tamenu* (1970), Yutaka Takanashi's *Toshi-e* (1974), and, of course, Daidō Moriyama's *Shashin yo Sayonara* (1972). Moving even further into formal experimentation than Klein, the *Provoke* photographers developed an extraordinary aesthetic of *are-bure-boke* ("grainy, blurry, out of focus"). This Japanese aesthetic dimmed after 1974, when John Szarkowski, photography's international tastemaker in the 1960s, presented the exhibition *New Japanese Photography* at the Museum of Modern Art in New York, and opined that good photographs always need white borders.[41]

Klein's book was especially important to Daidō Moriyama, who first saw *Life Is Good and Good for You*

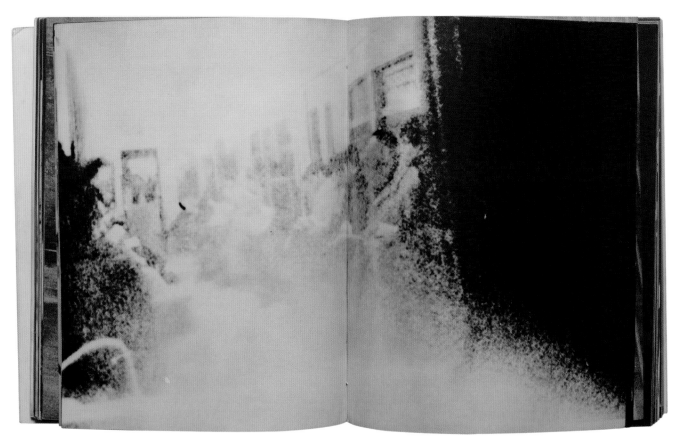

FIGURE 137 Spread from Daido Moriyama, *Shashin Yo Sayonara* (Tokyo: Shashin Hyoron-sha, 1972), n.p. Gravure, spread: 9 × 14 in. (23 × 34 cm).

in New York in 1959, and was "mesmerized and shocked" by it.[42] Trained as a graphic designer, Moriyama was deeply influenced by Klein's graphic experimentation and his creative uses of photography, although Klein broke through the camera's distancing capabilities more radically than Moriyama. The Japanese photographer was also impacted by the photographs of Weegee and Atget, and by Andy Warhol and the Beat poets. As Baker writes, with Moriyama, "You are reminded all the time you are looking through a view finder, moving around, getting close. Whereas, with Klein, there's almost no camera. You are right there in the crowd."[43] Both photographers, however, shared a passion for depicting the margins of society and exploding the book format. Like Klein, Moriyama included walls, screens, disintegrating billboards, portions of negatives, and urban fragments in his *Shashin yo Sayonara* (1972), and like Klein, but even more extreme in form, he tried to destroy what he saw as the complacency of photography, making a language of blur, fragment, scratches, and dust instead of legible subjects (figure 137).

Of *Shashin yo Sayonara*, which translates into English as *Farewell, Photography*, Moriyama explains, "Some may find the title sarcastic, but it expresses my animosity and my valedictory address towards photography which is too self-confident to challenge its own meaning and in the end loses reality." Moriyama found that photography books were an entirely different medium than single photographic prints, and he found books much more interesting. "My photographs are made complete on the printed page. . . . That transformation is something that I find really interesting." Echoing the collaboration between publishers, designers, and photographers in France, Moriyama allowed two editors at Shashin Hyoron-sha the full authority for the layout of *Shashin yo Sayonara:* "They made the book. I let them do whatever they wanted." In an extension of Klein's abrupt strategies to make reality strange, Moriyama also explored the connections between reality and the dream world, discovering—in an echo of Mac Orlan's concept of the social fantastic—that "photographic space could be simultaneously 'documentary' and 'phantasmagoric.'"[44]

Shashin yo Sayonara, like Brassaï's *Paris de nuit,* is a relatively small, gravure-printed volume that one can hold between one's palms. Like *Paris de nuit,* it has no white whatsoever on its pages, and the mysterious and fragmented urban views, television images, figures, and sometimes almost abstract images draw the viewer into their black depths. As part of the aesthetic championed by the radical photography magazine *Provoke,* it uses blurs, scratches, graininess, stains, light leaks, and dust marks as an aesthetic style meant to have an anonymous yet potent, alienated, political meaning. Moriyama's work, however, has a political edge far more gripping than that of Brassaï in interwar Paris. "The more [Moriyama] tries to avoid political themes the more political his work seems to become," according to one analysis, and other photographic books in Japan were overtly political. Like the *Provoke* movement's magazine, many postwar Japanese photobooks responded to the nuclear bombing of Hiroshima and to the growth of American imperialism and capitalist society, commenting on the nation's "post-apocalyptic stress syndrome."[45]

Other Japanese photographers broke open the format of the photography book even further than Moriyama, expanding the black and gritty quality of earlier French photogravure printing processes such as those of Brassaï, creating portfolio books in three dimensions, and incorporating Klein's and Frank's use of grease pencil marks on contact sheets into their book compositions. In the 1960s, Japanese photographers made self-conscious commentaries on the act of choosing, reselecting, and editing photographs in sequence. The designer of Frank's *Lines of My Hand,* Kohei Sugiura, also designed another seminal Japanese photobook, Kikuji Kawada's *Chizu* (1965) (figures 138, 139). Printed in inky gravure with images bleeding off the pages like Brassaï's *Paris de nuit,* through a series of unfolding pages designed by Sugiura, Kawada creates a metaphorical map from the ruins of Hiroshima's Atomic Bomb Dome (a memorial on the site of the remains of Hiroshima's Prefectural Industrial Exhibition Hall) and the horrible detritus left there twenty years after the bomb. The pages lie flat, as do Brassaï's, and the act of folding and unfolding leaves within the book "physically

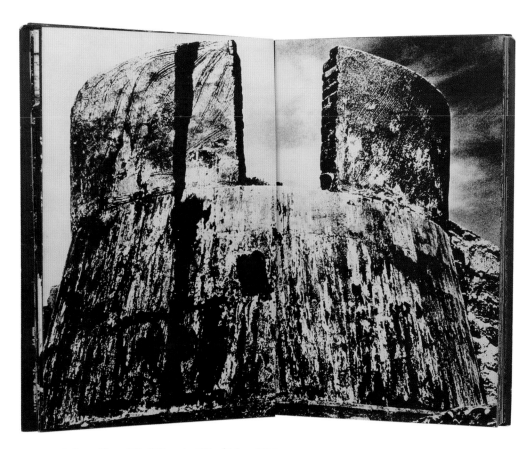

FIGURE 138 Spread from Kikuji Kawada, *Chizu* (Tokyo: Bijutsu Shuppan-sha, 1965), n.p. Gravure, folded spread: 9 × 11½ in. (23 × 30 cm).

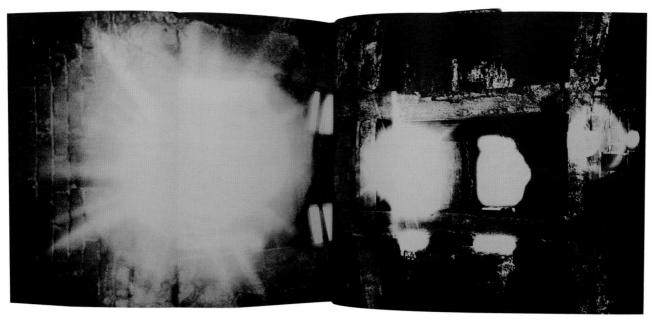

FIGURE 139 Unfolded spread from Kikuji Kawada, *Chizu* (Tokyo: Bijutsu Shuppan-sha, 1965), n.p. Gravure, unfolded spread: 9 × 23 in. (23 × 60 cm).

engages the viewer, addressing the photobook's structure as an object, . . . and its relationship with the reader."[46]

In the book's introduction, Japanese author Kenzaburo Oe writes, "I saw a map close to my wounded eyes. While it was nothing but a little piece of ground stained with heavy oil, it really appeared to me like a map of the world full of violence, in which I was to live henceforth."[47] Published on August 6, 1965, twenty years after the Hiroshima bombing, the book is a black and abstract symbol of violence and loss, with its "blistered and radiated wall surfaces from Hiroshima." Parr and Badger suggest, "Kawada has conjured a brilliant simile for the photograph itself—scientific record, memory trace, cultural repository, puzzle and guide."[48]

Although we have no evidence that Kawada knew them, *Chizu* indirectly reflects many of the French books studied here. Readers of Krull's *Métal* in 1928 had shared a similar physical engagement with the portfolio cover and its loose plates. The physicality of experiencing *Chizu*, unfolding first the intricate casing, and then unfolding each page to see the larger images inside, echoes the three-dimensionality of reading *Métal*, coupled with the disturbing fascination of Brassaï's *Graffiti* images that celebrate ruin and the urban fabric itself. And although Kawada did not know Jahan's work, and the French photographer's *La*

mort et les statues does not unfold as does *Chizu*, Kawada, like Jahan, also constructs a "lieu de mémoire" about World War II, this time engaging Hiroshima in a creative reengagement in three dimensions, an homage to the suffering experienced there.

After the 1969 end of the *Provoke* movement, one of its founders, Yutaka Takanashi, made a book, *Toshi-e* (1974), that marks another high point of Japanese book experimentation; it is one of Japan's most striking postwar publications (figure 140). As is seen in the English translation of the title, *Towards the City*, Takanashi's book refers formally back to many of the themes of French photobooks while presumably referencing Tokyo: montage, dreamlike imagery, alienation, large-scale imagery, and the blurry/grainy/out of focus imagery first present in *Les Américains* and *New York Is Good and Good for You*. Takanashi's enormous book lives in its own box and has a round, slightly convex silver mirror on its cover. The silver disc, spanning ten and a quarter inches across the black cover, may symbolize Japan's flag and rising sun. In actually experiencing the book, however, it reflects us (the readers) and the world around us like a fish-eye camera lens, and suggests the metaphorical uses of convex mirrors in sixteenth- and seventeenth-century European paintings. The book reads right to left, and the sixty-four images are mostly

FIGURE 140 Spread from Yutaka Takanashi, *Toshi-e* (Tokyo: Izara Shobo [self-published], 1974). Gravure, page: 16½ × 10⅞ in. (41.9 × 27.6 cm), with small, inset book, *Note: Tokyo-Jin,* 10⅛ × 7¼ in. (25.7 × 18.4 cm).

horizontal, so that one must read the enormous pages like a flip book, from the side, and each page is fronted by a blank gray facing page that threatens to snuff out the dark images by flipping closed on top of it as one reads the book. Also designed by Sugiura, as was Kawada's *Chizu,* Takanashi's box also contains a second smaller, hidden volume tucked into the bottom of the portfolio, *Tokyo-jin.* This paperback volume modeled on a school notebook is equally startling, with fifty-six grainy images of city life and people. Both books are meant to be read vertically, and *Toshi-e* repeats gradually darkening images on separate pages to disorient and suggest time.[49] The book begins with a series of the same shoreline shot printed in different degrees of light, and ends with a series of six pages of the same factory view, darkening to almost black as the pages progress. Printed in gravure, the large book is enormous—larger than *Images à la sauvette;* the pages are more contemplative than the raw imagery of Moriyama's imagery, and in a language that has echoes of the lyrical montage of 1920s French photobooks, it addresses the complexity of Japan's economic status and urban existence.

French photobooks dominated the public discourse of photography from 1928 to 1958, and, as we have seen, Japanese photobooks continued the tradition of commenting on society in the 1960s and 1970s. At the present moment, photography books have retaken the center of the world of photographic discourse, both in honoring its historical stars and in encouraging new photographic book projects by contemporary artists who recognize that books are part of photography's natural language as much as individual prints or magazine picture stories. The market has recognized the importance of historical photobooks, and Krull's *Métal,* Moï Ver's *Paris,* Brassaï's *Paris de nuit,* Jahan's *La mort et les statues,* Cartier-Bresson's *Images à la sauvette,* and William Klein's *Life Is Good and Good for You in New York* have all been republished in facsimile reprints in the last fifteen years, signaling a resurgent interest in this period in France.[50] These reprints reflect the market value of photographic books as collector's objects, but increasingly the collectors include not only wealthy patrons but working photographers who continue to mine them for inspiration.

Contemporary photographers in all parts of the world have also returned to the book format as a central form for photography. Stephen Shore, who has been taking color photographs since the 1960s, has published more than twenty-five books, and in 2018 his books were displayed hanging from the ceiling at the Museum of Modern Art, New York, an exhibition installation of bound volumes that were seen as equally central to his monographic overview as the framed prints on the wall.[51] Perhaps the best current example of book aficionados among photographers is the Indian artist Dayanita Singh, who won the 2018 Infinity Award from the International Center for Photography. Like Moriyama, she believes that her art form is the photobook, not the single image, because one can touch and smell books, and engage them with one's physical body. She applauds the democratic role of the book, allowing broad dissemination, and her work, *Museum Bhavan,* is a collection of nine "exhibitions in a box," each constructed as a leporello or accordion format so that they can be unfolded and displayed differently by each viewer—much as Krull's *Métal* could be seen.[52] Brassaï's *Paris de nuit* and Klein's *Life Is Good and Good for You in New York* traveled around the world through the conventional means of book sales and exchange, not quite as self-consciously as Singh's organized travel itinerary for *Museum Bhavan,* but the issues of democratic image diffusion, tactility, radically individual sequencing, and portability continue to be extremely important today. The formal structures of "making strange," of breaking apart narrative photographic progression through montage, dream imagery, memory, and combinations of nostalgia and political commentary, all developed first in France, in the years from 1928 to 1958, and they are continuing to scatter their seeds around the world, almost a century later. The formal strategies have proved to be useful not only as a commentary on European modernity, but also as an international series of pictorial languages that can be used in other parts of the world and other political moments.

NOTES

INTRODUCTION

1. Simmel, "Metropolis and Mental Life," 409–10, 414; Baudelaire, *Painter of Modern Life,* 9. Also see Benjamin, *Charles Baudelaire.*

2. Shklovsky, "Art as Technique," 3–24. Benjamin Sher translates it as "enstrangement" in his translation of the same essay as "Art as Device"; see Shklovsky, "Art as Device," xix; Brecht, *Brecht on Theater.*

3. Breton, "Preface," *Nadja* (1964), 6.

4. Krauss and Livingston, *L'Amour fou;* Foster, *Compulsive Beauty,* xvii. Also see Ades, *Dada and Surrealism Reviewed;* Ades and Baker, *Undercover Surrealism;* Ades and Baker, *Close-Up;* Bajac and Chéroux, *Subversion des images;* Baker, *Exposed;* Foster, *Compulsive Beauty;* and Walker, *City Gorged with Dreams.*

5. Robin Walz explores Aragon's Surrealist novel *Le paysan de Paris,* the Fantômas crime novels, the mass murderer Landru, and popular fascination with suicide in Walz, *Pulp Surrealism.*

6. Mac Orlan, *Écrits sur la photographie.* His first essays citing the term are "La photographie et le fantastique sociale," *Les annales politiques et littéraires,* no. 2321 (November 1, 1928): 413–14; and "Photographie. Elément de fantastique sociale," *Le crapouillot* (January 1929): 3–5; both are reprinted in Mac Orlan, *Écrits sur la photographie,* 59–63, 65–68.

7. Sliwinski, *Human Rights in Camera,* 17.

8. Sartre, "Camus's *The Outsider,*" 44.

9. Jameson, "Postmodernism and Consumer Society," 113. Tom McDonough defines "détournement" as suggesting "the act of diverting or rerouting a body in motion from its habitual course." McDonough, *Reinventing the Language of Contestation,* 8–9, 25, 44.

10. Benjamin, "Unpacking My Library," 60–61; see also "Work of Art," "Short History of Photography."

11. I define a photographic book as one where images drive the narrative, so that I can explore just how sequencing and structure take place. This excludes certain kinds of text-driven projects, such as Jacob Riis's *How the Other Half Lives* (1890), in which Riis's prose is dominant and the images illustrate his words. It also excludes certain of the best photographic projects published in the golden age of American documentary photography, such as Paul Taylor and Dorothea Lange's *American Exodus* (1939), in which photographs and text are equal in power, and James Agee and Walker Evans's *Let Us Now Praise Famous Men* (1941), whose words far outnumber the photographs in bulk, if not in impact. Photographic books discussed here are largely image-based, with captions, certainly, and afterwords or texts. But the images are dominant, and we tend to read them in a nonverbal fashion. And the author, reviled as irrelevant for several decades, is an important factor in these books, whether as editor, image-maker, or writer of picture prose. This is not to suggest that photographic books are not mediated by politics, by place, by gender, or by class or race, but the voice of the individual is a factor, too.

12. Appadurai, *Social Life of Things,* 5; for a seminal approach to material culture reading, see Prown, "Mind in Matter."

13. De Thézy, *Photographie humaniste,* 33. Gravure printing required the copying of images onto copper plates, and it was costly. In contrast, offset lithography was developed as an inexpensive way to reproduce visual information on paper, by photographing an image through a screen that breaks up the image into dots called halftones and transfers to rubber blankets that, when printed via a revolving drum, replicate the image in ink on paper. For a technical history of printing processes, see Benson, *Printed Picture,* 210–73.

14. For a detailed history of Delpire, see *Delpire et Cie;* Serry, *Éditions du Seuil,* 15.

15. Drucker, *Century of Artists' Books.* Drucker's chapter "Artists' Books and the Early Twentieth Century Avant-Garde" is an important source for the materials discussed here.

16. Mallarmé, *Coup de dés jamais.* See Drucker, *Century of Artists' Books,* 34; and Arnar, *Book as Instrument,* 217.

17. Apollinaire, *Calligrammes;* Marinetti, *Zang Tumb Tumb;* Mayakovsky and El Lissitzky, *Dlya Golossa;* Tzara, *Dada;* Cendrars and Delaunay-Terk, *Prose du Transsibérien;* Iliazd (Il'ia Zdanevich), *Ledentu le phare;* Drucker, *Century of Artists' Books,* 54.

18. For a history of Draeger Frères, see Seaver, "Exhibit of Draeger Frères," 9–12.

19. Martin Parr's collection of twelve thousand photography books entered the collection of the Tate Modern in 2017, Manfred Heiting's collection of twenty-two thousand photographic books was acquired by the Museum of Fine Arts, Houston, in 2013 (although many of Heiting's volumes were tragically destroyed in the 2018 Malibu fires), and the David and Reva Logan Collection of fifteen hundred photobooks arrived at the Bancroft Library at University of California, Berkeley, in 2013.

20. Badger and Parr, *Photobook;* Roth, ed., *Book of 101 Books;* Rabb, *Literature and Photography: Interactions;* Brunet, *Photography and Literature.*

21. Heiting, ed., *Japanese Photobook*; Fernández, *Latin American Photobook*; Giertsberg and Suermondt, eds., *Dutch Photobook*; Parr and WassinkLundgren, eds., *Chinese Photobook*; Curtis, ed., *Photographic Memory*; Kaneko and Vartanian, *Japanese Photobooks; and* Heiting and Karasik, eds., *Soviet Photobook*. Bouqueret's *Paris: Les livres de photographie* and Koetzle's *Eyes on Paris* present dozens of French book titles, but do not study them in depth. For American photobooks, see Trachtenberg, *Reading American Photographs*; Guimond, *American Photography*; Hunter, *Image and Word*; Mitchell, *Picture Theory*; Sandweiss, *Print the Legend*; Schloss, *Invisible Light*; and Stott, *Documentary Expression and Thirties America*.

22. Bourke-White and Caldwell, *You Have Seen Their Faces*; Evans, *American Photographs*; Lange and Taylor, *American Exodus*; Wright, *12 Million Black Voices*.

23. Di Bello and Zamir, "Introduction," 1–3. For the largest overview of photobooks to date, see Badger and Parr, *Photobook*. See Eisenstein, "Word and Image," 7–8.

24. Hughes and Noble, "Introduction," 3–4.

25. Talbot, *Pencil of Nature*; Carol Armstrong, "A Scene in a Library," in *Scenes in a Library*, 107–78; Larry Schaaf, "Third Census of H. Fox Talbot's *The Pencil of Nature*," *History of Photography* 36, no. 1 (2012): 99–120; Brunet, *Photography and Literature*; Batchen, *Burning with Desire*.

26. Armstrong, *Scenes in a Library*; Nickel, *Francis Frith*.

27. Goldin, *Ballad of Sexual Dependency*; Steichen, ed., *Family of Man*; DeCarava, *Sweet Flypaper of Life*; Blossfeldt, *Urformen der Kunst*; Becher and Becher, *Typologies of Industrial Buildings*; Bernd Becher and Hilla Becher, *Water Towers* (Cambridge, MA: MIT Press, 1988).

28. Trachtenberg, *Reading American Photographs*, 240; Greenough, *Looking In*.

29. Moholy-Nagy, *Malerei Photographie Film*; Renger-Patzsch, *Die Welt ist Schön*; Blossfeldt, *Urformen der Kunst*; and Lerski, *Köpfe des Alltags*. Molzahn, "Nicht mehr sehen! Lesen!," 81. See Stetler, whose title comes from Mohlzahn's essay, *Stop Reading! Look!*, 6–13, 14, 18–19.

30. Magilow, *Photography of Crisis*, 6, 11, 93, 122. Eco, *Open Work*. See Magilow's discussion of Ferdinand Bucholtz and Ernst Jünger's photographic anthology, *Der gefährliche Augenblick* (Berlin: Junker und Dünnhaupt, 1931), 123–34.

31. See Benjamin, "Work of Art," 217–52.

32. Turvey, *Filming of Modern Life*.

33. See Frizot, *VU*; Sichel, *Germaine Krull: Photographer of Modernity*, chap. 6.

34. Except for Atget, Nadar, and Laure Albin-Guillot, all of the Salon de l'Escalier exhibitors were foreign-born: Abbott and Man Ray were American; D'Ora, Austrian; Hoynigen-Huene, Russian-born; Kertész, Hungarian; and Krull, German-born. For a further discussion of foreigner photographers in Paris, see Sichel, "Photographes étrangers à Paris," 329–45.

35. Germaine Krull, the most prolific of the group, published *Métal, 100 x Paris, Études de nu, Marseille, La route Paris-Biarritz,* and *Le Valois*, in addition to her "photo-roman" with Georges Simenon, *La folle d'Itteville*. Krull also contributed thirty-eight of the ninety-six images in *La route de Paris à la Méditerranée*, and published *La bataille d'Alsace* during World War II. Laure Albin-Guillot published *Micrographie décorative*, and André Kertész produced *Enfants, Paris vu par André Kertész*, and *Nos amies les bêtes*. Other important books include Brassaï's *Paris de nuit, Voluptés de Paris*, and *Graffiti: Zwei Gespräche mit Picasso*; Henri Cartier-Bresson's four books, *Images à la sauvette, Les Européens, D'une Chine à l'autre*, and *Moscou*; Robert Doisneau's *La banlieue de Paris* and *Instantanés de Paris*; Izis's *Paris des rêves*; Pierre Jahan's *La mort et les statues* and *Les gisants*; Willy Ronis's *Belleville-Ménilmontant*; and Moï Ver's *Paris*.

36. Krull, *Métal*; Moï Ver, *Paris*.

37. Shklovsky, "Art as Device," 14. For a further discussion of Krull and Eisenstein, see Sichel, *Germaine Krull: Photographer of Modernity*, 74–75.

38. Breton, *Nadja* and *L'amour fou*; Fargue, *Banalité* (1930), photographs by Roger Parry.

39. Nora, "Between Memory and History," 7.

40. Schall, *Paris sous la botte des Nazis*; Miller, *Wrens in Camera*; *KZ*. For a fascinating overview of French photography just after the liberation, see Tambrun, ed., *Paris libéré*.

41. Doisneau, *Banlieue de Paris*.

42. Cartier-Bresson, *Images à la sauvette* and *Les Européens*.

43. Golan, *Modernity and Nostalgia*, ix–x.

44. Frank, *Les Américains*; Klein, *Life Is Good*.

CHAPTER 1. MONTAGE

1. Krull, *Métal*. *Métal* has often been inaccurately listed as a 1927 publication. The Bibliothèque National Dépot Légal lists it as a 1929 publication, but it must have appeared in late 1928 for a review to be published in *Jazz* and *Variétés* in mid-January 1929. (See Frizot, *Germaine Krull*, 45, which concurs with a 1928 publication date.)

2. A very similar image of the same ship's smokestack and tower is illustrated with three photographs by Germaine Krull and three by Eli Lotar in Salmon, "Toulon," 345. It is identified as "Warship in the Port of Toulon, 1926" in the 2003 re-edition of *Métal*, n.p.

3. For further information on Krull and her career, see Sichel, *Germaine Krull: Photographer of Modernity;* and Frizot, *Germaine Krull*. Krull's published books from 1926 to 1936 include *Métal* (1928); *100 x Paris* (1929); *Études de nu* (1930); *Le Valois*, text by Gérard de Nerval (1930); *La folle d'Itteville*, text by Georges Simenon (1931); *La route Paris-Biarritz*, text by Claude Farrère (1931); and *Marseille*, text by André Suarès (1935). She published many more books during her life, but these are her monographic French productions between the world wars.

4. These two seminal German photography books were also published in 1928: Blossfeldt, *Urformen der Kunst*; and Renger-Patzsch, *Die Welt ist Schön*. For an overview of German photography books, see Stetler, *Stop Reading! Look!*

5. *Métal* was advertised in *Variétés* 2, no. 2 (January 15, 1929): 128. Rough equivalencies for 1929 are that 1 French franc equals 3.9 cents, or $5.86 in 1929 dollars. With inflation, the original cost would be about $80 in 2015 dollars.

6. Krull, *Métal*. For an earlier discussion of *Métal*, see Sichel, *Germaine Krull: Photographer of Modernity*.

7. Lou Tchimoukow (or Louis Bonin, or Lou Bonin-Tchimoukow) was a member of the October group, active in left-wing cinema during the 1930s, and linked to the anti-Breton Surrealists. The group was a 1933 spin-off from an amateur group called Les Prémices, founded in 1929. As the group's principal film director, Tchimoukow was closely associated with Jacques Prévert and his brother Pierre. For more details, see Colin Crisp, *The Classic French Cinema* (Bloomington: Indiana University Press, 1993), 181.

8. For a fuller account of the artistic relationship between Ivens and Krull, see Sichel, *Germaine Krull: Photographer of Modernity*, 68–77.

9. Rotterdam Bridge images in *Métal* include plates 13, 25, 31, 32, 34, 40–42, 46, and 48. In the 2003 re-edition of *Métal*, Krull also identified plates 9, 14, 17, 24, 30, 43, 38, 43, 49, 52, 58, 63, and 64 as being from the ports of Rotterdam and Amsterdam. Krull, *Vie mène la danse* (1980–81), 117.

10. For further information on Fels, see Denoyelle, *Lumière de Paris*, 128. For a lengthy discussion of the *VU* Eiffel Tower article, see Sichel, *Germaine Krull: Photographer of Modernity*, 102–6.

11. Ann and Jürgen Wilde unsuccessfully tried to republish *Métal* in 1978, and Krull identified the plates then; a facsimile reprint appeared only twenty-five years later, in 2003. Krull, *Métal* (2003), afterward with list of plates identified by Krull in 1978, n.p.

12. Rops, "Review of *Métal*," repr. in Mac Orlan, *Germaine Krull*, 15.

13. Fels, "Dans toute sa force," 284, with three photographs by Krull. For a fuller account of Krull's multiple exposures and photomontages, see Sichel, "Contortions of Technique"; Frizot, *Germaine Krull*, 43–44; and Sichel, *Germaine Krull: Photographer of Modernity*, 91–93.

14. Fels, "Preface," repr. in Phillips, ed., *Photography in the Modern Era*, 13–14.

15. For a biography, see Danahy, "Marceline Desbordes-Valmore," 121–33. I am grateful to Dorothy Kelly for this citation.

16. Fels, "Preface."

17. Emners, "Protest gegen ein unmögliches Bauwerk," 106–11. Contemporary reviews include: Auclair, "Tour Eiffel, soeur aînée des avions"; Bost, "Les livres"; Fels, "Acier"; Gallotti, "Photographie est-elle un art?"; Rops, "Review of *Métal*"; Saunier, "Métal: Inspirateur d'art"; *Variétés*, unsigned review. Other critics included Frédéric Lefèvre for *République*, J.-J. Brousson for *Nouvelles littéraires*, Jean Cocteau (a longtime admirer of her work), and Georges Charensol (all essays repr. in Mac Orlan, *Germaine Krull*).

18. Fels, "Premier salon indépendant de la photographie," 445; Mac Orlan, *Germaine Krull*, 6; Fels, "Acier," 232–34. See Sichel, *Germaine Krull: Photographer of Modernity*, 94, for further discussion.

19. Fels, "Dans toute sa force," 284; Fels, "Acier," 232–34; Gallotti, "Photographie est-elle un art?," 530; Florent Fels, "Préface," in Krull, *100 x Paris*, xiv–xvi.

20. Krull, "Click entre deux guerres," 12. Similar stories are published in other versions of her memoirs, notably *Vie mène la danse* (1980–81), 125; and *Vita conduce la danza*, 147–48.

21. Frizot, *VU*, 307. For an in-depth look at picture essays in *VU*, see Sichel, *Germaine Krull: Photographer of Modernity*, 97–112.

22. Prévost, *Eiffel*, plates 43–48; Auclair, "Tour Eiffel," 743–44.

23. Bost, "Livres," 92; Frizot, *Germaine Krull*, 46.

24. Saunier, "Métal: Inspirateur d'art," 361, 368–69.

25. Gallotti, "Photographie est-elle un art?," 526–28, 530; Frizot, *Germaine Krull*, 47–48.

26. Mac Orlan, *Germaine Krull*, 6. Also see Ribemont-Dessaignes, *Man Ray*.

27. Mac Orlan, *Germaine Krull*, 7.

28. Benjamin, "Short History of Photography." Krull made a portrait of Benjamin in 1926 and corresponded regularly with him through the late 1930s.

29. Molderings, "Photographic History," 328, 330.

30. Benjamin, "Short History of Photography," repr. in Trachtenberg, *Essays on Photography*, 213, 203.

31. Benjamin, "Short History of Photography," 211, 203. Herbert Molderings usefully identifies the term "optical unconscious" as one Benjamin learned from Moholy-Nagy's publications in *i10*. Molderings, "Photographic History," 323.

32. Magilow, *Photography of Crisis*, 93, 68, 14.

33. Blossfeldt, *Plante*. As an instructor at the Kunstgewerbeschule in Berlin from 1898 to 1930, he photographed thousands of plants in magnification and other extraordinary detail, and they were exhibited in many avant-garde photography shows in the late 1920s, in including the *Film und Foto* exhibition in Stuttgart in 1929, where Krull's works were also seen.

34. Frizot, *Germaine Krull*, 46.

35. Clouzot, *Tissus nègres*. The vast majority of cloth reproduced in this book is from the Bakuba in the Congo; many of these specimens come from the collection of Dada poet Tristan Tzara.

36. Krull, *Études de nu*.

37. Albin-Guillot, *Micrographie décorative*, is a book of twenty photogravures, eight on metallic paper. Desveaux and Houlette, "Laure Albin-Guillot," n.p. Also see Desveaux et al., *Laure Albin Guillot*.

38. Benjamin, "Short History of Photography," 209, 215.

39. Krull recounts this memory in several memoirs, but no record of such an exhibition exists and it seems unlikely, at best. The quality of their friendship, however, is unquestionable. See Krull, *Vie mène la danse* (1980–81), 7.

40. Several dozen Krull photographs of Sonia Delaunay-Terk's designs can be found in the Fonds Delaunay at the Bibliothèque Nationale in Paris. For more, see Sichel, *Germaine Krull: Photographer of Modernity*, 84–85; and Godefroy, "Images simultanées," 99–113.

41. Bury, *Breaking the Rules*, 35; and for more on this volume, see Wye, *Artists and Prints*.

42. Guillaume Apollinaire, *Les peintres cubistes* (Paris: Eugène Figuière, 1913). In his chapter on the Salon de la Section d'Or, Apollinaire coined the term "Orphism" to refer to the simultaneous color contrasts of his close friends Robert and Sonia Delaunay.

43. Translation from Stephen Spender Trust, "La Tour Eiffel"/"The Eiffel Tower," http://www.stephen-spender.org/2013_prize/open_commend_CH.png.

44. Michelson, "Dr. Crase and Mr. Clair," 35, 39.

45. Michelson, "Dr. Crase and Mr. Clair," 43, 44.

46. Michelson, "Dr. Crase and Mr. Clair," 30.

47. For biographical details, see Sichel, *Germaine Krull: Photographer of Modernity*, 40–42, 66–76. Krull and Ivens married in 1927 to get her a Dutch passport, and although they were no longer partners, they did not divorce officially until 1943. Krull, "Click entre deux guerres," 6.

48. Eisenstein and Pudovkin debated this issue intensely. See Eisenstein, "Cinematographic Principle and the Ideogram," 28–44.

49. Earlier versions of this discussion were published in Sichel, *Germaine Krull: Photographer of Modernity*, 78.

50. Eisenstein, "Dialectic Approach to Film Form," 52–54, 60.

51. For a comparative study of German and American industrial photography, see Sichel, *From Icon to Irony*; Renger-Patzsch, *Die Welt ist Schön* and *Eisen und Stahl*.

52. Moholy-Nagy, *Malerei Photographie Film*, 116.

53. Tupitsyn, *Soviet Photograph*, 67, 72; Aleksandr Rodchenko, "Puti sovremennogo foto," *Novyi LEF*, no. 9 (1928): 31.

54. See Sichel, *Germaine Krull: Photographer of Modernity*, 162–63.

55. Rops, review of *Métal*, 15; Carl Georg Heise, "Introduction," in Renger-Patzsch, *Die Welt ist Schön*, 9.

56. Moholy-Nagy, "Scharf oder unscharf?," trans. as "Sharp or Unsharp: A Reply to Hans Windisch," in Phillips, ed., *Photography in the Modern Era*, 136.

57. Benjamin, "Author as Producer," 230, 222.

58. From Abbott, Interview; René Zuber, unpublished text in Bouqueret, *Paris, les livres de photographie*, 20; Man Ray's comment is quoted in Roth, ed., *Book of 101 Books*, 46–47.

59. Moï Ver, *Ein Ghetto im Osten—Wilna*. Part of the series *Schaubücher*, published with the assistance of Emil Schaeffer. See Molderings, "Moshé Raviv-Vorobeichik (Moï Ver)," 75; Nelson, "Reading Photobooks," 253.

60. Léger, "Introduction," in Moï Ver, *Paris*, n.p. See Ingelmann, "Moï Wer"; and Moï Ver,

61. Ingelmann, "Moï Wer." For a discussion of Krull's sandwiching techniques, see Sichel, "Contortions of Technique."

62. Nelson, "Reading Photobooks," 255.

63. *Arts et métiers graphiques*, no. 23 (May 15, 1931): 283; and no. 22 (March 15, 1931): 85. Jean Bullier, "Les éditions de luxe," *La quinzaine critique des livres et des revues* 33, no. 3 (May 31, 1931): 486.

64. The maquette for *Ci-contre* had remained in Franz Roh's possession.

65. Krull, *100 x Paris*.

66. For a view of just a few of these *Métal* spin-offs, see Peissi, *Eiffel*; Eberhard Fiebig, *Der Eiffelturm* (Selb: Notos, 1976); Barthes and Martin, *Tour Eiffel*; and Hervé, *Eiffel Tower*.

67. Evans, "Reappearance of Photography"; George, "Photographie-vision du monde," 142, 144.

68. Belinda Rathbone, *Walker Evans* (New York: Houghton Mifflin, 1995), 34. Crane, *Bridge* (Paris, 1930). Slightly different images appeared in the second edition, *Bridge* (New York, 1930—two printings). For details, see Trachtenberg, *Brooklyn Bridge*, 186–88.

69. Trachtenberg, *Brooklyn Bridge*, 192.

70. Unfinished letter from Walker Evans to Ernestine Evans, February 1934, repr. in Jerry Thompson, *Walker Evans at Work* (New York: Thames and Hudson, 1984), 98. See Trachtenberg, *Reading American Photographs*, 244, 233.

71. Lincoln Kirstein, "Photographs of America: Walker Evans," in Evans, *American Photographs* (1988), 193, 194.

72. Trachtenberg, *Reading American Photographs*, 241–42.

CHAPTER 2. DREAM DETECTIVES

Epigraph: Brassaï, quoted in Bequette, "Rencontre avec Brassaï," 11.

1. Brassaï, *Paris de nuit*; English ed., *Paris after Dark*. The French edition was reprinted several times in 1933 for a total run of twelve thousand—then a large number for a press run.

2. Brassaï Archive.

3. Brassaï, *Paris de nuit* (1987). An unauthorized German edition, re-photographed from the original 1932 book, had appeared earlier—Brassaï, *Nächtliches Paris/Paris de nuit* (1979).

4. Bachelard, *Poetics of Space*, xv–xvi, xxxvi–xxxvii, 6, 19, 26.

5. Brassaï, *Voluptés de Paris*. His other Paris books include *Camera in Paris*, published right after the war; and *Graffiti* (1960).

6. See Aubenas and Bajac, *Brassaï: Paris Nocturne*, 192, for the influence; and Sichel, *Germaine Krull: Photographer of Modernity*, for an in-depth discussion of Krull's clochards in the popular press. Krull, *Folle d'Itteville*.

7. See Ades and Baker, *Undercover Surrealism*; Foster, *Compulsive Beauty*; Krauss and Livingston, *L'Amour fou*; Mundy, *Surrealism: Desire Unbound*; and Walker, *City Gorged with Dreams*.

8. Miller, "Eye of Paris," repr. in Miller, *Max and the White Phagocytes*, 241.

9. Population growth also slowed to a crawl. France's population grew only 3 percent from 1900–39, whereas Germany grew 35 percent, and Britain grew 23 percent. Gordon Wright, *France in Modern Times* (Chicago: Rand McNally, 1974), 373; and Weber, *Hollow Years*, 11–13.

10. Golan, *Modernity and Nostalgia*, ix. Ian Walker comments on the blend of poetic realism and Mac Orlan's "social fantastic" and sees the work as "next to Surrealism rather than within it." He also repeats Brassaï's often-cited comments from a 1980 interview that in opposition to the Surrealists, the photographer always concentrated on everyday life. Walker, *City Gorged with Dreams*, 152. Brassaï's postwar book *Camera in Paris* is an example of his humanistic photography output.

11. Durrell and Brassaï, cited in Durrell, "Essay," 12–13.

12. Aubenas and Bajac, *Brassaï: Paris Nocturne*, 21; author's interview with Gilberte Brassaï, Paris, June 1988; Tucker, *Brassaï: The Eye of Paris*, 36.

13. Surya, *Georges Bataille*, 68–69.

14. Brassaï, "Excerpt from *Paris de nuit*," 388–96.

15. Aubenas and Bajac, *Brassaï: Paris Nocturne*, 14, 15. Aubenas also cites Brassaï's letter disliking the "red lettering" and preferring some with "white and silver lettering," although no such copies have been located.

16. See Krauss, "Nightwalkers," 33–38; and Foster, *Compulsive Beauty*.

17. For an overview of Bataille, see Ades and Baker, "Introduction," in *Undercover Surrealism*, 11–15; Bataille, "Abattoir," 328–30. For a fuller discussion of the abattoir, see Walker, *City Gorged with Dreams*, 127–32. Also see Hollier, *Against Architecture*; Ades and Baker, *Undercover Surrealism*; and Bois and Krauss, *Formless*, 43.

18. The boundary reallocations after World War I made Brassaï's hometown, Brasov, a part of Romania.

19. Brassaï to his parents, 24 January 1931 and 27 July 1931, in *Letters to My Parents*, 182, 184; Brassaï, *Neuf* (1952), n.p., cited in Aubenas and Bajac, *Brassaï: Paris Nocturne*, 98–99. The tale of Kertész's and Brassaï's interactions, beginning when Brassaï bought Kertész and Rogi André photographs to publish in German magazines, has been discussed in previous monographs. See Sayag and Lionel-Marie, *Brassaï*; Tucker, *Brassaï: The Eye of Paris*, 30–31; Warehime, *Brassaï*.

20. Aubenas and Bajac, *Brassaï: Paris Nocturne*, 185–86.

21. An exception is Aubenas and Bajac, *Brassaï: Paris Nocturne*, which has recently and thoroughly examined the totality of Brassaï's output. They skillfully reconstruct the book's planning and production, its place within Brassaï's larger body of work, the book's precursors and counterparts in night photography, and complementary projects in film, literature, and photography. Also see Brassaï, *Letters to My Parents*; and Brassaï, *Henry Miller: Grandeur nature*.

22. Brassaï to his parents, 5 November and 4 December 1931, in *Letters to My Parents*, 187–88, 190. In fact, the book was advertised in 1933 for 45 francs, not 100 francs.

23. Brassaï to his parents, 1 April 1932, 4 December 1932, and 9 November 1932, in *Letters to My Parents*, 193, 204, 207.

24. Morand, *L'intransigeant*, 8; *Les nouvelles littéraires*, unsigned review, 1–2; *L'instantané*, unsigned review, 30; Henriot, "Photos de Paris," 15; Bernier, "Paris de nuit," 144; Fernand Pouey, "Un pur," n.p.; Levy, "Quelques visions," 6; Maraï, "A Párisi éjszaka"; Root, "Brassaï Makes Photo Record"; O. R., "Bibliographie: Livres illustrés," 18; *Les amitiés Franco-Canadiennes*, unsigned review, 29; Vetheuil, "Ville photogénique," 1–2. In Japan, "Excerpt from *Paris de nuit*" [excerpt in *Asahi Camera*], 388–96. For a complete bibliography of Brassaï, see Tucker, *Brassaï: The Eye of Paris*. Among the press reviews of *Paris de nuit*, the most penetrating was by Émile Henriot, "Photos de Paris," writing for *Le temps*: "In leafing through this beautiful publication, where the amateur of nocturnal Paris can taste such a vivid pleasure, we attempt to see just what creates such an effect: truth, poetry, analysis and intention, rendered atmosphere, the material fidelity or fantastic transposition."

25. Brassaï to his parents, 7 December 1933, in *Letters to My Parents*, 210.

26. Rochester Institute of Technology, "History of Deberny et Peignot," http://amgweb.rit.edu/dphist2.htm. Balzac's mistress was Louise-Antoinette-Laure de Berny, and her son, Alexandre de Berny, eventually took over the business—hence the name Deberny.

27. *Arts et métiers graphiques* measured 12¼ by 9⅝ inches. For an overview of the journal, see Denoyelle, "Arts et métiers graphiques," 6–17. Soon after the press opened in 1927, Peignot's Arts et Métiers Graphiques published the book *Suite de photos* by Maurice Cloche (1930), followed by a book on clouds, *À traver les nuages*, by Manfred Curry (1932); *Études de nus* edited by Abel Bonnard (1936); *Femmes* by Sasha Stone (1933); and G. Petit's *Madagasacar* (1933). Only then did the publisher publish *Paris de nuit*, and, buoyed by its success, followed with the publication of Roger Schall's *Paris de jour* (1937) and Bill Brandt's *Londres de nuit* (1938).

28. Photogravures, or héliogravures, are photomechanical prints made in two stages: a photographic negative is transferred to a copper etching plate dusted with rosin powder, etched with ferric chloride solutions, and the intaglio print from that plate is then hand-pulled on an inked press to create the final image. The process was first used in France by publisher Jacques-Henri Lagrange in *Le Visage de la France* (Paris: Horizons de France, 1927). See de Thézy, *Photographie humaniste*, 33.

29. Simone Kahn, Breton's first wife, suggests that Bernier was one of the most important early influences on Breton. For more on Bernier, see Surya, *Georges Bataille*, 69, 70. Bernier, "Paris de nuit," 144.

30. Van Noort, *Paul Morand*, 12; Winegarten, "Who Was Paul Morand?," 73. See Morand, *New York, Londres, Bucarest*.

31. The long tradition of books about Paris at night dates back to the nineteenth century. However, they generally concentrated on the gentleman's tour of "Paris léger," and on a city's genteel evening amusements rather than its seedier underbelly. As armchair travelers, readers were led to the opera, the theater, Montmartre, the quays, the Place de la Concorde. For added excitement, the guidebooks occasionally led the reader to an illicit dancehall, as a taste of the darker Paris beyond his ken, but rapidly returned to the safety of the light. For example, see *Paris after Dark* (1877); *Paris at Night*; McCabe, *Paris by Sunlight and Gaslight*. The genre continued into the twentieth century, often with a nostalgic yearning for the great days of the *boulevardier*, the flâneur, and the Second Empire. For instance, see de la Vaissière, "Nuits changées," 1. Also see Bertault, *Belles nuits de Paris*, for a typical example, and for an insightful view of the place of photographers among other night wanderers. In a description of the Montparnasse Café de la Rotonde, Bertault writes: "Here we see photographers, an epileptic, models of all sorts, and even the little grocer who is called 'the red bean'" (297). Art critics in the twenties wrote similar articles, as in Cheronnet, column, *L'art vivant*, and following issues.

32. Morand, "Introduction," in *Paris de nuit*, n.p. English translations of *Paris de nuit* cited here are from Stuart Gilbert's translation in the 1987 re-edition, Brassaï, *Paris by Night*, n.p.

33. Morand, "Introduction."

34. Morand, "Introduction," in *Paris de nuit*, n.p. The tradition of dangerous Paris in literature comes from Romanticism, and the novels of Victor Hugo, although they were later present in Baudelaire. For a discussion of Morand's postwar anxieties, see Saulnier, "Morand ou 'l'homme-frontière'"; and Charbonnier, "À Valéry Larbaud."

35. Root, "Brassaï Makes Photo Record," n.p.

36. For Nadar, see Philippe Néagu and Jean-Jacques Poulet-Allamagny, *Le Paris soutérrain de Felix Nadar* (Paris: Caisse nationale des monuments historiques et des sites, 1982). For an example of Paris picture agencies, see Agence Roger Viollet, Paris. Ermanox and Leica cameras were in common use by the late 1920s, although Brassaï and many of his colleagues used a camera like the Voigtländer that had small glass plates (6½ by 9 cm) instead of 35-mm negatives. Faster films included halogen film. Brassaï used Agfa Gevaert SSS Super Sensima, Special Anti-Halo film (see the *Paris de nuit* glass-plate boxes recovered at Flammarion, Paris).

37. See Quentin Bajac in Aubenas and Bajac, *Brassaï: Paris Nocturne*, 194, for a list of Brassaï's essays on night photography. Brassaï, "Technique de la photographie de nuit," 24–27. Brassaï utilized the standard methods, which were well documented in technical journals and books of the decade. For instance, a manual with sixty-six plates, *Photographie bei Nacht*, was published in 1928 and promptly reviewed in *Le photographe*.

38. As Quentin Bajac has written, from 1929 until the spring of 1933, Brassaï used a relatively old-fashioned Voigtländer Bergheil camera with a Heliar 10.5-cm lens, and used 6-by-9-cm glass plates, using gelatin film plates only in 1933. He needed a tripod for long exposures at night, and he traveled with only twenty-four plates at a time. Only in 1935 did he acquire a Rolleiflex with a 7.5-cm Zeiss Tessar lens, so that he could finally dispense with his tripod. Aubenas and Bajac, *Brassaï: Paris Nocturne*, 196, 198–200. For Brassaï's exposure timing, see Brassaï, "Chez les voyous et dans le beau monde," cited in Aubenas and Bajac, *Brassaï: Paris Nocturne*, 196.

39. Aubenas and Bajac, *Brassaï: Paris Nocturne*, 204.

40. Aubenas and Bajac, *Brassaï: Paris Nocturne*, 103. Sylvie Aubenas gives a good overview of authors whom Brassaï admired, and a thorough overview of the illustrated press that published night imagery, including *Détective*, edited by Georges Kessel, and *Voilà*, edited by Kessel and Florent Fels (Aubenas and Bajac, *Brassaï: Paris Nocturne*, 113). See Brassaï, *Proust sous l'emprise de la photographie*.

41. *Paris de nuit*, 1932, caption, n.p.; English trans. from *Paris by Night* (1987), n.p.

42. Quentin Bajac writes that a similar, differently cropped image is numbered N1 in the first "Night" box of contact prints. Aubenas and Bajac, *Brassaï: Paris Nocturne*, 189.

43. The carved forms of eyes in urban graffiti are, for Brassaï, the beginning of all human form. "We have seen these pairs of holes looming up from the Paris walls a hundred or a thousand times. These are eyes. But for children they are the discovery of the face, of mankind." Brassaï, *Graffiti* (1961), 9.

44. Brassaï to his parents, 7 December 1933, in *Letters to My Parents*, 210.

45. Chéroux, "Pourtant Mac Orlan," 7–8. Mac Orlan's texts include *Atget photographe de Paris*; *Cahun, Aveux non avenus*; *Germaine Krull*; *Paris vu par André Kertész*; *Belleville-Ménilmontant* (with Willy Ronis); and *Le NU international* (with Otto Steinert).

46. Mac Orlan, "Photographie. Éléments de fantastique social," 3–5; Mac Orlan, "Elements of a Social Fantastic," repr. in Phillips, ed., *Photography in the Modern Era*, 32–33.

47. Mac Orlan, "Elements of a Social Fantastic," 31; Mac Orlan, *Quai des brumes; Villes; Tradition de minuit*.

48. Mac Orlan, *Pierre Mac Orlan*, 13, 83.

49. *Paris de nuit* (1932), n.p.

50. This photograph may be an homage to Brassaï's friend Henry Miller. In *Henry Miller: Grandeur nature*, Brassaï recounts Miller's fascination with all the interdictions posted around Paris (32).

51. Brassaï, "Du mur des cavernes," *Minotaure*, nos. 3–4 (1933); and Brassaï, *Graffiti* (1960).

52. Marie-Claire Bancquart, *Paris des Surréalistes* (Paris: Éditions de la Différence, 2004), 41.

53. Benjamin, "Short History of Photography," 210, 215.

54. Brassaï, *Secret Paris*, n.p. His night-walking habit was shared by poets and writers; Surrealists such as André Breton, Louis Aragon, and Philippe Soupault were also noctambulists. Other fellow nightwalkers were Léon-Paul Fargue and Henry Miller. Gilberte Brassaï recalls that Raymond Queneau, Robert Desnos, Maurice Raynal, and Roger Vitrac often accompanied Brassaï. (Letter to the author, 1 December 1984.)

55. Messac, *Detective novel*, 9. A popularized version is serialized in *VU*: Wolfe, "Detection scientifique du crime." The history of scientific method in the work of the modern detective harks back to the first French detective, Eugène Vidocq, in the mid-nineteenth century (his story inspired Balzac, Hugo, and Poe).

56. Four covers were reproduced in *Documents*, no. 7 (1929), but attracted attention only for their design, not their sensationalism. True crime stories were also published in *Documents*. See Simon Baker, "Crime," in Ades and Baker, *Undercover Surrealism*, 102.

57. Krull, *Folle d'Itteville*, 1931. A second novel, *L'affaire des sept*, was planned, and advertised on the back cover of *La folle d'Itteville*, but it never appeared in print.

58. Narcejac, *Esthétique du roman policier*.

59. Walz, *Pulp Surrealism*.

60. Germaine Krull, "Une femme erre de trottoir en trottoir," and Eli Lotar, "Dans les salles d'attente des troisièmes classes," illustrations for Bringuier, "Mystère des gares." Eli Lotar, "Service de nuit," *Détective* 1, no. 6 (December 6, 1928): cover. Kessel, "Paris la nuit"; Dudley and Ungar, *Popular Front Paris*, 294.

61. This statue by Hippolyte Maindron, commissioned in 1843, is known as one of the first Romantic sculptures. It is over six feet high. Brassaï, *Paris de nuit*, n.p. English trans. from 1987 ed., *Paris by Night*, n.p.

62. Brassaï's Surrealism has been thoroughly explored in the work of Marja Warehime, Rosalind Krauss, and Anne Wilkes Tucker. Warehime, *Brassaï*, chap. 4, is a more in-depth view of *Voluptés de Paris* and a formal comparison to *Les Paris secret des années 30*, but she does not go into great depth on the seamiest side of Mac Orlan's "social fantastic." Finally, Ian Walker compares *Paris de nuit*, *Les Paris secret des années 30*, and the Brassaï photographs published in *Minotaure* and Breton's *L'amour fou* but downplays the importance of the vernacular detective links and seamy *Voluptés de Paris*. (Walker, *City Gorged with Dreams*, 145–62.)

63. "Tériade" is the gallicized name for the Greek-born Parisian publisher Efstratios Eleftheriades. Brassaï and Dalí collaborated on two projects for *Minotaure*, "Sculpture involontaires" and "De la beauté terrifiante."

64. Bequette, "Rencontre avec Brassaï," 12; Brassaï, *Conversations avec Picasso*, 23.

65. Brassaï, *Conversations with Picasso*, 47.

66. Krauss, "Nightwalkers," 38; Bequette, "Rencontre avec Brassaï," 15.

67. Brassaï, *Graffiti* (1960).

68. Brassaï, *Henry Miller: The Paris Years*, 7–8.

69. Brassaï, *Henry Miller: The Paris Years*, 121.

70. Miller, *Tropic of Cancer*, 189–90; Miller, "Eye of Paris," repr. in Miller, *Max and the White Phagocytes*, 241.

71. Brassaï, *Henry Miller: Grandeur nature*; *Henry Miller: Rocher heureux*; *Henry Miller: The Paris Years*, 35. Brassaï anxiously worked, at least in the 1970s, to distance himself from Miller's unrepentant vulgarisms, and he deconstructed Miller's description of him almost line by line to deny vehemently that they visited brothels and other unsavory places together. Brassaï, *Henry Miller: The Paris Years*, 127–41.

72. Bequette, "Rencontre avec Brassaï," 10.

73. Frank Dobo identified Brassaï as the figure in this image, and also under the Metro in plate 47. Tucker, *Brassaï: The Eye of Paris*, 43. One of the prints has a handwritten note identifying the photographer as the figure.

74. *Paris de nuit* (1932), plate 11, caption, n.p.; Brassaï, *Paris Secret*, n.p.

75. Tucker, *Brassaï: The Eye of Paris*, 43.

76. The Rue Quincampoix is a mere two blocks from Les Halles, and the heart of an *ilot insalubre*, or unhealthy quarter, that was razed after World War II to create what is now the Centre Georges Pompidou. The "quartier Beaubourg" was known not only for financial gambling under Louis XV but also for its slums, its cholera outbreaks, its left-wing political tendencies, and the notorious massacre on the nearby Rue Transnonain in the uprisings of 1834. Its tradition as a center for prostitution is centuries old. Brassaï liked this area, writing about it in *The Secret Paris of the 1930s*: "I preferred the district around Les Halles. Famous for its central market—known as the belly of Paris—the area also dealt in the lower parts of the body" (n.p.).

77. Although the film and the book appeared the same year, we have no information about whether Brassaï saw the film.

78. Bijou was clearly an emblematic figure for Brassaï; a close-up view is the last plate in the Museum of Modern Art 1968 catalogue, and she reappeared in *Les Paris secret des années 30* in 1976. The original glass negative for *Paris de nuit* shows all of the mirrors above her head, with the indistinct reflection of water facing us above her head. A mirror on the right frames a man with a hat, looking left, so that the original image had a trio of figures, not just one central one.

79. In *The Secret Paris of the 1930s*, Brassaï later describes his 1932 encounter with her in the Bar de la Lune with both acuity and a certain generous humor: "Her face with its white clown make-up was softened by a green veil decorated with roses. And yet, behind her glittering eyes, still seductive, lit with the lights of the Belle Epoque, as if they had escaped the onslaughts of age, the ghost of a pretty girl seemed to smile out" (n.p.). He then describes her reaction to the publication of her photographs: "Miss Diamonds put in an unforgettable appearance at my publisher's office. Swathed in her tawdry finery, outrageously made up, she created a panic. Removed from her surroundings, deprived of the night's complicity, revealed in the light of day, she was monstrous. . . . 'Do I seem to be escaped out of a nightmare of Baudelaire? Do I? Me, a nightmare? You'll pay for it!' And she refused to leave until the publisher had paid her for the 'insult'" (n.p.).

80. *Paris de nuit* (1932), caption, n.p.; English trans. from *Paris by Night* (1987), n.p.

81. Collection Musée Nationale d'Art Moderne, Centre Georges Pompidou, Paris.

82. These literary connections are thoroughly discussed in Quentin Bajac's essay in Aubenas and Bajac, *Brassaï: Paris Nocturne*, 103–13. Fargue, *Piéton de Paris*; and *Banalité*; illustrated ed. with photographs by Roger Parry, 1930.

83. Fargue, "Banalité," in *Sous la lampe*, 224.

84. Malraux was very close to Florent Fels, and in 1930 he was responsible for publishing the Krull monograph in the NRF series *Photographes nouveaux*. Berthoud, "Banalité."

85. The illustrated edition of *Banalité* was printed on Hollande Pannekoek paper, with thirty-five additional deluxe copies on Japan Imperial paper. Fargue, *Banalité* (1930).

86. Man Ray's *Les champs délicieux*, the first presentation of his rayographs, was a true artist's album, produced in an edition of only forty copies. The album's title is inspired by another Dada/Surrealist volume, *Les champs magnétiques*, with automatic writings by André Breton and Philippe Soupault.

87. Parry was trained in decorative and industrial arts at the École Nationale des Arts Décoratifs, and briefly worked for the department store Printemps. After

1929 he joined Tabard, the new director of Deberny-Peignot's studios, as an assistant, and began making their advertising images before opening his own photographic studio in 1930. The photographer provided illustrations for Malraux's projects well into the 1950s, including *Les voix du silence* and *L'univers des formes*. Mekouar and Berthoud, *Roger Parry*, 48.

88. Book covers from the Médiathèque de l'Architecture et du Patrimoine, Paris: Archives Gallimard, Paris. Covers reproduced in Mekouar and Berthoud, *Roger Parry*, 80–101.

89. Aubenas and Bajac, *Brassaï: Paris Nocturne*, 21, 18.

90. Tucker, *Brassaï: The Eye of Paris*, 46. Circulation figures from Bouqueret, *Des années folles*, 159.

91. Introduction, in Brassaï, *Voluptés de Paris*, n.p. Trans. and cited in Aubenas and Bajac, *Brassaï: Paris Nocturne*, 21, 33n42. The Bibliothèque Nationale in Paris owns both versions. In the censored version, the fifth, twelfth, nineteenth, and twentieth sheets were removed. See Sylvie Aubenas, "Rapport sur l'offre de dation de la succession Brassaï," Cabinet des Estampes, Bibliothèque Nationale, Paris.

92. Brassaï, "Du mur des caverns au mur d'usine," 6–7. The book came out in Germany in 1960, followed in 1961 with a Paris edition. The book begins with two "Conversations with Picasso," which in effect highlight the painter's admiration for graffiti and for Brassaï.

93. Printing terminology defines "bleed" as a layout with type or pictures that extend beyond the trim marks on a page. Illustrations that spread to the edge of the paper without margins are often referred to as "bled off."

94. H. Jonquières, Arts et Métiers Graphiques, to M. Bréger, Hélio-Cachan, 4 June 1937, Arts et Métiers Graphiques Archives, at Flammarion, Paris. The printer's documents also show a receipt for many Roger Schall photographs delivered to the printer on September 4, 1937.

95. Cocteau, "Introduction *Paris de jour.*"

96. Patricia Bosworth, *Diane Arbus* (New York: Knopf, 1984), 307, cited in Tucker, *Brassaï: The Eye of Paris*, 118.

97. Brassaï, "Excerpt from *Paris de nuit*," 388–96; Imahashi, "Brassaï," 7, 9.

98. See Moriyama, *Shashin Yo Sayonara*; and *Nippon Gekigyō Shashin*. Ryuichi Kaneko and Ivan Vartanian, "Photography in Print: An Interview with Daidō Moriyama," in *Japanese Photobooks*, 28.

99. Kawada, *Chizu*; Kawada, "Points of Memory," 3.

100. Rosler, *Three Works*, 79; Martha Rosler, Interview, "Watch and Listen," Whitney Museum of Art, http://whitney.org /WatchAndListen.

CHAPTER 3. ELEGY

1. Jean Cocteau, in Jahan, *Mort et les statues* (1946), plate 15, caption, n.p.

2. The alligators were cast from sketches by Dalou. There is some question as to whether they are alligators (common in the southern United States and China) or crocodiles (common in Africa, Australia, and South America). State sources in France variously identify them as sea monsters, alligators, and crocodiles, and several early twentieth-century postcards clearly label them as crocodiles. Cocteau specifically termed them alligators, and I follow his lead in this discussion (plate 12). The more U-shaped jaw suggests the sculptor may have been looking at alligators.

3. Jahan, *Mort et les statues*, n.p.

4. Jahan met Cocteau while photographing the author Colette, on commission for *Images de France*; Jahan, *Objectif*, 16; Cocteau, in Jahan, *Mort et les statues* (2008), n.p.

5. Nora, "Between Memory and History," 7, 14, 18–19, 24. Also see Brown, "Remembering the Occupation," 296.

6. Adorno, "Cultural Criticism and Society," 34; Saltzman, *Anselm Kiefer*, 2, 32, 47.

7. For an overview of French books published between the liberation and 1946, see Chadwyck-Healey, "Literature of Liberation." The Chadwyck-Healey Liberation Collection 1944–1946 is housed at the Cambridge University Library and has over five hundred books published during this period. For recent discussions, see Denoyelle, *Photographie d'actualité*; and Tambrun, ed., *Paris libéré*.

8. Photography books about occupied Paris include Wimmer, *Reflets de Paris*; Boudot-Lamotte, *Paris*; Foucault, *Paris*; and de Bary and Ruthenbeck, *Das verschleierte Bild von Paris*. For books published after the liberation, see *Semaine héroïque*; Aury, *Délivrance de Paris*; de Lacretelle, *Libération de Paris 1945*; Schall, *Paris sous la botte des Nazis*; Lennad, *Hommes verts*; Barbelay, *Un an*; Barbelay, *Victoires des Français en Italie*; Mauriac, *Paris libéré*; Boucher, *Grande délivrance de Paris*; *Avenue des Champs-Élysées*; and d'Espezel and Schall, *Paris Relief*. For further details, see Koetzle, *Eyes on Paris*.

9. Clark, "Capturing the Moment," 824. Also see Tambrun, *Paris libéré*; and Denoyelle, "De la collaboration à la libération."

10. Schall, *Paris sous la botte des Nazis*; Lennad, *Hommes verts*; Barbelay, *Un an*.

11. Jahan's biography recounts that during the years 1941–44, he photographed the Palais Royal writers in Paris, as well as (in secret) scenes from the occupation and the removal of the statues. He exhibited in a show called *La douce France* at the Galerie Jean Loize in 1941, and in an exhibition of Surrealist photographs at Square du Roule in 1945. See the "Exhibitions" section of the website "Pierre Jahan: Photographe," http://pierrejahan .free.fr/pjahan/pj_homme.php.

12. Ory, "Oeil du désastre," 8; Thackara, *Public Monuments*, 364. It is unclear if these events have any relation to the book's reappearance, but 1977 marked the first year when Parisians could elect a mayor since 1871; the office had been abolished at the beginning of the Third Republic. The year 2008 marked the start of the Great Recession.

13. Sougez, "Manifesto." The thirteen founding members of Le Rectangle were Pierre Adam, Marcel Arthaud, Serge Boiron, Louis Caillaud, Yvonne Chevalier, André Garban, Pierre Jahan, Henri Lacheroy, Gaston Paris, Philippe Pottier, Jean Roubier, René Servant, and Emmanuel Sougez. Jahan participated in the first show of the photographers' group Le Rectangle at the Galerie du Chasseur d'Image in Paris in 1936—a group of ten including Sougez. He was in three shows during the war: *La douce France* at Galerie Jean Loize in Paris in 1941, *Photos surréalistes* at Square du Roule in Paris in 1943, and *20 illustrations photographiques de Pierre JAHAN* at Galerie le Dragon in Paris in 1945. See "Pierre Jahan: Photographe." The members of the later Groupe des XV included Marcel Bovis, Yvonne Chevalier, Jean Dieuzaide, Robert Doisneau, André Garban, Edith Gérin, René-Jacques, Pierre Jahan, Henri Lacheroy, Lucien Lorelle, Daniel Masclet, Philippe Pottier, Willy Ronis, Jean Séeberger, and René Servant.

14. They include *Sénanque*; *L'église de la Sorbonne*; *Lourdes*; *Études sur les chapiteaux*; *Route de Chartres*; *Gisants*; *Voyage de Paris*; and *Paris*.

15. Jahan, *Objectif*, 16. Biographical information is from Jahan's website, "Pierre Jahan: Photographe."

16. Jahan, "Mort et les statues, 1941," 154; Jahan, *Objectif*, 21.

17. Freeman, *Bronzes to Bullets*, 228; Olivier Lacroix, conversation with the author, Paris, June 12, 2016.

18. Jean Cocteau, "Introduction," in *Mort et les statues* (1946), n.p.

19. Wallace Fowlie, "Introduction," citing André Maurois, in Cocteau, *Journals of Jean Cocteau*, 8, 10–11.

20. Cocteau, *Journals of Jean Cocteau*, 48.

21. Fowlie, "Introduction," 16; Brown, "Remembering the Occupation," 288.

22. Lessing, *Laocoön*, 8–9.

23. Steegmuller, *Jean Cocteau and the French Scene*, 31.

24. Cocteau, "Salut à Breker," 1.

25. Cone, *Artists under Vichy*, 29, 12.

26. Steegmuller, "Jean Cocteau 1889–1964," 31.

27. *La belle et la bête* (1946) and *L'amitié noire* (1943, released 1946), written and narrated by Jean Cocteau, directed, shot, and edited by François Villiers, with the collaboration of Germaine Krull and Pierre Bernard. For more information on *L'amitié noire*, see Sichel, "Germaine Krull and *L'amitié noire*," 257–80.

28. Brown, "Remembering the Occupation," 290–92.

29. For more on Zuber and Alliance Photo, see Gunther and de Thézy, *Alliance Photo*, 50–54.

30. The following caption information and numbers are from the digital Jahan Collection at Agence Roger Viollet: its general captions all read: "War 1939–1945. Occupation. Destruction of statues to recuperate metal. Paris, 1941," with additional information in some cases. In addition to the published images, there are two more of Marat, one more of Thiers, and a total of seven alligators from the Place de la Nation in the Roger Viollet Archive. Images are labeled "Paris, 1941."

31. Cocteau, *Mort et les statues* (1946), caption, n.p

32. Cocteau, *Mort et les statues* (1946), caption, n.p.

33. Cocteau, *Mort et les statues* (1946), caption, n.p.

34. A. J., "Statues Parisiennes," 149–52.

35. Sherman, *Worthy Monuments*, 58; Freeman, *Bronzes to Bullets*, 123; A. J., "Statues Parisiennes," 149.

36. Karlsgodt, "Recycling French Heroes," 154. The word "*navet*" (turnip) is also a term used to describe bad art, a "revanche du goût." Michalski, *Public Monuments*, 50.

37. See Michalski, *Public Monuments*, 31.

38. Willam Cohen, cited in Freeman, *Bronzes to Bullets*, 172. I am indebted to Kirrily Freeman for much general information about the campaign to melt down statuary in Vichy France. Also see Agulhon, *Marianne into Battle*.

39. Michalski, *Public Monuments*, 49; Ory, "Oeil du désastre," 10.

40. Darlan, draft of report to Pétain, August 1941, Centre Historique des Archives Nationales, Paris, 68 AJ 312. However, a central committee, led by Louis Hautecoeur, Sécrétaire Générale des Beaux-Arts, Ministère de l'Éducation Nationale, soon oversaw these commissions. Hautecoeur mendaciously denied much of his involvement in a later memoir, but he did try to protect those statues he felt were worth saving (a political decision). Legislation in October 1941 determined that war memorials were not to be destroyed, nor were monuments of "historic or aesthetic significance," a more fluid category. By the next summer, "historic significance" was limited by Darlan to nationalist figures such as Joan of Arc, Henri IV, Louis XIV, and Napoleon Bonaparte, and most statuary removed dated from after the 1870s. (Freeman, *Bronzes to Bullets*, 11, 55–74.)

41. They were bought by the Rohstoffhandelsgesellschaft (ROGES), or Raw Material Trading Company; Karlsgodt, "Recycling French Heroes," 159; Freeman, *Bronzes to Bullets*, 220n170; Pierre Jahan, "Postface à l'édition de 1977," in *Mort et les statues* (2008), 80.

42. Winn, *Poetry of War*, 1, 4; Jean Cocteau, cited in Steegmuller, *Jean Cocteau and the French Scene*, 15.

43. Éluard, "Liberty," 5–8.

44. Isidor Ducasse, "Maldoror," in *Maldoror and Poems*, 216–17. Lyford, *Surrealist Masculinities*, 22–23.

45. Breton, *Nadja*, 190. Also see Foster, *Compulsive Beauty*; and Walker, *City Gorged with Dreams*.

46. Cocteau, *Mort et les statues* (1946), caption, n.p.

47. Cocteau, *Journals of Jean Cocteau*, 124, 128.

48. Cocteau, *Mort et les Statues* (1946), caption, n.p. Also see A. J., "Statues Parisienne," 149–52.

49. Desnos, "Pygmalion et le Sphinx," 33–40. For a fuller discussion of this article, see Baker, "Surrealism in the Bronze Age of Statuophobia," 189–213.

50. Sontag, *Regarding the Pain of Others*, 22–23, 26.

51. Baer, *Spectral Evidence*, 3–7.

52. Cocteau, *Mort et les statues* (1946), caption, n.p.

53. Cocteau, *Mort et les statues* (1946), caption, n.p.

54. Photo Presse Libération. Caption: Schall, *Paris sous la botte des Nazis*, n.p.

55. Cocteau, *Mort et les statues* (1946), caption, n.p.

56. Sontag, *Regarding the Pain of Others*, 26.

57. Adorno, repr. in Weissberg, "In Plain Sight," 15; and Weissberg, "In Plain Sight," 15, 18, 25.

58. Mieke Bal offers one of the clearest overviews of varying philosophical views on the representation of pain in art. Bal, "Pain of Images," 100, referring to Scarry, *Body in Pain*.

59. Zelizer, *Remembering to Forget*, 4–5; George Rodger, cited in Zelizer, *Remembering to Forget*, 88, 256n5.

60. Hirsch, "Surviving Images," 218, 221.

61. Sontag, *Regarding the Pain of Others*, 14–15.

62. Hite, "Exhume, Confront, Rebury," 12.

63. *KZ*, caption, n.p.

64. Sliwinski, *Human Rights in Camera*, 86.

65. Gardner, *Gardner's Photographic Sketch Book of the War*, 80.

66. Lee and Young, *On Alexander Gardner's Photographic Sketch Book*, 6.

67. Lee and Young, *On Alexander Gardner's Photographic Sketch Book*, 9, 36.

68. Many of these images are available through the Agence Roger-Viollet, one of the largest photographic picture agencies in France, which includes 113 Jahan images of the liberation. Also see "Pierre Jahan: Photographe."

69. "As Paris restaged what they thought a righteous and just uprising should look like, photographers captured its visual legacy in ways learned from generations of images of such uprisings." Clark, "Capturing the Moment," 833–34.

70. "Pierre Jahan: Photographe." These images were included in a 2009 exhibition and catalogue at the Louvre. Fonkenell, ed., *Louvre during the War*; Jahan, *Objectif*, 37.

71. Jahan, *Gisants*.

72. Jean Cocteau, cited in Jahan, *Objectif*, 54.

73. Lannes, "Preface," n.p.

74. Cocteau, *Two Screenplays*; Sliwinski, *Human Rights in Camera*, 18; and Lee Miller, undated dispatch to *Vogue*, Lee Miller Archives, cited in Sliwinski, *Human Rights in Camera*, 101.

75. Miller, *Wrens in Camera*; letter from Ami Bouhassane to the author, 7 November 2018.

76. Schall, *Paris sous la botte des Nazis*, with 85 photographs by Roger Schall. Other photographers with more than a handful of images included Vals (forty-three), Roger Parry (twelve), Joublin (eleven), Papillon (ten), Jarnoux (thirteen), Berson (twelve), with a handful of others by Roughol, Pichonnier, Jahan (three), Viguier, France-Presse Libération, Seeberger, Caron, and Coutant.

77. Chadwyck-Healey, "Literature of Liberation," 1.

78. Schall, *Paris sous la botte des Nazis,* back cover and colophon.

79. Clark, "Capturing the Moment," 828.

80. Chadwyck-Healey, "Literature of Liberation," 1–21. After the liberation, a purge committee attached seals to Schall's studio door, but he was not further punished. Françoise Denoyelle, "Photography in France during the Second World War," in Tambrun, *Paris libéré,* 69.

81. Friedlander, *American Monument.* For a more complete discussion, see Sichel, "Lee Friedlander," 40–56.

82. Whitman, "To Working Men." Friedlander, *American Monument,* epigraph.

83. Friedlander's earlier books until about 2000 include *Self-Portrait* (1992); *The American Monument* (1976); *Photographs; Factory Valleys: Ohio and Pennsylvania* (1982); *Nudes* (1991); *Letters from the People* (1993); and *The Desert Seen* (1996).

84. Maisel, *Library of Dust;* David Maisel, "Library of Dust," davidmaisel.com /portfolio-item/library-of-dust.

CHAPTER 4. NOSTALGIA

1. Cartier-Bresson, *Images à la sauvette/ The Decisive Moment (1952),* n.p. Captions and text discussions will refer to the 1952 English edition.

2. Cartier-Bresson, *Decisive Moment,* n.p.

3. De Thézy, *Photographie humaniste,* 11.

4. De Thézy, *Photographie humaniste,* 16, 18.

5. De Thézy, *Photographie humaniste,* 27–41.

6. Huit included Doisneau's *Les Parisiens tels qu'ils sont* (1953), Cartier-Bresson's *Les danses à Bali* (1954), and Georges Rodger's *Le village des Noubas* (1955). *Neuf* included Brassaï's *Seville en Fête* (1954), Werner Bischof's *Japon* (1954), and Cartier-Bresson's books *D'une Chine à l'autre* (1954), with an introduction by Jean-Paul Sartre, and *Moscou* (1955). *Dix* included larger albums.

7. Doisneau, *Banlieue de Paris;* Izis and Prévert, *Paris des rêves;* Izis and Prévert, *Grand bal du printemps;* and Ronis, *Belleville-Ménilmontant.* For a more comprehensive list of French humanist books during this period, see de Thézy, *Photographie humaniste;* and Hamilton, "France and Frenchness in Post-War Humanist Photography," 110, 126.

8. Ronis, cited in Hamilton, "France and Frenchness in Post-War Humanist Photography," 103, 125, 126.

9. Doisneau, *Banlieue de Paris.* La Guilde du Livre also published *Paris des rêves* by Izis (1950) and Paul Strand's *La France de profil* (1952).

10. Hamilton, *Robert Doisneau,* 11–12, 54, 166, 113–14.

11. Hamilton, *Robert Doisneau,* 180, 116.

12. Hamilton, *Robert Doisneau,* 147.

13. Hamilton, *Robert Doisneau,* 154; Cendrars, *Homme foudroyé.*

14. Hamilton, *Robert Doisneau,* 158; see Botella, ed., *Doisneau rencontre Cendrars.*

15. Cendrars, "Sud," in Doisneau, *Banlieue de Paris* (1983), 7–8.

16. Cendrars, "Est" and "Nord," in Doisneau, *Banlieue de Paris* (1983), 33–36, 43.

17. Hamilton, *Robert Doisneau,* 168, 176n24, 180.

18. Hamilton, *Robert Doisneau,* 164. For an overview of all their books, see *Guilde du Livre.*

19. Other members of RAPHO included Brassaï, Nora Dumas, Ylla, Willy Ronis, Émile Savitry, and Ergy Landau.

20. Hamilton, *Robert Doisneau,* 124, 126.

21. At Magnum, Robert Capa and Seymour Chim covered Europe, George Rodger covered Africa, and Cartier-Bresson went to Asia.

22. *Photographs by Henri Cartier-Bresson: Anti-Graphic Photography* (1933); *The Photographs of Henri Cartier-Bresson,* Museum of Modern Art, New York (1947); *Henri Cartier-Bresson: Photographies, 1930–1955* (1955). For a complete list of the photographer's books, exhibitions, and periodical press publications, see Galassi, *Henri Cartier-Bresson, The Modern Century.*

23. Galassi, *Henri Cartier-Bresson: The Early Work;* and Walker, *City Gorged with Dreams,* 173–74, 181–83. Late in his life, Cartier-Bresson published portraits of Breton in the 1990s, recalling, "It is to surrealism that I owe allegiance, for it has taught me to allow the camera lens to rummage in the debris of the unconscious and of chance" (Cartier-Bresson, *André Breton: Roi soleil,* n.p.).

24. Frizot, ed., *Henri Cartier-Bresson: Scrap Book,* 33, 27. "I always thought I had to give them quantity. I never had the nerve to say, 'This is what I have, four photos and no more!'" Cited in Frizot, *Henri Cartier-Bresson Scrap Book,* 29.

25. *Five French Photographers,* Museum of Modern Art, New York, December 18, 1951– February 24, 1952, included Cartier-Bresson, Brassaï, Doisneau, Izis, and Ronis. Night views comprised only a half-dozen of the sixty-eight Brassaï images; he had shifted away from night photography. Cartier-Bresson included only eight European images; all the rest were Asian. In the press release, Edward Steichen characterized them as sharing "the deeply poetic understanding of human kind" (press release,

Museum of Modern Art exhibition, *Five French Photographers,* https://www.moma.org/documents /moma_press-release_325810.pdf).

26. Kirstein, "Henri Cartier-Bresson," 8.

27. Kirstein, "Henri Cartier-Bresson," 11.

28. Kirstein, "Henri Cartier-Bresson," 8.

29. "Speaking of Pictures," *Life,* March 3, 1947, 14.

30. Kirstein, "Henri Cartier-Bresson," 40. See Cartier-Bresson's film *Le retour* (Office of War Information, 1945).

31. Kirstein, "Artist with a Camera," 12.

32. Ian Walker suggests that since 1946, when Robert Capa told him not to allow himself to be labeled a Surrealist photographer, there have been two Cartier-Bressons: one journalist and one Surrealist. Walker suggests the Surrealist one resonates more with current audiences, and he traces the photographer's links to the movement. This view, however, elides the historical context of when and how the 1950s publications were made. Walker, *City Gorged with Dreams,* 168–69.

33. Cartier-Bresson, "Interview," 69; Cartier-Bresson, *Images à la sauvette,* n.p.

34. Chéroux, "Bible for Photographers," 21, 7.

35. *Verve* ran from 1937 to 1960. In *Verve* 1 (no. 1), see photographs of Matisse by Brassaï; images of "Celestial Tresses" by Man Ray, Erwin Blumenfeld, and Cartier-Bresson; Dora Maar's photograph of *Guernica* in Picasso's studio; an eight-page portfolio of photographs including images by Marcel Bovis, Eli Lotar, Cartier-Bresson, Florence Henri, Nora Dumas, Brassaï, Blumenfeld, and André Zucca; another portfolio with photographs of Maillol by Brassai and Blumenfeld; and a final eight-page portfolio of images by Louis Guichard.

36. Chéroux, "Bible for Photographers," 6n23, 27.

37. Chéroux, "Bible for Photographers," 15, 13–14n45.

38. Pat Hagan to Richard L. Simon, 1 April 1952, Fondation Henri Cartier-Bresson, cited in Chéroux, "Bible for Photographers," 15.

39. Szymusiak, "Matisse et Tériade," 75.

40. Tériade to Richard L. Simon, 27 March 1952, Simon Papers; cited in Chéroux, "Bible for Photographers," 6, 28n48.

41. "I wonder if there is time to change the jacket of THE DECISIVE MOMENT.... The great difficulty with it is that the volume itself does not look like a photographic book; rather it looks more like a book of paintings and design." Richard L. Simon to Louis Sol, Draeger Frères, 25 July 1952, Simon Papers.

42. Draeger, cable to Richard L. Simon, 28 July 1952, and letter to Simon, 29 July 1952, Simon Papers.

43. Deschin, "Right Moment," X15.

44. Chéroux, "Bible for Photographers," 9; White, "Henri Cartier-Bresson/The Decisive Moment," 41.

45. Margot Shore to Richard Simon, 14 May 1952, Simon Papers.

46. "In the Nineteen-Thirties," Evans writes humorously, "Henri Cartier-Bresson, an extremely intelligent young French photographer-at-large, was discovered and discovered by this and that local esthete of influence. He was relatively unharmed by the experience." Evans marks Cartier-Bresson's sustained ability to capture a decisive moment in his photographs, and notes the photographer's soon-to-be-famous introduction, too: the "fourteen-page preface essay has something rather peculiar about it." Evans, "Cartier-Bresson," 7.

47. Interview notes, Mr. Simon and Cartier-Bresson, Simon Papers.

48. Cartier-Bresson, "Forward," *Decisive Moment*, n.p.

49. Cartier-Bresson, "Forward," *Decisive Moment*, n.p.

50. Chéroux, "Bible for Photographers," 16.

51. For a comprehensive overview of Cartier-Bresson's travels, see Galassi, *Henri Cartier-Bresson: The Modern Century*, 290–327.

52. Fondation Henri Cartier-Bresson, "Filmography," http://www.henricartier bresson.org/en/hcb/filmography/.

53. For a fuller discussion of Cartier-Bresson's Surrealist imagery, see Galassi, *Henri Cartier-Bresson: The Early Work*.

54. Cartier-Bresson, *Mind's Eye*, 15; Cartier-Bresson, *Images à la sauvette*, n.p.

55. Tabard, "Cartier-Bresson et Geometrie." Hambidge, *Parthenon and Other Greek Temples*; and Ghyka, *L'esthétique des proportions*, both cited as footnotes in Tabard's essay. For the reference to Cartier-Bresson's ownership of these books, see Chéroux, *Henri Cartier-Bresson: Here and Now*, 27.

56. Cartier-Bresson's secretary wrote to Richard Simon, "The Tabard text on Geometry has been dropped. . . . But you know how careful Henri is of other people's feelings." Margot Shore to Richard L. Simon, 24 May 1952, Simon Papers. Richard Simon replies, "He must have had a tough time with his friend Tabard during the process of dropping the Geometry text. I trust Henri's instinct on this. I always felt that it was something that might make the book seem more important, but personally,

I couldn't understand it at all." Richard L. Simon to Margot Shore, 4 June 1952, Simon Papers.

57. Tabard, "Cartier-Bresson et Geometrie."

58. Michel Frizot, "Unpredictable Glances," in Frizot, ed., *Henri Cartier-Bresson Scrap Book*, 41, 43, 45.

59. Interview notes, Mr. Simon and Cartier-Bresson, Simon Papers.

60. Interview notes, Mr. Simon and Cartier-Bresson, Simon Papers.

61. Deschin, "Right Moment," X15.

62. Galassi, *Henri Cartier-Bresson: The Modern Century*, 295.

63. Robert Capa to Richard L. Simon, 6 October 1952, Fondation Henri Cartier-Bresson; William Eggleston, Interview with Mark Holborn, February 1988, afterward to *The Democratic Forest* (London: Secker and Warburg, 1989), 172; Walker Evans, "Cartier-Bresson, a True Man of the Eye," *New York Times*, October 19, 1952, 7. All cited in Chéroux, "Bible for Photographers," 3, 10, 26–27.

64. Monroe Wheeler to Richard Simon, 7 November 1952; Carmel Snow to Richard Simon, 6 October 1952; Jun Miki to Richard Simon, 1 November 1952, all in Simon Papers; Cartier-Bresson, "Henri Cartier-Bresson: Intruder on Tiptoe," 163.

65. Margot Shore to Richard L. Simon, 24 May 1952; Richard Simon to Henri Cartier-Bresson, 16 March, 1954; Henri Cartier-Bresson to Richard Simon, 5 January 1955; Henri Cartier-Bresson to Richard Simon, 24 January 1955; Richard L. Simon to Louis Sol, Draeger Frères, 27 July 1955, all in Simon Papers.

66. Richard L. Simon to "Dear Fellow Photographer," 6 December 1955; "Two New Books by Henri Cartier-Bresson," publicity description for *The Europeans*, in Simon Papers.

67. Henri Cartier-Bresson, *The Europeans/Les Européens*, n.p. Citations will be from the English edition.

68. Philippe Halsman, "Photographer Recognized by the Louvre as a Living Master of Modern Art," *Herald Tribune Book Review*, December 25, 1955, n.p., scrapbook, Fondation Henri Cartier-Bresson Archives.

69. Cartier-Bresson, *Europeans*, n.p.

70. Henri Cartier-Bresson to Richard Simon, 2 August 1955, Simon Papers.

71. Cartier-Bresson, *Europeans*, n.p.

72. Cartier-Bresson, *Europeans*, n.p.

73. Deschin, "Focusing on Europe," 71.

74. Robert Capa to Henri Cartier-Bresson, 23 January 1948, Fondation Henri

Cartier-Bresson Archives. The foundation holds multiple binders of typed captions for all the Chinese and Russian images.

75. Robert Delpire, 1954 brochure, *Neuf* series.

76. Cartier-Bresson, *From One China to the Other*, n.p.; Magnum Agency, telegram to Henri Cartier-Bresson, 25 November 1948, Fondation Cartier-Bresson Archive.

77. Wilson Hicks, telegram to Henri Cartier-Bresson, 24 December 1948, Fondation Cartier-Bresson Archive.

78. Cartier-Bresson, "Preface," in *China*, n.p.

79. Cartier-Bresson, *D'une Chine à l'autre*, with text by Jean-Paul Sartre and Henri Cartier-Bresson; *China Gestern und Heute*, text by Henri Cartier-Bresson; *From One China to the Other*, with text by Han Suyin and Henri Cartier-Bresson; *China in Transition*, text by Henri Cartier-Bresson; *Da una Cina all'altra*.

80. Fondation Cartier-Bresson Archive; *From One China to the Other*, plate 96, caption.

81. Fatouros, "Review: Sartre on Colonialism." For further discussion, see Sartre, *Critique de la raison dialectique* and *Situations I* (Paris: Gallimard, 1947).

82. Jean-Paul Sartre, "From One China to Another," in Sartre, *Colonialism and Neocolonialism*, 17–19, 21, 26.

83. Sartre, "From One China to Another," 26.

84. Sartre, "From One China to Another," 34.

85. Smith, *"From One China to the Other,"* 60, 62, 63; Sontag, *On Photography*, 111.

86. Han Suyin, "Preface," in Cartier-Bresson, *From One China to the Other*, n.p.

87. Henri Cartier-Bresson, "A Decade Later," in *China*, n.p.

88. Cartier-Bresson, *Moscou, vu par Henri Cartier-Bresson*; *The People of Moscow*; *Mosca vista da Henri Cartier-Bresson*; *The People of Moscow, as Seen and Photographed by Henri Cartier-Bresson*; *Menschen in Moskau*. A letter from Richard L. Simon to Henri Cartier-Bresson explains the American nervousness about how this book would be received by American viewers (21 December 1954, Simon Papers).

89. The images were published in *Life* on January 17 and 31, 1955, and subsequently in *Paris Match*, *Stern*, *Picture Post*, and *Epoca*. *Life* paid $40,000 for them.

90. Richard L. Simon to John Morris, 2 June 1955, Simon Papers.

91. Nina Bourne to Richard Simon, 13 July 1955, and Richard L. Simon to Henri Cartier-Bresson, 21 December 1954, in Simon Papers.

92. Cartier-Bresson, *The People of Moscow*, n.p.

93. Steichen consulted actively with Cartier-Bresson about the *Family of Man* show, beginning in 1952 on a trip to Paris, and

in a 1952 letter he writes, "I am particularly anxious to have your ideas and your counsel on the matter." Edward Steichen to Henri Cartier Bresson, 16 June 1952, Edward Steichen Archive, Museum of Modern Art, New York. Cited in Gresh, "European Roots of *The Family of Man*," 333.

94. Barthes, "Preface" and "The Great Family of Man," 11, 100–102.

95. Sandeen, *Picturing an Exhibition*, 2.

96. Frank, in Janis and MacNeil, "Robert Frank," *Photography within the Humanities*, 56.

97. Chéroux, "Bible for Photographers," 18.

98. O'Hagan, "Cartier-Bresson's Classic Is Back."

CONCLUSION

Epigraphs: Robert Frank, from a series of conversations with Susan E. Cohen and William S. Johnson, 1983 and 1985, cited in Eric Rosenheim, "Robert Frank and Walker Evans," in Greenough, *Looking In*, 151, 346n26. William Klein, "Preface," 5.

1. Gautrand, "Looking at Others," 619; Frank, in Janis and MacNeil, "Robert Frank," in *Photography within the Humanities*, 56.

2. Raymond Grosset, "Un William Klein, aimait se moquer des gens," cited in de Thézy, *Photographie humaniste*, 55; Moroz, "William Klein."

3. Frank, application for Guggenheim fellowship, in Greenough, *Looking In*, 362.

4. Klein, "Preface," 4–5.

5. Klein, "Preface," 5.

6. Kozloff, "William Klein and the Radioactive Fifties."

7. Klein, "Preface," 5; Frank, application for Guggenheim fellowship.

8. Michel Frizot, "Robert Frank and Robert Delpire," in Greenough, *Looking In*, 190.

9. Frizot, "Robert Frank and Robert Delpire," 193. For comments on the circus issue, see Frizot, "Interview with Robert Delpire," 199–200.

10. Frank, *Indiens des hauts-plateaux*; Frizot, "Robert Frank and Robert Delpire," 194; Bischof, Frank, and Verger, *Indiens pas morts*.

11. Delpire's *Huit* series included three titles: Doisneau's *Les Parisiens tels qu'ils sont* (1953), Cartier-Bresson's *Danses à Bali* (1954), and Rodger's *Le village des Noubas* (1955). The *Neuf* series included *Paris 1925* (1957), *Arts sauvages* (1957), *Le soleil* (1958), *Paris fin de siècle* (1958), *Les Américains* (1958), Jacques Berque's *Les Arabes* (1959), *Arts fantastiques* (1960), *Le ciel* (1960), *L'évolution* (1960), *Les ballons* (1960), *Les volcans* (1961), *L'écriture* (1961), *Les avions* (1962), *L'arbre* (1962), Réné Burri's *Les Allemands* (1963), *L'oiseau* (1963), *Arts baroques* (1963), *Les Juifs* (1964), *Les explorateurs* (1965), *Arts premiers* (1965), *La main* (1968), *L'or* (1968), and *L'insecte* (1968). For a thorough overview of Delpire's publishing projects, see Frizot, "Interview with Robert Frank" and "Robert Frank and Robert Delpire," in Greenough, *Looking In*.

12. Frizot, "Interview with Robert Delpire," 200–201.

13. Frizot, "Robert Frank and Robert Delpire," 196.

14. Frizot, "Robert Frank and Robert Delpire," 196.

15. Frizot, "Interview with Robert Delpire," 201.

16. Tocqueville, 1853, cited in Frank, *Américains*, 6.

17. For a fuller discussion on the impact of these books on Frank, see Sarah Greenough, "Resisting Intelligence: Zurich to New York," in *Looking In*, 11–24; Michel Guerrin, "Robert Frank raconte sa passion pour Tuggener et 'le miracle Suisse,'" *Le Monde* (February 18, 2000): 26, cited in Greenough, *Looking In*, 337n43.

18. Greenough, "Disordering the Senses," in *Looking In*, 132; Alexander, "Robert Frank Discusses *The Americans*," 42; Andrea Nelson, "Making and Remaking *The Americans*," in Greenough, *Looking In*, 459; Greenough, *Looking In*, 342n57.

19. Alexander, "Robert Frank Discusses *The Americans*," 34–43; Sarah Greenough, "Transforming Destiny into Awareness: *The Americans*," in *Looking In*, 177–78, 181.

20. Greenough, "Transforming Destiny into Awareness: *The Americans*," 177; "Disordering the Senses," 343n77; *Carrefour*, unsigned review; Paul Caso, "Peinture américaine au Palais des Beaux-Arts," *Le soir* (December 11, 1958): 2; Martine, "Trois voyageurs."

21. White, "Book Review: Les Américains," 127.

22. Greenough, *Looking In*, 139, 176.

23. Klein, *Rome*, with chapters on "Citizens of Rome," "The Street," "The Eternal City," "Boys," and the "Catholic World"; and texts by Fellini, Taine, Michelet, Pier Paolo Passolini, Jean Cocteau, Albert Moracia, G. Avonarola, Stendhal, G. G. Belli, Henry James, Mark Twain, and Leopardi. Klein, *MOSKAU*; this series may have been meant as Christmas presents by the newspaper *Die Zeit*, not as a commercial publication. Chapters include the people of Moscow, the privileged class, parks and places, and streets. Klein, *Tokio*, with three chapters: ceremonies, album, and ikebana.

24. Campany, *William Klein: ABC*, 6.

25. Moroz, "William Klein."

26. Campany, *William Klein: ABC*, 4; Small, "Lens on William Klein," 1.

27. Klein's films include work on Fellini's *Nights of Cabiria* (1957) and Louis Malle's *Zazie dans le Métro* (1960), and his own films *Who Are You, Polly Magoo?* (1966), *Mister Freedom* (1967–69), *Muhammed Ali, The Greatest* (1964), *Loin du Vietnam* (1967), *Maydays* (1978), and many others.

28. O'Rawe, "Eclectic Dialectics," 50, 52.

29. Klein, "Preface," 4.

30. The industries include clothing, printing publishing, food processing, brewing "of course," sugar refining, metalworking, manufacturing of drugs and medicines, automobile assembling, and shipbuilding, as well as "many great museums, fine art galleries, musical organizations, universities, a great seaport, famous shops and restaurants, places of entertainment, striking architecture and a rich historic background." Klein, "Manhadoes," in *New York Is Good and Good for You*, n.p.

31. Canevari, "William Klein and the Photographic Book," 19–20.

32. Friedlander, *Letters from the People*.

33. Weegee, *Naked City*; Lee and Meyer, *Weegee and Naked City*, 1.

34. Kozloff, "William Klein and the Radioactive Fifties."

35. Breton, *Nadja*, 190.

36. Cited in Stevens, "Isabel Stevens on Chris Marker's 'Petite Planète'"; Lupton, *Chris Marker*, 44.

37. Klein, *Tokyo* (Hamburg: Nannen, 1964; New York: Crown, 1964; Italy: Silvana Editoriale d'Arte, 1964; Paris: Delpire, 1964; and Tokyo: Zokeisha, 1964); and Frank, *Lines of My Hand*.

38. Simon Baker, cited in Bicker, Review.

39. Ivan Vartanian, "The Japanese Photobook: Toward an Immediate Media," in Kaneko and Vartanian, *Japanese Photobooks*, 17; Badger and Parr, *Photobook*, 271.

40. Vartanian, "Japanese Photobook," 12; Moriyama, *Shashin Yo Sayonara*; Takanashi, *Toshi-e*; Nakahira, *Kitanubeki Kotoba no Tamenu*.

41. Heiting, ed., *Japanese Photobook*, 13.

42. "Daidō Moriyama," n.p.

43. Cited in Colin Herd, "William Klein + Daidō Moriyama," *Aesthetica* 49 (2013), www.aestheticamagazine.com /William_klein_daido_moriyama/.

44. *Daidō Moriyama*, n.p.; Ivan Vartanian, "Photography in Print, An Interview with Daidō Moriyama," in Kaneko and Vartanian, *Japanese Photobooks*, 27, 29; Charrier, "Making of a Hunter," 269.

45. Martin Parr and Gerry Badger, "Provocative Materials for Thought: The Postwar Japanese Photobook," in Badger and Parr, *Photobook*, 298–99, 267.

46. Kawada, *Chizu;* Kaneko and Vartanian, *Japanese Photobooks,* 88.

47. Cited in Badger and Parr, *Photobook,* 286.

48. Badger and Parr, *Photobook,* 286.

49. Takanashi, *Toshi-e;* Kaneko and Vartanian, *Japanese Photobooks,* 168.

50. Brassaï, *Paris de nuit* (1979, 1987, 2001); *Klein, Life Is Good and Good for You in* New York (1995, 2016); Krull, *Métal* (2003); Moï Ver, *Paris* (2002); Jahan, *La mort et les statues* (1977, 2008); Cartier-Bresson, *Images à la sauvette* (2014).

51. See Bajac, *Stephen Shore.*

52. Singh, *Museum Bhavan* (2017). See "Museum Bhavan," http://dayanitasingh.net.

BIBLIOGRAPHY

ARCHIVES

Archives Gallimard, Paris

Arts et Métiers Graphiques, Archives, Flammarion, Paris

Atelier Robert Doisneau, Paris

Brassaï Archive, Musée National d'Art Moderne, Centre Georges
Pompidou, Paris

Centre Historique des Archives Nationales, Paris

Chadwyck-Healey Liberation Collection 1944–1946, Cambridge
University Library, Cambridge

Département des Estampes et de la Photographie, Bibliothèque
Nationale, Paris

Fondation Henri Cartier-Bresson, Paris

Fonds Delaunay, Bibliothèque Nationale, Paris

Germaine Krull Nachlass, Fotografische Sammlung, Museum
Folkwang, Essen

Musée Carnavalet, Paris

Musée National d'Art Moderne, Centre Georges Pompidou, Paris

Pierre Jahan Archives, Institut Mémoires de l'Édition Contemporaine
(IMEC), Abbaye d'Ardennes, Normandy

Richard L. Simon Papers, Columbia University Library, New York

PUBLISHED WORKS

ABBOTT, BERENICE. Interview by James McQuaid and David Tait.
July 1975. On deposit at the Library of the George Eastman House,
Rochester, NY.

ADES, DAWN. *Dada and Surrealism Reviewed.* London: Hayward Gallery,
1978.

ADES, DAWN, AND SIMON BAKER. *Close-Up: Proximity and
De-Familiarization in Art, Film and Photography.* London: Fruitmarket
Gallery, 2008.

——. *Undercover Surrealism: Georges Bataille and Documents.* Cambridge,
MA: MIT Press, 2004.

ADORNO, THEODOR. "Cultural Criticism and Society" (1967). In *Prisms*,
translated by Samuel Weber and Shierry Weber, 17–34. Cambridge,
MA: MIT Press, 1967.

AGEE, JAMES, AND WALKER EVANS. *Let Us Now Praise Famous Men.*
Boston: Houghton Mifflin, 1941.

AGULHON, MAURICE. *Marianne into Battle: Republican Imagery and
Symbolism in France, 1789–1880.* Cambridge: Cambridge University
Press, 1981.

ALBIN-GUILLOT, LAURE. *Micrographie décorative.* Paris: Draeger, 1931.

ALEXANDER, STUART. "Robert Frank Discusses *The Americans* at
George Eastman House, 17 and 18 August 1967." *Katalogue: Journal of
Photography and Video* 9, no. 4 (Fall 1997): 34–43.

LES AMITIÉS FRANCO-CANADIENNES. Unsigned review, "Paris la nuit."
April 1, 1933, 29.

APOLLINAIRE, GUILLAUME. *Calligrammes: Poèmes de la paix et de la guerre.*
Paris: Mercure de France, 1918.

APPADURAI, ARJUN. *The Social Life of Things: Commodities in Cultural
Perspective.* Cambridge: Cambridge University Press, 1988.

ARMSTRONG, CAROL. *Scenes in a Library: Reading the Photograph in the
Book, 1843–1875.* Cambridge, MA: MIT Press, 1998.

ARNAR, ANNA. *The Book as Instrument: Stéphane Mallarmé, the Artist's
Book, and the Transformation of Print Culture.* Chicago: University of
Chicago Press, 2011.

AUBENAS, SYLVIE, AND QUENTIN BAJAC. *Brassaï: Paris Nocturne.* London:
Thames and Hudson, 2013.

AUCLAIR, MARCELLE. "Tour Eiffel, soeur aînée des avions." *L'art vivant* 4
(October 1, 1928): 743–44.

AURY, BERNARD. *La délivrance de Paris 19–26 août 1944.* Paris: B. Arthaud,
1945.

AVENUE DES CHAMPS-ÉLYSÉES. New York: American Relief for France,
1944.

BACHELARD, GASTON. *The Poetics of Space.* Translated by Maria Jolas.
Boston: Beacon, 1994.

BADGER, GERRY, AND MARTIN PARR. *The Photobook: A History.* Vols. 1–3.
London: Phaidon, 2004, 2009, 2014.

BAER, ULRICH. *Spectral Evidence: The Photography of Trauma.* Cambridge,
MA: MIT Press, 2002.

BAJAC, QUENTIN. *Stephen Shore.* New York: Museum of Modern Art,
2017.

BAJAC, QUENTIN, AND CLÉMENT CHÉROUX. *La subversion des images:
Surréalisme, photographie, film.* Paris: Centre Pompidou, 2009.

BAKER, SIMON. *Exposed: Voyeurism, Surveillance and the Camera since 1870.*
London: Tate Gallery, 2010.

——. "Surrealism in the Bronze Age of Statuephobia and the Efficacy
of Metaphorical Iconoclasm." In *Iconoclasm: Contested Objects,
Contested Terms*, edited by Stacy Boldrick and Richard Clay, 189–213.
Aldershot: Ashgate, 2007.

BAL, MIEKE. "The Pain of Images." In *Beautiful Suffering: Photography and
the Traffic in Pain*, edited by Mark Reinhardt, Holly Edwards, and
Erina Duganne, 93–115. Chicago: University of Chicago Press, 2007.

BARBELAY, JEAN-LOUIS. *Un an.* Paris: Raymond Schall, 1946.

——. *Victoires des Français en Italie.* Paris: Raymond Schall, 1946.

BARTHES, ROLAND. "Preface" (1957) and "The Great Family of Man" (1957). In *Mythologies,* translated by Annette Lavers, 11–15, 100–103. New York: Farrar, Straus, Giroux, 1972.

BARTHES, ROLAND, AND ANDRÉ MARTIN. *La Tour Eiffel.* Paris: Delpire, 1964.

DE BARY, HERBERT, AND ERIKA RUTHENBECK. *Das verschleierte Bild von Paris.* Paris: Prisma, 1943.

BATAILLE, GEORGES. "Abattoir." *Documents* (November 1929): 328–30.

BATCHEN, GEOFFREY. *Burning with Desire: The Conception of Photography.* Cambridge, MA: MIT Press, 1999.

BAUDELAIRE, CHARLES. *The Painter of Modern Life and Other Essays* (1863). Translated by Jonathan Mayne. Reprint, London: Phaidon, 1965.

BECHER, BERND, AND HILLA BECHER. *Typologies of Industrial Buildings.* Cambridge, MA: MIT Press, 2004.

DI BELLO, PATRIZIA, AND SHAMOON ZAMIR. "Introduction." In *The PhotoBook: From Talbot to Ruscha and Beyond,* edited by Di Bello, Colette Wilson, and Zamir, 1–16. London: I. B. Tauris, 2012.

BENJAMIN, WALTER. "The Author as Producer." Address at the Institute for the Study of Fascism, Paris, April 27, 1934. Reprinted in *Reflections,* edited by Peter Demetz, translated by Edmond Jephcott, 220–38. New York: Harcourt Brace Jovanovich, 1978.

——. *Charles Baudelaire: A Lyric Poet in the Era of High Capitalism.* Translated by Harry Zohn. London: New Left Books, 1973. Reprint, London: Verso, 1987.

——. "A Short History of Photography" (1931). In *Classic Essays on Photography,* edited by Alan Trachtenberg, translated by Paul Patton, 199–216. New Haven: Leete's Island Books, 198.

——. "Unpacking My Library" (1931). In *Illuminations,* edited by Hannah Arendt, translated by Harry Zohn, 59–67. New York: Schocken, 1968.

——. "The Work of Art in the Age of Mechanical Reproduction" (1936). In *Illuminations,* edited by Hannah Arendt, translated by Harry Zohn, 217–52. New York: Schocken, 1968.

BENSON, RICHARD. *The Printed Picture.* New York: Museum of Modern Art, 2008.

BEQUETTE, FRANCE. "Rencontre avec Brassaï." *Culture et communication,* no. 27 (1980): 8–15.

BERNIER, JEAN. "Paris de nuit." *VU,* no. 255 (February 1, 1933): 144.

BERQUE, JACQUES. *Les Arabes.* Paris: Delpire, 1959.

BERTAULT, JULES. *Les belles nuits de Paris.* Paris: Flammarion, 1927.

BERTHOUD, CHRISTOPHE. "*Banalité,* une autre conquête de la photographie." In *Roger Parry: Photographies, dessins, mises-en-pages,* edited by Mouna Mekouar, 34–49. Paris: Gallimard/Jeu de Paume, 2007.

BICKER, PHIL. Review, "William Klein + Daidō Moriyama: Double Feature." *Time,* October 15, 2012. http://time.com/3792413/william-klein-daido-moriyama-double-feature.

BISCHOF, WERNER, ROBERT FRANK, AND PIERRE VERGER. *Indiens pas morts.* Collection Neuf, no. 17. Paris: Delpire, 1956.

BLOSSFELDT, KARL. *La plante; cent vingt planches en héliogravure d'après des details très agrandis de forms végétales.* Introduction by Charles Nierendorf. Paris: Librairie des Arts Décoratifs, 1929.

——. *Urformen der Kunst.* Berlin: Ernst Wasmuth, 1928.

BOEHM, HANS. *Photographie bei Nacht.* Berlin: Guido Hackebeil, 1928.

BOIS, YVE-ALAIN, AND ROSALIND KRAUSS. *Formless: A User's Guide.* Cambridge, MA: MIT Press, 2000.

BONNARD, ABEL. *Études de nus.* Paris: Arts et Métiers Graphiques, 1936.

BOST, PIERRE. "Les livres: *Métal.*" *Jazz,* no. 2 (January 15, 1929): 90, 92.

BOTELLA, ANNE, ED. *Doisneau rencontre Cendrars.* Paris: Buchet/Chastel, 2006.

BOUCHER, FRANÇOIS. *La grande délivrance de Paris.* Paris: Jacques Haumont, 1945.

BOUDOT-LAMOTTE, EMMANUEL. *Paris: Wanderung durch eine Stadt.* Paris: Deutschen Arbeitsfront, 1942.

BOUQUERET, CHRISTIAN. *Des années folles aux anneés noires. La nouvelle vision en France 1920–1940.* Paris: Marval, 1997.

——. *Paris: Les livres de photographie des années 1920 aux années 1950.* Paris: Gründ, 2012.

BOURKE-WHITE, MARGARET, AND ERSKINE CALDWELL. *You Have Seen Their Faces.* New York: Modern Age, 1937.

BRANDT, BILL. *The English at Home.* London: Batsford, 1936.

——. *Londres de nuit.* Paris: Arts et Métiers Graphiques, 1938.

——. *A Night in London.* London: Batsford; New York: Charles Scribner's, 1938.

BRASSAÏ. *Camera in Paris.* London: Focal, 1949.

——. "Chez les voyous et dans le beau monde." Interview by Claude Bonnefoy. *Les nouvelles littéraires* (October 17, 1976): n.p.

——. *Conversations avec Picasso.* Paris: Gallimard, 1964.

——. *Conversations with Picasso.* Translated by Jane Marie Todd. Chicago: University of Chicago Press, 1999.

——. "Du mur des cavernes au mur d'usine." *Minotaure,* nos. 3–4 (1933): 6–7.

——. "Excerpt from *Paris de nuit.*" *Asahi Camera* (October 1933): 388–96.

——. *Graffiti: Deux conversations avec Picasso.* Paris: du Temps, 1961.

——. *Graffiti: Zwei Gespräche mit Picasso.* Stuttgart: Belser, 1960.

——. *Henry Miller: Grandeur nature.* Paris: Gallimard, 1975.

——. *Henry Miller: The Paris Years.* New York: Arcade, 1995.

——. *Henry Miller: Rocher heureux.* Paris: Gallimard, 1975.

——. *Letters to My Parents.* Chicago: University of Chicago Press, 1997.

——. *Nächtliches Paris/Paris de nuit.* Essays by Paul Morand, Lawrence Durrell, and Henry Miller. Munich: Schirmer/Mosel, 1979.

——. *Neuf* (January 1952), n.p.

——. *Paris after Dark.* London: Batsford, 1933.

——. *Paris by Night.* Reprint of *Paris de nuit* (1932). Translated by Stuart Gilbert. New York: Pantheon; London: Thames and Hudson, 1987.

——. *Paris de nuit.* Essay by Paul Morand. Paris: Arts et Métiers Graphiques, 1932. Reprint, Paris: Arts et Métiers Graphiques, 1933; Paris: Flammarion, 1987; Tokyo: Misuzu Shobo, 1987.

——. *Le Paris secret des années 30.* Paris: Gallimard, 1976.

——. *Picasso vu par Brassaï.* Essay by Marie-Laure Bernadac. Paris: Musée Picasso, 1987.

——. *Proust sous l'emprise de la photographie.* Paris: Gallimard, 1997.

——. *The Secret Paris of the 1930s.* New York: Pantheon, 1976. Reprint, London: Thames and Hudson, 2001.

——. "Technique de la photographie de nuit." *Arts et métiers graphiques,* no. 33 (January 1933): 24–27.

——. *Voluptés de Paris.* Paris: Paris-Publications, 1935.

BRASSAÏ, AND SALVADOR DALÍ. "De la beauté terrifiante et comestible, de l'architecture 'Modern Style.'" *Minotaure,* no. 3 (1933): 68.

——. "Sculptures involontaires." *Minotaure,* no. 3 (1933): 69–76.

BRECHT, BERTOLT. *Brecht on Theater: The Development of an Aesthetic.* Edited and translated by John Willett. 1963–64. Reprint, New York: Hill and Wang, 1977.

BRETON, ANDRÉ. *L'amour fou.* Paris: Gallimard, 1937.

——. *Nadja.* Paris: Gallimard, 1928. Reprint, Paris: Gallimard, 1964.

BRETON, ANDRÉ, AND PHILIPPE SOUPAULT. *Les champs magnétiques.* Paris: Gallimard, 1920.

BRINGUIER, PAUL. "Mystère des gares." Photographs by Eli Lotar. *Détective* 1, no. 24 (June 29, 1929): 3.

BROWN, KATHRYN. "Remembering the Occupation: *La mort et les statues* by Pierre Jahan and Jean Cocteau." *Forum for Modern Language Studies* 49, no. 3 (October 2012): 286–99.

BRUNET, FRANÇOIS. *Photography and Literature.* London: Reaktion, 2009.

BURRI, RÉNÉ. *Les Allemands.* Paris: Delpire, 1963.

BURY, STEPHEN. *Breaking the Rules: The Printed Face of the European Avant-Garde, 1900–1937.* London: British Library, 2007.

CAMPANY, DAVID. *William Klein: ABC.* New York: Abrams, 2013.

CAMUS, ALBERT. *L'étranger.* Paris: Gallimard, 1942.

CANEVARI, JACQUELYN. "William Klein and the Photographic Book." Unpublished paper, Boston University, 2011.

CARREFOUR. Unsigned review, "Les Américains." November 19, 1958, 14.

CARTIER-BRESSON, HENRI. *André Breton: Roi soleil.* Paris: Fata Morgana, 1995.

———. *China.* New York: Bantam, 1964.

———. *China Gestern und Heute.* Text by Henri Cartier-Bresson. Dusseldorf: Karl Rauch, 1955.

———. *China in Transition.* Text by Henri Cartier-Bresson. London: Thames and Hudson, 1956.

———. *Da una Cina all'altra.* Text by Henri Cartier-Bresson. Milan: Artimport, 1956.

———. *Les danses à Bali.* Paris: Delpire, 1954.

———. *The Decisive Moment.* New York: Simon and Schuster, 1952. Reprint, with an essay by Clément Chéroux, Göttingen: Steidl, 2014.

———. *D'une Chine à l'autre.* Texts by Jean-Paul Sartre and Henri Cartier-Bresson. Paris: Delpire, Collection Neuf, 1954.

———. *The Europeans.* New York: Simon and Schuster, 1955.

———. *Les Européens.* Paris: Verve, 1955.

———. *From One China to the Other.* With text by Han Suyin and Henri Cartier-Bresson. New York: Universe, 1956.

———. "Henri Cartier-Bresson: Intruder on Tiptoe." *Harper's Bazaar,* October 1952, 163.

———. *Images à la sauvette.* Paris: Verve, 1952. Reprint, with an essay by Clément Chéroux, Göttingen: Steidl, 2014.

———. "Interview." In *Dialogue with Photography,* by Paul Hill and Thomas Cooper, 69–79. New York: Farrar, Straus, Giroux, 1979.

———. *Menschen in Moskau.* Dusseldorf: Karl Rauch, 1955.

———. *The Mind's Eye: Writings on Photography and Photographers.* New York: Aperture, 2005.

———. *Mosca vista da Henri Cartier-Bresson.* Paris: Robert Delpire; Milan: Artimport, 1955.

———. *Moscou, vu par Henri Cartier-Bresson.* Paris: Delpire, Collection Neuf, 1955.

———. *The People of Moscow.* New York: Simon and Schuster, 1955.

———. *The People of Moscow, as Seen and Photographed by Henri Cartier-Bresson.* London: Thames and Hudson, 1955.

CENDRARS, BLAISE. *L'homme foudroyé.* Paris: DeNoël, 1945.

CENDRARS, BLAISE, AND SONIA DELAUNAY-TERK. *La prose du Transsibérien et de la petite Jehanne de France.* Paris: Des Hommes Nouveaux, 1913.

CHADWYCK-HEALEY, CHARLES. "Literature of Liberation." *Parenthesis,* no. 20 (Spring 2011): 1–21.

CHARBONNIER, GIL. "À Valéry Larbaud. Paul Morand discipulus: Morand-Larbaud: le jeu des influences créatrices." In *Paul Morand, singulier et pluriel,* edited by Catherine Douzou, 151–62. Lille: Collection UL3 Travaux et Recherches, Université Charles-de-Gaulle-Lille, 2007.

CHARRIER, PHILIP. "The Making of a Hunter: Moriyama Daidō, 1966–1972." *History of Photography* 34, no. 3 (August 2010): 268–90.

CHERONNET, LOUIS. Column. *L'art vivant* 3 (January 1, 1927): 26–27.

CHÉROUX, CLÉMENT, ED. "A Bible for Photographers." In *The Decisive Moment,* by Henri Cartier-Bresson, 1–30. Göttingen: Steidl, 2014.

———. *Henri Cartier-Bresson: Here and Now.* London: Thames and Hudson, 2014.

———. "Pourtant Mac Orlan: La photographie et le fantastique social." In *Pierre Mac Orlan: Écrits sur la photographie,* edited by Chéroux, 7–27. Paris: Textuel, 2011.

CLARK, CATHERINE E. "Capturing the Moment, Picturing History: Photographs of the Liberation of Paris." *American Historical Review* 121, no. 3 (June 2016): 824–60.

———. *Paris and the Cliché of History: The City and Photographs, 1860–1970.* Oxford: Oxford University Press, 2018.

CLOCHE, MAURICE. *Suite de photos.* Paris: Arts et Métiers Graphiques, 1930.

CLOUZOT, HENRI. *Tissus nègres.* Paris: Librairie des Arts Décoratifs, 1921.

COCTEAU, JEAN. *The Journals of Jean Cocteau.* Edited and translated by Wallace Fowlie. New York: Criterion, 1956.

———. "Salut à Breker." *Comoedia* (May 23, 1942): 1.

———. *Two Screenplays: The Blood of a Poet and The Testament of Orpheus.* New York: Marion Boyars, 1985.

CONE, MICHÈLE C. *Artists under Vichy: A Case of Prejudice and Persecution.* Princeton: Princeton University Press, 1992.

CRANE, HART. *The Bridge.* With photographs by Walker Evans. Paris: Black Sun, 1930. Reprint, New York: Liveright, 1930.

CURRY, MANFRED. *À travers les nuages.* Paris: Arts et Métiers Graphiques, 1932.

CURTIS, VERNA, ED. *Photographic Memory: The Album in the Age of Photography.* New York: Aperture, 2011.

"DAIDŌ MORIYAMA." In *Daidō Moriyama,* edited by Hervé Chandès, n.p. Paris: Fondation Cartier pour l'art contemporaine, Actes Sud, 2003.

DANAHY, MICHAEL. "Marceline Desbordes-Valmore (1786–1859)." In *French Women Writers,* edited by Eva Martin Sartori and Dorothy Wynne Zimmerman, 121–33. Lincoln: University of Nebraska Press, 1994.

DECARAVA, ROY. *The Sweet Flypaper of Life.* New York: Simon and Schuster, 1955.

DELPIRE ET CIE: COFFRET. 3 vols. Paris: Delpire, 2009.

DELPIRE, ROBERT. 1954 brochure. *Neuf* series. Paris: Delpire, 1954.

DENOYELLE, FRANÇOISE. "Arts et métiers graphiques: Histoires d'images d'une revue de caractère." *La recherche photographique* 3 (December 1987): 6–17.

———. "De la collaboration à la libération: Quels photographes pour quels types d'images?" In *Les médias et la libération en Europe, 1945–2005,* edited by Christian Delporte and Denis Maréchal, 163–79. Paris: Centre d'Histoire Culturelle des Sociétés Contemporaines/Institut National de l'Audiovisuel, 2006.

———. *La lumière de Paris: Les usages de la photographie 1919–1939.* Paris: L'Harmattan, 1997.

———. *La photographie d'actualité et de propaganda sous le régime de Vichy.* Paris: CNRS, 2003.

———. "Photographie et collaboration: Les épurations de l'industrie et les agencies photographiques." *Histoire et archives: Revue de la Société des Amis des Archives de France,* no. 9 (January–June 2001): 125–65.

DESCHIN, JACOB. "Focusing on Europe: Cartier-Bresson Produces a New Volume." *New York Times,* December 11, 1955, 171.

———. "Mankind in Pictures, Steichen Planning Exhibit on International Theme." *New York Times,* September 21, 1952, X17.

———. "The Right Moment: Work of Cartier-Bresson Is Lesson in Timing." *New York Times,* October 19, 1952, X15.

———. "The Work of French Photographers: Museum Show Points Up Their Ability to Use the Commonplace." *New York Times,* December 21, 1951, X14.

DESNOS, ROBERT. "Pygmalion et le Sphinx." *Documents* 1 (January 1930): 32–39.

DESVEAUX, DELPHINE, MARTA GILI, CATHERINE GONNARD, MICHAËL HOULETTE, AND PATRICK-GILLES PERSIN. *Laure Albin Guillot, l'enjeu classique.* Paris: Jeu de Paume/de La Martinière, 2013.

DESVEAUX, DELPHINE, AND MICHÄEL HOULETTE. "Laure Albin-Guillot (1879–1962): The Question of Classicism." *Le petit journal, Jeu de Paume* 100 (February 26–May 12, 2013): n.p.

DOCUMENTARY AND ANTI-GRAPHIC: PHOTOGRAPHS BY CARTIER-BRESSON, WALKER EVANS, AND ALVAREZ BRAVO. Göttingen: Steidl, 2004.

DOISNEAU, ROBERT. *La banlieue de Paris.* Text by Blaise Cendrars. Paris: Seghers/La Guilde du Livre, 1949. Reprint, Paris: Denoël, 1983.

———. *Instantanés de Paris.* Paris: Arthaud, 1955.

———. *La Loire.* Paris: Denoël-Filipacchi, 1978.

———. *Le mal de Paris.* Paris: Arthaud, 1980.

———. *Les Parisiens tells qu'ils sont.* Paris: Delpire, Collection Huit, 1954.

———. *Trois seconds d'éternité.* Paris: Contrejour, 1979.

———. *Le vin des rues.* Paris: Denoël, 1983.

DRUCKER, JOHANNA. *The Century of Artists' Books.* New York: Granary, 2004.

DUCASSE, ISIDOR. *Maldoror and Poems.* Translated by Paul Knight. London: Penguin Classics, 1988.

DUDLEY, ANDREW, AND STEPHEN UNGAR. *Popular Front Paris and the Politics of Culture.* Cambridge, MA: Harvard University Press, 2005.

DUFOUR, DIANE, AND MATTHEW WITKOVSKY, EDS. *Provoke: Between Protest and Performance.* Göttingen: Steidl, 2016.

DURRELL, LAWRENCE. "Essay." In *Brassaï,* edited by John Szarkowski, 9–15. New York: Museum of Modern Art, 1968.

ECO, UMBERTO. *The Open Work.* Cambridge, MA: Harvard University Press, 1989.

EHRENBOURG, ILYA. *Moj Parisz.* Moscow: Isogiz, 1933.

EISENSTEIN, SERGEI. "The Cinematographic Principle and the Ideogram" (1929). Afterword in N. Kaufman, ed. *Yaponskoye kino.* Moscow, 1930. Reprinted in *Film Form: Essays in Film Theory,* edited by Jay Leyda, translated by Ivor Montagu and S. S. Nolbandov, 28–44. New York: Harcourt, Brace, 1949.

———. "A Dialectic Approach to Film Form" (1929). Manuscript in Eisenstein Collection, Museum of Modern Art Film Library, New York. Reprinted in *Film Form: Essays in Film Theory,* edited by Jay Leyda, translated by John Winge, 45–63. New York: Harcourt, Brace, 1949.

———. "Word and Image" (1938, first published as "Montage"). Reprinted in *The Film Sense,* edited and translated by Jay Leyda, 3–69. New York: Meridian, World, 1957.

ÉLUARD, PAUL. "Liberty." Translated by George Dillon. *Poetry* (October 1945): 5–8.

EMNERS, L. "Protest gegen ein unmögliches Bauwerk: Eine interessante Prophezeiung aus dem Jahre 1889." *UHU* (December 1927): 106–11.

D'ESPEZEL, PIERRE, AND ROGER SCHALL. *Paris Relief.* Paris: Chantecler, 1945.

EVANS, WALKER. *American Photographs.* Afterword by Lincoln Kirstein. New York: Museum of Modern Art, 1938. 2nd ed., New York: Museum of Modern Art, 1962. 50th anniversary ed. New York: Museum of Modern Art, 1988. Rev. ed., New York: Errata, 2011. 75th anniversary ed., New York: Museum of Modern Art, 2012.

———. "Cartier-Bresson, a True Man of the Eye." *New York Times,* October 19, 1952, BR7.

———. "The Reappearance of Photography." *Hound and Horn* 5, no. 1 (1931).

FARGUE, LÉON-PAUL. *Banalité.* Paris: NRF/Gallimard, 1928. Illustrated edition with photographs by Roger Parry, Paris: NRF/Gallimard, 1930.

———. *Le piéton de Paris.* Paris: Gallimard, 1939.

———. *Sous la lampe.* Paris: NRF/Gallimard, 1929.

FATOUROS, A.A. "Review: Sartre on Colonialism." *World Politics* 17, no. 4 (July 1965), 703–19.

FELS, FLORENT. "Acier." *Jazz* 5 (April 15, 1929): 232–34.

———. "Dans toute sa force." *VU,* no. 11 (May 30, 1928): 284.

———. "Preface." In *Métal,* by Germaine Krull, n.p. Paris: Librairie des Arts Décoratifs, A. Calavas, 1928.

———. "Le premier salon independent de la photographie." *L'art vivant* 83 (June 1, 1928): 445.

———. "Steel." *VU,* no. 3 (April 4, 1928): 43.

FERNÁNDEZ, HORACIO. *The Latin American Photobook.* New York: Aperture, 2011.

FIVE FRENCH PHOTOGRAPHERS. New York: Museum of Modern Art, 1952.

FONKENELL, GUILLAUME, ED. *The Louvre during the War–Photographs 1938–1947.* Paris: Musée du Louvre, 2009.

FOSTER, HAL. *Compulsive Beauty.* Cambridge, MA: MIT Press, 1995.

FOUCAULT, MARC. *Paris.* Paris: Tel, 1942.

FRANK, ROBERT. *Les Américains.* Texts by Alain Bosquet, Simone de Beauvoir, Bernard Iddings Bell, John Brown, Erskine Caldwell, F. R. de Chateaubriand, Stephen Crane, John Dewey, John Dos Passos, William Faulkner, Benjamin Franklin, Abraham Lincoln, André Maurois, Henry Miller, Franklin D. Roosevelt, Claude Roy, André Siegfried, John Steinbeck, Adlai Stevenson, Alexis de Tocqueville, Harry S. Truman, George Washington, and Walt Whitman. Encyclopédie essentielle 5; serie histoire no. 3. Paris: Robert Delpire, 1958.

———. *The Americans.* Introduction by Jack Kerouac. New York: Grove, 1959. 50th anniversary ed., Göttingen: Steidl, 2008.

———. *Indiens des hauts-plateaux.* Text by Georges Arnaud. Neuf, no. 8. Paris: Delpire, 1952.

———. *The Lines of My Hand.* Tokyo: Yugensha, 1972.

FREEMAN, KIRRILY. *Bronzes to Bullets: Vichy and the Destruction of French Public Statuary, 1941–44.* Palo Alto: Stanford University Press, 2009.

FRIEDLANDER, LEE. *The American Monument.* New York: Eakins, 1976.

———. *Letters from the People.* New York: Distributed Art Publishers, 1993.

FRIZOT, MICHEL. *Germaine Krull.* Paris: Jeu de Paume, 2015.

———, ED. *Henri Cartier-Bresson: Scrap Book, 1932–1946.* Introduction by Agnès Sire. London: Thames and Hudson, 2007.

———. "Interview with Robert Delpire" and "Robert Frank and Robert Delpire." In *Looking In: Robert Frank's The Americans,* ed. Sarah Greenough, 190–200. Washington, D.C.: National Gallery of Art, 2009.

———. *VU: The Story of a Magazine.* London: Thames and Hudson, 2009.

GALASSI, PETER. *Brassaï.* Madrid: Fundación Mapfre, 2018.

———. *Henri Cartier-Bresson: The Early Work.* New York: Museum of Modern Art, 1987.

———. *Henri Cartier-Bresson: The Modern Century.* New York: Museum of Modern Art, 2010.

GALLOTTI, JEAN. "La photographie est-elle un art? Germaine Krull." *L'art vivant* 5 (July 1, 1929): 526–27, 530.

GARDNER, ALEXANDER. *Gardner's Photographic Sketch Book of the War.* Washington, D.C.: Philip and Solomons, 1866. Reprint, New York: Delano Greenidge, 2001.

GAUTRAND, JEAN-CLAUDE. "Looking at Others: Humanism and Neo-Realism." In *A New History of Photography,* edited by Michel Frizot, 612–32. Cologne: Könemann, 1988.

GEORGE, WALDEMAR. "Photographie-vision du monde." In *Arts et métiers graphiques "Photographie,"* special edition, nos. 16, 5–20, 121–61. Paris: Arts et Métiers Graphiques, 1930.

GHYKA, MATILA. *L'esthétique des proportions dans la nature et dans les arts.* Paris: Gallimard, 1927.

GIERTSBERG, FRITS, AND RIK SUERMONDT, EDS. *The Dutch Photobook: A Thematic Selection from 1945 Onwards.* New York: Aperture, 2012.

GODEFROY, CÉCILE. "Images simultanées; les photographies de mode de Germaine Krull commandées par Sonia Delaunay." *Histoire de l'art,* no. 48 (June 2001): 99–113.

GOLAN, ROMY. *Modernity and Nostalgia: Art and Politics in France between the Wars.* New Haven: Yale University Press, 1995.

GOLDIN, NAN. *The Ballad of Sexual Dependency.* New York: Aperture, 1987.

GOLDSCHMIDT, LUCIEN, AND WESTON J. NAEF. *The Truthful Lens: A Survey of the Photographically Illustrated Book 1844–1914.* New York: Grolier Club, 1980.

GREENOUGH, SARAH. *Looking In: Robert Frank's The Americans.* Expanded edition. Washington, D.C.: National Gallery of Art/Steidl, 2009.

GRESH, KRISTEN. "The European Roots of *The Family of Man.*" *History of Photography* 9, no. 4 (Winter 2005): 331–43.

LA GUILDE DU LIVRE: LES ALBUMS PHOTOGRAPHIQUES, 1941–1977. Paris: Yeux Ouverts, 2012.

GUIMOND, JAMES. *American Photography and the American Dream.* Chapel Hill: University of North Carolina Press, 1991.

GUNTHER, THOMAS MICHAEL, AND MARIE DE THÉZY. *Alliance Photo.* Paris: Paris Bibliothèques, 1989.

——. *Images de la libération de Paris.* Paris: Paris-Musées, 1994.

HAMBIDGE, JAY. *The Parthenon and Other Greek Temples: Their Dynamic Symmetry.* New Haven: Yale University Press, 1924.

HAMILTON, PETER. "France and Frenchness in Post-War Humanist Photography." In *Representation: Cultural Representations and Signifying Practice,* edited by Stuart Hall, 75–150. London: Sage/Open University, 1997.

——. *Robert Doisneau: A Photographer's Life.* New York: Abbeville, 1995.

HEITING, MANFRED, ED. *The Japanese Photobook, 1912–1990.* Göttingen: Steidl, 2017.

HEITING, MANFRED, AND MIKHAIL KARASIK, EDS. *The Soviet Photobook, 1920–1941.* Göttingen: Steidl, 2015.

HENRI CARTIER-BRESSON: PHOTOGRAPHIES, 1930–1955. Paris: Musée des Arts Décoratifs, Pavillon Marsan, Palais du Louvre, 1955.

HENRIOT, ÉMILE. Review, "Photos de Paris." *Le temps* (January 30, 1933): 15.

HERVÉ, LUCIEN. *The Eiffel Tower.* New York: Princeton Architectural Press, 2002.

HIRSCH, MARIANNE. "Surviving Images." In *Visual Culture and the Holocaust,* edited by Barbie Zelizer, 215–46. New Brunswick, NJ: Rutgers University Press, 2000.

HITE, TESSA. "Exhume, Confront, Rebury." Unpublished essay, Boston University, spring 2015.

HOLLIER, DENIS. *Against Architecture: The Writings of Georges Bataille.* Cambridge, MA: MIT Press, 1989.

HORINO, MASAO. *Kamera. Me x tetsu. Kosei* [Camera: Eye x Steel: Composition]. Tokyo: Mokuseisha Shoin, 1932. Reprint, Tokyo: Kokusho Kankokai, 2005.

HUGHES, ALEX, AND ANDREA NOBLE. "Introduction." In *Phototextualities: Intersections of Photography and Narrative,* edited by Alex Huges and Andrea Noble, 1–16. Albuquerque: University of New Mexico Press, 2003.

HUNTER, JEFFERSON. *Image and Word: The Interaction of Twentieth-Century Photographs and Texts.* Cambridge, MA: Harvard University Press, 1987.

ILIAZD (ILIA ZDANEVICH). *Ledentu le phare: poéme dramatique en zaoum.* Paris: Éditions du 41°, 1923.

IMAHASHI, EIKO. "Brassaï: Crossing Boundaries in Paris." In *Brassaï: Au delà des frontières de Paris,* translated by Ruth S. McCreery, 7–9. Tokyo: Hakusuisha, 2007.

INGELMANN, INKA GRAEVE, "Moï Wer." In *Ci-Contre: 110 Photos de Moï Wer (Moshé Raviv-Vorobeichic),* translated by Rachel Riddell, n.p. Zülpich: Ann und Jürgen Wilde, 2004.

L'INSTANTANÉ. Unsigned review, "Extrait de *Paris de nuit.*" February 1933, 30.

IZIS, AND JACQUES PRÉVERT. *Grand bal du printemps.* Lausanne: Clairefontaine, 1951.

——. *Paris des rêves.* Lausanne: Clairefontaine, 1950.

J., A. "Les statues Parisiennes de grands hommes." *Gazette des beaux-arts* 83, no. 1262 (March 1974): 149–52.

JAHAN, PIERRE. *Les chapiteaux de Chauvigny.* Paris: du Rocher, 1959.

——. *Dévot Christ de la cathédrale Saint-Jean de Perpignan.* Paris: O.E.T., 1934.

——. *L'eglise de la Sorbonne.* Paris: du Cerf, 1946.

——. *études sur les chapiteaux de l'église de Chauvigny.* Monte Carlo: de Monaco, 1947.

——. *Les gisants: vingt-cinq rois et reines de France.* Paris: Paul Morihien, 1949.

——. "La guerre de 1939 à 1945." Musée National d'Art Moderne, Centre Georges Pompidou, AM 2007–108.

——. *Lourdes.* Paris: du Cerf, 1946.

——. *La mort et les statues.* Text by Jean Cocteau. Paris: du Compas, 1946. Reprint, Paris: Seghers, 1977; Paris: de l'Amateur, 2008.

——. "La mort et les statues, 1941." *Gazette des beaux-arts* 119, nos. 1296–1301 (1977): 154.

——. *Le mystère des cathédrales.* Paris: J. J. Pauvert, 1964.

——. *Objectif.* Paris: Marval, 1994.

——. *Paris.* Paris: du Panorama, 1951.

——. *La route de Chartres.* Paris: du Cerf, 1948.

——. *Sénanque, les monastères de France.* Paris: du Cerf, 1946.

——. *Voyage de Paris.* Paris: Nouvelle France, 1950.

JAHAN, PIERRE, AND JEAN COCTEAU. *Plain-chant.* Paris: Galerie Michelle Chomette, 1988.

JAMESON, FREDRIC. "Postmodernism and Consumer Society" (1982). Whitney Museum Lecture. Reprinted in *The Anti-Aesthetic: Essays on Postmodern Culture,* ed. Hal Foster, 111–25. Seattle: Bay, 1983.

JANIS, EUGENIA PARRY, AND WENDY MACNEIL, EDS. *Photography within the Humanities.* Danbury, NH: Addison, 1977.

KANEKO, RYŪICHI, AND IVAN VARTANIAN. *Japanese Photobooks of the 1960s and '70s.* New York: Aperture, 2009.

KARLSGODT, ELIZABETH CAMPBELL. "Recycling French Heroes: The Destruction of Bronze Statues under the Vichy Regime." *French Historical Studies* 29, no. 1 (Winter 2006): 143–81.

KAWADA, KIKUJI. *Chizu* [The Map]. Text by Kenzaburō Oe. Tokyo: Bijutsu Shuppa-sha, 1965.

——. "Points of Memory: Kikuji Kawada, Conflict Time, Photography." *Tate Etc.,* no. 32 (Autumn 2014). http://www.tate.org.uk/context-comment/articles/points-memory-kikuji-kawada.

KERTÉSZ, ANDRÉ. *Day of Paris.* New York: J. J. Augustin, 1945.

——. *Enfants.* Paris: d'Histoire et d'Art, 1933.

——. *Nos amies les bêtes.* Paris: d'Histoire et d'Art, 1934.

——. *Paris vu par André Kertész.* Paris: d'Histoire et d'Art, 1934.

KESSEL, JOSEPH. "Paris la nuit." *Détéctive*, no. 3 (November 15, 1928): 3.

KIRSTEIN, LINCOLN. "Artist with a Camera." *New York Times*, February 2, 1947, 12.

——. "Henri Cartier-Bresson: Documentary Humanist." In *The Photographs of Henri Cartier-Bresson*, ed. Beaumont Newhall, 7–11. New York: Museum of Modern Art, 1947.

KLEIN, WILLIAM. *Life Is Good and Good for You in New York: Trance Witness Revels.* Paris: du Seuil, 1956; Milan: Feltrinelli, 1956; London: Photography Magazine, 1956. Reprint, New York: Errata Editions, 2016.

——. *MOSKAU.* Hamburg: Nannen, 1964; New York: Crown, 1964; Italy: Silvana editorial d'arte, 1964; Tokyo: Zokeisha, 1964.

——. "Preface." In *New York 1945–55* [reprint of *Life Is Good and Good for You in New York: Trance Witness Revels*], 4–5. Manchester: Dewi Lewis, 1995.

——. *Rome.* Paris: du Seuil/Album Petite Planète 3, 1959; Rome: Giangiacomo Feltrinelli, 1959; London: Vista/Edward Hulton, 1959; New York: Viking, 1959.

——. *Tokio.* Hamburg: Nannen, 1964.

——. *Tokyo.* Paris: Delpire, 1964; New York: Crown, 1964; Italy: Silvana, 1964; Tokyo: Zokeisha, 1964.

KOETZLE, HANS-MICHAEL. *Eyes on Paris: Paris im Fotobuch 1890 bis Heute.* Hamburg: Hirmer, 2011.

KOZLOFF, MAX. "William Klein and the Radioactive Fifties." *Artforum* 19, no. 9 (May 1981): 34–41.

KRAUSS, ROSALIND, AND JANE LIVINGSTON. *L'Amour fou: Photography and Surrealism.* New York: Abbeville, 1985.

——. "Nightwalkers." *Art Journal* 41, no. 1 (Spring 1981): 33–38.

KRULL, GERMAINE. *100 x Paris.* Berlin: Reihe, 1929.

——. *La bataille d'Alsace.* Text by Roger Vailland. Paris: Jacques Haumont, 1945.

——. "Click entre deux guerres." Unpublished manuscript, 1976. Germaine Krull Nachlass, Folkwang Museum, Essen.

——. *Études de nu.* Paris: Librairie des Arts Décoratifs, 1930.

——. *La folle d'Itteville.* Text by Georges Simenon. Paris: Jacques Haumont, 1931.

——. *Marseille.* Text by André Suarès. Paris: Art et d'Histoire, 1935.

——. *Métal.* 1928. Paris: Librairie des Arts Décoratifs, A. Calavas, 1928. Reprint, Cologne: Ann und Jürgen Wilde, 2003.

——. *La route Paris-Biarritz.* Text by Claude Farrère. Paris: Jacques Haumont, 1931.

——. *La route de Paris à la Méditerranée.* Edited by Paul Morand. With additional photographs by André Kertész and others. Paris: Firmin-Didot, 1931.

——. *Le Valois.* Text by Gérard de Nerval. Paris: Firmin-Didot, 1930.

——. *La vie mène la danse.* Unpublished memoir, 1980–81. Germaine Krull Nachlass, Folkwang Museum, Essen. Published as *La vie mène la danse.* Paris: Textuel, 2015.

——. *La vita conduce la danza.* Translated by Giovanna Chiti. Florence: Giunti Gruppo Editoriale, 1992.

KZ: BILDBERICHT AUS FÜNF KONZENTRATIONSLAGERN. Washington, D.C.: American War Information Unit, 1945.

DE LACRETELLE, JACQUES. *La libération de Paris 1945.* Paris: Fasquelle, 1945.

LANGE, DOROTHEA, AND PAUL TAYLOR. *An American Exodus.* New York: Reynal and Hitchcock, 1939.

LANNES, ROGER. "Preface." In *Les gisants: Tome premier; Vingt-cinq rois et reines de France*, by Jean-François Noël and Pierre Jahan, n.p. Paris: Paul Morihien, 1949.

LEE, ANTHONY W., AND RICHARD MEYER. *Weegee and Naked City.* Berkeley: University of California Press, 2008.

LEE, ANTHONY W., AND ELIZABETH YOUNG. *On Alexander Gardner's Photographic Sketch Book of the Civil War.* Berkeley: University of California Press, 2007.

LENNAD, ROLAND. *Les hommes verts.* Photographs by Roger Schall. Paris: Raymond Schall, 1945.

LERSKI, HELMAR. *Köpfe des Alltags: Unbekannte Menschen.* Berlin: Hermann Reckendorf, 1931.

LESSING, GOTTHOLD EPHRAIM. *Laocoön: An Essay on the Limits of Painting and Poetry* (1767). Translated by Edward Allen McCormick. Indianapolis: Bobbs-Merrill, 1962.

LEVY, RENÉ. Review, "Quelques visions du monde en photographie." *Le Monde*, no. 244 (February 4, 1933): 6.

LUPTON, CATHERINE. *Chris Marker: Memories of the Future.* London: Reaktion, 2004.

LYFORD, AMY. *Surrealist Masculinities: Gender Anxiety and the Aesthetics of Post–World War I Reconstruction in France.* Berkeley: University of California Press, 2007.

MAC ORLAN, PIERRE. *Claude Cahun, Aveux non avenus.* Paris: Carrefour, 1930.

——. *Écrits sur la photographie.* Edited by Clément Chéroux. Paris: Textuel, 2011.

——. "Elements of a Social Fantastic" (1929). Reprinted in *Photography in the Modern Era: European Documents and Critical Writings, 1913–1940*, edited by Christopher Phillips, translated by Robert Erich Wolf, 31–33. New York: Metropolitan Museum of Art/Aperture, 1989.

——. *Germaine Krull: Les photographes nouveaux.* Paris: NRF/Gallimard, 1931.

——. *Paris vu par André Kertész.* Paris: Éditions d'Histoire et d'Art/ Librairie Plon, 1934.

——. "Photographie. Éléments de fantastique social." *Le crapouillot* (January 1929): 3–5.

——. "Preface." In *Atget photographe de Paris*, 1–23. Paris: Henri Jonquières; New York: E. Weyhe, 1930.

——. *Quai des brumes.* Paris: Gallimard, 1927.

——. *La tradition de minuit.* Paris: Émile-Paul Frères, 1930.

——. *Villes.* Paris: Gallimard, 1929.

MAC ORLAN, PIERRE, AND OTTO STEINERT. *Le NU International.* Paris: Braun, 1954.

MAGILOW, DANIEL H. *The Photography of Crisis: The Photo Essays of Weimar Germany.* University Park: Pennsylvania State University Press, 2012.

MAISEL, DAVID. *Library of Dust.* San Francisco: Chronicle, 2008.

MALLARMÉ, STÉPHANE. *Un coup de dés jamais n'abolira le hasard.* Paris: Gallimard, 1914.

MANDÉRY, GUY. *Robert Doisneau: Un photographe et ses livres.* Melun: Yeux Ouvertes, 2013.

MARAÏ, SANDOR. Review, "A Párisi éjszaka [Paris Nights]." *Az Ujsag* (February 26, 1933): n.p.

MARINETTI, FILIPPO. *Zang Tumb Tumb.* Milan: Futurista di "Poesia," 1914.

MARTINE, CLAUDE. "Trois voyageurs nous livrent une Amérique préfabriquée." *Arts: lettres, spectacles* (December 17–23, 1958): 3.

MAURIAC, FRANÇOIS. *Paris libéré.* Paris: Flammarion, 1945.

MAYAKOVSKY, VLADIMIR, AND EL LISSITSKY. *Dlya Golossa* [For the Voice]. Berlin: Gozisdat, 1923.

MCCABE, JAMES. *Paris by Sunlight and Gaslight: A Work Descriptive of the Miseries, the Virtues, the Vices, the Splendors and the Crimes of Paris.* Philadelphia: National, 1869.

MCDONNELL, HUGH. *Europeanising Spaces in Paris, c. 1947–1962.* Liverpool: Liverpool University Press, 2016.

MCDONOUGH, TOM. *"The Beautiful Language of My Century": Reinventing the Language of Contestation in Postwar France, 1945–1968.* Cambridge, MA: MIT Press, 2007.

MEISTER, SARAH HERMANSON. *Bill Brandt: Shadow and Light.* New York: Museum of Modern Art, 2013.

MEKOUAR, MOUNA, AND CHRISTOPHE BERTHOUD. *Roger Parry: Photographies, dessins, mises en pages.* Paris: Gallimard/Jeu de Paume, 2007.

MESSAC, RÉGIS. *Le detective novel et l'influence de la pensée scientifique.* Paris: Librairie Ancienne Honoré Champion, 1929.

MICHALSKI, SERGIUSZ. *Public Monuments: Art in Political Bondage 1870–1997.* London: Reaktion, 1998.

MICHELSON, ANNETTE. "Dr. Crase and Mr. Clair." *October* 11 (Winter 1979): 31–53.

MILLER, HENRY. "The Eye of Paris." *Globe* (November 1937). Reprinted in Henry Miller, *Max and the White Phagocytes,* 239–52. Paris: Obelisk, 1938.

———. *Tropic of Cancer.* Paris: Obelisk, 1934; New York: Grove, 1961.

MILLER, LEE. *Wrens in Camera.* London: Hollis and Carter, 1945.

MITCHELL, W. J. T. *Picture Theory: Essays on Verbal and Visual Representation.* Chicago: University of Chicago Press, 1995.

MOHOLY-NAGY, LÁSZLÓ. *Malerei Photographie Film.* Munich: Albert Langen, 1925.

———. "Scharf oder unscharf?" *i10* 2, no. 20 (1929): 163–67.

MOLDERINGS, HERBERT. "Moshé Raviv-Vorobeichik (Moï Ver)." In *Photography at the Bauhaus,* edited by Jeannine Fiedler, 74–84. Cambridge, MA: MIT Press, 1990.

———. "Photographic History in the Spirit of Constructivism: Reflections on Walter Benjamin's 'Little History of Photography.'" Translated by John Brogden. *Art in Translation* 6, no. 3 (2014): 317–44.

MOLZAHN, JOHANNES. "Nicht mehr sehen! Lesen!" *Das Kunstblatt* 12, no. 3 (March 1928): 81.

MORAND, PAUL. *Bucarest.* Paris: Plon, 1935.

———. *Londres.* Paris: Plon, 1933.

———. *New York.* Paris: Flammarion, 1930.

———. *Ouvert la nuit.* Paris: NRF/Gallimard, 1922.

———. "Visages de Paris: La nuit." *L'intransigeant,* November 7, 1932, 8.

MORIYAMA, DAIDŌ. *Daidō Moriyama.* Paris: Actes Sud; New York: Thames and Hudson, 2003.

———. *Nippon Gekigyō Shashin* [Japan: A Photo Theater]. Tokyo: Muromachi Shobo, 1968.

———. *Shashin Yo Sayonara* [Farewell, Photography]. Tokyo: Shashin Hyoron-sha, 1972.

MOROZ, SARAH. "William Klein, 'My Pictures Showed Everything I Resented about America.'" *Guardian,* November 6, 2014, 1–4.

MUNDY, JENNIFER, ED. *Surrealism: Desire Unbound.* London: Tate Gallery; Princeton: Princeton University Press, 2001.

NAKAHIRA, TAKUMA. *Kitanubeki Kotoba no Tamenu* [For a Language to Come]. Tokyo: Fudosha, 1970.

NARCEJAC, THOMAS. *Esthétique du roman policier.* Paris: Le Portulan, 1947.

NELSON, ANDREA. "Reading Photobooks: Narrative Montage and the Construction of Modern Visual Literacy." PhD diss., University of Minnesota, 2007.

NEW YORK TIMES. "Books Published Today." October 15, 1952, 29.

NICKEL, DOUGLAS. *Francis Frith in Egypt and Palestine: A British Photographer Abroad.* Princeton: Princeton University Press, 2003.

NIEUWE ROTTERDAMSCHE COURANT AVONDBLAD. "Boekaankondigingen: Fransche Letteren." December 29, 1932, 2.

NOËL, JEAN-FRANÇOIS, AND PIERRE JAHAN. *Les gisants: Vingt-cinq rois et reines de France.* Paris: Paul Morihien, 1949.

VAN NOORT, KIMBERLY PHILPOT. *Paul Morand: The Politics and Practice of Writing in Postwar France.* Amsterdam: Rodopi, 2001.

NORA, PIERRE. "Between Memory and History: *Les lieux de mémoire.*" *Representations* 26 (Spring 1989): 7–24.

———. *Les lieux de mémoire.* 3 vols. Paris: Gallimard, 1984–93.

LES NOUVELLES LITTÉRAIRES, ARTISTIQUES ET SCIENTIFIQUES. Unsigned review, "Paris de nuit," no. 536, January 21, 1933, 1–2.

O'HAGAN, SEAN. "Cartier-Bresson's Classic Is Back—But His Decisive Moment Has Passed." *Guardian,* December 23, 2014. https://www .theguardian.com/artanddesign/2014/dec/23/henri-cartier-bresson -the-decisive-moment-reissued-photography.

O'RAWE, DES. "Eclectic Dialectics: William Klein's Documentary Method." *Film Quarterly* 66, no. 1 (Fall 2012): 50–61.

ORY, PASCAL. "L'oeil du désastre." In *La mort et les statues,* by Pierre Jahan and Jean Cocteau, 7–13. Paris: de l'Amateur, 2008.

PARIS AFTER DARK. Paris: Jules Boyer, 1877.

PARIS AT NIGHT: MYSTERIES OF PARIS HIGH LIFE AND DEMI-MONDE. Paris: A. Chaie, 1869.

PARR, MARTIN, AND WASSINKLUNDGREN, EDS. *The Chinese Photobook: From the 1900s to the Present.* New York: Aperture, 2015.

PEISSI, PIERRE. *Eiffel.* Paris: du Verger, 1946.

PETIT, GEORGES. *Madagascar.* Photographs by R. Mourlan. Paris: Arts et Métiers Graphiques, 1933.

PHILLIPS, CHRISTOPHER, ED. *Photography in the Modern Era: European Documents and Critical Writings, 1913–1940.* New York: Metropolitan Museum of Art/Aperture, 1989.

PIERRE JAHAN PHOTOGRAPHE. http://pierrejahan.free.fr/pjahan /pj_homme.php.

PHOTOGRAPHY BY HENRI CARTIER-BRESSON: ANTI-GRAPHIC PHOTOGRAPHY. New York: Julien Levy Gallery, 1935.

POUEY, FERNAND. "Un pur." With photographs by Brassaï. *Paris Magazine* (April 1933), n.p.

PRÉVOST, JEAN. *Eiffel.* Paris: Rieder, 1929.

PROWN, JULES. "Mind in Matter: An Introduction to Material Culture Theory and Method." *Winterthur Portfolio* 17, no. 1 (Spring 1982): 1–19.

R., O. Review, "Bibliographie: Livres illustrés." *L'illustration,* no. 4698 (March 18, 1933): 18.

RABB, JANE. *Literature and Photography: Interactions, 1840–1990: A Critical Anthology.* Albuquerque: University of New Mexico Press, 1995.

RAY, MAN. *Les champs délicieux.* Portfolio of twelve photograms, preface by Tristan Tzara. Paris, 1922.

———. *Électricité.* Paris: Compagnie Parisienne de Distribution d'Electricité, 1931.

RENGER-PATZSCH, ALBERT. *Die Welt ist Schön.* Munich: Kurt Wolff, 1928.

———. *Eisen und Stahl.* Berlin: Hermann Reckendorf, 1931.

RIBEMONT-DESSAIGNES, GEORGES. *Man Ray: Peintres nouveaux.* Paris: Gallimard, 1930.

ROCHE, ANTOINE. *Paris.* Paris: Librairie des Arts Décoratifs, 1928, 1929, 1930.

RODGER, GEORGES. *Le village des Noubas.* Paris: Delpire, 1954.

RONIS, WILLY. *Belleville-Ménilmontant.* Text by Pierre Mac Orlan. Paris: Arthaud, 1954.

ROOT, WAVERLY LEWIS. Review, "Brassaï Makes Photo Record of Nocturnal Paris." *Chicago Daily Tribune,* Paris edition, March 13, 1933, 2.

ROPS, DANIEL. "Review of *Métal.*" *Europe,* November 27, 1929. Reprinted in Pierre Mac Orlan, *Germaine Krull: Les photographes nouveaux.* Paris: NRF/Gallimard, 1931, 15.

ROSLER, MARTHA. *Three Works*. Halifax: Nova Scotia College of Art and Design, 1981.

ROTH, ANDREW, ED. *The Book of 101 Books: Seminal Photographic Books of the Twentieth Century*. New York: PPP/Roth Horowitz, 2001.

——, ED. *The Open Book: A History of the Photographic Book from 1878 to the Present*. Göteborg: Hasselblad Center, 2004.

RUSCHA, ED. *Twenty-Six Gasoline Stations*. Hollywood: National Excelsior [self-published], 1962.

RUSCHA, ED, PATRICK BLACKWELL, AND MASON WILLIAMS. *Royal Road Test*. Self-published, 1967.

SALMON, ANDRÉ. "Toulon." *Jazz* 8 (August 15, 1929): 343–46.

SALON DE L'ESCALIER, 1ER SALON INDÉPENDANT DE LA PHOTOGRAPHIE. Museum of Modern Art Archives, New York.

SALTZMAN, LISA. *Anselm Kiefer and Art after Auschwitz*. Cambridge: Cambridge University Press, 1999.

SANDEEN, ERIC J. *Picturing and Exhibition: The Family of Man and 1950s America*. Albuquerque: University of New Mexico Press, 1995.

SANDWEISS, MARTHA. *Print the Legend: Photography and the American West*. New Haven: Yale University Press, 2002.

SARTRE, JEAN-PAUL. "Camus's *The Outsider*" (1947). Reprinted in *Literary and Philosophical Essays*, translated by Annette Michelson, 26–44. New York: Collier, 1962.

——. *Colonialism and Neocolonialism*. Translated by Azzedine Haddour, Steve Brewer, and Terry McWilliams. 1964. Reprint, London: Routledge, 2001.

——. *Critique de la raison dialectique*. Paris: Gallimard. 1960.

——. "Preface." In *D'une Chine à l'autre*, by Henri Cartier-Bresson, n.p. Paris: Delpire, Collection Neuf, 1954.

SAULNIER, SERGE. "Morand ou 'l'homme-frontière.'" In *Paul Morand, singulier et pluriel*, edited by Catherine Douzou, 107–19. Lille: Collection UL3 Travaux et Recherches, Université Charles-de-Gaulle-Lille, 2007.

SAUNIER, CHARLES. "Le métal: Inspirateur d'art." *L'art vivant* 5 (May 1, 1929): 361, 368–69.

SAYAG, ALAIN, AND ANNICK LIONEL-MARIE. *Brassaï*. Paris: Centre Pompidou/Seuil; London: Thames and Hudson, 2000.

SCARRY, ELAINE. *The Body in Pain: The Making and Unmaking of the World*. Oxford: Oxford University Press, 1985.

SCHALL, ROGER. *Paris de jour*. Paris: Arts et Métiers Graphiques, 1937.

——, ED. *À Paris sous la botte des Nazis*. Text by Jean Eparvier. Paris: Raymond Schall, 1944.

SEAVER, RAY. "An Exhibit of Draeger Frères, Paris, Sometimes Called World's Finest Printers." *Direct Advertising* 38, no. 2 (1952): 9–12.

LA SEMAINE HÉROÏQUE. Paris: S. E. P. E., 1944.

SERRY, HERVÉ. *Les éditions du Seuil: 70 ans d'histoire*. Paris: Seuil, 2007.

SHERMAN, DANIEL. *Worthy Monuments: Art Museums and the Politics of Culture in Nineteenth-Century France*. Cambridge, MA: Harvard University Press, 1989.

SHKLOVSKY, VIKTOR. "Art as Device" (1917). Reprinted in *Theory of Prose*, translated by Benjamin Sher, 1–14. Normal, IL: Dalkey Archive, 1990.

——. "Art as Technique" (1917). Reprinted in *Russian Formalist Criticism: Four Essays*, edited and translated by Lee T. Lemon and Marion J. Reis, 3–24. Lincoln: University of Nebraska Press, 1965.

SHLOSS, CAROL. *In Visible Light: Photography and the American Writer*. Oxford: Oxford University Press, 1987.

SICHEL, KIM. "Contortions of Technique: Germaine Krull's Experimental Photography." In *Object: Photo. Modern Photographs: The Thomas Walther Collection 1909–1949*, edited by Mitra Abbaspour, Lee Ann Daffner, and Maria Morris Hambourg, 1–8. New York: Museum of Modern Art, 2014. http://www.moma.org/interactives /objectphoto/assets/essays/Sichel.pdf.

——. *From Icon to Irony: German and American Industrial Photography*. Boston: Boston University Art Gallery; Seattle: University of Washington Press, 1995.

——. *Germaine Krull: Avantgarde als Abenteuer: Leben und Werk der Photographin Germaine Krull*. Munich: Schirmer/Mosel, 1999.

——. *Germaine Krull: Photographer of Modernity*. Cambridge, MA: MIT Press, 1999.

——. "Germaine Krull and *L'amitié noire*: World War II and French Colonialist Film." In *Colonialist Photography: Imag(in)ing Race and Place*, edited by Eleanor Hight and Gary Sampson, 257–80. London: Routledge, 2002.

——. "Lee Friedlander, *The American Monument*, and Eakins Press." *Exposure* 47, no. 1 (Spring 2014): 40–56.

——. *Paris le jour, Paris la nuit*. Paris: Musée Carnavalet, 1988.

——. "Les photographes étrangers à Paris durant l'entre deux guerres." In *Le Paris des étrangers depuis un siècle*, edited by André Kaspi and Antoine Marès, 329–45. Paris: Imprimerie Nationale, 1989.

SIMMEL, GEORG. "The Metropolis and Mental Life" (1903). Reprinted in *The Sociology of Georg Simmel*, translated by Kurt Wolff, 409–26. Glencoe, IL: Free Press, 1950.

SINGH, DAYANITA. *Museum Bhavan*. Göttingen: Steidl, 2017.

SLIWINSKI, SHARON. *Human Rights in Camera*. Chicago: University of Chicago Press, 2011.

SMALL, RACHEL. "A Lens on William Klein." *Interview*, March 1, 2013, 1–5. http://www.interviewmagazine.com/art/william-klein#.

SMITH, DOUGLAS. "*From One China to the Other*: Cartier-Bresson, Sartre, and Photography in the Age of Decolonization." *Photographies* 2, no. 1 (March 2009): 59–71.

SONTAG, SUSAN. *On Photography*. New York: Farrar, Straus, Giroux, 1977.

——. *Regarding the Pain of Others*. New York: Farrar, Straus, Giroux, 2003.

SOUGEZ, EMMANUEL. "Manifesto, Le rectangle." *Photos-Illustrations*, no. 33 (June 1938).

STEEGMULLER, FRANCIS. *Jean Cocteau and the French Scene*. New York: Abbeville, 1984.

STEICHEN, EDWARD, ED. *The Family of Man: The Photographic Exhibition*. New York: Simon and Schuster/Museum of Modern Art, 1955.

STETLER, PEPPER. *Stop Reading! Look! Modern Vision and the Weimar Photographic Book*. Ann Arbor: University of Michigan Press, 2015.

STEVENS, ISABEL. "Isabel Stevens on Chris Marker's 'Petite Planète.'" *Aperture* 217 (Winter 2014): 1–7. http://aperture.org/blog/isabel -stevens-chris-markers-petite-planete.

STONE, SASHA. *Femmes*. Paris: Arts et Métiers Graphiques, 1933.

STOTT, WILLIAM. *Documentary Expression and Thirties America*. Chicago: University of Chicago Press, 1973, 1986.

STRAND, PAUL. *La France de profil*. Lausanne: La Guilde du Livre, 1952.

SURYA, MICHEL. *Georges Bataille: An Intellectual Biography*. Translated by Krzysztof Fijalkowski and Michael Richardson. New York: Verso, 2002.

SZYMUSIAK, DOMINIQUE. "Matisse et Tériade, le peintre et le poète." In *Matisse et Tériade*, edited by Dominique Szymusiak and Casimiro di Crescenzo, 55–66. Florence: Artificio, 1996.

TABARD, MAURICE. "Cartier-Bresson et Geometrie." Undated typescript. Richard L. Simon Papers, Columbia University Library, New York.

TAKANASHI, YUTAKA. *Toshi-e* [Towards the City]. Tokyo: Izara Shobo [self-published], 1974.

TALBOT, WILLIAM HENRY FOX. *The Pencil of Nature*. London: Longman, Brown, Green and Longmans, 1844–46.

TAMBRUN, CATHERINE, ED. *Paris libéré, photographié, exposé.* Paris: Musée Carnavalet, 2015.

TAYLOR, PAUL, AND DOROTHEA LANGE. *An American Exodus.* New York: Reynal and Hitchcock, 1939.

THACKARA, DIVINA. Review of *Public Monuments: Art in Political Bondage, 1870–1997,* by Sergiusz Michalski. *Burlington Magazine* 141, no. 1155 (June 1999): 364.

DE THÉZY, MARIE. *La photographie humaniste 1930–1960: Histoire d'un movement en France.* Paris: Contrejour, 1992.

TRACHTENBERG, ALAN. *Brooklyn Bridge: Fact and Symbol.* Chicago: University of Chicago Press, 1979.

——. *Reading American Photographs: Images as History, Mathew Brady to Walker Evans.* New York: Hill and Wang, 1989.

TUCKER, ANNE WILKES. *Brassaï: The Eye of Paris.* Houston: Museum of Fine Arts, 1999.

——. *Robert Frank: From New York to Nova Scotia.* Boston: New York Graphic Society/Little, Brown, 1986.

TUGGENER, JAK. *Fabrik: Ein Bildepos der Technik.* Zurich: Roteapfel, 1943.

TUPITSYN, MARGARITA. *The Soviet Photograph, 1924–1937.* New Haven: Yale University Press, 1996.

TURVEY, MALCOLM. *The Filming of Modern Life: European Avant-Garde Films of the 1920s.* Cambridge, MA: MIT Press, 2011.

TZARA, TRISTAN, ED. *Dada,* no. 3. Zurich, 1918.

DE LA VAISSIÈRE, ROBERT. "Les nuits changées, 1910–1927." *Les nouvelles littéraires* (April 7, 1928): 1.

VARIÉTÉS. Unsigned review, "*Métal* par Germaine Krull." January 15, 1929, 1, no. 9, 509–10.

VER, MOÏ (VORBEICHIC, M.). *Ci-contre. 110 Photos de Moï Wer (Moshé Raviv-Vorobeichic).* Zülpich: Ann und Jürgen Wilde, 2005.

——. *Ein Ghetto im Osten—Wilna.* Zurich: Orell Füssli, 1931.

——. *Paris: 80 Photographs de Moï Ver.* Paris: Jeanne Walter, 1931. Reprint, Paris: Éditions 2L, 2002.

VETHEUIL, JEAN. "La ville photogénique." *Photo-ciné-graphie,* no. 21 (November 1934): cover, 1–2.

WALKER, IAN. *City Gorged with Dreams: Surrealism and Documentary Photography in Interwar Paris.* Manchester: Manchester University Press, 2002.

WALZ, ROBIN. *Pulp Surrealism: Insolent Popular Culture in Early Twentieth-Century Paris.* Berkeley: University of California Press, 2000.

WAREHIME, MARJA. *Brassaï: Images of Culture and the Surrealist Observer.* Baton Rouge: Louisiana University Press, 1996.

WEBER, EUGEN. *The Hollow Years: France in the 1930s.* New York: Norton, 1994.

WEEGEE. *Naked City.* New York: Essential, 1945.

WEISSBERG, LILIANE. "In Plain Sight." In *Visual Culture and the Holocaust,* edited by Barbie Zelizer, 13–27. New Brunswick, NJ: Rutgers University Press, 2000.

WESTERBECK, COLIN. "Night Light: Weegee and Brassaï." *Artforum* 15, no. 4 (December 1976): 34–45.

WHITE, MINOR. "Book Review: Les Américains." *Aperture* 7, no. 3 (1959): 127.

——. "Henri Cartier-Bresson/The Decisive Moment." *Aperture* 2, no. 4 (1953): 41.

WHITMAN, WALT. "To Working Men." In *Leaves of Grass,* 61. Brooklyn: Walter Whitman, 1855.

WIMMER, ROBERT. *Reflets de Paris. Impressions d'un soldat allemande.* Paris: Librairie Française de Documentation, 1941.

WINEGARTEN, RENÉE. "Who Was Paul Morand?" *New Criterion* 6 (November 1987): 71–73.

WINN, JAMES ANDERSON. *The Poetry of War.* Cambridge: Cambridge University Press, 2008.

WOLFE, H. ASHTON. "La detection scientifique du crime." *VU,* no. 81 (September 11, 1929): 722–23. [Continued in issue nos. 84, 93, 99, 124, 138.]

WRIGHT, RICHARD. *12 Million Black Voices.* New York: Viking, 1941.

WYE, DEBORAH. *Artists and Prints: Masterworks from the Museum of Modern Art.* New York: Museum of Modern Art, 2004.

ZELIZER, BARBIE. *Remembering to Forget: Holocaust Memory through the Camera's Eye.* Chicago: University of Chicago Press, 1998.

ILLUSTRATION CREDITS

The photographers and the sources of visual material other than the owners indicated in the captions are as follows. Every effort has been made to supply complete and correct credits; if there are errors or omissions, please contact Yale University Press so that corrections can be made in any subsequent edition.

Brassaï (dit), Halász Gyula (1899–1984) photographe: © Estate Brassaï—RMN-Grand Palais; photo Don Ross SFMOMA (figs. 1, 33)

© Estate Germaine Krull, Folkwang Museum, Essen; photo The J. Paul Getty Museum, Los Angeles (fig. 2)

© Estate Germaine Krull, Folkwang Museum, Essen; photo Courtesy Harvard Library Imaging Services (figs. 3–12)

© Estate Germaine Krull, Folkwang Museum, Essen (figs. 13, 83)

© Karl Blossfeldt Archiv/Ann and Jürgen Wilde/Cologne, Germany/Artists Rights Society (ARS), NY, photo Economic Botany Library of Oakes Ames, Harvard University (fig. 14)

Photo Courtesy Harvard Library Imaging Services (figs. 15, 133)

© Estate Germaine Krull, Folkwang Museum, Essen; photo Courtesy Harvard Library Imaging Services (figs. 16, 17)

Photo The J. Paul Getty Museum, Los Angeles (figs. 18, 19)

© Pracusa 2018658, © Blaise Cendrars pour le texte/poésies complètes/éditions Denoel, photo Yale University Library (fig. 20)

© 2018 Estate of László Moholy-Nagy/Artists Rights Society (ARS), New York; photo Courtesy Harvard Library Imaging Services (fig. 24)

© 2018 Albert Renger-Patzsch Archiv/Ann and Jürgen Wilde, Zülpich/Artists Rights Society (ARS), New York (fig. 25)

Courtesy of the Moi Ver Estate and the Raviv Family, Tel Aviv (figs. 26–29)

© The Museum of Modern Art/licensed by SCALA/Art Resource, NY and © The Walker Evans Archive, The Metropolitan Museum of Art (figs. 30, 32)

The J. Paul Getty Museum, Los Angeles, © Walker Evans Archive, The Metropolitan Museum of Art (fig. 31)

Brassaï (dit), Halász Gyula (1899–1984) photographe: © Estate Brassaï—RMN-Grand Palais, photo Courtesy Harvard Library Imaging Services (figs. 33–42, 45–48)

© Estate Germaine Krull, Folkwang Museum, Essen; photo © The Museum of Modern Art/Licensed by SCALA/Art Resource, NY (fig. 43)

© Roger Parry/dist. RMN-Grand Palais/Art Resource, NY; photo Courtesy Harvard Library Imaging Services (figs. 49, 50)

Brassaï (dit), Halász Gyula (1899–1984) photographe: © Estate Brassaï—RMN-Grand Palais, photo The Manhattan Rare Book Company (figs. 51, 52)

Brassaï (dit), Halász Gyula (1899–1984) photographe: © Estate Brassaï—RMN-Grand Palais (fig. 53)

© Roger Schall/Musée Carnavalet/Roger-Viollet (figs. 54, 55, 85)

Bill Brandt © Bill Brandt Archive (figs. 56, 57)

© 2019 Martha Rosler, photo Courtesy Harvard Library Imaging Services (fig. 58)

© Pierre Jahan/Roger-Viollet/The Image Works; photo National Gallery of Art Library, David K. E. Bruce Fund (figs. 59, 60, 62, 63, 66–73, 75, 77)

Wikimedia (fig. 61)

Courtesy Harvard Library Imaging Services (fig. 74)

Photo Library of Congress (fig. 79)

© Pierre Jahan/Roger-Viollet/The Image Works (figs. 80–82)

© Lee Miller Archives, England 2018. All rights reserved. www.leemiller.co.uk (fig. 84)

© Roger Parry/dist. RMN-Grand Palais/Art Resource, NY (fig. 86)

© Lee Friedlander, courtesy Fraenkel Gallery, San Francisco (fig. 87)

© David Maisel (fig. 88)

© 2020 Succession H. Matisse/Artists Rights Society (ARS), New York; photo Courtesy Fondation Henri Cartier-Bresson (fig. 89)

© 2020 Succession H. Matisse/Artists Rights Society (ARS), New York; Photography Collection, The New York Public Library (fig. 90)

© Henri Cartier-Bresson/Magnum Photos; photo Courtesy Harvard Library Imaging Services (figs. 91, 92)

© Ministère de la culture–Médiathèque du Patrimoine/Willy Ronis/dist. RMN/Art Resource, NY (fig. 93)

© Robert Doisneau/Gamma Rapho; photo National Gallery of Art Library, David K. E. Bruce Fund (fig. 94)

© Robert Doisneau/Gamma Rapho (figs. 95, 97–99)

© Henri Cartier-Bresson/Magnum Photos (figs. 96, 112–15)

© Henri Cartier-Bresson/Magnum Photos; photo Courtesy Harvard Library Imaging Services (figs. 100–107)

© Henri Cartier-Bresson/Magnum Photos; photo Richard L. Simon Papers, Columbia University Library (fig. 108)

INDEX